개정판
레이아웃 불변의 법칙
100가지

한 권으로 끝내는 그리드 사용법

개정판
레이아웃 불변의 법칙 100가지
한 권으로 끝내는 그리드 사용법

개정판 인쇄 | 2019년 12월 19일
개정판 발행 | 2020년 1월 17일

지은이 | 베스 톤드로
옮긴이 | 오윤성 · 이희수
발행인 | 안창근
기획 · 편집 | 안성희
디자인 | JR 디자인 고정희
영업 · 마케팅 | 민경조
펴낸곳 | 아트인북
출판등록 | 제2013-000297호
주소 | 서울시 마포구 동교로22길 22, 301호
전화 | 02 996 0715
팩스 | 02 996 0718
홈페이지 | www.koryobook.co.kr
이메일 | koryo81@hanmail.net
인스타그램 | www.instagram.com/artinbooks_
페이스북 | www.facebook.com/artinbooks
트위터 | https://twitter.com/koryobook
ISBN | 979-11-89375-02-7 93600

Layout Essentials, Revised and Updated
ⓒ 2009, 2019 Quarto Publishing Group USA Inc.
Korean translation copyright ⓒ 2020 by KORYOMUNHWASA PUBLISHING.
Korean translation rights arranged with Quarto Publishing Group USA Inc. through Agency-One, Seoul, Korea

* 잘못된 책은 구입처에서 바꿔 드립니다.
* 아트인북은 고려문화사의 예술 도서 브랜드입니다.

* 일러두기: 책 제목은 『 』로, 잡지와 신문, 그 밖의 간행물은 「 」로 표기하였다.

이 도서의 국립중앙도서관 출판예정도서목록(CIP)은 서지정보유통지원시스템 홈페이지(http://seoji.nl.go.kr)와
국가자료종합목록 구축시스템(http://kolis-net.nl.go.kr)에서 이용하실 수 있습니다.(CIP제어번호 : CIP2019034793)

혼합
신뢰할 수 있는
원천의 종이
FSC® C016973

개정판
레이아웃 불변의 법칙 100가지

한 권으로 끝내는 그리드 사용법

베스 톤드로 지음
오윤성·이희수 옮김

아트인북

"자연계의 질서 체계가 생물과 무생물의 성장과 구조를 지배하듯 인간의 활동도 초창기부터 자체의 질서를 추구하는 특징이 있었다."

— 요제프 뮐러 브로크만 JOSEF MÜLLER–BROCKMANN

"그리드는 판면 레이아웃 영역에서 가장 진가를 인정받지 못하고 오용되고 있는 요소다. 그리드는 그것이 다루고자 하는 재료에서 비롯되어야만 효과를 발휘한다."

— 데릭 버솔 Derek Birdsall, 『책 디자인에 관한 이야기들(*Notes on Book Design*)』

"디자이너가 판면에 나타나는 모든 표면적 문제를 해결했다고 해도, 그리드가 내포하는 획일성을 뛰어넘어 페이지의 처음부터 끝까지 그리드를 통해 독자의 관심을 사로잡는 요소들을 힘찬 시각적 내러티브로 보여줄 때에야 비로소 성공적인 그리드를 구사했다고 할 수 있다."

— 티모시 사마라 Timothy Samara 『그리드를 넘어서(*Making and Breaking the Grid*)』

친절하고, 다정하고, 재미있고, 세심하고, 쾌활하고,
짜증을 웃음으로 받아줄 만큼 참을성 있고, 게다가
요리까지 잘하는 등 가진 장점만 최소 아흔두 가지인
패트릭 제임스 오닐에게

목차

들어가는 말

그리드 시스템은 수많은 종류의 커뮤니케이션을 위해 공간을 체계적으로 구성하고 광범위한 내용을 보조하면서 질서를 명하고 유지하지만 대개는 눈에 잘 띄지 않습니다. 그리드는 배치도지 감옥이 아닙니다.

그리드는 이미 몇 백 년 전부터 사용되어 왔으며 그래픽 디자이너들은 스위스 디자인과 그리드를 서로 떼려야 뗄 수 없는 관계로 인식합니다. 1940년대의 '질서'에 대한 열망은 만물을 거의 다 시각화할 수 있는 방식을 창조했습니다. 세월이 흘러 20세기 말에 이르자 그리드가 단조롭고 지루한 것으로 여겨지게 되었습니다. 하지만 엄청난 양의 데이터와 이미지가 다양한 플랫폼을 넘나들며 빠르게 움직이는 지금, 그리드는 많은 신진 디자이너와 숙련된 현역 디자이너 모두에게 꼭 필요한 도구로 다시 인정받고 있습니다.

이 책은 그리드의 사용법에 대한 견해를 짧게 제시해놓은 입문서입니다. 100가지 법칙을 통해 레이아웃이나 커뮤니케이션 시스템을 구축하는 데 도움이 되는 핵심 정보를 제공하는 한편, 세계 곳곳의 디자이너와 디자인 회사들이 여러 매체에 작업한 프로젝트 이미지들을 풍부하게 소개해놓았습니다.

홀로 작동하는 법칙이란 존재하지 않습니다. 프로젝트나 시스템마다 여러 개의 법칙이 포함되어 있기 마련입니다. 그래서 이번 개정판에서는 몇몇 법칙들이 같은 프로젝트의 다른 부분이나 별개의 프로젝트를 교차 참조하는 양상을 목록으로 정리해봤습니다. 한 가지 사례가 하나 이상의 법칙에서 커뮤니케이션 시스템을 구성하는 요소로 등장할 것입니다. 이번 개정판은 인쇄물, 데스크톱, 태블릿, 모바일 기기에 적용된 디자인 사례가 전보다 훨씬 풍부해졌으며 앞에 언급된 매체 모두에 적용된 사례도 볼 수 있습니다.

이 책에 강점이 있다면 그것은 모두 재능과 아량을 겸비한 디자이너들의 작업에서 비롯된 것입니다. 영감을 주는 견고하고 유쾌하고 절제된 그들의 작업 덕분에 내용 면에서 내실을 다질 수 있었습니다. 개정판 『레이아웃 불변의 법칙 100가지』에 실린 모든 사례가 여러분에게 정보를 제공하고 호기심과 흥미를 불러일으킴과 동시에 꼭 명심해야 할 커뮤니케이션 수칙, 즉 여러분의 작업이 여러분이나 기획자가 전달하려는 것을 반영하고, 더욱 공고히 해야 한다는 사실을 다시 한 번 환기하는 계기가 되었으면 합니다.

그리드의 기초

1 요소를 파악하라

그리드를 구성하는 요소에는 단, 모듈, 마진, 스페이셜 존, 플로우라인, 마커가 있다. 새 프로젝트를 시작하는 것이 힘들 수 있다. 일단 목차부터 시작하고 마진과 단을 정하는 것으로 넘어가도록 하자. 여러 가지 조정이 필요하겠지만 복잡하게 생각하지 말고 일단 시작하자.

단
(COLUMNS)

활자나 이미지를 담는 수직 방향의 면이다. 내용에 따라 단의 너비나 한 페이지에 들어갈 단의 개수를 달리한다.

모듈
(MODULES)

일정한 간격으로 구획되는 단위 공간. 그리드에 반복성과 질서를 부여하는 요소다. 모듈을 조합하여 수직이나 수평으로 다양한 크기의 단을 구성할 수 있다.

마진
(MARGINS)

여유 공간. 판면에 담긴 내용과 재단선 사이의 빈 공간이다(양 페이지 사이의 여백도 마진이다). 마진에 주석이나 캡션 등 하위 정보를 배치하기도 한다.

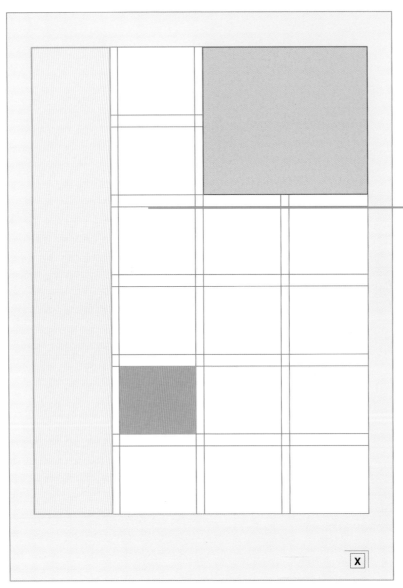

스페이셜 존
(SPATIAL ZONES)

몇 개의 모듈 혹은 몇 개의 단을 합친 것. 활자, 이미지, 광고 등을 배치하는 데 쓰인다.

플로우라인
(FLOWLINES)

판면을 가로로 나누는 정렬선이다. 실제로 표시되는 선은 아니고, 한 페이지 전체에서 독자의 시선을 유도할 수 있도록 공간과 요소들을 배치하는 기준선이다.

마커
(MARKERS)

전체 문서에서 해당 페이지의 위치를 알려주는 내비게이션 요소로, 페이지마다 같은 위치에 배치한다. 페이지 번호, 페이지 위아래에 표시하는 표제, 아이콘 등을 넣는다.

2 기본 구조를 익혀라

아래 도식은 흔히 사용하는 구조들이지만 기본 배열에 추가적으로 변형을 가한 것이다.
신문과 신문 사이트의 다단 그리드는 3단을 넘어 5단 이상으로 확장된다.

1단 그리드

설명글, 보고서, 단행본처럼
연속적인 글에 적용한다.
텍스트 블록이 페이지의
주요 요소다.

2단 그리드

텍스트 양이 많거나 정보의
성격이 다양할 때 단을
나누어 배치한다. 두 단의
너비가 같을 수도 있고
다를 수도 있다. 비대칭 2단
그리드에서 최상의 비율은
1:2다.

다단 그리드

다양한 너비의 단을
조합한 다단 그리드는
1단, 2단 그리드보다
활용도가 훨씬 높다.
잡지, 웹사이트용.

모듈 그리드

신문, 달력, 그래프,
목록처럼 복잡한 정보를
담아내기에 가장 좋은
그리드다. 판면을 수직과
수평으로 구획하여 공간을
작은 덩어리들로 쪼갠다.

계층 그리드

한 면을 몇 개의 구역으로
나누는 그리드다. 보통
여러 개의 가로 단으로
구성된다. 일부 잡지는
목차 페이지를 가로로
배치한다. 모바일 기기도
사용 편의와 효율을 위해
내용을 여러 개의 가로띠로
잘게 자르는 것이 많다.

먼저 질문해야 할 내용

• 내용이 무엇인가? 복잡한가?
• 양은 얼마나 되나?
• 목표는 무엇인가?
• 독자/방문자/사용자는 누구인가?

3 내용을 파악하라

내용, 마진, 이미지의 양, 적절한 쪽수(화면 수) 등 모든 요소를 고려하여 하나의 그리드를 선택하게 된다. 그중에서도 가장 중요한 결정 요소는 내용이다. 물론 각 작업의 특수한 디자인 이슈에 따라 다르지만 일반적으로는 다음과 같은 원칙에 따라 그리드를 결정한다.

- **1단 그리드**는 설명글이나 단행본처럼 연속적인 텍스트를 담을 때 사용한다. 다단 그리드보다 위화감이 적으면서 더 풍부하게 보인다. 미술 서적이나 카탈로그에 적합하다.

- **2단** 또는 **다단 그리드**는 텍스트가 다소 복합적일 때 사용한다. 한 단을 두 개로 나누면 그리드를 다양하게 응용할 수 있다. 다단 그리드는 웹사이트처럼 글, 영상, 광고 등 광범위한 정보를 동시에 처리하는 데 사용한다.

- **모듈 그리드**는 달력이나 일정표처럼 많은 양의 정보를 각 단위 정보로 나누어 담을 때 유용하다. 신문처럼 정보가 여러 구역으로 분할되는 내용에도 적합하다.

- **계층 그리드**는 판면이나 화면을 수평으로 구획한다. 계층 그리드가 가장 효과적으로 쓰이는 경우는 내용이 간단한 웹사이트로 스크롤바를 내려가면서 읽기 편하도록 정보 덩어리를 수평으로 정렬한다.

모든 그리드는 질서를 부여하기 위한 것으로, 어떤 경우에나 계획과 계산이 필요하다. 웹디자인, 책 디자인, 광고 디자인 등 어느 경우에나 질서 있고 합리적인 그리드를 구축하기 위해서는 정확한 계산이 필요하다는 것을 기억하자.

작업명
「*Good*」

의뢰인
Good Magazine, LLC

디자인
Open

디자이너
Scott Stowell

일류 디자이너가 어떤 방식으로 그리드를 개발하는지 보여주는 스케치다.

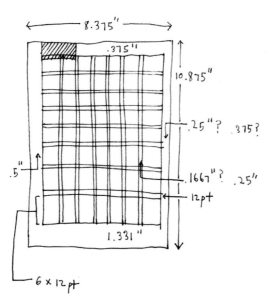

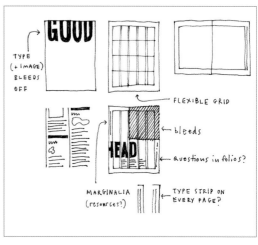

이 개발 단계의 스케치는 한 잡지의 판형에 어떤 그리드들을 도입할 수 있는지를 보여준다.

4 계산하라

우선 중심 텍스트를 파악하여 작업의 심도를 분석한다. 작업에는 대부분 판형, 쪽수, 색에 정해진 범위가 있다. 내용을 중심으로 판단하되 작업의 기준 요소들을 고려하자.

원고와 판면 또는 화면의 크기가 결정되었다면, 다음에는 텍스트를 판면에 어떻게 앉힐지를 생각한다. 텍스트만 있는 원고는 할당된 쪽수에 맞춰 텍스트를 배치한다. 텍스트 외에 이미지나 표제부, 박스 장치, 그래프 등 다른 요소를 함께 다룰 때는 먼저 텍스트 공간을 확보하고 나서 나머지 공간에 그 밖의 정보를 배치한다. 보통 함께 들어갈 요소 전체를 동시에 고려해서 계산해야 할 때가 많다.

내용과 판면 구성의 기본 방향을 설정했다면 이제 표제 및 정보의 체계를 자세하게 파악할 차례다. (다음 장으로 이어진다)

타이포그래피에 관한 조언

활자에서 느껴지는 질감은 활자의 크기, 자간, 장평, 행갈이에서 비롯된다. 연속적으로 이어지는 텍스트 문장을 일관적인 색으로 처리해야 읽는 사람이 쉽게 따라갈 수 있다. 원고의 양이 많을 때는 충분히 큰 활자를 사용하고 행간을 충분히 둬야 읽기가 수월하다. 단의 너비가 좁으면 활자 크기를 줄이거나 아니면 행의 왼쪽 끝은 맞추고 오른쪽은 흘리는 정렬 방식으로 단어 사이에 틈이 벌어지지 않도록 해야 한다.

서체가 다르면 활자도 다르게 조판되므로 활자 크기에 정답은 없다. 예를 들어 헬베티카체 10포인트(10pt. Helvetica) 활자는 가라몬드체 10포인트(10pt. Garamond) 활자보다 훨씬 커 보인다. 이 단락은 대부분 윤고딕체 8포인트로 조판되었으며 행간은 13포인트다. 서체는 연구할 가치가 있다.

작업명
『*Astronomy*』,
『*Symbols of Power*』

의뢰인
Harry N. Abrams, Inc.

디자인 감독
Mark LaRivière

디자인
BTDNYC

디자이너
Beth Tondreau,
Suzanne Dell'Orto,
Scott Ambrosino
(『*Astronomy*』만 작업)

그리드를 1단 또는 2단으로 할 것인가는 내용의 성격과 텍스트의 양에 따라 결정된다.

천문학 사진을 실은 이 책은 텍스트를 1단으로 처리하여 심원한 우주 공간의 이미지를 부각시켰다.

텍스트 양이 많은 이 카탈로그는 2단 그리드에 텍스트와 이미지를 배치했다.

정보의 구성

5 가독성을 높여라

한 원고에는 주 제목, 부제목, 표, 단락 구분점 등의 요소가 하나 혹은 여러 개 들어 있다. 이때 가장 중요한 정보는 활자 크기를 키우거나 볼드체로 설정하여 전면에 드러내거나, 다른 텍스트와 구별되도록 다른 종류의 서체를 사용한다. 서체의 종류, 크기와 두께 등을 이용하면 성격이 다른 텍스트를 서로 구분해주면서도 판면의 흐름을 해치지 않을 수 있다. 대신 명확한 목적에 따라 텍스트 스타일을 설정해야만 각 스타일 사이에 혼동이 생기지 않는다.

활자의 크기만큼 중요한 것이 여백이다. 제목의 위치와 여백의 정도를 조정하여 제목부를 강조할 수 있다. 읽는 이가 성격이 다른 여러 종류의 텍스트를 쉽게 구분할 수 있게 하려면 텍스트를 읽기 쉬운 단편으로 분할하는 것이 좋다. 인용문 장치는 뉴스의 헤드라인과 같은 역할을 하고, 사이드바, 박스 등은 여러 정보를 한눈에 구분할 수 있게 한다. 그리고 타이포그래피를 조절하여 읽는 이가 해당 내용의 성격을 즉시 파악할 수 있도록 한다.

작업명(왼쪽)
「*Symbols of Power*」

의뢰인
Harry N. Abrams, Inc.

디자인 감독
Mark LaRivière

디자인
BTDNYC

보도니(Bodoni)체를 사용한 고전적인 타이포그래피로 작품이 제작된 나폴레옹 시대의 분위기를 반영했다.

작업명(오른쪽)
「*Blueprint*」

의뢰인
Martha Stewart Omnimedia

디자인 감독
Deb Bishop

디자이너
Deb Bishop

현대적인 타이포그래피로 깔끔하고 유익하며 자신감이 넘치는 성격을 나타냈다.

한 종류의 서체로 작업할 때 가장 효과적인 타이포그래피 전략은 로마체 대문자와 소문자, 이탤릭체 대문자와 소문자를 조합하여 위계질서를 구축하는 것이다. 복합적인 정보를 다룰 때는 다양한 서체와 활자 크기를 이용해 각 텍스트를 적절히 구별해준다.

다양한 서체와 활자 크기, 박스 장치를 활용하여 성격이 다양한 정보를 적절히 배치한다.

6 순서를 정하라

한 작업에서 모든 이미지를 동일한 크기로 사용하는 일은 거의 없다. 텍스트가 정보를 전달하듯이 이미지의 크기는 해당 사건이나 주제의 중요성을 말해준다. 어떤 작업에서는 디자이너가 레이아웃을 결정하기에 앞서 그림을 크기 순서대로 정렬한다. 그런가 하면 이미지

크기를 다양하게 조절해 중요도를 결정하고 작업에 드라마를 부여하기도 한다. 물론 복잡한 이미지는 가독성을 높이기 위해서라도 크기를 키울 필요가 있다. 이미지 크기의 변화는 해당 이미지의 기능을 알려주고 기승전결 구조의 구축은 물론 판면에 변화를 주어 독자의 흥미를 유도한다.

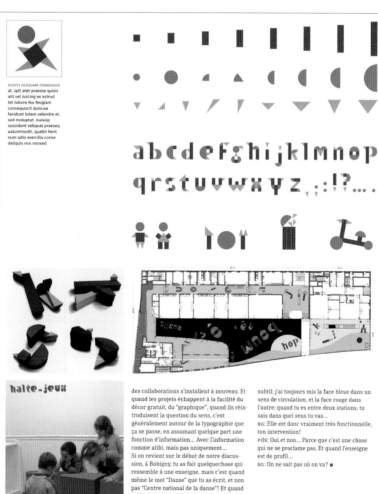

이미지의 너비는 단의 1/2이 될 수도 있고, 1단 혹은 2단이 될 수도 있다. 상황에 따라 그리드를 무시함으로써 극적인 효과를 더해 해당 이미지에 시선을 모으게 할 수도 있다. 이미지의 크기는 해당 이미지의 중요성을 나타내는 방법 중 하나다.

작업명
「*étapes*」

의뢰인
Pyramyd/「*étapes*」

디자인
Anna Tunick

이미지를 다양한 크기로 처리하여 정보 간의 위계를 구축했다.

7 모든 요소를 동시에 고려하라

작업이나 매체의 성격에 따라 그리드를 사용해 각
요소들을 분리할 수 있다. 한 단 혹은 한 구역에는 활자를,
그리고 다른 단에는 이미지를 배치하는 것이다. 대부분의
그리드는 활자와 이미지를 함께 배치한다. 이때 읽는 이가
정보를 명확하게 파악할 수 있도록 각 요소의 성격을
분명히 드러내도록 한다.

텍스트를 강조했다. 한쪽은 텍스트만, 다른 쪽은 그림으로 구성했다.

왼쪽과 아래: 단을 가로질러 수평으로 이미지를 배치하고 이미지
아래에 캡션을 배치하거나 또는 이미지를 수직으로 쌓아 올리고
그 옆에 캡션을 배치할 수도 있다.

작업명
「*MOHAWK VIA
THE BIG HANDBOOK*」

의뢰인
Mohawk Fine Papers Inc.

디자인
AdamsMorioka, Inc.

디자이너
Sean Adams, Chris Taillon

종이 판촉이 목적인 작업.
그리드로 다양한 이미지를
처리했다.

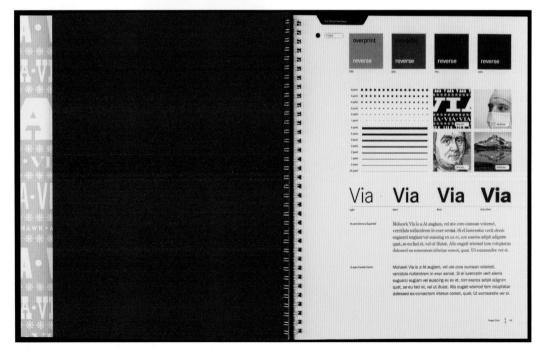

8 색으로 공간을 규정하라

색을 이용하여 모듈이나 구역을 부각시킬 수 있다. 색은 공간을 규정할 뿐만 아니라 한 판면 안에 여러 요소를 조직적으로 배치하는 기능도 한다. 색은 판면에 생기를 주고, 거기에 담긴 메시지의 성격에 부합하는 심리적 신호를 발산한다. 색을 선택할 때는 무엇보다 예상 독자를 고려해야 한다. 짙은 색은 시선을 끌어당기고, 옅은 색은 구성 요소를 돋보이게 한다. 지나치게 많은 색을 사용하면 판면이 번잡해져 내용을 읽어나가기 어려워진다.

화면에서의 색과 종이에서의 색

우리가 사는 세상은 삼원색(RGB)의 세계다. 의뢰인이나 디자이너가 작업할 때 사용하는 모니터 역시 RGB로 구성되며, 모니터상의 색깔은 선명하고 강렬하며 아름답다. 그런데 화면상의 색상과 실제로 종이에 인쇄된 색상은 아주 다르다. 전통적인 4도 인쇄로 화면상의 선명한 색을 대략이나마 재현할 수 있으려면 용지를 신중하게 선택하고 색 보정을 충분히 해야 한다.

색은 개별 정보들을 담아내는 장치로 사용할 수 있다.

색은 모듈, 박스, 블록 등 어디에서나 각 정보를 효과적으로 배치하는 기능을 한다. 색을 담은 모듈은 텍스트 박스와 대조를 이루는 장식적 요소 정도로 사용할 수도 있고, 다양한 텍스트 박스 간의 성격을 구별해주는 기능적 요소로 사용할 수도 있다.

작업명
『*Color Design Workbook*』

의뢰인
Rockport Publishers

디자인
Sean Adams

색이 어떤 방식으로 효과적인 기능을 하고 책에 무게와 활기를 주는지를 설명해준다.

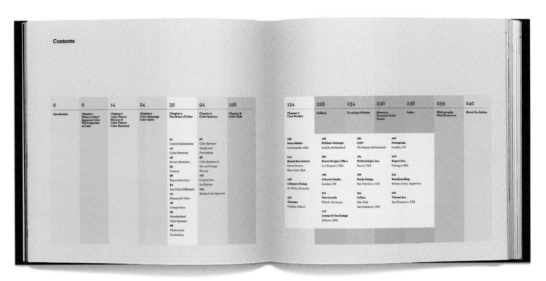

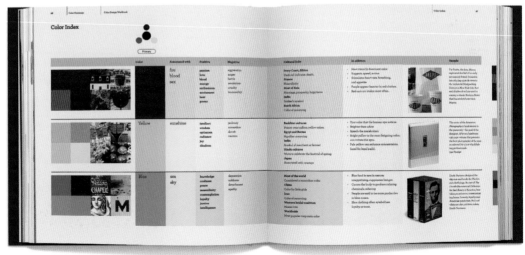

9 여백을 그래픽 요소로 사용하라

여백은 양감을 준다. 그리드는 강렬하고 명확한 효과로 일련의 정보를 전달할 수 있어야 하지만, 그렇다고 그리드의 모든 부분을 꽉 채워야 하는 것은 아니다. 여백은 메시지를 돋보이게 하고, 텍스트를 읽고 이해하는 데 필요한 여유 공간을 적절히 부여한다. 디자이너는 의도적으로 널찍한 여백을 두어 드라마와 포커스를 창출할 수 있다. 여백은 미적 쾌락을 주기도 하고 정보의 중요성을 강조하기도 한다. 여타의 요소를 완전히 배제한 판면은 미적 감각을 발산한다.

참조할 페이지
176 – 177

Self-Portrait (5 Part), 2001.
Five daguerreotypes, each 8 1/2 x 6 1/2 in.
(21.6 x 16.5 cm)

디자이너는 독자가 호흡을 가다듬을 수 있도록 의도적으로 여백을 사용한다.

작업명
『*Chuck Close: Work*』

의뢰인
Prestel Publishing

디자인
Mark Melnick

디자인이든 예술이든 결국은 여백의 문제다.

10 페이스를 조절해 관심을 유지하라

가능한 한 많은 정보를 담기 위해 이미지나 텍스트를 담은 단을 기계적이고 반복적으로, 단순하면서도 질서정연하게 배치하는 그리드가 있다. 그러나 대부분의 그리드는 음악적인 움직임으로 하나의 정보 구역에서 다음 정보 구역으로, 한 판면에서 다음 판면으로, 한 화면에서 다음 화면으로 넘어갈 수 있게 구성된다. 한 면에 담긴 정보의 리듬은 보는 이의 관심을 끌고 그것을 유지시키는 데 결정적인 역할을 한다. 판면에 리듬을 부여하려면 이미지나 타이포그래피의 크기와 위치를 다양하게 설정하거나 각 이미지의 마진 양을 달리해야 한다.

바비 마틴(Bobby Martin)이 이끄는 OCD 팀은 깊이 있는 글과 역사적인 이미지가 빼곡한 획기적인 출판물을 디자인할 때 스프레드를 전부 벽에 붙여놓고 위치와 드라마와 흐름을 검토하고 조정한다.

작업명
「*King*」
(마틴 루터 킹 주니어 목사 서거 50주년 기념 특별호)

의뢰인
「*The Atlantic*」

크리에이티브 디렉터
Paul Spella

아트 디렉터
David Somerville

디자인 회사
OCD | Original Champions of Design

디자이너
Bobby C. Martin Jr.,
Jennifer Kinon

레이아웃의 흐름이 100% 명쾌한 이야기를 들려준다.

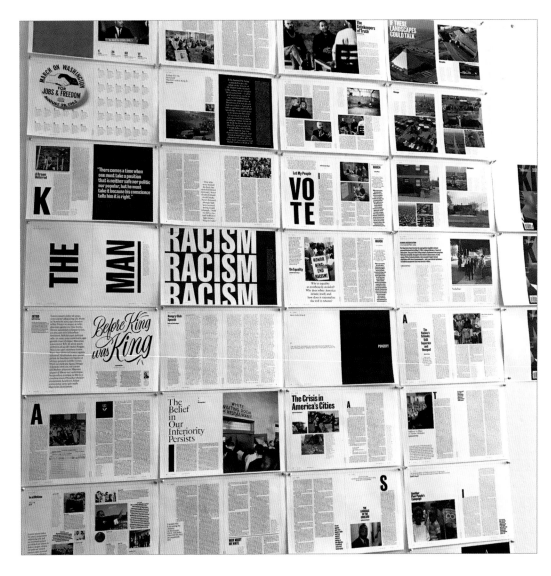

실전 그리드

11 주제에 걸맞은 서체를 사용하라

1단 그리드 판면(화면)에 어울리는 서체를 고르는 경우에는 무엇보다 주재료의 성격을 파악하는 것이 중요하다. 어떤 서체는 유행을 타지 않고 중성적이어서 어떤 내용에나 잘 어울리는가 하면, 어떤 서체는 내용에 대한 판단을 드러내고 내용의 주제를 거의 그대로 반영한다. 또 어떤 서체는 뚜렷한 성격이 있고 어떤 것은 내성적이라고 할 수 있다. 시대감각을 살리려면 역사적 사실을 조사하되 활자는 반대로 사용하라. 타이포그래피에 관한 고정관념을 뒤엎으라는 말이다. 활자의 너비, 크기, 행간이 모두 전체적인 짜임새와 느낌에 영향을 미친다.

참조할 페이지
25

이 프로젝트는 산세리프 서체인 지오메트릭(Geometric)을 써서 핑크에는 예쁜 글씨체가 어울린다는 고정관념을 탈피한 대신, 펑크의 위력을 공고히 했다.

작업명
『*Pink*』

의뢰인
Thames and Hudson

디자인
BTDNYC

깔끔한 세리프체로 텍스트를 처리한 무지 판면이 간단명료하고 장식도 없는 산세리프체에 의해 구획되어 있다.

there were at least "two pinks" in the 1950s: a feminine pink and "young, daring—and omnisexual" pink.[69]

THE NAVY BLUE OF INDIA

Pink has long been a very popular color in India for both men's clothing and adornment. In Rajasthan, for example, it is still commo men wearing hot pink turbans. India's polychromatic sensibility h many Westerners. Already in 1956, Norman Parkinson did an infl

행간은 세심하게 다뤄야 한다. 행간을 충분히 두어 활자들이 잉크 덩어리로 보이지 않게 한다. 한편, 행간이 지나치게 넓으면 읽는 텍스트(text)라기보다는 텍스처(texture), 즉 성긴 직물처럼 느껴질 수 있다.

왼쪽의 샘플은 10/15.75pt 대문자 지오메트릭 서체와 10/15.75pt 메리디안 서체를 실제 크기로 보여준다. 활자 조판 시 산세리프체가 세리프체보다 자리를 더 많이 차지하는 것에 주목하라.

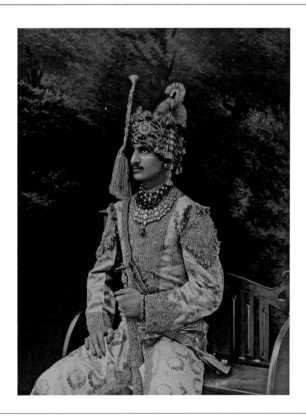

**82. Joshua Reynolds, *Mrs. Abington as Miss Prue
in "Love for Love" by William Congreve*, 1771.**
Oil on canvas. Yale Center for British Art, Paul Mellon Collection.

FEMININE DESIRE AND FRAGILITY:
PINK IN EIGHTEENTH-CENTURY
PORTRAITURE

A. Cassandra Albinson

A SURVEY OF OBJECTS MADE IN FRANCE AND BRITAIN
IN THE EIGHTEENTH CENTURY REVEALS A REMARKABLE
NUMBER OF PINK ITEMS: coverings for furniture; colored
prints; porcelain; paint for interiors; paint for works of art;
suits for men; and especially dresses and ribbons for women.
Aside from its plentitude, what did the color pink represent
in women's clothing? Portraiture provides us with a fruitful
entryway because we often have indications about the sitter's
life and circumstances that can provide further understanding
of the choices they made in terms of costume and adornment.[1]
In comparable portraits of Jeanne-Antoinette Poisson, Marquise de
Pompadour, (1721–1764) and Frances Abington (1737–1815), each woman is
depicted close to the picture plane and from the waist up. Both Pompadour and
Abington were exceedingly famous at the time they were painted, and their fame
and fortune rested in large measure on their physical beauty and prowess. And
each woman had the means to be painted by the most famous artist of her day:
François Boucher for Pompadour, Joshua Reynolds for Abington.[2] Each woman
gestures toward herself and suggests a touch, either in the immediate future—in
the case of Pompadour, who holds a rouge brush as if poised to apply color to her
cheeks—or concurrently with being painted in the case of Abington in the role
of Miss Prue. Hands in each portrait are as important as faces and are stressed
by the inclusion of bracelets at the wrist. Both portraits also feature a second
figure around the sitter's midriff. In the case of Pompadour we see a miniature
portrait of her lover, the French king, Louis XV, while a fluffy white dog sits on

**83. François Boucher,
*Jeanne-Antoinette
Poisson, Marquise
de Pompadour*,
1750, with
later additions.**
Harvard Art Museums.

without one." A few years later, it was back, "beautifully refreshed" in a variety
of styles—"pink evening shirts, pink-shirt dresses, even a pink swimming shirt,"
not to mention "one of 1953's prettiest little-evening blouses."[67]

"Across the US, a pink peak in male clothing has been reached as manu-
facturers have saturated more and more of their output with the pretty pastel,"
reported *Life* magazine in 1955. "Sole responsibility lies with New York's Brooks
Brothers," whose pink shirt "was publicized for college girls and caught on for
men too." Gradually, pink neckties, dinner jackets, golf jackets, trousers, and
other garments also became increasingly visible. "Like most male fashions,
including the Ivy League Look, this pink hue and cry has taken some time to
develop." But by 1955, the "traditionally feminine color" had become "a staple
for [the] male."[68]

Elvis Presley not only wore pink suits, jackets, and trousers, he also drove a
pink car and slept in a pink bedroom. Was he influenced by African-American
style? His fans wore lipstick in Heartbreak Hotel Pink, and rock and roll extolled
the color with songs like "Pink Pedal Pushers" (1958), "Pink Shoe Laces" (1959),
and "A White Sport Coat (and a Pink Carnation)" (1957). Meanwhile, the warm
carotenoid pink of flamingos was increasingly associated with newly affordable,
warm-weather vacations in places like Florida and the Caribbean. So perhaps
there were at least "two pinks" in the 1950s: a feminine pink and an emerging
"young, daring—and omnisexual" pink.[69]

THE NAVY BLUE OF INDIA

Pink has long been a very popular color in India for both men's and women's
clothing and adornment. In Rajasthan, for example, it is still common to see many
men wearing hot pink turbans. India's polychromatic sensibility has influenced
many Westerners. Already in 1956, Norman Parkinson did an influential photo
shoot in India for British *Vogue*. One of his striking images juxtaposed a Western
model in the latest fashion with an Indian girl in a hot pink sari. Another, shot
in Jaipur, the "Pink City," posed the model in pale pink with a group of Indian
men in bright pink coats and turbans. Diana Vreeland, then editor of *Harper's
Bazaar*, saw the images and allegedly said, "How clever of you, Mr. Parkinson,
also to know that pink is the navy blue of India."[70]

Traditionally, there were many rules about color in clothing related to age,
region, caste, occasion, complexion, and time of day. More recently, the indi-
vidual's personal taste has played an increasingly important role. In their book

**43. Unknown artist, *Portrait of an Indian Prince Wearing a
Wedding Sehra* [headgear], ca. 1920–40, Rajputana Photo Art Studio.**
Gelatin silver print and watercolor. 14⅜ × 11 in. (36.5 × 28 cm). The Alkazi Collection of Photography.

12 마진을 정하라

페이지 수가 많은 책의 경우에는 양 페이지 안쪽 부분의 마진을 넉넉히 주어 제본했을 때 텍스트가 가운데로 몰려, 보이지 않게 되는 일이 없도록 하자. 책 디자인 작업에서 화면이나 레이저 프린트로 볼 때는 균형이 맞다가도 실제로 인쇄, 제본 과정을 마친 결과물은 전혀 그렇지 않을 때도 많다. 책 안쪽 마진의 손실 양은 책이나 브로슈어의 두께와 제본 방식에 따라 다르다. 무선철, 사철, 중철 어떤 방식이든 제본할 때는 본문 가운데 부분의 손실 여부를 미리 확인해보는 것이 좋다.

제본 방식과 그에 따른 마진 설정

페이지의 양에 따라 어떤 제본 방식은 다른 방식에 비해 페이지 사이의 안쪽 여백이 많이 손실되기도 한다. 사철 제본 책은 풀로 붙이는 무선철보다 책을 더 평평하게 펼칠 수 있다는 장점이 있다. 무선철 제본은 책 가운데 안쪽으로 활자가 몰려 손실될 수 있고, 독자가 책을 펼칠 때 양 페이지 사이가 갈라질까봐 신경 쓰게 될 수도 있다. 이 밖에 스프링 제본 책은 스프링 구멍을 낼 수 있도록 가운데 마진을 충분히 두어야 한다.

참조할 페이지
22—23

작업명
「Sauces」

의뢰인
John Wiley and Sons

디자인
BTDNYC

800쪽이 넘는 전문적인 요리 정보 서적이므로 가운데 마진을 널찍하게 설정했다.

이미지 제공
「Sauces」, ©James Peterson, John Wiley and Sons, 2008

안쪽 마진을 넉넉하게 잡은 덕에 텍스트가 페이지 사이 안쪽 여백으로 말려들어가지 않았고 중요한 조리법의 내용도 읽기 쉬워졌다. 그밖에도 부제목과 도표처럼 텍스트 블록 바깥으로 튀어나올 수 있는 요소들까지 고려하고 있다. 바닥글, 페이지 번호와 같은 마커들이 들어갈 수 있을 정도로 마진이 넉넉해서 고요하고 여유로운 느낌이다.

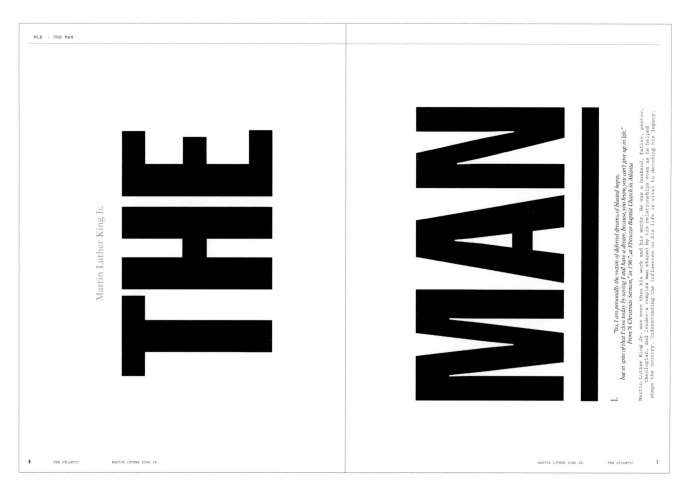

Martin Luther King Jr.

THE

MAN

"Yes, I am personally the victim of deferred dreams, of blasted hopes, but in spite of that I close today by saying I still have a dream, you know, you can't give up in life."
From "A Christmas Sermon," in 1967, at Ebenezer Baptist Church in Atlanta

Martin Luther King Jr. was more than his work and his words. He was a husband, father, pastor, theologian, and leader—a complex man shaped by his relationships even as he helped shape the country. Understanding the influences on his life is vital to decoding his legacy.

작업명
「*King*」
(마틴 루터 킹 주니어 목사 서거
50주년 기념 특별호)

의뢰인
「*The Atlantic*」

크리에이티브 디렉터
Paul Spella

아트 디렉터
David Somerville

디자인 회사
OCD | Original Champions
of Design

디자이너
Bobby C. Martin Jr.,
Jennifer Kinon

마커가 들어갈 마진을 빠듯하게
잡으면 크기와 공간의 역학상
활기와 긴장감이 고조된다.

반면에 마진을 일부러 빠듯하게 둬서 긴장감과 백척간두에 서 있는 역사적 느낌을 강조할 수도 있다(2단 이상일 때 효과적). 여기에 있는 스프레드나 85페이지에 실린 스프레드의 경우, 페이지 번호와 섹션 정보가 상단 재단선이나 하단 재단선에 닿을 만큼 아슬아슬하게 디자인되어 있다. 이것이 텅 빈 여백과 대비를 이루면서 내용의 중요성에 대한 인식을 높여준다.

경험 법칙

인쇄 마진에 적용할 만한 법칙이 있으면 알려달라는 질문을 많이 받았다. 만능 해결책은 없지만 1.25cm(0.5")를 기본으로 해서 더하거나 빼라고 제안하고 싶다. 바깥 마진을 6mm(0.25") 미만으로 잡으면 인쇄기에서 종이가 튀는 '바운스(bounce)' 현상에 노심초사하게 될 것이다. 최종 결정은 페이지와 그 안에 들어가는 내용의 비율에 따라 달라진다. 인쇄물 프로젝트라면 출력업체에 따라서도 달라진다. 인쇄물 제작 시 가장 흔히 저지르는 실수는 텍스트 영역은 너무 넓고 마진은 너무 좁은 것이다. 웹이나 태블릿, 기타 기기의 경우에도 마진은 중요하지만 마진이 좁을수록 잃어버리는 정보를 줄일 수 있다.

기술적으로 보면 1단 그리드지만 이번 호는 전체적으로 좁은 마진을 차용하고 있다. 최종 재단된 크기가 19.5x26.4cm (7 3/4" x10 7/16")인데 상단 재단선과 머리글 사이, 하단 재단선과 맨 아래 페이지 번호 부분과 바닥글 사이에 5mm (7/32")의 바깥 마진을 둔 것은 인쇄와 재단의 한계를 뛰어넘는 시도이며 확실한 효과를 보고 있다.

13 비례를 생각하라

언제나 비례를 염두에 두자. 이때 판면 아래 마진까지 고려해야 한다. 아무리 단순해 보이는 판면이라도 공간을 계획적으로 사용해야 인쇄된 페이지에 들어가는 내용을 구획할 수 있다. 이론적으로는 화면에서도 마찬가지다.

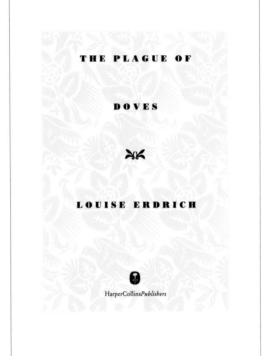

작업명
『*The Plague of Doves*』

의뢰인
HarperCollins

디자인
Fritz Metsch

투명한 수정 유리잔처럼 단아한 텍스트 판면 디자인으로 일류 문학가의 작품에 빛을 더했다. 타이포그래피 디자이너이자 연구자인 비어트리스 워드 (Beatrice Warde)는 『수정 유리잔: 타이포그래피에 관한 16개의 에세이(*The Crystal Goblet: Sixteen Essays on Typography*)』에서 "활자는 투명해야 한다"고 말하며 간결한 디자인은 수정 유리잔과 같다고 표현했다. "타이포그래피란 무릇 그것이 전달하고자 하는 아름다움을 가리는 일 없이 잘 드러내야 한다."

아래 마진이 위 마진보다 조금 더 넓다. 제목 활자는 볼드체로 강한 질감을 부여하면서도 작은 크기로 절제된 느낌을 자아내고, 그 뒤에 패턴 디자인을 깔아 우아한 표제지를 구성했다.

가운데에 배치한 페이지 번호가 고전적인 디자인임을 나타낸다.

cousin John kidnapped his own wife and used the ransom to keep his mistress in Fargo Despondent over a woman, my father's uncle, Octave Harp, managed to drown himself in two feet of water And so on As with my father, these tales of extravagant encounter contrasted with the modesty of the subsequent marriages and occupations of my relatives We are a tribe of office workers, bank tellers, book readers, and bureaucrats The wildest of us (Whitey) is a short order cook, and the most heroic of us (my father) teaches Yet this current of drama holds together the generations, I think, and my brother and I listened to Mooshum not only from suspense but for instructions on how to behave when our moment of recognition, or perhaps our romantic trial, should arrive.

The Million Names

IN TRUTH, I thought mine probably had occurred early, for even as I sat there listening to Mooshum my fingers obsessively wrote the name of my beloved up and down my arm or in my hand or on my knee If I wrote his name a million times on my body, I believed he would kiss me I knew he loved me, and he was safe in the knowledge that I loved him, but we attended a Roman Catholic grade school in the early 1960's and boys and girls known to be in love hardly talked to one another and never touched We played softball and kickball together, and acted and spoke through other children eager to deliver messages I had copied a series of these second hand love statements into my tiny leopard print diary with the golden lock The key was hidden in the hollow knob of my bedstead Also I had written the name of my beloved, in blood from a scratched mosquito bite, along the inner wall of my closet His name held for me the sacred resonance of those Old Testament words written in fire by an invisible hand Mene, mene, teckel, upharsin I could not say his name aloud I could only write it on my skin with my fingers without cease until my mother feared I'd gotten lice and coated my hair with mayonnaise, covered my head with a shower cap, and told me to sit in the bathtub adding water as hot as I could stand.

The bathroom, the tub, the apparatus of plumbing was all new Because my father and mother worked for the school and in the tribal offices, we were hooked up to the agency water system I locked the bathroom door,

9

자간이 넓은 볼드체 표제와 페이지 번호가 활자로만 이루어진 전체 판면을 짜임새 있게 보이도록 한다. 마진과 행간이 넉넉하여 잘 읽히는 판면이다.

황금 비율

황금 비율은 수천 년 전부터 미술과 건축 분야에서 사용해온 것으로 황금 분할이라고도 한다. 높이, 너비와 같은 요소 간의 비율을 가리키는 황금 비율은 구체적으로 약 0.618 또는 1대 1.618이다. 예를 들어 가로의 길이가 짧고 세로가 길 때 가로(a)와 세로(b)의 비율은 세로와 가로, 세로를 더한 값의 비율과 같다 (a : b = b : (a +b)). 실제로 디자이너가 황금비 디자인을 할 때 가로가 22파이카라면 세로는 35파이카 6포인트가 된다. 오른쪽 그림은 정확하게 황금비를 이루는 두 개의 직사각형을 보여준다. 디자이너들은 대개 정확한 숫자를 사용하지 않고 눈대중과 직감으로 작업하지만 그러면서도 보기 좋은 비율을 만들어낸다.

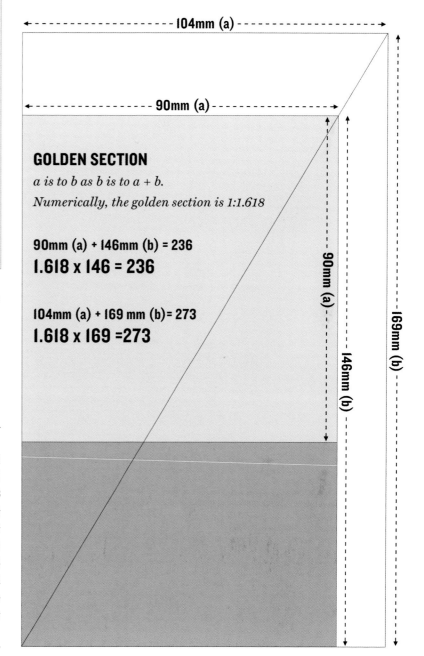

GOLDEN SECTION

a is to b as b is to a + b.
Numerically, the golden section is 1:1.618

90mm (a) + 146mm (b) = 236
1.618 x 146 = 236

104mm (a) + 169 mm (b)= 273
1.618 x 169 =273

104mm (a)

90mm (a)

90mm (a)

146mm (b)

169mm (b)

14 균등성을 생각하라

두 단이 균등한 2단 그리드는 많은 양의 정보를 담아낼
수 있다. 대칭 단을 사용하면 매우 질서 정연한 구조 아래
이미지 크기와 여백의 양을 자유롭게 조절할 수 있다.
2단 대칭 그리드는 같은 정보를 두 가지 언어로 병기할 때
어느 한쪽으로 무게가 치우치지 않게 배치할 수 있다. 대상
독자의 국적이 다양한 출판물에 안성맞춤이다.

텍스트 단의 양끝을 맞추는 전통적인 판면은 질서정연하고 안정감이
있어 보수적인 성격의 편집자나 독자에게 어울린다.

작업명
「*Return to the Abstract*」

의뢰인
Palace Editions,
Russian State Museums

디자인
Anton Ginzburg,
Studio RADIA

러시아어와 영어, 2개 언어를
2단 그리드로 처리했다.

оказывается совершенно неспособным проявлять свои функции прозрачности и ясности. Разбросанные в пространстве произведения отвердевшие «знаки-образы художника», чем-то напоминающие «блочные структуры», устойчивую эмблематику социальных систем, перефразированные элементы поп-арта, откровенно обнажают идеологию арт-дилерств Евгения Чубарова, его открытость к языкам массовой культуры. Но в художественных измерениях картинного пространства они транслируются, скорее, как уловки, как внезапные описки, споткнулся о немое «что-то не так», превращаясь или возвращаясь в комическую сатиру. Эти «случайные» ошибки дарят нам шок сопрякновения с невзрачным при контакте с, казалось бы, заведомо освоенным. Они опровергают диктат идеи однородной абстракции над витальностью знако-творчества как выпад против здравого смысла, как выпадение в целительное безумие. В такой стратегии их образы утверждают новый принцип абстракции, освобожденный от власти личного монолога художника, но реализующий себя в контексте нового смыслового поля, «запакованных» непосредственное чувство в интеллектуальную рефлексию. Она естественно возникает в своих сгущениях и пустотах, наплывах и разрывах как горизонтальная модель

нового художественного сознания, прорывая гипноз знаковой поверхности через жест своеобразной «деконструкции».

Сама технология живописи Евгения Чубарова, ее способность комментировать и описывать саму себя порождает эффект картины как некого живописного объекта, где сама живопись раскрывается как чистая ностальгия по живописи, как воспоминание о картине, где в гуще информационного шума спрятан в коконе былой «абстрактный шедевр», «нетленка», по выражению Ильи Кабакова. Ее «почерк», ее многослойный ландшафт, блестяще выстроенный со всеми самыми ассоциативными рядами, где подвижные слои художественной реальности просвечивают сквозь профанные, подбрасывая загадки – все это свидетельствует о новых глубинных ориентациях в искусстве абстракции. Они говорят о ветшании и абстрактных авангардных моделей и о рождении ее абсолютно новой телесности, отрефлексированной и генетически преображенной. Эти новые формы манипулируют следами и обломками и исторического прошлого и последствиями собственного личного внутреннего опыта художника. В них проступают сознательные цитаты мирового культуронаследия, включающие целые

abstraction, one that is free from the pressure of the artist's monologue and one that realizes itself in the context of a new field of meaning, packaging spontaneous feelings into intellectual reflection. It emerges naturally as densities and empty spots, inflows and gaps, as a horizontal model of a new artistic consciousness, breaking through the hypnosis of the sign surface by way of a deconstructing gesture.

The technology of Chubarov's art, its capacity for self-commentary and self-description, creates paintings that have the effect of being objects of pure nostalgia for painting. A recollection of a painting where in the thick of the information noise, as in a cocoon, a former masterpiece of abstract art is concealed, "Imperishables" to quote Ilya Kabakov. Its style and complex landscapes, brilliantly structured with all their associations, suggesting different layers of artistic reality show through the profane, suggesting all sorts of riddles – all this testifies to the new, deep-going orientations in abstract art. They demonstrate the withering of the abstract avant-garde models and the emergence of a new corporeality, carefully thought out and genetically transformed. These new forms manipulate with the traces and debris of history and the consequences of the artist's personal experience. Intentional quotation from the world cultural heritage is evident in

this art, including whole movements and trends, skillfully woven into a new cultural context. Moreover, you find in this art, including whole movements and trends, skillfully Chubarov's self-quotation and his mythologies existing in the collisions of dissimilar returns above the imagery and style of abstract expressionism, turning his heroic structures into archeological finds and ready-made objects. Both Jackson Pollock and Mark Toby as well as the German 'New Wild' are impressed in Chubarov's intellectual energy much like film stars' names are on Hollywood plates. Post-historic hand-writing reveals obvious legends in their contours of the remains of gilding, where respect borders on notions much broader than cultural memory, where irony alludes to the games in the labyrinths of time and space. In Einstein's shifted geometry with its "parallel" curvilinearity and relativity, these endless labyrinths bring to mind the abandoned caves and tunnels in Egyptian pyramids. Half-filled with crumbled stone, sand-drifts and excrescencies: they can be viewed both horizontally and vertically. Here you find forgotten and lost texts that were once declared revelations and prophecies. These multi-dimensional sign-bearing structures are being cleared and sorted out to be transformed into illuminations or oppositions like paradoxical tactile surfaces or jottings on the margins where the artist himself 'archeologizes' his mysterious verbalism weaving the fabric of a universal manuscript that

Псевдоживопись Зигмара Польке с использованием новых технологий возвращает к чисто «вещественности» и материальности Текста. Именно проблема «пространство как текст» сегодня становится общей для европейской и русской культуры, переводя из «ткани» - смысла в «ткань» - пространства. Евгений Чубаров в этих текстовых слоях обретает свое собственное измерение.

Зигмар Польке, «Eggboil», 1984

Pseudo-painting of Sigmar Polke, based on new technologies, returns us to pure "objectivity" and materiality of the text as such. It is precisely the problem of "space as text" that has become common for European and Russian cultures, marked by the fact of transition from the texture of meaning to the texture of space. In these textual layers Evgeny Chubarov acquires his own dimension.

Sigmar Polke, Eggboil, 1984

Для Е.Чубарова, так же как и для А.Пенка, обращение к подсознанию давало выход в иные формы работоспособности, чем окружающая тоталитарная реальность. «Динозавры» А.Пенка, символизирующие абсолютное сопротивление тоталитарной социальности, фактически та же змееподобные существа – знаки, наполняющие слоем динамикой композиции Е.Чубарова.

А.Пенк, «G.B.I.», 1988

For Chubarov, the same as for A. Penk, address to the subconscious provided an outlet to other form of working, distinct from those offered by the surrounding totalitarian reality. Penk's "Dinosaurs", symbolizing absolute resistance to totalitarian sociality, are in fact the same snake-like creatures-signs, which infuse with dynamism Chubarov's compositions as well.

A.R.Penk, "G.B.I.", 1988

단의 너비가 충분하고 텍스트 양이 많지 않으면 양쪽 단 모두 고르고 읽기 쉬운 질감을 형성하게 된다. 텍스트 형식이 질서정연하면 박스, 그래프, 이미지 등의 요소들을 배치하기도 용이하다.

15 기능에 맞춰 디자인하라

2단 그리드의 기본은 대칭 그리드지만, 얼마든지 두 단의 너비를 달리할 수 있다. 설명적인 성격이 강한 내용을 개방적인 판면과 가독성이 높은 독자 친화적인 판면으로 구성하고자 할 때, 두 단 중에 하나는 좁고 하나는 넓은 그리드를 선택한다. 넓은 단에는 길게 이어지는 텍스트를 배치해 글쓴이가 전달하고자 하는 일관된 흐름의 내러티브를 전달하고, 좁은 단에는 캡션이나 이미지, 표 등의 정보를 담을 수 있다.

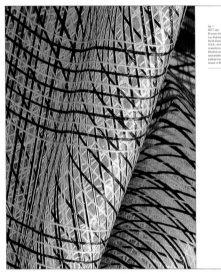

캡션 공간으로 쓰인 좁은 단은 정보의 가독성이 높으며, 이 캡션 장치는 새로운 장이나 텍스트 페이지의 시작을 알리는 기능을 한다. 장 도입부에서는 다른 텍스트 페이지보다 위쪽 여백을 넓게 두고 텍스트를 배치하는 것이 좋다.

작업명
「*Extreme Textiles*」
전시 카탈로그

의뢰인
Smithsonian, Cooper-Hewitt,
National Design Museum

디자인
Tsang Seymour Design

디자인 감독
Patrick Seymour

디자이너
Susan Brzozowski

전시 카탈로그는 내용상의 필요에 따라 다양한 정보 배열 방식을 조합한다.

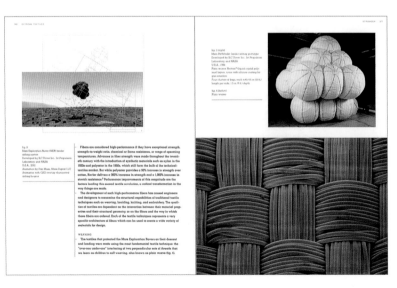

비대칭 2단 그리드에서 효과적이고 균형 잡힌 판면을 구성하려면 넓은 단의 너비가 좁은 단 너비의 2배가 되도록 만든다. 서체는 좁은 단(캡션)에서나 넓은 단(주 텍스트)에서나 같은 것을 쓰되, 좁은 단에서는 활자 두께를 더 얇게 처리한다. 이렇게 활자의 두께에 변화를 주면 판면의 질감이 풍부해진다.

fig. 5
Impressions left by the airbags of the Mars Exploration Rover (MER) Opportunity in Martian soil, January 24, 2004

This classic plain weave has the greatest strength and stability of the traditional fabric structures. While no textiles survive from the earliest dates, impressions in clay of basic woven cloth demonstrate its use from at least 7000 BC.[5] Older than basic woven cloth—perhaps even older than agriculture, cloth-weaving has a very primary relationship to the pursuits of humankind.[4]

It is fitting, then, that among the first marks made by man in the soil of Mars was that of a plain woven fabric: an impression made by the impact of the airbags (fig. 5).[5] Each bag has a double bladder and several abrasion-resistant layers made of tightly woven Vectran. Like most synthetic fibers, Vectran liquid crystal polymer is extruded from a liquid state through a spinneret, similar to a shower head, and drawn into filament fibers. The stretching of the fiber during the drawing process orients the polymer chains more fully along the fiber length, creating additional chemical bonds and greater strength. Vectran provides equal strength at one-fifth the weight of steel. Weight is of premium importance for all materials used for space travel, and Warwick Mills, the weaver of the fabric for the bags, achieved a densely woven fabric at a mere 2.4 ounces per square yard, but with a strength of 350 pounds per inch.[6]

The materials are also required to perform at severe temperatures. Because impact occurs two to three seconds after the inflation of the airbags, the fabrics endure the greatest stresses at both extremes of temperature: the explosive gasses that inflate the bags may elevate the temperature inside the

bladder layers to over 212°F, but the temperature on the Martian surface is –117°F. Retraction of the airbags to allow the egress of the rovers required that the fabrics remain flexible at these very low temperatures for an extended period of time—over ninety minutes for the deflation and retraction process. Two other fiber types, aramid fibers (Kevlar 29 and Technora T-240) and ultra-high molecular weight polyethylene (UHMWPE) Spectra 1000, were also considered during the development of the Pathfinder airbags. Spectra, a super-drawn fiber, is among the strongest fibers known—fifteen times stronger than steel. However, it performs poorly at extreme temperatures, and so was eliminated early in the development process. Vectran was ultimately selected for the best performance at low temperatures, but Kevlar 129 was used for the tethers inside the bags because of its superior performance at higher temperatures.

The rovers themselves are also textile-based; they are made from super-strong, ultra-lightweight carbon-fiber composites, which are being widely used for aerospace components as well as high-performance sports equipment.[7] As composite reinforcements, textiles offer a high level of customization with regard to type and weight of fiber, use of combinations of fibers, and use of different weaves to maximize the density of fibers in a given direction. Fiber strength is greatest along the length. The strength of composite materials derives from the intentional use of this directional nature. While glass fibers are the most commonly used for composites, for high-performance products the fiber used is often carbon or aramid, or a combination of the two, because of their superior strength and light weight.

One advantage of composite construction is the ability to make a complex form in one piece, called monocoque construction. A woven textile is hand-laid in a mold; the piece is wetted out with resin and cured in an autoclave. The textile can also be impregnated with resin and cured without a wet stage. The same drape or hand that makes twill the preferred weave for most apparel is also desirable for creating the complex forms of boats, paddles, bicycle frames, and other sports equipment. The weft in a twill, rather than crossing under and over each consecutive warp, floats over more than one warp, and with each subsequent weft the grouping is shifted over one warp, creating the marked diagonal effect typical of twills (fig. 8).

Boat builders were among the first to experiment with carbon-reinforced composites. One early innovator, Edward S. ("Ted") Van Dusen, began making carbon-fiber composite racing shells in the 1970s (fig. 7). The critical factor in shell design is the stiffness-to-weight ratio, with greater stiffness meaning that more of the rower's power is translated into forward motion. Van Dusen found that all of the standard construction materials had about the same specific stiffness, or stiffness per unit weight, and began experimenting with glass, boron, and carbon fiber-reinforced composites.[8]

For his Advantage racing shells, Van Dusen uses glass fiber in a complex twill commonly known as satin weave. In a satin, each weft may float over

The numbers in these tables represent typical values of some important fiber properties; the actual behavior of fibers may differ as variants are produced for diverse end uses. These numbers were compiled from many different sources and are meant for illustration purposes only.

COMPARISON OF YARN STRENGTH

M5
PBO
LCP
HMPE
P-Aramid
Carbon
Ceramic
Glass
Polyester
Nylon
Steel

0 1 2 3 4 5

—— Yarn strength based on area of fiber (GPa)
—— Yarn strength based on weight of fiber (N/tex)

COMPARISON OF MODULI

M5
PBO
LCP
HMPE
P-Aramid
Carbon
Ceramic
Glass
Polyester
Nylon
Steel

0 200 400 600

—— Modulus based on area of fiber (GPa)
—— Modulus based on weight of fiber (N/tex)

CARBON

Thomas Edison first used carbon fiber when he employed charred cotton thread to conduct electricity in a lightbulb (he patented it in 1879). Only in the past fifty years, however, has carbon developed as a high-strength, high-modulus fiber.[9] Oxidized then carbonized from polyacrylonitrile (PAN) or pitch precursor fibers, carbon's tenacity and modulus vary depending on its starting materials and processing.

Less dense than ceramic or glass, lightweight carbon-fiber composites save fuel when used in aerospace and automotive vehicles. They also make for strong, efficient sports equipment. Noncorroding, carbon reinforcements strengthen deep seawater concrete structures such as petroleum production risers.[10] Fine diameter carbon fibers are woven into sails to minimize stretch.[11] In outer apparel, carbon fibers protect workers against open flames (up to 1000°C/1,800°F) and even burning napalm: they will not ignite, and shrink very little in high temperatures.[12]

ARAMIDS

Aramids, such as Kevlar (DuPont) and Twaron® (Teijin), are famous for their use in bulletproof vests and other forms of ballistic protection, as well as for cut resistance and flame retardance. Initially developed in the 1960s, aramids are strong because their long molecular chains are fully extended and packed closely together, resulting in high-tenacity, high-modulus fibers.[13]

Corrosion- and chemical-resistant, aramids are used in aerial and mooring ropes and construction cables, and provide mechanical protection in optical fiber cables.[14] Like carbon, aramid-composite materials make light aircraft components and sporting goods, but aramids have the added advantages of impact resistance and energy absorption.

LIQUID CRYSTAL POLYMER (LCP)

Although spun from different polymers and processes, LCPs resemble aramids in their strength, impact resistance, and energy absorption, as well as their sensitivity to UV light. Compared to aramids, Vectran (Celanese), the only commercially available LCP, is more resistant to abrasion, has better flexibility, and retains its strength longer when exposed to high temperatures. Vectran also surpasses aramids and HMPE in dimensional stability and cut resistance: it is used in wind sails for America's Cup races, inflatable structures, ropes, cables and restraint-lines, and cut-resistant clothing.[15] Because it can be sterilized by gamma rays, Vectran is used for medical devices such as implants and surgical-device control cables.[16]

HIGH-MODULUS POLYETHYLENE (HMPE)

HMPE, known by the trade names Dyneema (Toyobo/DSM) or Spectra (Honeywell), is made from ultra-high molecular-weight polyethylene by a special gel-spinning process. It is the least dense of all the high-performance

DECOMPOSITION TEMPERATURE

M5
PBO
LCP
HMPE (melts)
P-Aramid
Carbon
Glass (melts)
Polyester (melts)
Nylon 6.6 (melts)
Steel (melts)

0 500 1000 1500 2000 2500 3000 3500

Degrees Celsius

DENSITY

M5
PBO
LCP
HMPE
P-Aramid
Carbon
Ceramic
Glass
Polyester
Nylon 6.6
Steel

0 1 2 3 4 5 6 7 8

grams per cm³

fibers, and the most abrasion-resistant. It is also more resistant than aramids, PBO, and LCP to UV radiation and chemicals.[17] It makes for moorings and fish lines that float and withstand the sun, as well as lightweight, cut-resistant gloves and protective apparel such as fencing suits and soft ballistic armor. In composites, it lends impact resistance and energy absorption to glass- or carbon-reinforced products. HMPE conducts almost no electricity, making it transparent to radar.[18] HMPE does not withstand gamma-ray sterilization and has a relatively low melting temperature of 150°C (300°F)—two qualities that preclude its use where high temperature resistance is a must.

POLYPHENYLENE BENZOBISOXAZOLE (PBO)

PBO fibers surpass aramids in flame resistance, dimensional stability, and chemical and abrasion resistance, but are sensitive to photodegradation and hydrolysis in warm, moist conditions.[19] Their stiff molecules form highly rigid structures, which grant an extremely high tenacity and modulus. Apparel containing Zylon® (Toyobo), the only PBO fiber in commercial production, provides ballistic protection because of its high energy absorption and dissipation of impact. Zylon is also used in the knee pads of motorcycle apparel, for heat-resistant work wear, and in felt used for glass formation.[20]

PIPD

PIPD, M5 fiber (Magellan Systems International), expected to come into commercial production in 2005, matches or exceeds aramids and PBO in many of its properties. However, because the molecules have strong lateral bonding, as well as great strength along the oriented chains, M5 has much better shear and compression resistance. In composites it shows good adhesion to resins. Its dimensional stability under heat, resistance to UV radiation and fire, and transparency to radar expands its possible uses. Potential applications include soft and hard ballistic protection, fire protection, ropes and tethers, and structural composites.[21]

HYBRIDS

A blend of polymers in a fabric, yarn, or fiber structure can achieve a material better suited for its end use. Comfortable fire-retardant, anti-static clothing may be woven primarily from aramid fibers but feature the regular insertion of a carbon filament to dissipate static charge. Yarns for cut-resistant applications maintain good tactile properties with a wrapping of cotton around HMPE and fiberglass cores. On a finer level, a single fiber can be extruded from two or more different polymers in various configurations to exhibit the properties of both.

이미지가 많지 않거나 전혀 없는 내용이라면 비대칭 2단 그리드를 사용해 좁은 단을 비우면 된다.

괘선은 공간을 분할하는 장치 혹은 두 단을 하나의 공간으로 연결하는 장치로 기능한다. 이 작업에서 파란색 괘선은 내용을 침범하지 않는 선에서 판면 전체를 유기적으로 연결하며, 또한 각 단락의 시작부도 나타낸다.

16 괘선으로 조절하라

지침서, 설명서의 경우 정보가 매우 자잘한 덩어리로 세분되어 있어 두 단 사이에 적당한 여백을 주는 것만으로는 가독성이 확보되지 않는 경우가 있다. 이럴 때는 두 단을 분명하게 가르는 수직 괘선을 사용한다.

수평 괘선은 한 단 안에서 정보를 구분하는 데 쓰이는데 주 텍스트와 박스 정보를 구분한다든가 또는 전체 텍스트 영역과 바닥글, 페이지 번호를 나누는 식이다. 하지만 괘선을 지나치게 많이 사용하면 판면의 산뜻함이 떨어진다.

수직 괘선을 사용하여 매우 복잡한 성격의 내용을 각 단에 배치했다. 서체 또한 볼드체, 전체 대문자, 이탤릭체, 분수 등으로 각 정보에 걸맞은 다양한 특징을 부여했다.

작업명
『*America's Test Kitchen Family Cookbook*』

의뢰인
America's Test Kitchen

아트 디렉터
Amy Klee

디자인
BTDNYC

상하 수평 괘선을 사용하면 정보나 형식을 하나의 독립적인 박스 장치로 구획할 수 있다.

NONFAT ROASTED GARLIC DRESSING

MAKES about 1 ½ cups
PREP TIME: 10 minutes
TOTAL TIME: 2 hours (includes 1 ½ hours roasting and cooling time)

To keep this recipe nonfat, we altered our usual technique for roasting garlic, replacing the oil we typically use with water.

2	**large garlic heads**
2	**tablespoons water**
	Salt
2	**tablespoons Dijon mustard**
2	**tablespoons honey**
6	**tablespoons cider vinegar**
½	**teaspoon pepper**
2	**teaspoons minced fresh thyme, or**
	½ teaspoon dried
½	**cup low-sodium chicken broth**

1. Adjust an oven rack to the upper-middle position and heat the oven to 400 degrees. Following the photos on page 000, cut ½ inch off the top of the garlic head to expose the tops of the cloves. Set the garlic head cut side down on a small sheet of aluminum foil, and sprinkle with the water and a pinch of salt. Gather the foil up around the garlic tightly to form a packet, place it directly on the oven rack, and roast for 45 minutes.

2. Carefully open just the top of the foil to expose the garlic and continue to roast until the garlic is soft and golden brown, about 20 minutes longer. Allow the roasted garlic to cool for 20 minutes, reserving any juices in the foil packet.

3. Following the photo on page 000, squeeze the garlic from the skins. Puree the garlic, reserved garlic juices, ¾ teaspoon salt, and the remaining ingredients together in a blender (or food processor) until thick and smooth, about 1 minute. The dressing, covered, can be refrigerated for up to 4 days; bring to room temperature and whisk vigorously to recombine before using.

LOWFAT ORANGE-LIME DRESSING

MAKES about 1 cup
PREP TIME: 10 minutes
TOTAL TIME: 1 hour (includes 45 minutes simmering and cooling time)

Although fresh-squeezed orange juice will taste best, any store-bought orange juice will work here. Unless you want a vinaigrette with off flavors make sure to reduce the orange juice in a nonreactive stainless steel pan.

2	**cups orange juice (see note above)**
3	**tablespoons fresh lime juice**
1	**tablespoon honey**
1	**tablespoon minced shallot**
½	**teaspoon salt**
½	**teaspoon pepper**
2	**tablespoons extra-virgin olive oil**

1. Simmer the orange juice in a small saucepan over medium heat until slightly thickened and reduced to ⅔ cup, about 30 minutes. Transfer to a small bowl and refrigerate until cool, about 15 minutes.

2. Shake the chilled, thickened juice with the remaining ingredients in a jar with a tight-fitting lid until combined. The dressing can be refrigerated for up to 4 days; bring to room temperature, then shake vigorously to recombine before using.

Test Kitchen Tip: **REDUCE YOUR JUICE**

Wanting to sacrifice calories, but not flavor or texture, we adopted a technique often used by spa chefs in which the viscous quality of oil is duplicated by using reduced fruit juice syrup or roasted garlic puree. The resulting dressings are full bodied and lively enough to mimic full-fat dressings but without the chemicals or emulsifiers often used in commercial lowfat versions. Don't be put off by the long preparation times of these recipes—most of it is unattended roasting, simmering, or cooling time.

Salads **65**

EASY JELLY-ROLL CAKE

MAKES an 11-inch log
SERVES 10
PREP TIME: 5 minutes **TOTAL TIME:** 1 hour

Any flavor of preserves can be used here. For an added treat, sprinkle 2 cups of fresh berries over the jam before rolling up the cake. This cake looks pretty and tastes good when served with dollops of freshly whipped cream (see page 000) and fresh berries.

¾	cup all-purpose flour
1	teaspoon baking powder
¼	teaspoon salt
5	large eggs, at room temperature
¾	cup sugar
½	teaspoon vanilla extract
1¼	cups fruit preserves
	Confectioners' sugar

1. Adjust an oven rack to the lower-middle position and heat the oven to 350 degrees. Lightly coat a 12 by 18-inch rimmed baking sheet with vegetable oil spray, then line with parchment paper (see page 000). Whisk the flour, baking powder, and salt together and set aside.

2. Whip the eggs with an electric mixer on low speed, until foamy, 1 to 3 minutes. Increase the mixer speed to medium and slowly add the sugar in a steady stream. Increase the speed to high and continue to beat until the eggs are very thick and a pale yellow color, 5 to 10 minutes. Beat in the vanilla.

3. Sift the flour mixture over the beaten eggs and fold in using a large rubber spatula until no traces of flour remain.

4. Following the photos, pour the batter into the prepared cake pan and spread out to an even thickness. Bake until the cake feels firm and springs back when touched, 10 to 15 minutes, rotating the pan halfway through baking.

5. Before cooling, run a knife around the edge of the cake to loosen, and flip the cake out onto a large sheet of parchment paper (slightly longer than the cake). Gently peel off the parchment paper attached to the bottom of the cake and roll the cake and parchment up into a log and let cool for 15 minutes.

MAKING A JELLY-ROLL CAKE

1. Using an offset spatula, gently spread the cake batter out to an even thickness.

2. When the cake is removed from the oven, run a knife around the edge of the cake to loosen, and flip it out onto a sheet of parchment paper.

3. Starting from the short side, roll the cake and parchment into a log. Let the cake cool seam-side down (to prevent unrolling) for 15 minutes.

4. Unroll the cake. Spread 1¼ cups jam or preserves over the surface of the cake, leaving a 1-inch border at the edges.

5. Re-roll the cake gently but snugly around the jam, leaving the parchment behind as you go.

6. Trim thin slices of the ragged edges from both ends. Transfer the cake to a platter, dust with confectioners' sugar, and cut into slices.

	TYPE OF BEAN	AMOUNT OF BEANS	AMOUNT OF WATER	COOKING TIME
	BLACK BEANS			
	Soaked	1 pound	4 quarts	1½ to 2 hours
	Unsoaked	1 pound	5 quarts	2¼ to 2½ hours
	BLACK-EYED PEAS			
	Soaked	1 pound	4 quarts	1 to 1¼ hours
	Unsoaked	1 pound	5 quarts	1½ to 1¾ hours
	CANNELLINI BEANS			
	Soaked	1 pound	4 quarts	1 to 1¼ hours
	Unsoaked	1 pound	5 quarts	1½ to 1¾ hours
	CHICKPEAS			
	Soaked	1 pound	4 quarts	1½ to 2 hours
	Unsoaked	1 pound	5 quarts	2¼ to 2½ hours
	GREAT NORTHERN BEANS			
	Soaked	1 pound	4 quarts	1 to 1¼ hours
	Unsoaked	1 pound	5 quarts	1½ to 1¾ hours
	NAVY BEANS			
	Soaked	1 pound	4 quarts	1 to 1¼ hours
	Unsoaked	1 pound	5 quarts	1½ to 1¾ hours
	PINTO BEANS			
	Soaked	1 pound	4 quarts	1 to 1¼ hours
	Unsoaked	1 pound	5 quarts	1½ to 1¾ hours
	RED KIDNEY BEANS			
	Soaked	1 pound	4 quarts	1 to 1¼ hours
	Unsoaked	1 pound	5 quarts	1½ to 1¾ hours
	LENTILS Brown, Green, or French du Puy *(not recommended for red or yellow)*			
	Unsoaked	1 pound	4 quarts	20 to 30 minutes

각 단위 정보 사이에 여백을 주어 요소들을 수평으로 분리하고 판면을 명쾌하게 구성했다.

수평 괘선은 판면의 구성 요소들을 정리하기도 한다. 설명적인 성격이 강한 내용을 배치할 때는 수평 괘선을 사용하여 핵심 정보와 페이지 번호나 바닥글 같은 부수적인 정보를 분리한다.

17 질서를 유지하되 융통성을 발휘하라

이미지를 큼직하게 사용하고
장평에 변화를 주었다.

2단 그리드는 가독성이 매우 높은 구조다. 이미지는 단 안에 자유롭게 배치하고, 그 위나 아래에 캡션을 덧붙이면 된다. 그런데 과연 그것만으로 충분할까? 기본 구조가 확실하게 정해져 있다면, 판면에 얼마든지 변화를 줄 수 있다. 크게 쓸 이미지는 너비를 2단 전체까지 키우고 캡션을 마진 쪽으로 밀어내면, 작품 전체적으로 경쾌한 분위기가 생기는 동시에 질서와 리듬감을 부여할 수 있다.

작업명
「*Design for the Other 90%*」
전시 카탈로그

의뢰인
Smithsonian, Cooper-Hewitt,
National Design Museum

디자인
Tsang Seymour Design

디자인 감독
Patrick Seymour

아트 디렉터, 디자이너
Laura Howell

이미지의 너비를 다양하게 한
보고서. 매우 읽기 쉬운 판면이다.

1. Felix Murun with his MoneyMaker Hip Pump on his farm in Maragua District, Kenya

lawn mowers, and cell phones. They are made in large quantities in big factories. The economy of scale created by centralized manufacturing lowers the price, making the product affordable and ensuring higher quality and reliability. KickStart does the same thing. By centralizing our manufacturing in the most advanced factories available, we can produce high-quality, durable products at a lower cost (figs. 7, 8). Wholesalers and middlemen move these goods from factory to marketplace, making a profit in the process. A network of more than 500 local retail shops in three countries stock and sell our pumps. This supply chain needs no artificial support, and will exist as long as there is consumer demand. KickStart also uses donor funds to market the new technologies and generate demand. As with any new product, this takes both time and money. When you are selling an expensive item to the poorest people in the world, it takes even longer and is more expensive (again, the KCI is a perfect example). But eventually, we will reach a point where we can end our marketing efforts and sell each pump at a profit, which we will then reinvest in developing new technology and expanding into new countries. This is a sustainable supply chain.

Third, there is a question of fairness. I have heard people say that it is not "fair" to ask poor people to invest in their own future, but is it fair to give one person or one village a gift when there are others just as needy? By making our products available through the marketplace, they are available to everyone, without patronage or favoritism. This is perhaps the hardest lesson for someone who wants to do good in the world. We see people in desperate need and want to alleviate their suffering. This spirit of generosity is human nature at its best. But as noble as this motivation is in the giving, it is demoralizing in the receiving. When people invest in themselves and their own futures, they have full ownership of their success, and that creates dignity.

INDIVIDUAL OWNERSHIP WORKS BEST

A good question to ask about any program is, Who will own the new technology? If the answer is unclear, or vague, then the program is unlikely to succeed in the long term. We have learned that individual ownership works better than group ownership. Africa is covered with failed community-owned technologies—tractors, water pumps, ambulances, water purification and irrigation systems, etcetera. The list goes on.

There is a common idea that poor people will come together for their collective benefit, or that "investing" in a community is more cost effective or efficient than working with individuals. There are some situations where this works, like building roads or farmers' cooperatives. But it is much less likely to be effective with the joint ownership of a physical asset. The problem is that if everybody owns an asset, in reality, nobody owns it, and if nobody owns it, nobody will maintain it. Unless there is a way to extract a payment from everyone who uses the asset to cover the

costs of maintenance, repair, and replacement, you have the classic free-rider problem.

It comes down to this. The poorest people in the world are just like you and me. No matter how community-minded we are, we will take care of the needs of our family first. And we value the most the items we had to work for.

DESIGN FOR AFFORDABILITY

Our best-selling Super MoneyMaker Pump can be used to irrigate more than two acres of land, and on average the users make $1,000 profit from selling fruits and vegetables in the first year of use. We continue to work to reduce the cost, but at $95, it is still too expensive for many families.

In response, we designed the Hip Pump, which can irrigate almost an acre and retails for less than $35. It looks like a bicycle-tire pump pivoted on a hinge at the end of a small platform. However, unlike a bicycle pump, it uses the operator's whole body. It is lightweight, portable, and extremely easy to use.

The Hip Pump has been a tremendous success. Its initial production run of 750 units sold out almost immediately. One of them was bought by Felix Murun, a young man from rural Kenya. He had a wife and three children to support, but they owned no land. Felix left his family to seek work in Nairobi, where he managed to earn $40 a month working in a restaurant in the city's slums, sending what he could home to his wife and children. When he saw the Hip Pump, he realized he could make more money farming back in his village. He saved his money, bought a pump, went home, and rented six small plots of land. He grew tomatoes, kale, baby corn, and French beans, which he sold to middlemen who took them to the city. Felix planted different crops on each of his small plots so he would have harvests at different times of the year. When we visited Felix three months after he started using his pump, he had already made $580 profit, and he and his wife were talking eagerly about buying land and building their own house. This small pump had enabled Felix to turn his own sweat and drive into cash, look after his family, and plan for his future (fig. 5).

MEASURE THE IMPACT OF WHAT YOU DO

Measuring real impact or outcome is where many would-be social entrepreneurs fail. The number of products you have sold or distributed tells the world nothing. You have to measure the change you are hoping to create with your invention. It is hard and expensive to do, but it is vital. We have learned a great deal from our impact-monitoring efforts. Not only does it enable us to measure ourselves against the goals we have set, it has also been hugely valuable in the design and improvement of our products and marketing efforts.

These are KickStart's core values, and they come together to create a very cost effective and sustainable way to help people help themselves out of poverty. None of these principles are unique to KickStart or our technologies.

6. A farmer waters her French bean crop with water from a MoneyMaker pump, outside of Nairobi, Kenya

7, 8. Kenya Vehicle Manufacturers (KVM), located in Thika, north of Nairobi, is one of the companies KickStart partners with to manufacture MoneyMaker Pumps

They can be applied to many other technologies to make a real difference in the world. Each of these is important individually, but in our experience it is their combination that makes them truly effective.

Finally, for those people who are driven to innovate for the developing world (and also for those who are eager to fund such efforts), I offer this test. A truly successful program to develop and promote new technologies and/or business models needs to meet the following four criteria:

DOES THE PROGRAM CREATE MEASURABLE AND PROVEN IMPACT?

This means that you need to carefully define the problem you are trying to solve, then carefully monitor and measure the actual impact you are having on that problem. In the case of KickStart, we are trying to bring people out of poverty by enabling them to earn more money. So we carefully measure how much more money the buyers of our technologies make as a result of owning them. If a program cannot create and prove real impact, then it is not worth implementing.

IS THE PROGRAM COST-EFFECTIVE?

There are limited funds for developing and promoting new technologies, and we need to ensure that whatever is done uses these funds efficiently. "Cost-effective" is a subjective measure, so we offer this comparison. KickStart spends about $250 of donor funds to take an average family out of poverty, whereas a more traditional aid program claims on its Web site to do the same for $2,750.

IS THERE A SUSTAINABLE EXIT STRATEGY?

One has to ensure that the benefits will continue to accrue for both the existing and new beneficiaries, even after the donor funds are depleted. Creating a program that continues to depend on donor funds forever is not a viable

solution. There are four different ways that an effort can become sustainable: 1) build and leave in place a profitable supply chain to continue providing the goods/services; 2) hand over the program to a government which will fund it using tax money; 3) create a local situation that can continue to prosper without the injection of any new outside funds, for instance, establishing a local group savings and loan (merry-go-round) system; 4) completely eliminate the problem, such as eradicating a disease.

IS THE MODEL REPLICABLE AND SCALABLE?

The problems we are trying to solve—poverty and climate change, among others—are very large in scale, and it is expensive to develop new technologies and new business models. So we want to ensure that the technologies themselves as well as the dissemination models are not too dependent on specific local conditions, and can be easily adapted to many different settings and locations.

Incorporating all of these guidelines into your work will be a challenge, but great inventors and designers enjoy a challenge. I can tell you that this experience has been an exciting, sometimes frustrating, often exhausting, and immensely satisfying journey. I wish you a fantastic journey of your own.

KICKSTART'S DESIGN PRINCIPLES:

Any tool or technology KickStart produces must meet all of the following design criteria:

INCOME-GENERATING —Any tool must have a profitable business model attached to it.

RETURN ON INVESTMENT —The business opportunity must be available to thousands of people; and the business must be profitable enough that the entrepreneur recoups his or her investment in six months or less.

AFFORDABILITY —We design our tools to retail at less than a few hundred dollars, ideally less than $100.

ENERGY-EFFICIENCY —All of our tools are human powered, so they must be extremely efficient in converting human power into mechanical power.

ERGONOMICS AND SAFETY —Our products must be able to be used for long periods of time without injury.

PORTABILITY —Tools must be small and light enough to transport from store to home on foot, by bike, or by minibus.

EASE OF INSTALLATION AND USE —Tools must be easy to set up and use, without additional tools or training.

STRENGTH AND DURABILITY —Our tools are used in harsh conditions and will be pushed to their limits. They must be built to withstand abuse. We offer a one-year guarantee on all of our products.

DESIGN FOR AVAILABLE MANUFACTURING CAPACITY —Mass production keeps cost down, but locally available materials and processes can dictate the design.

CULTURAL ACCEPTABILITY —Local cultures will not change to adopt a new technology; the technology has to be adapted to local customs.

ENVIRONMENTAL SUSTAINABILITY —Our tools must not create a negative impact on the environment.

18 이해하기 쉽게 영역을 나눠라

훌륭한 디자인은 내용 자체의 성격을 표현하고, 이를 통해 독자와의 접점을 만든다. 어떤 종류의 책이든 디자이너는 타이포그래피를 이용하여 명확하고 이해하기 쉬운 영역들을 구성해야 한다. 그 영역들은 하나의 기사 안에 가로쓰기와 세로쓰기를 혼용하면서도 완벽한 통일성을

유지할 수 있다. 가장 중요한 것은 내용과 형식이 서로 부합해야 한다는 점이다. 독자가 한눈에 대략적인 내용을 파악할 수 있는 판면을 구성해야 한다. 제목부를 분명하게 구별하고, 캡션(특히 설명을 위한 캡션)은 해당 이미지와 자연스럽게 연결되는 위치에 놓아야 한다.

작업명
「Croissant」

의뢰인
「Croissant」

아트 디렉터, 디자인
Seiko Baba

30대 이상의 주부를 겨냥한 일본 잡지 「크루아상(Croissant)」은 세련되고 명쾌한 디자인으로 요리법을 소개한다. 사진의 지면은 「크루아상」의 편집자들이 만든 무크지의 일부다. 제목은 '昔ながらの暮しの知恵', 번역하면 '녹슬지 않는 생활의 지혜'다.

제목부는 텍스트와 분리하여 배치한다. 때로는 페이지 오른쪽 끝에, 때로는 페이지 정중앙에 배치한다. 여백이나 괘선으로 각 텍스트를 분리하고 캡션 또한 독립적인 영역으로 처리한다.

左・大根の二杯酢柚子香り漬け。こうしておくと、いつまででももつ。いつ何どき人が来ても、慌てずに出せる。お茶とでもお酒とでもおいしい。中・大根の葉はキンピラにする。「ちょっとだけ砂糖を入れるとおいしいんですよ。ほんのちょっとだけですよ。で、唐辛子入れて――一味ないとダメよ。飛び上がっちゃうから、で、お醤油をタラーッとまわしかけて。味は自分の好みで」右・大根の葉は油揚げと炒める。味付けはショウガが緑色。この葉っぱと皮の本体は、37ページで見た大根。

大根は、葉っぱから尻尾まで全部食べられるのよ、皮はキンピラにして、ね。

薬用酒各種。「山梔の実、カリン、アロエ、ビワの葉、ニンニク、ナナカマド、タコ、クロモジ、専門以外は、みんな薬用酒になります。効くよ」。左から二つ目のアロエのお酒の作り方は、アロエの葉の棘を包丁でこそげ取り、1cmの厚さに切る。レモンも同じくらいの厚さの輪切りにする。広口瓶にアロエとレモンを入れ、果実酒用焼酎を入れて、2~3ヶ月したら飲める。

右・お客さん用の布鞋。玄関に鞋が並びきらず、廊下にも。また人はこの鞋を自分の鞋も入れ、廊下にも。「関係ないよ」と、案外結局、いろいろな色で作ったんです。上・下駄箱の戸は空気が通るよう隙間がある。

上左・押し寿司の押し器。上右・籠膳のお弁当箱と、曲げわっぱのお弁当箱は「根のいいきを使わないと薄く剥けないんですって」。手前・かつまみ入れ。「全部、お蔵に伏せると平らになって、上にものがのっかるの」

薬用酒なんて、台所の納戸にい～っぱい！昔のものは、一つのものに効くんでなく、「効くんだとさ」、なんです。

「この麹は、いきさの産地の九州は八代で作ってもらったの。夏、マットの上に敷いて寝れば冷却剤より。「ヨガにも使うし、巻いとけば場所とらないしね」

会った木曽地方のおばあさんが作ったもの。これ、知人の恵が、今でその寺の庫裏に人たちの産物と柚子と梅茶の家に、人たちの産物と、薬用酒がいいという。作り方、今でそのまま引いてたいのよ。

「大根、二杯酢に漬けておくと便利よ。大根なんてキュウリと酢と砂糖で漬けるんでって。焼酎漬けでもいいし、しなわせてまた味噌を１ヶ月、焼酎漬けでもいいし、しなやかにして。大根は皮はリッキュウと同じ日干しにする。

佐橋さんの柚子味噌を紹介しようと思ったんですけど。

「これは私が作った柚子味噌。これがおいしいんですよ。

「これは私が作ったものよ。今日は大根がないから、今日は大根がないからセロリをでめんたしましょう」

「3切れに身を切る、1切れを5切れ、3切れ。」

「人は切る。で、切って。1切れを5切れ。それで充分。」と言うと。

野菜の二杯酢漬けと柚子味噌。それに、1切れ、1切れ、3切れ。

鹿児島の焼酎漬け。35度の焼酎で。

활자를 각 영역에 분리, 배치하여 정보의 성격을 드러낸다.
이 작업에서는 주 텍스트와 단계별 사용법을 서로 다른 영역에 배치했다.

실전 그리드 **37**

19 변화에 일관성을 부여하라

효과적인 그리드란 일관성, 질서, 명확성, 견고한 구성을
갖춰야 한다. 그리고 그 위에 한 가지 개성을 더한 것이다.
2단 그리드에서는 두 단의 너비를 각각 다르게 하여
판면에 긴장감과 리듬감을 부여할 수 있다. 기본 구성이
탄탄하다면 판면의 안정성을 해치지 않으면서도 그 위에
기발한 아이디어를 가미하여 극적 효과를 발휘할 수 있다.
반드시 유지해야 할 요소는 다음과 같다.

- 제목은 페이지 맨 위쪽에 놓는다.
- 텍스트 박스는 왼쪽/오른쪽 페이지 어디에서나 항상 같
 은 위치에 놓아 읽는 이에게 길잡이 역할을 할 수
 있어야 한다.
- 페이지 아래쪽에 바닥글과 페이지 번호를 달아 읽는
 이에게 전체의 흐름을 알려준다.

브로슈어 전체에 마스터 포맷을
적용하여 주 정보를 담아냈다.
설명적인 주 텍스트와 부가
정보를 잘 구별하여 읽을 수
있는 판면이다. 명확한 구조는
역동적인 장식 요소에 쉽게
흔들리지 않는다.

작업명
페체이스 칼리지
(Purchase College)
공연 예술센터 브로슈어

의뢰인
SUNY Purchase

디자인
Heavy Meta

아트 디렉터
Barbara Glauber

디자이너
Hilary Greenbaum

탄탄하고 짜임새 있는 구조에
기발한 변화를 줌으로써 판면에
활기를 부여한다.

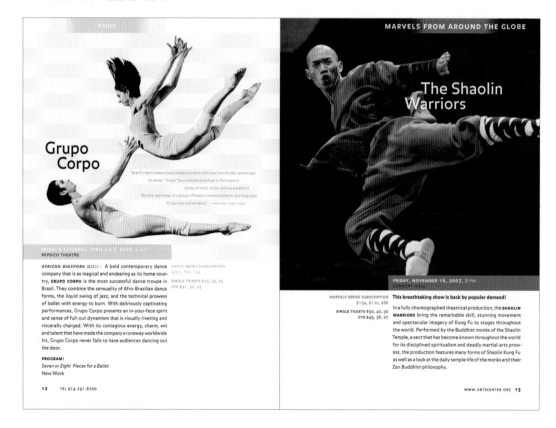

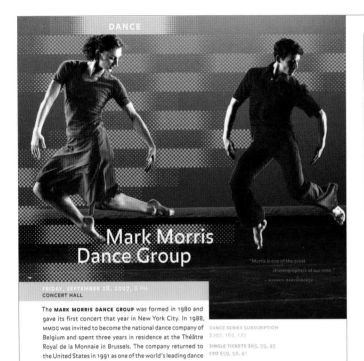

Mark Morris Dance Group

FRIDAY, SEPTEMBER 28, 2007, 8 PM
CONCERT HALL

The **MARK MORRIS DANCE GROUP** was formed in 1980 and gave its first concert that year in New York City. In 1988, MMDG was invited to become the national dance company of Belgium and spent three years in residence at the Théâtre Royal de la Monnaie in Brussels. The company returned to the United States in 1991 as one of the world's leading dance companies, performing across the U.S. and at major international festivals. MMDG is noted for its commitment to live music, a feature of every performance on its full international touring schedule since 1996. The company's 25th Anniversary celebration included over 100 performances throughout 26 U.S. cities and ten U.K. cities.

PROGRAM:
The Argument
Sang-Froid
Italian Concerto
Love Song Waltzes

DANCE SERIES SUBSCRIPTION
$207, 167, 122

SINGLE TICKETS $65, 55, 45
CYO $59, 50, 41

"Morris is one of the great choreographers of our time."
—MIKHAIL BARYSHNIKOV

8 TEL 914.251.6200

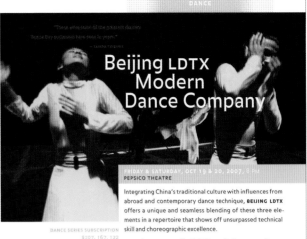

Beijing LDTX Modern Dance Company

"These were some of the greatest dancers Tara-Bay audiences have seen in years."
—TAYPA TOIEPNE

FRIDAY & SATURDAY, OCT 19 & 20, 2007, 8 PM
PEPSICO THEATRE

Integrating China's traditional culture with influences from abroad and contemporary dance technique, **BEIJING LDTX** offers a unique and seamless blending of these three elements in a repertoire that shows off unsurpassed technical skill and choreographic excellence.

FRIDAY'S PROGRAM: *The Cold Dagger* is the company's new full-evening work, choreographed by Li Han-zhong and Ma Bo. Based on the traditional Chinese game of Weigi, this intricately choreographed look at human confrontation juxtaposes incredible acrobatics with paired movement that would be otherwise impossible on a normal stage.

SATURDAY'S PROGRAM: A rep program that includes *All River Red*, a striking piece performed to Stravinsky's classic, *The Rite of Spring*; coupled with the company's newest commissioned work *Pilgrimage*, featuring music by the "father of Chinese rock," Cui Jian.

DANCE SERIES SUBSCRIPTION
$207, 167, 122
SINGLE TICKETS $45, 35, 25
CYO $41, 32, 23

WWW.ARTSCENTER.ORG 9

위: 안정적인 구조와 함께 타이포그래피 간의 명확한 위계가 돋보인다. 제목부 활자는 큼직하게, 이어서 부제는 페이지마다 동일한 크기로 반복되는 박스 안에 작은 활자로 배치했다. 날짜와 장소 정보는 박스와 같은 지정색을 쓰면서도 더욱 직접적으로 전달했다. 모든 요소 간의 관계를 면밀히 파악하고 정보 간의 위계를 명확히 설정한 것이다.

38쪽 아래: 대부분의 이미지가 판면을 수평으로 꽉 채우는 크기로 처리되었다. 그러면서도 컬러 바와 텍스트 박스를 이미지와 겹치도록 배치해 역동적이고 극적인 효과를 노렸다. 이미지에 따라 공연자의 이름이 잘 보이도록 다양한 위치에 배치함으로써 짜임새를 부여하고 발랄한 분위기를 만들어냈다.

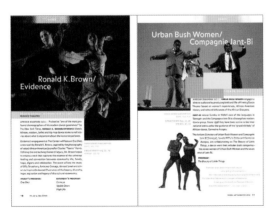

색상과 정보가 조화를 이룬다.

윤곽과 흰 여백을 변주하여 다양한 리듬을 만들어냈다.

20 구조를 변주하라

책 한 권 안에서도 몇 가지 다른 그리드와 타이포그래피 체계를 사용할 때가 있다. 특히 정보의 성격이 다양하다면 정해진 2단 그리드를 적절히 응용하여 더욱 명료하고 균형 잡힌 판면을 구성할 수 있다.

작업명
2007 – 2008 시즌 극장 상영 프로그램 가이드

의뢰인
The Metropolitan Opera

디자인
AdamsMorioka, Inc.

크리에이티브 디렉터
Sean Adams,
Noreen Morioka

아트 디렉터
Monica Schlaug

디자이너
Monica Schlaug,
Chris Taillon

절제되고 고전적이면서도 역동적인 디자인으로 오페라라는 고풍스러운 예술 장르를 표현하는 이미지에 발랄한 에너지를 불어넣었다.

하나로 이어지는 이야기나 시놉시스처럼 연속적인 텍스트를 너비가 같은 2단 그리드에 배치했다.

공연을 설명하는 각 섹션 도입부에 극적인 분위기의 사진을 큼지막하게 배치했다.

Alice Coote and Christine Schäfer sing the title roles.

Engelbert Humperdinck
HANSEL *and* GRETEL

GRETEL WAKES HANSEL,
and the two find themselves in front of a gingerbread house.

PREMIERE: HOFTHEATER, WEIMAR, 1893

Originally conceived as a small-scale vocal entertainment for children, *Hansel and Gretel* outgrew its original design to become the most successful fairy-tale opera ever created. Like so many children's classics, *Hansel and Gretel* achieved greatness because it resonates with both adults and kids. The composer Engelbert Humperdinck was a protégé of the musical titan Richard Wagner, and the score of *Hansel and Gretel* is flavored with the sophisticated musical lessons he learned from his idol while maintaining a charm and a light touch that were entirely Humperdinck's own. The ancient tale of the young brother and sister who get lost in a dark forest and almost get eaten by an old witch became a classic of German literature in the famous collected stories of the Brothers Grimm. The opera acknowledges the darker features present in the story, yet presents them within a frame of grace and humor. Humperdinck's fellow composer Richard Strauss was delighted with this score from the start and conducted its world premiere. *Hansel and Gretel* has been internationally popular ever since and must be one of the very few operas that can boast equal acclaim from such diverse and demanding critics as children and musicologists.

THE CREATORS

Engelbert Humperdinck (1854–1921) was a German composer who began his career as an assistant to Richard Wagner in Bayreuth in a variety of capacities, including tutoring Wagner's son Siegfried in music and composition. Humperdinck even composed a few minutes of orchestral music for the world premiere of Wagner's *Parsifal* (1882) when extra time was needed to effect a scene change. (This music is not included in the printed score of *Parsifal* and is no longer performed). *Hansel and Gretel* was Humperdinck's first complete opera and remains the foundation of his reputation. The world premiere of his later opera *Königskinder* took place at the Met and was one of the sensations of the company's 1910–11 season, following less than three weeks after the world premiere of Puccini's *La Fanciulla del West. Hansel and Gretel*, however, is the only one of Humperdinck's works to remain in the repertory. The libretto was written by his sister, Adelheid Wette (1858–1916), and is based on the famous fairy tale from the Grimms' collection. The brothers Jacob (1785–1863) and Wilhelm (1786–1859) Grimm were German academics whose groundbreaking linguistic work revolutionized the understanding of language development. Today, they are best remembered for editing and publishing collections of folk tales.

THE SETTING

In the libretto, the opera's three acts move from Hansel and Gretel's home to the dark forest to the witch's gingerbread house deep in the forest. Put another way, the drama moves from the real, through the obscure, and into the unreal and fantastical. In this production, which takes the idea of food as its dramatic focus, each act is set in a different kind of kitchen, informed by a different theatrical style: a D.H. Lawrence-inspired setting in the first, a German Expressionist one in the second, and a Theater of the Absurd mood in the third.

THE MUSIC

The score of *Hansel and Gretel* successfully combines accessible charm with subtle sophistication. Like Wagner, Humperdinck assigns musical themes to certain ideas and then transforms the themes according to new developments in the drama. Much of this development occurs in the orchestra, like the chirpy cuckoo, depicted by the winds in Act II, which becomes

ACT II

Gretel sings while Hansel picks strawberries. When they hear a cuckoo calling, they imitate the bird's call, eating strawberries all the while, and soon there are none left. In the sudden silence of the woods, the children realize that they have lost their way and grow frightened. The Sandman comes to bring them sleep by sprinkling sand on their eyes. Hansel and Gretel say their evening prayer. In a dream, they see 14 angels protecting them.

ACT III

The Dew Fairy appears to awaken the children. Gretel wakes Hansel, and the two find themselves in front of a gingerbread house. They do not notice the Witch, who decides to fatten Hansel up so she can eat him. She immobilizes him with a spell. The oven is hot, and the Witch is overjoyed at the thought of her banquet. Gretel has overheard the Witch's plan, and she breaks the spell on Hansel. When the Witch asks her to look in the oven, Gretel pretends she doesn't know how: the Witch must show her. When she does, peering into the oven, the children shove her inside and shut the door. The oven explodes, and the many gingerbread children the Witch had enchanted come back to life. Hansel and Gretel's parents appear and find their children. All express gratitude for their salvation.

정보의 성격에 따라 차별화한 타이포그래피는 세리프체와 산세리프체로 뚜렷하게 구분된다.

Q&A 같은 성격의 정보를 담아낼 때는 2단 그리드가 효과적이다. 좁은 단에는 질문을, 넓은 단에는 답변을 담는다.

that Tristan is simply performing his duty. Isolde maintains that his behavior shows his lack of love for her, and asks Brangäne to prepare a death potion. Kurwenal tells the women to prepare to leave the ship, as shouts from the deck announce the sighting of land. Isolde insists that she will not accompany Tristan until he apologizes for his offenses. He appears and greets her with cool courtesy ("Herr Tristan trete nah"). When she tells him she wants satisfaction for Morold's death, Tristan offers her his sword, but she will not kill him. Instead, Isolde suggests that they make peace with a drink of friendship. He understands that she means to poison them both, but still drinks, and she does the same. Expecting death, they exchange a long look of love, then fall into each other's arms. Brangäne admits that she has in fact mixed a love potion, as sailors' voices announce the ship's arrival in Cornwall.

ACT II

In a garden outside Marke's castle, distant horns signal the king's departure on a hunting party. Isolde waits impatiently for a rendezvous with Tristan. Horrified, Brangäne warns her about spies, particularly Melot, a jealous knight whom she has noticed watching Tristan. Isolde replies that Melot is Tristan's friend and sends Brangäne off to stand watch. When Tristan appears, she welcomes him passionately. They praise the darkness that shuts out all false appearances and agree that they feel secure in the night's embrace ("O sink hernieder, Nacht der Liebe"). Brangäne's distant voice warns that it will be daylight soon ("Einsam wachend in der Nacht"), but the lovers are oblivious to any danger and compare the night to death, which will ultimately unite them. Kurwenal rushes in with a warning: the king and his followers have returned, led by Melot, who denounces the lovers. Moved and disturbed, Marke declares that it was Tristan himself who urged him to marry and chose the bride. He does not understand how someone so dear to him could dishonor him in such a way ("Tatest Du's wirklich?"). Tristan cannot answer. He asks Isolde if she will follow him into the realm of death. When she accepts, Melot attacks Tristan, who falls wounded into Kurwenal's arms.

ACT III

Tristan lies mortally ill outside Kareol, his castle in Brittany, where he is tended by Kurwenal. A shepherd inquires about his master, and Kurwenal explains that only Isolde, with her magic arts, could save him. The shepherd agrees to play a cheerful tune on his pipe as soon as he sees a ship approaching. Hallucinating, Tristan imagines the realm of night where he will return with Isolde. He thanks Kurwenal for his devotion, then envisions Isolde's ship approaching, but the Shepherd's mournful tune signals that the sea is still empty. Tristan recalls the melody, which he heard as a child. It reminds him of the duel with Morold, and he wishes Isolde's medicine had killed him then instead of making him suffer now. The shepherd's tune finally turns cheerful. Tristan gets up from his sickbed in growing agitation and tears off his bandages, letting his wounds bleed. Isolde rushes in, and he falls, dying, in her arms. When the shepherd announces the arrival of another ship, Kurwenal assumes it carries Marke and Melot, and barricades the gate. Brangäne's voice is heard from outside, trying to calm Kurwenal, but he will not listen and stabs Melot before he is killed himself by the king's soldiers. Marke is overwhelmed with grief at the sight of the dead Tristan, while Brangäne explains to Isolde that the king has come to pardon the lovers. Isolde, transfigured, does not hear her, and with a vision of Tristan beckoning her to the world beyond ("Mild und leise"), she sinks dying upon his body.

SCALING THE HEIGHTS

Deborah Voigt and **Ben Heppner** on how they'll ascend opera's Mount Everest—the title roles of *Tristan und Isolde*—with a little help from Maestro James Levine.

Debbie, you've only sung Isolde on stage once before, several years ago. Why the long interval?

Deborah Voigt: I first sang the part in Vienna five years ago. It came along sooner than I anticipated, but the circumstances were right and I decided to go ahead and sing it. When you sing a role as difficult as Isolde, people are going to want you to sing it a lot, and I didn't want to have a lot of them booked if it didn't go well. So I didn't book anything until the performances were over. The first opportunity I had after Vienna are the Met performances.

Ben, what makes you keep coming back to Tristan?

Ben Heppner: Before it starts, it feels like I'm about to climb Mount Everest. But from the moment I step on the stage to the last note I sing it feels like only 15 minutes have gone by. There is something so engaging about this role that you don't notice anything else. It takes all of your mental, vocal, and emotional resources to sing. And I like the challenge of it.

The two of you appear together often, and you've also both worked a lot with James Levine.

DV: Maestro Levine is so in tune with singers—how we breathe and how we work emotionally. I remember I was having trouble with a particular low note, and in one performance, he just lifted up his hands at that moment, looked at me and took a breath, and gave me my entrance. The note just landed and hasn't been a problem since.
BH: He has this wonderful musicality that is so easy to work with. As for Debbie, we just love singing together and I think that is really its own reward.

This *Tristan* will be seen by hundreds of thousands of people around the globe. How does that impact your stage performance?

DV: None of us go out to sing a performance thinking that it is any less significant than another, so my performance will be the same. But when you are playing to a huge opera house, gestures tend to be bigger. For HD, some of the operatic histrionics might go by the wayside.
BH: When the opera house is filled with expectant listeners—that becomes my focus. The only thing I worry about is that it's a very strenuous role, and I'm basically soaking wet from the middle of the second act on! ∎

21 간결하게 보여라

대부분의 성공적인 디자인은 언뜻 보기에는 단순해 보이지만 실제로는 매우 유연한 구조를 가지고 있다. 개방적이고 단순한 디자인 형식은 많은 정보를 담아낼 수 있어서 특히 책이나 카탈로그 작업에 유용하게 쓰인다.

텍스트와 이미지를 함께 다루는 작업에서는 두 요소 간의 비율을 생각하여 각각 어느 정도의 공간을 할애할 것인지를 결정한다. 캡션의 길이가 길고 정보가 많은, 자료 제공자 목록이나 보충 설명 같은 경우에는 캡션 서체를 본문 서체와 달리하거나 활자 크기를 작게 하거나 또는 요소 간 여백의 양을 조절하여 본문 텍스트와 캡션을 확실히 구분한다.

이를 위해 쓸 수 있는 그리드는 3단 그리드면서도 1단이나 2단으로 구조화할 수 있는 그리드다. 텍스트는 세 단 중에서 오른쪽 두 단에 1단 박스로 배치한다. 그러면 긴 텍스트를 명확하게 읽을 수 있다. 또한 남은 왼쪽 1단에는 길이가 긴 캡션을 여유롭게 배치할 수 있다.

정보의 성격에 따라 세 단 중 두 단에 1단 텍스트 대신 캡션을 2단으로 배치하기도 한다. 이 방법을 사용하면 캡션과 이미지가 같은 페이지에 담겨 가독성이 높아진다. 3단 그리드에서 이미지의 크기는 1단 너비, 2단 너비, 3단 너비 또는 페이지 전체 너비로 설정할 수 있다.

작업명
『*Beatific Soul*』

의뢰인
New York Public Library/
Scala Publishers

디자인
Katy Homans

소설가 잭 케루악(Jack Kerouac)의 삶과 업적, 작품, 일기, 원고 등을 선보인 전시회 편람으로, 그의 대표작 『길 위에서(*On the Road*)』를 중심으로 꾸며졌다. 3단 그리드를 다양하게 응용하여 매우 유연한 판면을 구성했다. 공간감 있고 차분하면서도 비트 세대 (케루악으로 대표되는 미국의 히피 세대)다운 심플함을 느낄 수 있는 판면이다.

단순하지만 유연한 다단 그리드를 사용하여 그 어떤 성격의 정보든 자연스럽게 담아냈다. 주 텍스트는 세리프체를 사용하고 행간을 넉넉히 주어 가독성을 높였다. 캡션은 맨 왼쪽 단에 배치했으며, 서체를 산세리프체로 설정하여 극도의 단순함을 부여했다. 이러한 구성의 판면은 성격이 변화무쌍하게 바뀌는 텍스트도 무리 없이 담아낼 수 있다.

3단 그리드는 폭이 좁은 이미지와 병렬 캡션을 배치하는 데 매우 효과적이다. 왼쪽 페이지에서 주 텍스트 자리에 캡션을 배치하고 폭이 좁은 이미지를 맨 왼쪽 단에 실었다. 오른쪽 페이지에는 텍스트만 담았다.

판면에 리듬을 부여하고 명쾌함을 살리기 위해 큰 이미지로 한 페이지 전체를 채우기도 한다. 이 작업에서는 잭 케루악이 타자기로 쓴 원고 이미지를 오른쪽 페이지 전체에 배치하여 차분한 느낌의 왼쪽 텍스트 페이지와 대비를 이루게 했다.

주석이나 색인 등 참고 정보에서 3단 그리드가 자주 쓰인다.

3단 그리드

22 타이포그래피로 단을 구분하라

타이포그래피로도 얼마든지 각 단의 성격을 규정할 수 있다. 서체의 두께와 크기를 달리하여 정보에 질서를 부여하고, 이를 통해 수평적 위계(제목부, 설명부, 중요도) 혹은 수직적 위계(단락, 왼쪽에서 오른쪽으로의 흐름)를 창출할 수 있다. 목록 형식의 정보는 산세리프체처럼 차별화된 서체를 사용하여 긴 텍스트나 설명 부분과

차이를 둔다. 볼드체로 처리한 제목, 설명부의 숫자는 독자의 눈길을 끌고 판면 전체에 강렬한 느낌을 가져온다. 두주(본문 위쪽에 적는 주석)나 부속 텍스트에는 두께가 얇거나 다른 서체를 사용하는 것이 좋다. 공간을 명확히 구성하기만 한다면 다양한 서체를 사용하면서도 시각적인 혼란을 피할 수 있다.

작업명
『*Martha Stewart's Cookies*』

의뢰인
MSL Clarkson Potter

디자인
Barbara deWilde

세련된 사진과 서체로 가정살림의 권위자인 마사 스튜어트의 높은 안목과 취향을 표현했다.

재료 설명은 산세리프체로, 요리 설명은 세리프체로 설정했다. 산세리프체를 볼드체로 써서 강세를 주었다.

Coconut-Cream Cheese Pinwheels

Rich cream cheese dough, coconut-cream cheese filling, and a topper of jam make these pinwheels complex—chewy on the outside, creamy in the center. Create a variety of flavors by substituting different fruit jams for the strawberry. MAKES ABOUT 2½ DOZEN

for the dough:

 2 cups all-purpose flour, plus
 more for work surface
 ⅔ cup sugar
 ½ teaspoon baking powder
 ½ cup (1 stick) unsalted butter,
 room temperature
 3 ounces cream cheese,
 room temperature
 1 large egg
 1 teaspoon pure vanilla extract

for the filling:

 3 ounces cream cheese,
 room temperature
 3 tablespoons granulated
 sugar
 1 cup unsweetened shredded
 coconut
 ¼ cup white chocolate chips

for the glaze:

 1 large egg, lightly beaten
 Fine sanding sugar, for
 sprinkling
 ⅓ cup strawberry jam

1. Make dough: Whisk together flour, sugar, and baking powder in a bowl. Put butter and cream cheese into the bowl of an electric mixer fitted with the paddle attachment; mix on medium-high speed until fluffy, about 2 minutes. Mix in egg and vanilla. Reduce speed to low. Add flour mixture, and mix until just combined. Divide dough in half, and pat into disks. Wrap each piece in plastic, and refrigerate until dough is firm, 1 to 2 hours.

2. Preheat oven to 350°F. Line baking sheets with nonstick baking mats (such as Silpats).

3. Make filling: Put cream cheese and sugar into the bowl of an electric mixer fitted with the paddle attachment; mix on medium speed until fluffy. Fold in coconut and chocolate chips.

4. Remove one disk of dough from refrigerator. Roll about ¼ inch thick on a lightly floured surface. With a fluted cookie cutter, cut into fifteen 2½-inch squares. Transfer to prepared baking sheets, spacing about 1½ inches apart. Refrigerate 15 minutes. Repeat with remaining dough.

5. Place 1 teaspoon filling in center of each square. Using a fluted pastry wheel, cut 1-inch slits diagonally from each corner toward the filling. Fold every other tip over to cover filling, forming a pinwheel. Press lightly to seal. Use the tip of your finger to make a well in the top.

6. Make glaze: Using a pastry brush, lightly brush tops of pinwheels with beaten egg. Sprinkle with sanding sugar. Bake 6 minutes. Remove and use the lightly floured handle of a wooden spoon to make the well a little deeper. Fill each well with about ½ teaspoon jam. Return to oven, and bake, rotating sheets halfway through, until edges are golden and cookies are slightly puffed, about 6 minutes more. Transfer sheets to wire racks; let cool 5 minutes. Transfer cookies to rack; let cool completely. Cookies can be stored in single layers in airtight containers at room temperature up to 3 days.

정보들을 위아래로 쌓아 놀이를 하는 듯한 기분을 냈다. 독특한 서체로 전체 판면에 특색을 부여함으로써 독자가 즐기면서 요리를 배울 수 있도록 만들었다.

23 과밀은 금물

다단 그리드 디자인에서는 모든 공간을 완벽하게 채울 필요가 없다는 것을 알아두자. 어떤 단은 텅 빈 그대로 두어도 좋다. 독자가 흰 여백을 따라 판면을 읽어나가면서 이야기, 이미지, 로고 타입 등 여러 내용 중에서 원하는 것을 골라 읽도록 하면 된다. 다양한 두께의 괘선을 이용하여 정보를 조직화하고 강렬한 시각 효과를 창출할 수 있다.

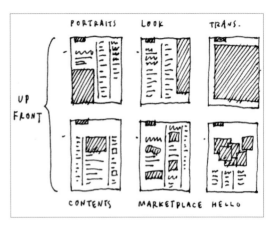

초기 스케치가 공간을 어떻게 구성할 것인지를 보여준다.

작업명
『Good』 008호

의뢰인
Good Magazine, LLC

디자인 감독
Scott Stowell

디자인
Open

여백을 충분히 둔 재치 있고 신선한 디자인이다. 독자는 지구를 더 나은 곳으로 만들기 위한 진지하고 무거운 이야기들을 살아 있는 다채로운 이야기로 즐겁게 읽어나갈 수 있다.

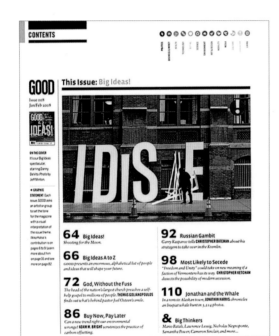

보통 목차는 조직적으로 구성하기 매우 어려운 내용이다. 이 작업에서는 복잡한 요소를 전부 배제하여 독자가 잡지에 수록된 내용을 쉽게 찾아볼 수 있도록 했다. 다양한 크기와 두께의 타이포그래피를 사용해 흥미로우면서도 균형 잡힌 판면을 구성했다. 오른쪽 위에 배치한 아이콘들이 잡지 전체에 하나의 포맷으로 적용되었다.

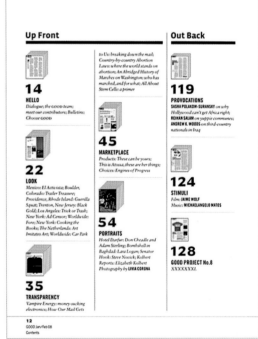

이 페이지는 독자가 명확하고 쉽게 이해할 수 있도록 정보를 5단계로 나누고 그것을 깔끔한 타이포그래피와 넉넉한 여백으로 처리했다.

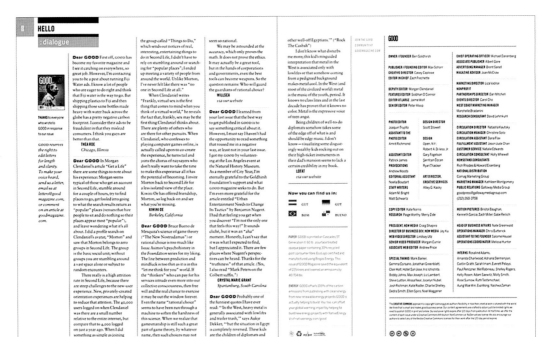

괘선과 면밀하게 설정한 타이포그래피를 사용하여 다양한 성격의 정보를 짜임새 있게 선보였다.

박력 있는 타이포그래피로 여백을 장식한 페이지와 역시 힘 있는 일러스트레이션 페이지를 대비시켰다.

'심각한 이야기'를 전달해야 한다면? 활자를 키워라! 큼직한 장식 대문자는 이야기의 시작을 경쾌하게 알리기도 하고, 제목 활자로 언어유희 효과를 발휘하기도 한다. 목차 페이지에 배치한 아이콘 중에서 내용에 관련된 아이콘들이 목차 페이지에서처럼 페이지 오른쪽 위에 나타난다.

24 단의 높이를 낮춰라

3단 그리드의 모든 단에 텍스트를 배치하면 자칫 밀도가 지나치게 높아질 수 있다. 그럴 때 독자가 흥미를 잃거나 위압감을 느끼지 않도록 3단 텍스트를 편안하게 내보이는 좋은 방법이 있다. 단의 높이를 낮추어 판면에 정갈한 느낌과 역동적인 분위기를 부여하는 것이다. 텍스트 단의 높이를 낮추면 위쪽 여백에 머리글, 페이지 번호, 면 제목, 두주, 사진 등 텍스트의 선행 요소들을 자유롭게 배치할 수 있다는 또 하나의 이점이 있다.

8

Pew Environment Group

Halloween 1948 was all trick and no treat in Donora, Pennsylvania. In the last week of October, this town of 14,000 in the western part of the state underwent a weather event called a "temperature inversion," trapping at ground level the smog from local metal factories.

Nearly half of Donora's residents experienced breathing problems, hundreds suffered permanent heart and lung damage, and some 50 deaths were attributed to the disaster. Sixty years ago, public policy gave Americans relatively little protection from industrial accidents. However, Donora and similar disasters helped focus national attention on the government's responsibility to protect the population from environmental hazards. Eventually, the Donora catastrophe led to the Air Pollution Control Act of 1955, the United States' first piece of federal legislation on this issue and an early step in what has become an ongoing effort to save the environment, for the sake of the natural world as well as public health.

A related development in 1948 produced no fatalities but was a harbinger of a situation that was ultimately even more serious. As energy demand and prices soared in the postwar boom and Western companies discovered vast oil fields in the Middle East, the

United States for the first time became a net importer of oil.

Sixty years later, this country—indeed, the world—faces unprecedented environmental challenges. Changes to terrestrial and marine environments resulting from climate change, overfishing, agriculture, grazing and logging are already transforming the planet in ways that impair its ability to be hospitable to life—both ours and that of the countless other species that occupy it with us. The Pew Environment Group is focused on reducing the scope and severity of three major global environmental problems:

• Dramatic changes to the Earth's climate caused by the increasing concentration of greenhouse gases in the atmosphere;

• The erosion of large wilderness ecosystems that contain a great part of the world's remaining biodiversity;

• The destruction of the world's oceans, with a particular emphasis on global marine fisheries.

Climate change. To reduce the threat of climate change, we are urging the adoption of a mandatory national policy to reduce greenhouse gas emissions. While its centerpiece is a market-based cap and trade system, complementary measures are needed to create additional incentives to invest in less polluting technologies in key sectors, particularly transportation.

Early in 2007, we launched the Pew Campaign for Fuel Efficiency to promote legislation to increase fuel-efficiency standards for passenger vehicles to 35 miles per gallon by 2020. Nationwide, vehicles account for two-thirds of oil consumption and one-third of greenhouse gas emissions, with light-duty passenger vehicles—cars, pick-ups, minivans and SUVs—producing about 60 percent of transportation-related emissions. Globally, U.S. transportation accounts for about 8 percent of all greenhouse

Seeking protection from the smog in Donora, Pa., in 1948

Car emissions, a leading contributor to climate change

Sharks, sought for their fins, among the sea's endangered creatures

gas pollution and 17 percent of an increasingly tight and volatile world oil market. Higher standards would reduce our country's dependence on foreign oil, enhance national security, save consumers money and reduce global warming pollution.

Wilderness protection. Due to the spread of human civilization, habitat destruction and, increasingly, climate change, scientists estimate that we may be losing as many as 30,000 species each year. To slow or stop this loss, many conservation biologists say, we need to create new parks, wildlife refuges and protected areas where extractive activity and development are prohibited. Pew has played a critical role in the permanent protection of more than 200 million acres of wilderness in the United States and Canada since 1990. More recently, we have launched a joint initiative with The Nature Conservancy to establish new national parks and indigenous protected areas in Australia. Together, these three countries contain more than 30 percent of the

world's remaining old growth forests and an even larger share of pristine wilderness areas.

Ocean conservation. Overfishing, chemical and nutrient pollution, habitat alteration, introduction of exotic species and climate change are taking what may be an irreversible toll on the world's marine environment. The Pew Environment Group has helped lead the way in bringing about many of the major improvements in fisheries management and marine conservation in the United States since the mid-1990s. In recent years, we have expanded our oceans work internationally and are working in various other regions of the world to curtail overfishing, protect critical marine habitat and reduce the amount of unintended bycatch—the fish, seabirds, sharks, whales and other species that are routinely thrown back into the sea, either dead or dying.

Pew today is in a stronger position to address all of these problems as the result of the merger of our Environ-

ment Program with the National Environmental Trust. The consolidated team has a domestic and international staff of more than 100, making us one of the nation's largest environmental scientific and advocacy organizations with a presence across not only the United States but also Australia, Canada, Europe, the Indian Ocean, Latin America and the Western Pacific.

Society has historically invested little time, thought or effort in protecting the environment for posterity. Sixty years ago, once the smog in Donora had cleared, most people simply assumed that things would return to the way they had been. We can no longer afford to make that mistake.

Joshua S. Reichert
Managing Director
Pew Environment Group

변화는 디자인의 양념과 같다. 도입부를 1단으로 넓게 디자인함으로써 대비 효과를 내고, 두주의 서체를 판면의 다른 곳에서는 전혀 사용하지 않은 것으로 설정하여 독특한 질감을 가미했다.

작업명
「*Pew Prospectus 2008*」

의뢰인
The Pew Charitable Trusts

디자인
IridiumGroup

편집
Marshall A. Ledger

공동 편집, 프로젝트 매니저
Sandra Salmans

비영리 단체인 퓨 자선기금
(The Pew Charitable Trusts)의
작업은 진지하면서도 우아한
분위기를 연출했다.

Culture

Change was sweeping the arts scene in 1948, with an impact that would not be fully realized for years. American painters led the way into abstract expressionism, reshaping both the visual arts and this country's influence on the art world.

Long-playing records, enthralling the public in 1948

The Village of Arts and Humanities, revitalizing North Philadelphia

Development workshops for Bill Irwin's *The Happiness Lecture*

Meanwhile, technology was setting the stage for revolutions in music and photography. The LP record made its debut, and the Fender electric guitar, which would define the rock 'n roll sound in the next decade and thereafter, went into mass production. Both the Polaroid Land camera, the world's first successful instant camera, and the first Nikon went on sale.

In New York, the not-for-profit Experimental Theatre, Inc., received a special Tony honoring its path-breaking work with artists such as Lee Strasberg and Bertolt Brecht. But in April it was disclosed that the theatre had run up a deficit of $20,000—a shocking amount, given that $5,000 had been the maximum allocated for each play—and in October *The New York Times* headlined, "ET Shelves Plans for Coming Year."

Apart from its miniscule budget, there is nothing dated about the travails of the Experimental Theatre. The arts

still struggle with cost containment and tight funds. But if the Experimental Theatre were to open its doors today, it might benefit from the power of knowledge now available to many nonprofit arts organizations in Pennsylvania, Maryland and California—and, eventually, to those in other states as well. Technology, which would transform music and photography through inventions in 1948, is providing an important tool to groups that are seeking to streamline a grant application process that, in the past, has been all too onerous.

That tool is the Cultural Data Project, a Web-based data collection system that aggregates information about revenues, employment, volunteers, attendance, fund-raising and other areas input by cultural organizations. On a larger scale, the system also provides a picture of the assets, impact and needs of the cultural sector in a region.

The project was originally launched in Pennsylvania in 2004, the brainchild of a unique collaboration among public and private funders, including the Greater Philadelphia Cultural Alliance, the Greater Pittsburgh Arts Council, The Heinz Endowments, the Pennsylvania Council on the Arts, Pew, The Pittsburgh Foundation and the William Penn Foundation. Until then, applicants to these funding organizations had been required to provide similar information in different formats and on multiple occasions. Thanks to the Pennsylvania Cultural Data Project, hundreds of nonprofit arts and cultural organizations throughout the state can today update their information just once a year and, with the click of a computer mouse, submit it as part of their grant applications. Other foundations, such as the Philadelphia Cultural Fund, the Pennsylvania Historical and Museum Commission and the Independence Foundation, have also adopted the system.

So successful has the project been that numerous states are clamoring to adopt it. In June, with funding from multiple sources, Maryland rolled out its own in-state Cultural Data Project. The California Cultural Data Project, more than five times the size of Pennsylvania's with potentially 5,000 nonprofit cultural organizations, went online at the start of 2008, thanks to the support of more than 20 donors. Both projects are administered by Pew.

As cultural organizations in other states enter their own data, the research will become exponentially more valuable. Communities will be able to compare the effects of different approaches to supporting the arts from state to state and city to city. And the data will give cultural leaders the ability to make a fact-based case that a lively arts scene enriches a community economically as well as socially.

The Cultural Data Project is not the first initiative funded by Pew's Culture portfolio to go national or to benefit from state-of-the-art technology. For example, the system used by Philly-FunGuide, the first comprehensive, up-to-date Web calendar of the region's arts and culture events, has been successfully licensed to other cities.

In addition to the Cultural Data Project, another core effort within Pew's Culture portfolio is the Philadelphia Center for Arts and Heritage and its programs, which include Dance Advance, the Heritage Philadelphia Program, the Pew Fellowships in the Arts, the Philadelphia Exhibitions Initiative, the Philadelphia Music Project and the Philadelphia Theatre Initiative. Since the inception of the first program in 1989, these six initiatives have supported a combined total of more than 1,100 projects and provided more than $48 million in funding for the Philadelphia region's arts and heritage institutions and artists.

Through its fellowships, Pew nurtures individual artists working in a variety of performing, visual and literary disciplines, enabling them to explore new creative frontiers that the marketplace is not likely to support. The center also houses the Philadelphia Cultural Management Initiative, which helps cultural groups strengthen their organizational and financial management practices.

Almost from the time it was established, Pew was among the region's largest supporters of arts and culture. While it continues in this role, committed to fostering nonprofit groups' artistic excellence and economic stability, and to expanding public participation, Pew—like the arts themselves—has changed its approach with the times.

Marian A. Godfrey

Managing Director
Culture and Civic Initiatives

2007 Milestones

Each year, we join with excellent organizations to produce work that exemplifies exactly what we mean in stating that Pew serves the public interest. On these pages, we highlight the results of some of the Pew-supported work that made a difference in 2007.

Environment

Pew's Environment Group and the National Environmental Trust finalize their **merger**. The consolidated team has a domestic and international staff of more than 100, making Pew one of the nation's largest environmental scientific and advocacy organizations, with a presence across the United States and in Australia, Canada, Europe, the Indian Ocean, Latin America and the Western Pacific.

Congress passes and the White House signs legislation requiring that by 2020 automakers produce fleets with an average consumption of 35 miles per gallon. The advance, advocated aggressively by the Pew Campaign for Fuel Efficiency, represents the highest **increase in fuel-efficiency standards** for the nation's cars and light trucks in more than 30 years.

The United States Climate Action Partnership, an unprecedented alliance of leading nongovernmental organizations and major corporations, calls upon the federal government to quickly enact strong national legislation to achieve significant reductions of **greenhouse gas emissions**. To develop regional strategies address-

ing climate change, two groups are launched: the Western Climate Initiative (Arizona, British Columbia, California, Manitoba, New Mexico, Oregon, Utah and Washington) and the Midwestern Greenhouse Gas Reduction Accord (Illinois, Iowa, Kansas, Manitoba, Michigan, Minnesota and Wisconsin).

The International Boreal Conservation Campaign helps secure the protection of 25.5 million acres of Canada's **boreal forest**, one of the earth's three largest remaining wilderness areas. Since 2000, Pew's boreal conservation efforts have contributed to the protection of more than 100 million acres, reaching that goal two years ahead of schedule.

Pew and The Nature Conservancy launch **Wild Australia**, an ambitious three-year project to protect the continent's terrestrial and marine wilderness and biodiversity. One goal is to establish up to a million acres of new protected areas.

Approximately one-fourth of the world's high seas will be off-limits to **bottom trawling** under an agreement by the 22 nations negotiating the establishment of a regional fisheries management organization for the

South Pacific. In addition, controls such as vessel-locator monitoring systems and observers will be mandatory on every bottom-trawling vessel. The agreement covers areas extending roughly from the equator to the Antarctic Circle and from Australia to the west coast of South America.

Pew's advocacy and public education efforts help reduce overfishing in various regions of the United States. Congress reauthorizes the Magnuson-Stevens Fisheries Management and Conservation Acts of 1996 and 2006 to contain the strongest **fisheries conservation** measures in U.S. history. The New England Fisheries Management Council makes **herring management** a priority in 2008. The Marine Aquaculture Task Force presents standards and practices for U.S. **marine aquaculture** that protect the health of marine ecosystems.

Health and Human Services

The College Cost Reduction and Access Act, signed into law, includes an income-based repayment program modeled on a proposal developed by the Pew-supported **Project on Student Debt** at the Institute for College

Access and Success. The new law makes loan payments fair and manageable by capping them at a reasonable percentage of income, recognizing borrowers' family responsibilities, forgiving buildup of interest, and canceling most remaining balances after 25 years (10 years for those in public service careers). It also reduces unnecessary lender subsidies and uses the savings to increase Pell grants, which will help more students avoid debt as they pursue higher education.

Bipartisan legislative proposals modeled on the policy recommendations of the **Pew Commission on Children in Foster Care** are introduced in the U.S. Senate and House of Representatives. The bills would improve opportunities for foster children to find safe, permanent homes through adoption or legal guardianship and ensure that American Indian children in foster care are eligible for federal foster-care funding and receive the services they need.

Bipartisan legislation to encourage the use of automatic individual retirement accounts is introduced in both houses of the U.S. Congress. Modeled on a proposal developed by the **Retirement Security Project**, this legislation would allow IRAs to be funded through automatic payroll deductions to help

workers whose employers do not offer a retirement plan. Delegates to the National Summit of Retirement Savings conference endorse the proposal, and several presidential candidates propose improving retirement saving through programs substantially similar to that recommended by the project.

The Project on Emerging Nanotechnologies, a partnership of Pew and the Woodrow Wilson International Center for Scholars, facilitates a first-ever collaboration between a major industrial user of nanotechnology, the DuPont company, and a public interest group, Environmental Defense, which results in the development of a voluntary agreement on the responsible use of engineered nanoscale materials. The project's chief science advisor testifies before the federal government's first public meeting focused exclusively on research into the environmental, health and safety risks of these substances.

Citing concerns over health risks and efficacy, a panel of safety experts at the U.S. Food and Drug Administration proposes banning over-the-counter cough and cold medicines for children under the age of six. The Baltimore, Maryland, health commissioner, who leads the FDA petition, cites data from the **Prescription Project** on medical

marketing. The project, which is supported by Pew and its partners, also calls on the American Medical Association to stop selling its comprehensive physician database to companies that use the information to market directly to doctors.

Pew Center on the States

New Web-based voter services become available to help the more than six million Americans living overseas, including members of the military, vote in upcoming elections. Created by the Overseas Vote Foundation with support from Pew, the new Web site and integrated voter-services applications offer a user-friendly online system to register to vote, request an absentee ballot and obtain information about voting requirements. Alabama, Minnesota and Ohio are the first states to adopt the new software for their own election Web sites.

The Pew Center on the States issues a groundbreaking report, *Promises with a Price*, which finds that, while states have promised at least $2.73 trillion in pension, health care and other retirement benefits for public employees over the next three decades, they have saved

25 형태를 요리하라

입문서의 경우, 사진이나 그림의 형태를 바꿈으로써 역동성을 부여하고 내용의 교육적 성격을 강화할 수 있다. 모든 요소가 같은 크기, 같은 너비라면 판면이 간결하긴 해도 지루해지는 것을 피할 수 없다. 변화를 줄 수 있다면 얼마든지 시도해보자. 그 편이 더 좋은 효과를 낸다.

작업명
『Martha Stewart Living』

의뢰인
Martha Stewart Omnimedia

디자인
Martha Stewart Living

크리에이티브 팀장
Gael Towey

견고함과 유연성을 동시에 갖춘 포맷에 상세한 일러스트레이션과 사진을 배치했다.

Handbook How-Tos

HOW TO WASH, DRY, AND STORE LETTUCE

1. Fill a clean basin or a large bowl with cold water, and submerge the lettuce leaves completely. (For head lettuce, first discard the outer leaves; they're most likely to harbor bacteria. Chop off the end, and separate the remaining leaves.) Swish the leaves around to loosen dirt.

2. Once sediment has settled, lift out the lettuce, pour out the dirty water, and refill the bowl with clean water. Submerge the lettuce again, and continue swishing and refilling until there are no more traces of dirt or sand in the bowl. You may need to change the water 2 or 3 times.

3. Dry the lettuce in a salad spinner until no more water collects at the bottom of the bowl. Alternatively, blot the leaves between layered paper towels or clean dish towels until no water remains.

4. If you plan to store the lettuce, arrange the dry leaves in a single layer on paper towels or clean dish towels. roll up, and seal inside a plastic bag. Lettuce can be stored this way in the refrigerator for 3 to 5 days. To prevent it from browning rapidly, don't tear the leaves into smaller pieces until you're ready to use them.

SOAK AND SPIN THE LEAVES

STORE IN A TOWEL

HOW TO IRON A BUTTON-FRONT SHIRT

For easier ironing and the best results, start with a thoroughly damp shirt. Mist the shirt with water using a spray bottle, roll it up, and keep it in a plastic bag for 15 minutes or up to a few hours. (If you can't iron the shirt sooner, refrigerate it in the bag so the shirt won't acquire a sour smell.) Most of the ironing will be on the wide end of the board. If you're right-handed, position the wide end to your left; if you're left-handed, it should be on your right.

1. Begin with the underside of the collar. Iron, gently pulling and stretching the fabric to prevent puckering. Turn the shirt over, and repeat on the other side of collar. Fold the collar along seam. Lightly press.

2. Iron the inside of the cuffs; slip a towel under the buttons to cushion them as you work. Iron the inside of the plackets and the lower inside portion of the sleeves, right above the cuffs. Iron the outside of the cuffs.

3. Drape the upper quarter of the shirt over the wide end of the board, with the collar pointing toward the narrow end of the board, and iron one half of the yoke. Reposition, and iron the other half.

4. Lay 1 sleeve flat on the board. Iron from shoulder to cuff. (If you don't want to crease the sleeve, use a sleeve board.) Turn the sleeve over, and iron the other side. Repeat with the other sleeve.

5. Drape the yoke over the wide end of the board, with the collar facing the wide end, and iron the back of the shirt.

6. Drape the left side of the front of the shirt over the board, with the collar pointing toward the wide end; iron. Repeat with the right front side, ironing around, rather than over, buttons. Let the shirt hang in a well-ventilated area until it's completely cool and dry, about 30 minutes. before hanging it in the closet.

62

텍스트나 설명을 명확하게 전달하고자 할 때는 조리, 작업 과정을 담은 일러스트레이션이나 상세한 사진을 사용하는 것이 효과적이다. 이미지는 활용도가 매우 높을 뿐만 아니라 다양한 형태로 응용하고 배치하여 판면에 리듬감을 부여할 수 있다.

51쪽: 이 작품에 쓰인 타이포그래피는 정교하고 기능적이면서도 그 자체로 매우 아름답다. 박스로 처리한 사이드바는 그 내용이 조리법과 따로 분리해서 다뤄야 할 만큼 중요한 정보임을 나타낸다.

SAUTÉED SOLE WITH LEMON
SERVES 2

Gray sole is a delicately flavored white fish. You can substitute flounder, turbot, or another type of sole.

½ cup flour, preferably Wondra
1 teaspoon coarse salt
½ teaspoon freshly ground pepper
2 gray sole fillets (6 ounces each)
2 tablespoons unsalted butter
2 tablespoons olive oil
2 tablespoons sliced almonds
1½ tablespoons chopped fresh parsley
 Finely chopped zest and juice from 1 lemon, plus wedges for garnish

1. Combine flour, salt, and pepper in a shallow bowl. Dredge fish fillets in flour mixture, coating both sides, and shake off excess.
2. Melt butter with oil in a sauté pan over medium-high heat. When butter begins to foam, add fillets. Cook until golden brown, 2 to 3 minutes per side. Transfer each fillet to a serving plate.
3. Add almonds, parsley, zest, and 2 tablespoons juice to pan. Spoon over fillets, and serve with lemon wedges.

HARICOTS VERTS
SERVES 2

 Coarse salt, to taste
8 ounces haricots verts
2 tablespoons extra-virgin olive oil
 Freshly ground pepper, to taste
1 bunch chives, for bundling (optional)

1. Bring a pot of salted water to a boil. Add haricots verts, and cook until bright green and just tender, 3 to 5 minutes. Drain, and pat dry. Transfer to a serving bowl.
2. Toss with oil, salt, and pepper. Tie into bundles using chives.

HOW TO BUNDLE GREEN BEANS

1. Cook haricots verts. Drain, and pat dry. Let stand until cool enough to handle.
2. Lay a chive on a work surface. Arrange 4 to 10 haricots verts in a small pile on top of chive. Carefully tie chive around bundle. Trim ends of chive if desired.

QUICK-COOKING CLASSIC Seared sole fillets glisten beneath a last-minute pan sauce made with lemon, parsley, and almonds. The resulting entrée, served with blanched haricots verts, is satisfyingly quick yet sophisticated.

26 리듬을 살려라

명확하고 계획적인 판면을 구성하기 위해서는 특정 요소를 반복하는 것이 중요하지만, 아무런 변화 없이 같은 요소를 반복해서는 독자를 지루하게 할 뿐이다. 디자이너는 텍스트 단을 이미지 요소의 형태에 맞춰 배치함으로써

답답한 구성을 피할 수 있다. 또한, 판면에 변화를 가미하여 설명적인 성격이 강한 딱딱한 내용을 더욱 잘 전달할 수 있다.

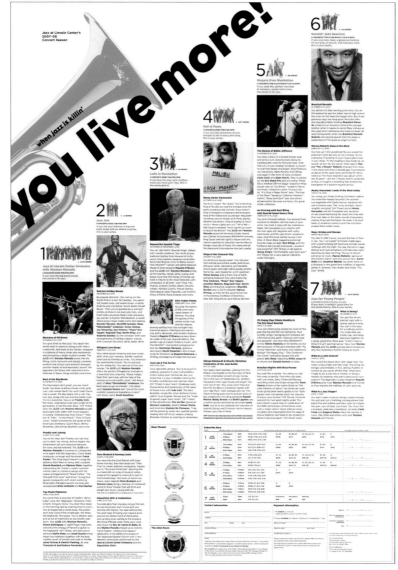

이 그리드에는 매우 많은 양의 정보가 담겨 있다. 트럼펫 형태의 이미지에 계단식으로 높이를 달리한 단들을 이어 붙였다. 이 구조가 각 단에 담긴 다채롭고 유려한 목록 형식의 정보를 한층 역동적으로 보이게 한다. 무엇보다 타이포그래피를 보라. 균형과 리듬, 세공 하나하나가 그 자체로 걸작이다.

작업명
프로그램 스케줄

의뢰인
Jazz at Lincoln Center

디자인
Bobby C. Martin Jr.

많은 양의 정보를 날렵한 레이아웃으로 다채롭게 담아냈다.

다단 그리드에 깔끔한 박스를
배치한 명확한 판면이다. 이때
박스는 여러 가지 기능을 한다.
정보를 담고, 입체적인 사진
위에 평면을 구축해 공간감을
형성하고, 판면을 떠다니며
리듬감을 발산한다.

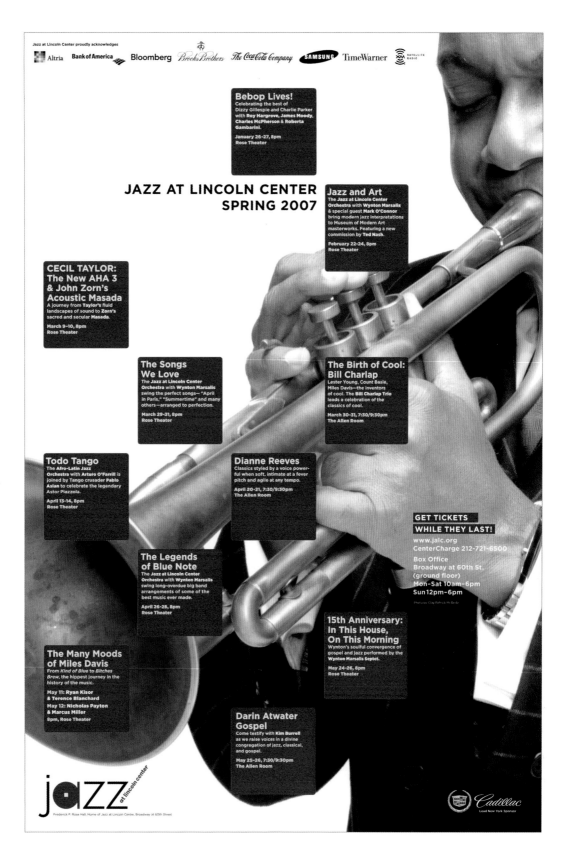

Bebop Lives!
Celebrating the best of
Dizzy Gillespie and Charlie Parker
with **Roy Hargrove, James Moody,
Charles McPherson & Roberta
Gambarini.**

January 26-27, 8pm
Rose Theater

JAZZ AT LINCOLN CENTER
SPRING 2007

Jazz and Art
The **Jazz at Lincoln Center
Orchestra** with **Wynton Marsalis**
& special guest **Mark O'Connor**
bring modern jazz interpretations
to Museum of Modern Art
masterworks. Featuring a new
commission by **Ted Nash.**

February 22-24, 8pm
Rose Theater

**CECIL TAYLOR:
The New AHA 3
& John Zorn's
Acoustic Masada**
A journey from **Taylor's** fluid
landscapes of sound to **Zorn's**
sacred and secular **Masada.**

March 9-10, 8pm
Rose Theater

**The Songs
We Love**
The **Jazz at Lincoln Center
Orchestra** with **Wynton Marsalis**
swing the perfect songs— "April
in Paris," "Summertime" and many
others—arranged to perfection.

March 29-31, 8pm
Rose Theater

**The Birth of Cool:
Bill Charlap**
Lester Young, Count Basie,
Miles Davis—the inventors
of cool. The **Bill Charlap** Trio
leads a celebration of the
classics of cool.

March 30-31, 7:30/9:30pm
The Allen Room

Todo Tango
The **Afro-Latin Jazz
Orchestra** with **Arturo O'Farrill** is
joined by Tango crusader **Pablo
Aslan** to celebrate the legendary
Astor Piazzola.

April 13-14, 8pm
Rose Theater

Dianne Reeves
Classics styled by a voice power-
ful when soft, intimate at a fever
pitch and agile at any tempo.

April 20-21, 7:30/9:30pm
The Allen Room

**GET TICKETS
WHILE THEY LAST!**
www.jalc.org
CenterCharge 212-721-6500

Box Office
Broadway at 60th St.
(ground floor)
Mon-Sat 10am-6pm
Sun 12pm-6pm

Photo by Clay Patrick McBride

**The Legends
of Blue Note**
The **Jazz at Lincoln Center
Orchestra** with **Wynton Marsalis**
swing long-overdue big band
arrangements of some of the
best music ever made.

April 26-28, 8pm
Rose Theater

**15th Anniversary:
In This House,
On This Morning**
Wynton's soulful convergence of
gospel and jazz performed by the
Wynton Marsalis Septet.

May 24-26, 8pm
Rose Theater

**The Many Moods
of Miles Davis**
From *Kind of Blue* to *Bitches
Brew*, the hippest journey in the
history of the music.

May 11: Ryan Kisor
& Terence Blanchard
May 12: Nicholas Payton
& Marcus Miller
8pm, Rose Theater

**Darin Atwater
Gospel**
Come testify with **Kim Burrell**
as we raise voices in a divine
congregation of jazz, classical,
and gospel.

May 25-26, 7:30/9:30pm
The Allen Room

jazz
at lincoln center
Frederick P. Rose Hall, Home of Jazz at Lincoln Center, Broadway at 60th Street

Cadillac
Lead New York Sponsor

27 섞어라

섞어라. 무엇을? 두께, 크기, 질감, 형태, 비율, 여백, 색상 등등을…. 그 모든 것을 섞어보자. 디자이너는 많은 요소를 이렇게 저렇게 조합하여 다채로우면서도 일관된 멋진 화면으로 구성한다. 우선 견고한 그리드를 바탕에 깐다. 그 위에 다양한 방식으로 많은 표제와 이미지를 배치할 수 있다. 활자의 두께와 크기, 이미지의 크기와 형태가 주는 효과를 이용하여 독자의 관심을 강하게 끌면서도 기본 내용을 읽어나가는 데에는 아무런 문제가 없는 판면을 구성하자.

페이지마다 일관되게 나타나는 뚜렷한 5단 그리드를 바탕으로 다양한 형태와 크기의 요소들을 배치했다. 판면의 구조가 매우 견고한데, 특히 이미지 주위의 여백이 매우 짜임새가 있다.

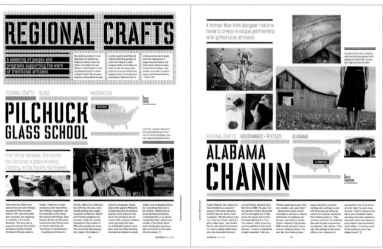

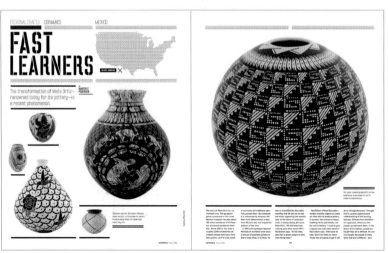

작업명
「Metropolis」

의뢰인
「Metropolis」

크리에이티브 디렉터
Criswell Lappin

전체적으로 짜임새가 있는 그리드는 각 부분을 돋보이게 한다. 바탕의 다단 그리드가 견고하다면 그 위에서 크기, 두께, 색깔을 자유롭게 바꿀 수 있다.

타이포그래피의 색상은 검은색과 한 가지 별색 뿐인데도, 스텐실 기법을 연상시키는 두꺼운 제목 서체와 작고 얇은 서체들의 대비로 더욱 생생한 질감과 색감이 구현되었다. 두께가 다양한 괘선 또한 마찬가지의 역할을 한다.

55쪽: 흔들의자 이미지 아래의 괘선이 의자를 지지하는 바닥 같은 기능을 한다.

HANDMADE HOME

A crafts group enlists local artisans to create a one-of-a-kind dwelling.

by
BELINDA LANKS

AKIRA SATAKE

CERAMICS

Satake produces functional ceramic pieces—from vases, platters, and bowls to decorative tile—with a refined Japanese aesthetic.

FATIE ATKINSON

FURNITURE

Employing a steam-bending technique, Atkinson can make this chair out of any open-pored wood, including hickory, ash, and white or red oak (shown).

BARBARA ZARETSKY

TEXTILES

Zaretsky creates earth-toned patterns using natural fibers, plant dyes, and textile paints.

HandMade in America has been fervently promoting craft in Western North Carolina since 1993, but this year marks the nonprofit's first foray into real estate. In a novel collaboration, the group has partnered with private developer Biltmore Farms to construct the HandMade

Home, a 3,700-square-foot model in Asheville showcasing the work of 100 local craftspeople. The house, which broke ground last September, is expected to meet the green-building standards of North Carolina's Healthy Built Homes program and fetch $2.25 million when it makes its debut

in October as part of the city's annual "Parade of Homes."

Founding executive director Becky Anderson hopes the project will spur other developers, architects, and homeowners to tap the region's greatest resource: the 4,500 resident artisans making everything from furniture and

lighting fixtures to tableware and rugs (examples shown above). To make it easy, HandMade in America has produced directories featuring the work of and contact information for the crafts-people in its network. But Ben

Brown, the project's publicist, recommends that people considering such an undertaking think smaller. "This is the first project of its kind, and it will probably be the last," Brown says. "With one hundred independent-minded artists involved, people are ready to shoot each other." ○

Courtesy HandMade in America

MOTAWI

The Frank Lloyd Wright Collection includes Avery (left) and Confetti (below) sizes shown: Montrose (above) and Ameriglio (right), an adaptation of a Louis Sullivan design.

DAVID ELLISON

Sold by Country Floors, the Apollo Plaque (above) is a reinterpretation of historic details found on buildings in New York's Flatiron District.

PEWABIC

The designs for Pewabic School at Cranbrook (top) or Bloomfield Hills, and Detroit's Comerica Park stadium (above) were custom made by the pottery's in-house team.

Eastern Michigan is home to one of the most active crafts movements in the country.

MOTOR CITY GLAZE

by
EVA HAGBERG

"We'd start doing these tile shows that were just tile, and we'd think, How could anyone make a living at this?" says Marcia Hovland, part of a loose-knit group of Michigan-based tile-makers, reminiscing about the good old days before the tile industry took off. "And now

everyone is doing really well."

Hovland is one of the artisans who came up through Detroit's famed Pewabic Pottery—a tile factory, exhibition space, and educational facility. She studied there with David Ellison—a name that comes up again and again in conversation with these eastern-

Michigan tile fiends—and realized that she could turn her painting and design background into a whole new bag of (ceramic) chips.

Karim Motawi runs Motawi Tileworks out of Ann Arbor with his sister, Nawal. The company makes historically influenced pottery in line with the types of

things that were produced in the earliest days of Pewabic in the 1900s. "We're literally plowing through the history books and the source books, the old catalogs," he says. "We're trying to re-create the lost craft." As the official Frank Lloyd Wright licensee, it's reproducing just fine.

Motawi Tileworks operates on a relatively tiny scale—it produces 16,000 square feet of tile a year, a drop in the bucket—and so do many of its local cohorts, which is why they're so happy to know Joseph Taylor, president of the Tile Heritage Foundation, which works to raise the historic craft's profile. "They are like tile cheerleaders," Motawi says. ○

Courtesy the manufacturers

BROOKLYN'S OWN

A crafty, DIY-inspired furniture movement emerges in New York's most creatively vibrant borough

ELUCIDESIGN

DANISH CHAIR

Inspired by the Scandinavian classics, this Chris Jordie–designed piece is made of maple and uses a hand-silkscreened linen for the back and seat.

WÜD

WÜD CHAIR

The dining-room chair, designed by Corey Springer and Eric Ervin in 2006, comes in a variety of woods, including cherry (shown), walnut, and maple.

UHURU DESIGN

DK METAL ARMCHAIR

Designed by Jason Horvath, this lounge chair consists of a one-inch-by-two-inch steel frame and upholstered cushions available in custom colors and patterns.

Far from the maddening crowds of the contemporary-furniture scene, a small group of intrepid designers is sprouting like trees in Brooklyn. Aesthetically, they're all over the map. Scrapile (from Greenpoint) is known for the pun it's named after: a scrap pile of locally sourced wood that designers Bart Bettencourt and Carlos Salgado turn into a building material; each block incorporates everything from walnut to ply-

wood and is then processed through a labor-intensive layering method. Uhuru, founded by Bill Hilgendorf and Jason Horvath, offers a line of sleek, multimaterial pieces, all of which, if viewed through a larger lens, are just as sustainable.

Those firms got started about four years ago, and they join the older guard Elucidesign, founded in 2001, and City Joinery, which set up shop in 1996. Elucidesign's

Redpoint collection is a beautifully spare series of pared-down pieces; City Joinery's range and look is broader and heavier. "We care a lot about design," City Joinery's Jonah Zuckerman says. "We care a lot about craft." Horvath brings up a similar tension: "We don't want to be this big furniture company that does

production overseas, but we don't want to be just building furniture in Red Hook." He shouldn't worry too much. His company and its compatriots are part of a new phenomenon—the rise of the artisan designer, Brooklyn division. ○

Courtesy the designers

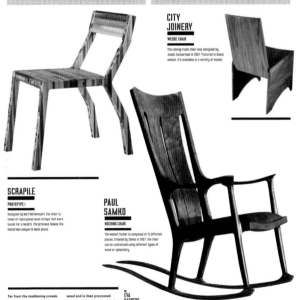

CITY JOINERY

WEDGE CHAIR

This dining-room chair was designed by Jonah Zuckerman in 2007. Pictured in black walnut, it's available in a variety of woods.

SCRAPILE

PROTOTYPE 1

Designed by Bart Bettencourt, the chair is made of repurposed wood scraps that were bound for a landfill. The process makes the materials unique to each piece.

PAUL SÁMKO

ROCKING CHAIR

The waisted rocker is composed of 15 different pieces. Created by Sámko in 2007, the chair can be customized using different types of wood or upholstery.

by
EVA HAGBERG

28 복잡한 요소들을 간소화하라

담고자 하는 많은 정보 중에 단 하나도 소홀히 다뤄서는 안 되는 작업에서는 다단 그리드가 매우 효과적이다. 계통도를 그려 정보를 여러 방식으로 조직화하자. 전문적인 내용을 전달하려면 단, 괘선, 텍스트 등을 다양한 크기와 서체, 색상으로 표현해야 한다.

57쪽 위: 두꺼운 괘선으로 구획한 널찍한 수평 구역에는 표제와 저자, 발신지, 로고가 실렸다. 제목부 아래의 괘선 곳곳을 각 단 사이의 여백에 맞춰 끊어놓았다. 맨 오른쪽의 'Conclusions'는 서체 크기와 행간을 키워 본문의 연구 내용과 구분했다. 캡션은 다른 서체와 구분되는 산세리프체를 사용하여 내용을 압축적이고 간결하게 나타냈다. 단 사이에 세로 괘선을 넣어 같은 단에 담긴 다른 정보를 구분했다.

Figure 2: The ICE probe is placed in the right heart for imaging during PFO closure and pulmonary vein isolation.

The ICE probe can be advanced into the inferior vena cava (IVC), enabling high quality imaging of the abdominal aorta (Figure 3).

작업명(57쪽 위)
포스터

의뢰인
NYU Medical Center

디자인
Carapellucci Design

디자이너
Janice Carapellucci

뉴욕 대학 메디컬 센터의 이 포스터는 정보 간 위계를 명확하게 설정한 모범적인 작업 사례로, 상세한 설명 텍스트가 쉽게 읽힌다. 정보에 따라 타이포그래피를 다르게 설정했고, 요소 간 좌우상하 간격도 매우 읽기 쉬운 완벽한 비율이다. 모든 구역이 정보로 가득하지만 전문가가 아닌 보통 사람들이 읽어도 얼마든지 이해할 수 있게 판면을 디자인하였다.

작업명(57쪽 아래)
SXSW의 워크숍 테이블 매트

의뢰인
smith + beta

디자인
Suzanne Dell'Orto

메이커들에 대한 배려가 돋보이는 상세하고 성실한 단계별 설명에 아이콘, 팁, 계층 구조, 체크리스트, 대담성 등 다양한 요소가 들어 있다.

57쪽 아래: 테이블 매트 상단 왼쪽에서 오른쪽으로 흐르는 텍스트가 가장 중요한 취지 설명이다. 가운데는 정보 항목들로 빼곡하다. 가로막대 부분이 목록의 가운데 부분과 흐름도와 참고자료를 분리시켜준다.

Evaluation of the Abdominal Aorta and its Branches Using an Intravascular Echo Probe in the Inferior Vena Cava

Carol L. Chen, MD
Paul A. Tunick, MD
Lawrence Chinitz, MD

Neil Bernstein, MD
Douglas Holmes, MD
Itzhak Kronzon, MD

New York University School of Medicine New York, NY USA

NYU Medical Center

Background

Ultrasound evaluation of the abdominal aorta and its branches is usually performed transabdominally. Not infrequently, the image quality is suboptimal. Recently, an intracardiac echocardiography (ICE) probe has become commercially available (Acuson, Mountain View CA, Figure 1). These probes are usually inserted intravenously (IV) and advanced to the right heart for diagnostic and monitoring purposes during procedures such as ASD closure and pulmonary vein isolation (Figure 2). Because of the close anatomic relation between the abdominal aorta (AA) and the inferior vena cava (IVC), we hypothesized that these probes would be useful in the evaluation of the AA and its branches.

Figure 2: The ICE probe is placed in the right heart for imaging during PFO closure and pulmonary vein isolation.

The ICE probe can be advanced into the inferior vena cava (IVC), enabling high quality imaging of the abdominal aorta (Figure 3).

Figure 3: The position of the ICE probe in the IVC allows for excellent imaging and Doppler flow interrogation of the abdominal aorta and its branches (renal arteries, SMA, celiac axis) and the diagnosis of diseases such as renal artery stenosis and abdominal aortic aneurysm.

Figure 1: ICE probe (AcuNav, Acuson)

Methods

Fourteen pts who were undergoing a pulmonary vein isolation procedure participated in the study. In each pt, the ICE probe was inserted in the femoral vein and advanced to the right atrium for the evaluation of the left atrium and the pulmonary veins during the procedure. At the end of the procedure, the probe was withdrawn into the IVC.

Results

High resolution images of the AA from the diaphragm to the AA bifurcation were easily obtained in all pts. These images allowed for the evaluation of AA size, shape, and abnormal findings, such as atherosclerotic plaques (2 pts) and a 3.2 cm AA aneurysm (1 pt). Both renal arteries were easily visualized in each pt. With the probe in the IVC, both renal arteries are parallel to the imaging plane (Figure 4), and therefore accurate measurement of renal blood flow velocity and individual renal blood flow were possible.

Calculation of renal blood flow: The renal blood flow in each artery can be calculated using the cross-sectional area of the artery ($\pi r2$) multiplied by the velocity time integral (VTI, in cm) from the Doppler velocity tracing, multiplied by the heart rate (82 BPM in the example shown).

Figure 4: Two-dimensional image with color Doppler, of the abdominal aorta at the level of the right (Rt) and left (Lt) renal ostia. Note visualization of the laminar renal blood flow in the right renal artery, toward the transducer (red) and the left renal artery, away from the transducer (blue).

Figure 6: Pulsed Doppler of the right renal artery blood flow. The diameter of the right renal artery was 0.65 cm, and the VTI of the right renal blood flow was 0.19 meters (19 cm). Therefore the right renal blood flow was calculated as 516 cc/minute.

CSA VTI
 . * HR = renal blood flow/min

Figure 5

Figure 7: Pulsed Doppler of the left renal artery blood flow. The diameter of the left renal artery was 0.51 cm, and the VTI of the left renal blood flow was 0.2 meters (20 cm). Therefore the left renal blood flow was calculated as 334 cc/minute.

The total renal blood flow (right plus left) in this patient was therefore 850 cc/min. (average normal = 1200 cc/min.)

Conclusions

High resolution ultrasound images of the AA and the renal arteries are obtainable using ICE in the IVC. The branches of the abdominal aorta can be visualized and their blood flow calculated. Renal blood flow may be calculated for each kidney using this method. This may prove to be the imaging technique of choice for intra-aortic interventions such as angioplasty of the renal arteries for renal artery stenosis, fenestration of dissecting aneurysm intimal flaps, and endovascular stenting for AA aneurysm.

Why making? *Are you a maker? We hope so.*

It is a particularly critical time to put intelligent, ethical thought into "things." Perhaps you are shaping products that move markets...or, knitting fluffy hats. Do you recognize, in an antique chair, its narrative... The hand of the artisan who reshaped a tree to offer comfort?

Have you ever optimistically pulled apart broken electronics with hope of resuscitation? Confused by new car engines? (You are not alone.) Since the onset of the Anthropocene Age, humans have been obsessed with things. We have allowed them to help us, crowd us, amuse us, comfort us, etc. **Joy, sustainability, curiosity and purpose** are some of the keywords for 21c making manifestos. One must have trust in invisible electronic worlds yet remember the many paths we have traveled.

Why make makers?

Since making can be manifested in so many ways—software, toys, or an epicurean meal, it is essential to recognize the elements of a making processes that transcend media.

Materials, meaning-making, and mastery come together as a guide for companies who value creative processes and courageous individuals.

> *I HEAR AND I FORGET. I SEE AND I REMEMBER. I DO AND I UNDERSTAND."*
> —Confucius

Making Makers Who Fearlessly Make

SXSW 2015

Lori Kent, Ed. D.
Allison Kent-Smith
Catherine McGowan

10 tips

1. Know what your team makes. Know their skills.
2. Design learning experiences that engage the senses...have emotional meaning and connect to everyday work.
3. Define common terminology around making. Acknowledge team's existing knowledge.
4. Manage people so that their inner imaginations soar. *Tell them that what they know recombines as "creativity."*
5. Encourage everyone around you to have pride in their craft and continue to grow over a lifetime.
6. Design learning experiences that support multiple learning styles and configure complementary teams.
7. Making EXPLICIT a vision and your provisional goals.
8. AND... create a work (making) process that is shared and iterative.
9. Get people to connect with their inner child to lift creative blocks. Take makers to unexpected places.
10. This workshop is a beginning. You have a specific culture, individual needs...**take a first step.**

 KNOW YOUR TALENT → GATHER TEAM & VISION → DESIGN & PLAN → TEACH & INSPIRE → EVALUATE & ADJUST

PROGRAM BUILDING STEP BY STEP

Resources

Texts
Shopcraft as Soulcraft: An Inquiry into the Value of Work by Matthew B. Crawford
The Courage to Create by Rollo May
Spark: How Creativity Works by Julie Bernstein (Studio 360)
Makers: The New Industrial Revolution by Chris Anderson
The Craftsmen by Richard Sennett
Ten Faces of Innovation by Kelley & Littman (IDEO)

WWW
http://aeon.co/magazine/being-human/
https://dschool.stanford.edu/groups/dhandbook/
http://edge.org/
http://makerfaire.com/
http://dx.cooperhewitt.org/lesson-plans/
http://www.fixerscollective.org/
http://www.techshop.ws/

Thanks to

Strawbees, SparkFun, Sally Oetttinger, Meredith Olsen, Grace Borchers, and the s & b teacher collective.
Designed by Suzanne Dell'Orto.

smith&beta
www.smithandbeta.com

3 ELEMENTS OF MAKING : MATERIALS, MEANING-MAKING, & MASTERY

Materials
* Materials tell you what to do.
* "Functional fixedness" is seeing a "thing" or material as having a specific use...rethink.
* Ordinary materials can inspire, transform....

Meaning-Making
* Be a generative thinker...able to sort, filter, bifurcate, combine and expand.
* Your experience gives you an incredibly rich "well" for making.
* Develop wonder. Think too much.

Mastery
* Mastery? What do you do best?
* How can you deconstruct process to teach mastery?
* How do you support individual and team mastery?

SXSW Evaluation Link: sxsw.feedogo.com/fdbk.do?sid=IAP36301

29 DIY가 쉽게 만들어라

실용적인 설명서의 제1원칙은 이해하기 쉬워야 한다는 것이다. 명확한 구조의 레이아웃은 심지어 독자가 해당 언어를 모를지라도 (어느 정도는) 그 내용을 이해할 수 있게 하는 힘이 있다. 이때 내용을 가장 잘 전달할 수 있는 장치는 숫자를 매긴 설명과 이미지다. 그러므로 그 자체로 내용을 뚜렷하게 전달하는 사진을 사용하고 또 그것을 가장 적절하게 내보일 수 있는 방법을 고려하여 재미있고 쉽게 읽히는 레이아웃을 구성하자.

작업명
「暮しの手帖」

의뢰인
「暮しの手帖」

디자이너
Shuzo Hayashi,
Masaaki Kuroyanagi

서양 문화의 캐릭터인 찰리 브라운과 그의 도시락 가방을 활용하는 동시에 동양적인 여백의 미를 살린 실용서다.

PEANUTS © United Feature Syndicate, Inc.

여유로운 여백과 설명글이 잘 어울린다. 만화는 다양한 문화를 뛰어넘는 소통의 매체다.

괘선 처리한 박스 장치 안에서 한 항목이 다른 항목으로 이어진다. 판면 위의 모든 요소가 짜임새 있는 그리드 안에 명확히 배치되어 있다.

아래: 실행 과정의 각 단계를 숫자로 표시하여 명확하게 나타냈다. 세부 단계에는 작은 원형 번호를 붙이고, 모든 요소가 질서 정연하게 배치되어 있다. 특히 그림 설명은 해당 언어를 모르는 사람이라도 솜씨만 있으면 이 책을 보고 똑같은 작품을 만들어낼 수 있을 만큼 이해하기 쉽다. 여백과 각 요소의 크기 비율, 깔끔한 사진 등이 더없이 상세한 설명을 친절하게 전달한다.

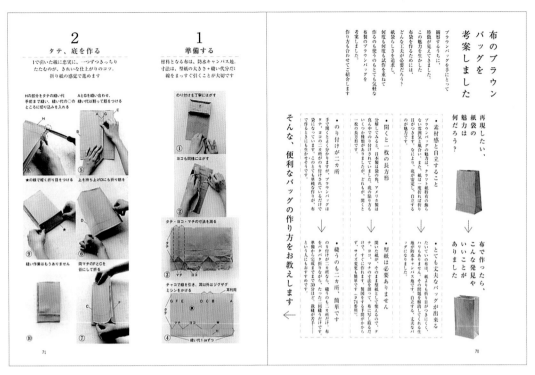

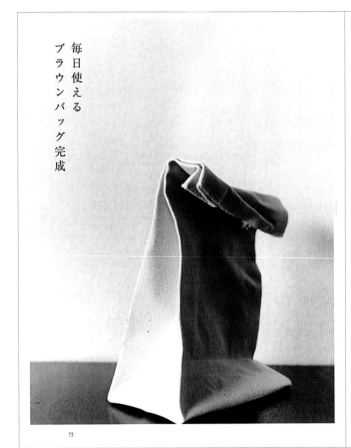

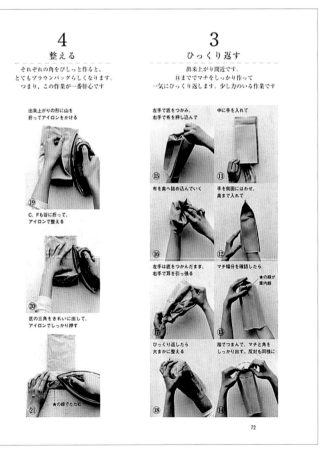

30 웹사이트의 기본 원리를 숙지하라

대형 웹사이트들은 엄청난 양의 정보를 소화하기 위해 그리드를 사용하여 화면을 구축한다. 화면을 각 부분으로 나누어 정보를 담아내는 것이다. 우선 반드시 들어가야 할 내용이 무엇인지 파악한다. 그러고 나서 화면의 마진, 작업 표시줄 같은 툴바, 브라우저 등의 화면 상태를 고려한다. 책 디자이너와 마찬가지로 웹 디자이너 역시 한정된 공간에 들어갈 모든 것을 고려하여 디자인한다. 일반적으로 웹사이트에는 광고, 영상을 비롯하여 제목, 부제, 필자 이름, 목록, 링크 등의 복잡한 요소들이 들어간다. 따라서 명확한 타이포그래피를 사용하는 것이 매우 중요하다.

화면 크기

화면의 크기는 사용자의 기기마다 다르다. 그래서 작은 화면에서도 읽기 쉽도록 많은 디자이너가 특정 값의 픽셀 너비와 돌출 깊이를 가진 라이브 영역을 정의한다. 컴퓨터 화면은 시간이 갈수록 커졌지만, 휴대용 소형 기기가 등장하면서 화면의 크기가 다양해지고 더 단순한 계층적 포맷이 나왔다.

작업명
nytimes.com

의뢰인
「The New York Times」

디자인
「The New York Times」

디자인 감독
Tom Bodkin

이 웹사이트는 실용적인 내용에 명확하고 세련되고 전통적인 타이포그래피를 세밀하게 구분하여 적용했다. 산세리프체로 세리프체를 뒷받침하면서 각 기사의 내용과 작성 시간을 색으로 강조했다.

촘촘한 구조 안에 분류 항목,
기사 제목, 다양한 크기의
이미지, 광고, 영상을 담아냈다.

뉴욕타임스의 전 디자인 디렉터
코이 빈(Khoi Vinh)에 따르면
"그리드를 구성하는 데는 기본
단위가 있습니다. 단위가 모여
단을 이루고 이것이 판면에
시각적인 구조를 만들어내지요"
라고 말한다. 또한 그는
이론적으로 가장 효과적인
디자인은 '단위를 3 또는 4의
배수로 배치하는 것'이며 '따라서
3과 4의 공배수인 12가 가장
이상적인 개수'라고 설명한다.
이 계산법은 겉으로 드러나지는
않지만 실제로는 각 단위와
단을 다루는 철저한 원칙으로
작용하여 화면 구성에 강력한
토대를 부여한다.

단위를 합쳐 단을 구성했다면,
그 다음에는 내용의 왼쪽과
오른쪽에 있는 남은 공간과
여타 삽입 장치를 디자인한다.
단에 이미지와 활자만 배치하든
텍스트 박스를 만들든 전체
디자인에는 일관성이 있어야
한다.

World »

Thai Cave Rescue Will Be Murky, Desperate Ordeal, Divers Say

English City, Stunned, Tries to Make Sense of New Poisonings

Japan Executes Cult Leader Behind 1995 Sarin Gas Subway Attack

U.S. »

A Black Oregon Lawmaker Was Knocking on Doors. Someone Called the Police.

Migrant Shelters Are Becoming Makeshift Schools for Thousands of Children

Trump Administration in Chaotic Scramble to Reunify Migrant Families

Politics »

Amy McGrath Set Her Sights on the Marines and Now Congress. Her Mother Is the Reason.

Trump Assails Critics and Mocks #MeToo. What About Putin? 'He's Fine'

Brett Kavanaugh, Supreme Court Front-Runner, Once Argued Broad Grounds for Impeachment

New York »

The Rise of the Stressed-Out Urban Camper

A City Founded by Alexander Hamilton Sets the Stage for Its Next Act

Culture of Fear and Ambition Distorted Cuomo's Economic Projects

Science »

Trilobites: Never Mind the Summer Heat: Earth Is at Its Greatest Distance From the Sun

The Lost Dogs of the Americas

Rhino Embryos Made in Lab to Save Nearly Extinct Subspecies

Health »

Global Health: In a Rare Success, Paraguay Conquers Malaria

Trilobites: Lots of Successful Women Are Freezing Their Eggs. But It May Not Be About Their Careers.

Voices: When a Vegan Gets Gout

Education »

'Access to Literacy' Is Not a Constitutional Right, Judge in Detroit Rules

Colleges and State Laws Are Clamping Down on Fraternities

In the Age of Trump, Civics Courses Make a Comeback

Real Estate »

New Buildings Rise in Flood Zones

Right at Home: Buried in Paperwork

The Hunt: Trading Chelsea Clatter for Greenpoint Calm

Business Day »

U.S. Hiring Stayed Strong in June Despite Trade Strains

The Unemployment Rate Rose for the Best Possible Reason

China Strikes Back at Trump's Tariffs, but Its Consumers Worry

Technology »

Tech Giants Win a Battle Over Copyright Rules in Europe

State of the Art: Employee Uprisings Sweep Many Tech Companies. Not Twitter.

The New New World: Why Made in China 2025 Will Succeed, Despite Trump

Fashion & Style »

Modern Love: This Is What Happens When Friends Fall in Love

The Secret Price of Pets

Fashion Review: A Declaration of Independence at Valentino and Fendi

Sports »

Neymar and the Art of the Dive

Garbiñe Muguruza and Marin Cilic Join the Wimbledon Exodus

On Pro Basketball: Finally Free From LeBron's Reign, the N.B.A. East Has No Reason to Change

Obituaries »

Ed Schultz, Blunt-Spoken Political Talk-Show Host, Dies at 64

Michelle Musler, Courtside Perennial in the Garden, Is Dead at 81

Claude Lanzmann, Epic Chronicler of the Holocaust, Dies at 92

Travel »

The Getaway: Looking for a Weekend Escape? Here Are 5 Family-Friendly Options

Carry On: What W. Kamau Bell Can't Travel Without

The Rise of the Stressed-Out Urban Camper

Food »

Wines of The Times: American Rosés Without Clichés

Hungry City: A Filipino Specialty Best Paired With a Brew in the East Village

Australia Fare: Yatala Pies Has Served Nostalgia for More Than 130 Years. Arguably.

The Upshot »

The Unemployment Rate Rose for the Best Possible Reason

There Isn't Much the Fed Can Do to Ease the Pain of a Trade War

Americans Are Having Fewer Babies. They Told Us Why.

Opinion »

What Nelson Mandela Lost

'Hope Is a Powerful Weapon': Unpublished Mandela Prison Letters

We'll All Be Paying for Scott Pruitt for Ages

Arts »

If It's on 'Love Island,' Britain's Talking About It

Four Musicals on Three Continents: An Australian Company's Big Bet

The Art of Staying Cool: 10 Can't-Miss Summer Shows in New York

Movies »

Lakeith Stanfield Is Playing Us All

Review: 'Ant-Man and the Wasp' Save the World! With Jokes!

Review: 'Sorry to Bother You,' but Can I Interest You in a Wild Dystopian Satire?

Theater »

Four Musicals on Three Continents: An Australian Company's Big Bet

Review: 'The Royal Family of Broadway,' This Time in Song

Critic's Notebook: Orlando Bloom and Aidan Turner Are Drenched in Blood in London

Television »

If It's on 'Love Island,' Britain's Talking About It

'Sharp Objects,' a Mesmerizing Southern Thriller, Cuts Slow but Deep

On Comedy: A Netflix Experiment Gives Deserving Comics Their 15 Minutes

Books »

Profile: Attention, Please: Anne Tyler Has Something to Say

Books of The Times: When It Comes to Politics, Be Afraid. But Not Too Afraid.

Captain America No. 1, by Ta-Nehisi Coates, Annotated

Magazine »

Feature: Can the A.C.L.U. Become the N.R.A. for the Left?

Letter of Recommendation: Letter of Recommendation: 'The Totally Football Show With James Richardson'

Feature: Who's Afraid of the Big Bad Wolf Scientist?

Times Insider »

Outsmarted by a Smart TV? Not This Reporter.

With Our World Cup App, Fans Are Part of the Action

The Times at Gettysburg, July 1863: A Reporter's Civil War Heartbreak

31 내용을 분해하라

도표와 단위로 구성된 정보가 있다. 이런 복잡한 정보를 디자인할 때의 기준은 명료성, 가독성, 여백 그리고 변화다. 여러 가지 성격의 정보가 어지럽게 섞여 있을 때, 이것을 알기 쉬운 덩어리들로 나누면 더 명확한 레이아웃을 구성할 수 있다.

다음과 같은 경우, 모듈 그리드가 가장 효과적이다.

- 수많은 독립적인 정보들의 덩어리들로 이루어져 있어서 하나로 이어지는 글로 읽을 필요가 없거나 불가능할 때
- 똑같은 크기의 블록에 정보들을 나열하고자 할 때
- 응집력 있는 포맷을 구축하고자 할 때
- 각 단위 정보에 숫자나 날짜가 붙어 있고 단위마다 정보량이 엇비슷할 때

정보를 잘게 나눌 때는 타이포그래피로 내용을 뒷받침해줘야 한다. 설명이 목적인 글과 달리 활자 크기와 두께를 자유로이 변형하여 읽기 쉬운 판면을 구성하는 것이다. 다른 장에서도 여러 번 설명했지만, 여러 서체를 적절히 사용하면 쉽지만 지루한 대신 독특하고 기발하게 내용을 전달할 수 있다.

63쪽: 이 생활 정보 목록에는 글마다 여백이 일정하고 글의 양에 따른 박스 크기도 대략 비슷하다. 박스 안 정보를 해치지 않는 적절한 두께의 괘선을 사용하여 각 정보들을 분리했는데, 그 모습이 마치 부가 정보를 나타내는 사이드바 같다.

어떤 언어를 사용하든 약물은 제목부에 강세를 주며, 크기와 두께를 달리하여 정보의 서열을 나타낼 수 있다.

정보에 숫자를 매길 때는 숫자의 크기와 두께에 따라 타이포그래피의 느낌이 달라진다. 아라비아 숫자와 한자를 사용하여 변화감을 주고, 유용하면서도 다소 색다른 생활 정보를 소박한 분위기로 전달한다. 7번 문항의 내용은 이렇다. "공기가 점점 오염되고 있습니다. 집으로 돌아오는 즉시 양치질을 할 수 있도록 세면대 옆에 깨끗한 컵을 준비해둡시다."

작업명
「暮しの手帖」

의뢰인
「暮しの手帖」

디자이너
Shuzo Hayashi,
Masaaki Kuroyanagi

이 실용서의 기사는 살림살이에 관한 유용한 정보를 간명한 분위기로 전달한다.

今日は
なにを

ここにならんでいるいくつかのヒントのなかで、ふと目についた項目を読んでみてください。たぶん、ああそうだったということになるでしょう

1 テーブルにコップを置くときは、静かに置くことを心がけましょう。やさしいしぐさが気持ちをやわらげます。

2 組み立て式の椅子やテーブルのネジは、意外とゆるんでいるものです。締めなおしておきましょう。

3 暮らしには笑顔が大事です。いろいろあっても、にっこり笑顔を忘れずに。

4 一年使った枕を新しいものに替えてみましょう。新しい気持ちで眠りにつけるでしょう。

5 今日こそゆるんだ水道のパッキンを取替えましょう。家中の蛇口をチェックします。

6 毎日の暮らしのなかで見て見ぬふりはやめましょう。そういう癖を身につけてはいけません。

7 空気が乾燥してきます。外から帰ったらすぐにうがいができるように、洗面所のコップをきれいにしておきましょう。

8 朝、目が覚めたら、ベッドの中で今日一日、何をするかを考えます。することがたくさんあれば、うかうかしていられず、すぐ起きるでしょう。

9 どんなことでもまずはお金を使わずにできるかを考えてみましょう。それが工夫の一歩になります。

10 言いたいことを言った後は、笑顔で接することが大事です。険悪にならないように、まわりに気を使いましょう。

11 日曜日の朝、天気が良かったら、外でご飯にしませんか。ごく簡単なお弁当を近所の公園などで食べるのです。散歩もかねて気分も変わります。

12 風邪をひいて、お風呂に入れないときは、足だけでも洗って、温めましょう。さっぱりして気分がよくなります。

13 今日は一歩ゆずってみましょう。その一歩がそのまま新しい一歩になるものです。

14 裁縫箱を整理しましょう。さびた針やよれた糸は処分して、新しいものに取替えます。

15 今夜は粗食デーにしましょう。味噌汁にお漬物とか、ありあわせのおかずで間に合わせます。明日は今夜の分もごちそうにしましょう。

16 冷蔵庫が夏の設定になっていませんか。気温も下がったし、あけての回数も減ってきたので、調節しておきます。

17 虫歯があったら、いますぐ治しておきましょう。年末年始のお医者さんが休みのときに痛くなったら大変です。

18 手紙ばさみを買ってみましょう。とても便利なので、毎日届く郵便をさっさと片づけられます。

19 今日は一日、お年寄りのお相手をつとめましょう。お茶を飲みながら、ゆっくりと昔話を聞いてあげたり、一緒に出かけたりします。

20 毎日を心地よく過ごすには、あまりに潔癖すぎてもいけません。よごれやけがれも受け入れてこそ暮らしがあるのです。人との関係も同様です。

21 きびしい肌寒さをおぼえる夜になりました。ことにお年寄りにはひざ掛けか、肩掛けを一枚、早めに用意してあげましょう。

22 しめきりの窓をあけて、敷居のゴミを払いましょう。アルミサッシの溝など、ほこりがつまっているものです。

23 洋服ダンスの防虫剤は大丈夫でしょうか。においはしていても、中身はもうなくなっていることが案外多いものです。

24 新しいチャレンジは自分で決めるものです。ひとに惑わされて後悔しないように。

25 ガス台の下やすきまを掃除しましょう。意外に汚れているものです。きれいになると気持ちよく料理ができるでしょう。

32 숨 쉴 여지를 남겨라

모듈 그리드라고 해서 모든 모듈을 채워야 하는 것은 아니다. 모듈 그리드는 정확하게 구획된 경작지와 같다. 디자이너는 모듈을 캐고 그 안에 다양한 요소를 심는다. 그리드의 모듈을 확연하게 드러내거나 혹은 그러지 않을 수도 있다. 또한 모듈을 크게 하거나 작게 할 수도 있다. 모듈은 견고한 구조를 만들고 그 안에 활자나 색, 장식물을 담을 수 있다. 무엇보다 그저 빈 공간으로 판면을 뒷받침할 수도 있다.

작업명
리스트레인트체
(Restraint Font)

의뢰인
Marian Bantjes

디자인
Marian Bantjes, Ross Mills

직접 만든 타이포그래피는 디지털 세계에 디짓(digit: 인간의 손길)을 구현한다.

위 장식 서체는 본문 텍스트용이 아니라 제목이나 표제용으로 개발되었다. 장식적인 서체는 크기를 작게 하면 활자를 구분할 수 없어 내용을 읽어내기가 어렵다.

판면 가운데의 모듈은 채우고 바깥쪽
모듈은 비웠더니 바깥쪽에 판면의
테두리가 생겼다.

위와 달리 가운데 모듈을 비워 프레임으로
삼을 수도 있다. 어느 경우에나 조화와
부조화를 판가름하는 것은 얼마나 절제를
했느냐에 달렸다.

리스트레인트 서체 사용에 관한 동의서이자
사용자 의무 조항은 그 자체로 아름다운
타이포그래피 작품이다.

RESTRAINTS

Font Software Product License
End-User License Agreement (EULA)
(page 1 of 2)

❂ PLEASE READ ❂
Some restrictions apply to the use of this software

The 'Restraint' typeface (Font Software) and designs contained therein is protected by copyright laws and international copyright treaties, as well as other intellectual property laws and treaties. The Font Software is licensed, not sold. This license is only valid when the licensee has been listed below and this agreement is signed by a representative of Tiro Typeworks. Please retain copies of this agreement.

Whereas 'Tiro Typeworks' is represented by one or both of the following individuals:
William Ross Mills of Galiano Island, British Columbia, Canada. DBA Tiro Typeworks and
John Hudson of Gabriola Island, British Columbia, Canada. DBA Tiro Typeworks

Subject to the foregoing, Tiro Typeworks grants (hereafter the 'licensee') :
M E Tondreau
611 Broadway
Room 511
New York, NY 10012
United States
a perpetual non-exclusive license to use the Restraint Font Software with the following terms and conditions:

1. ACCEPTANCE OF TERMS
Installation and use of this Font Software constitutes acceptanceof the terms of this licence agreement.

1.1 You acknowledge that the Font Software is the intellectual property of Tiro Typeworks and/or designers represented by Tiro Typeworks and contains copyrighted material authored by Tiro Typeworks and/or designers represented by Tiro Typeworks. The term Font Software shall also include any updates, upgrades, additions, modified versions, and development copies of the Font Software licensed to you by Tiro Typeworks. The media itself is and shall remain the property of Tiro Typeworks. Expanded versions, subsets or other derivatives of this design may also exist under other names and be distributed by Tiro Typeworks or other licensed Distributors.

2. GRANT OF LICENSE.
This document grants you the following rights:

2.1 INSTALLATION AND USE.
You may install and use the Font Software on up to five computer hard drives or other storage devices and up to two physical output devices (e.g. printers, imagesetters) based at one single geographical location stipulated by the licensee (laptops may be considered 'based' at a single location). The Font Software may not be used by more than five users on a network. Extended licenses may also be purchased, in which case a new license agreement will be drafted to reflect the new conditions.

For the sole purpose of data backup, additional backup copies of the Font Software may be made.

2.2 FAIR USE.
You may use the Font Software in most personal and commercial applications. However, under this license, you may not use the font software:

a) for the creation of logos or identities (including movie titles)

b) for the creation of signage or architectural details.

c) for the creation of advertising campaigns which include outdoor advertising (billboards, bus shelters, etc.) or television advertising, wherein the designs contained in the Font Software comprises the sole or major design element.

d) to manufacture products wherein the designs contained in the Font Software comprises the sole or major design element, including but not limited to T-shirts, jewellery, fridge magnets, greeting cards, ceramics, posters for sale, etc.

If you wish to use the Font Software for any of the above, please contact us at restraint@tiro.nu for additional licensing or royalty fees. If in doubt, ask.

2.3 MODIFICATION.
You are not allowed to without written approval granted by Tiro Typeworks:

a) modify and/or recompile the Font Software: this includes generating or re-compiling the Font Software from any font design program. (where a 'font design' program is any piece of software capable of reading and re-compiling any standard font format),

b) adapt modules, produce sub-sets or supersets or alter any internal font data thereof for your own developments,

c) put the software solutions embodied in the Font Softwareto any commercial use other than operating your own computer(s) or output device(s), or

d) merge, ship or embed the Font Software with other software programs.

PLEASE CONTACT TIRO TYPEWORKS OR A LICENSED DISTRIBUTOR IF THERE ARE SPECIFIC MODIFICATIONS THAT YOU REQUIRE.
We acknowledge that no typeface can solve all problems and accept that some clients may wish to have modifications made to suit their particular needs. We would be happy to help with this and no one knows better the typefaces you are licensing, so please ask first.

33 모듈을 결합하라

모듈 그리드를 도표로 나타내면 복잡해 보이지만, 사실은 그렇지 않다. 각각의 모듈을 전부 채울 필요는 없기 때문이다. 해당 공간에 넣어야 하는 정보의 양에 따라

하나의 모듈 안에 커다란 박스를 몇 개 만들어놓고 그 안에 여러 개의 이미지와 예를 들어 목차라든가 기타 색인 정보와 같은 핵심 정보를 담는 것이 가능하다.

사진 속 타일에도, 왼쪽 아래 구석에 있는 로고에도 모듈이 나타나 있다.

작업명
Flor 카탈로그

의뢰인
Flor

디자인
The Valentine Group

모듈형 바닥 타일 자재를 홍보하는 카탈로그다. 이 작품에서처럼 모듈 그리드는 공간을 경제적으로 구획하여 시각 정보를 단계적으로 전달하는 데 매우 적합한 포맷이다.

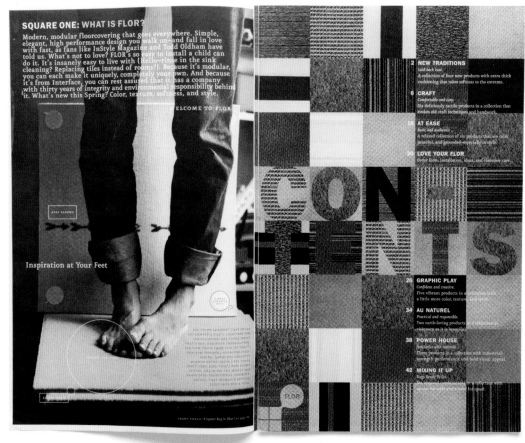

박스로 구획된 이 목차 페이지는 정보나 이미지가 눈에 쉽게 들어오며 색상도 다채롭다.

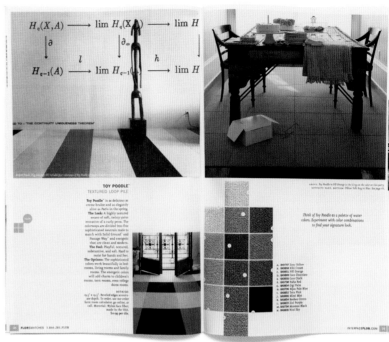

색상 견본 모듈과 재치 있게
연출된 사진, 널찍한 여백이
조화를 이룬다.

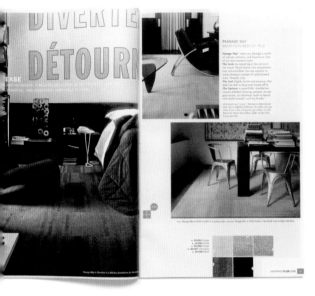

플로어(Flor)의 계산표. 완벽한
모듈형 도표다.

ROOM FEET APPROX	7'	9'	11'	12'	13'	15'	17'	18'	20'	22'	23'	25'	27'
4'	12 TILES	16	19	21	22	26	29	30	34	37	39	42	45
5'	15	19	23	26	28	32	36	38	42	46	48	52	56
7'	21	27	32	35	38	44	50	53	58	64	67	73	78
9'	27	34	41	45	49	56	64	67	75	82	86	93	100
11'	32	41	50	55	59	68	77	82	91	100	104	113	122
12'	35	45	55	60	65	75	84	89	99	109	114	124	133
13'	38	49	59	65	70	81	91	97	107	118	123	134	144
15'	44	56	68	75	81	93	105	111	124	136	142	154	167
17'	50	64	77	84	91	105	119	126	140	154	161	175	189
18'	53	67	82	89	97	111	126	133	148	163	170	185	200
20'	58	75	91	99	107	124	140	148	165	181	189	205	222
22'	64	82	100	109	118	136	154	163	181	199	208	226	244
23'	67	86	104	114	123	142	161	170	189	208	217	236	255
25'	73	93	113	124	134	154	175	185	205	226	236	256	277 TILES

34 공간을 의미 있게 사용하라

복잡한 정보를 분할 배치하는 일의 시작은 강력한
그리드를 디자인하는 것이다. 들어가야 할 정보를 토대로
각 모듈의 비율을 계획하라. 두서없어 보일 수 있는
내용까지 전부 명쾌해야 한다.

포스터는 판형이 커서 주의를 끌기에 좋은 매체다.
멀리서도 잘 보여서 사용자가 상세한 내용까지 전부
읽어보고 싶은 생각이 들도록 제목을 크게 조판하는 것이
좋다.

작업명
디자인에 의한 투표
(Voting by Design)
포스터

의뢰인
Design Institute,
University of Minnesota

편집, 감독
Janet Abrams

아트 디렉터, 디자인
Sylvia Harris

이 포스터는 선거라는 중요한
행위를 완벽하게 분석했다.
지면을 구석구석 활용하여 보는
이의 시선을 유도하는 질서
정연한 그리드를 구축했다.

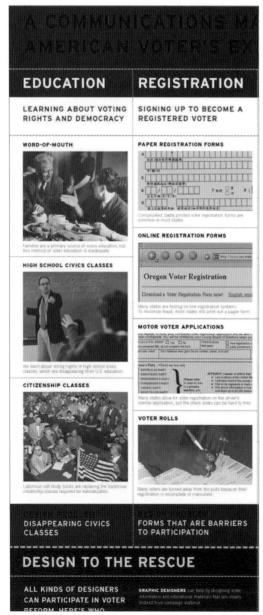

69쪽: 이 포스터는 일련의 과정을
각 단계로 나누어 많은 양의
정보를 이해하기 쉽게 전달한다.

VOTING BY DESIGN

The century began with an electoral bang that opened everyone's eyes to the fragility of the American voting system. But, after two years of legislation, studies and equipment upgrades, major problems still exist. Why?

Voting is not just an event. It's a complex communications process that goes well beyond the casting of a vote. For example, in the 2000 presidential election, 1.5 million votes were missed because of faulty equipment, but a whopping 22 million voters didn't vote at all because of time limitations or registration errors. These and many other voting problems can be traced not just to poor equipment, but also to poor communications.

Communicating with the public is what many designers do for a living. So, seen from a communications perspective, many voting problems are really design problems. That's where you come in.

Take a look at the voting experience map below, and find all the ways you can put design to work for democracy.

A COMMUNICATIONS MAP OF THE AMERICAN VOTER'S EXPERIENCE

EDUCATION	REGISTRATION	PREPARATION	NAVIGATION	VOTING	FEEDBACK
LEARNING ABOUT VOTING RIGHTS AND DEMOCRACY	SIGNING UP TO BECOME A REGISTERED VOTER	BECOMING INFORMED AND PREPARED TO VOTE	FINDING THE WAY TO THE VOTING BOOTH	INDICATING A CHOICE IN AN ELECTION	GIVING FEEDBACK ABOUT THE VOTING EXPERIENCE
WORD-OF-MOUTH Families are a primary source of civics education, but this method of voter education is inadequate.	**PAPER REGISTRATION FORMS** Complicated, badly-printed voter registration forms are common in most states.	**SAVE-THE-DATE CARD** VOTE To maintain our records accurately, it is important THAT YOU RETURN THIS CARD TO US if the person to whom it is addressed no longer lives here. Everything you need to know is often lost on the poorly-designed voting reminder postcard sent to every home.	**EXTERIOR STREET SIGNS** VOTER PARKING RESERVED PARKING Clear and legible temporary directional signs are needed to help voters find their way to the precinct door.	**HAND-COUNTED PAPER BALLOT** Paper ballots list all choices on a sheet of paper. They are easy for the voter to use, but hard to tabulate.	**CENSUS SURVEYS** 12. Reason for not voting 01 ☐ Too busy 02 ☐ Illness or emergency 03 ☐ Not interested 04 ☐ Out of town 05 ☐ Didn't like candidates 06 ☐ Other reason U.S. Census surveys are the best source of voter participation data. They track how when and why people vote.
HIGH SCHOOL CIVICS CLASSES We learn about voting rights in high school civics classes, which are disappearing from U.S. education.	**ONLINE REGISTRATION FORMS** Oregon Voter Registration Download a Voter Registration Form now! English only. Many states are testing on-line registration systems. To minimize fraud, most states still print out a paper form.	**PUBLIC SERVICE ANNOUNCEMENTS** VOTE Non-profits produce get-out-the-vote campaigns during elections, but they need more money and design help.	**PRECINCT SIGNAGE** VOTE HERE Temporary signs turn public buildings into precincts. They are often too small and poorly designed to be effective.	**MACHINE-COUNTED PAPER BALLOT** DEMOCRATIC PARTY WALTER F. MONDALE of MN. and GERALDINE A. FERRARO of N.Y. This ballot is a standardized test. It is designed for machine tabulation and not for voter ease of use. **MECHANICAL LEVER**	**EXIT POLLS** Polls are a legal way to find out what is on the voter's mind. They rarely ask about the voting process.
CITIZENSHIP CLASSES Laborious self-study books are replacing the traditional citizenship classes required for naturalization.	**MOTOR VOTER APPLICATIONS** Many states allow for voter registration on the driver's license application, but the check boxes can be hard to find. **VOTER ROLLS** Many voters are turned away from the polls because their registration is incomplete or inaccurate.	**PRE-ELECTION INFO PROGRAMS** Welcome to the 2001 Primary Election Voter Guide Pre-election instruction packages come in the mail, but get lost or burned in piles of junk mail. **CAMPAIGN LITERATURE** Many voters rely on political campaign literature to prepare for elections. It is accessible, but is it objective? **SAMPLE BALLOTS** Sample ballots can help voters to rehearse and plan what they will do in the voting booth.	**LINE AND BOOTH IDENTITY** 42 ELECTION DISTRICT How many voters waste time standing in the wrong line? Inadequate signage design and placement is often to blame. **PRECINCT WORKERS** Most voters depend on precinct staff to help them navigate the precinct. **CAMPAIGN WORKERS** Voters look for campaign workers as a signal that they are approaching the polls, but they are unreliable.	**PUNCHCARD** The voter puts a ballot book over the punch card and pokes a selection. Sometimes it works, sometimes not. **DIRECT RECORD ELECTRONIC** New ATM-like voting machines are coming, but the interfaces need extra design attention to ensure ease-of-use. **VOTING INSTRUCTIONS** Pull the red voting handle from left palanca grande de color rojo desde la izquierda Even the best voting technology won't work if the user instructions are confusing or hard to figure out.	**VOTING EXPERIENCE SURVEYS** How long did it take you to get here from home? How long did it take you to vote? Did you get help with the equipment? Who helped you? Surveys of voters' experience are rarely done but are very much needed to design a better voting process.
DISAPPEARING CIVICS CLASSES	FORMS THAT ARE BARRIERS TO PARTICIPATION	TOO MUCH OR TOO LITTLE INFORMATION	GETTING TO THE BOOTH ON TIME	USER-UNFRIENDLY VOTING MACHINES	FUTURE IMPROVEMENTS LACK VOTER INPUT

DESIGN TO THE RESCUE

ALL KINDS OF DESIGNERS CAN PARTICIPATE IN VOTER REFORM. HERE'S WHO SHOULD BE ON ANY VOTING DESIGN DREAM TEAM:

GRAPHIC DESIGNERS can help by designing voter information, also educational materials that are clearly distinct from campaign materials.

ENVIRONMENTAL GRAPHIC DESIGNERS can help voters get to the right place at the right time through effective signage and map-making.

INFORMATION DESIGNERS can make everything from legislation, forms, to voting machine interfaces easier to understand, by anticipating people's everyday navigation needs and understanding.

ARCHITECTS can work with election commissions to create consistent design guidelines, that would enable any public space to be turned into an efficient voting precinct.

INDUSTRIAL DESIGNERS can make the most complex voting machines as easy to use as a bank ATM.

EXPERIENCE DESIGNERS can analyze the effectiveness of the voting process for election officials and help in developing better-designed voting systems.

HOW YOU CAN GET INVOLVED

THERE IS WORK TO BE DONE TO IMPROVE VOTING BY DESIGN, STARTING WITH YOUR OWN COMMUNITY. HERE ARE FIVE THINGS THAT ANY DESIGNER CAN DO, TO MAKE A DIFFERENCE BEFORE THE 2004 ELECTIONS:

1. BECOME A POLLWORKER in your own precinct. By volunteering and spending here in your local polling place you can help make small improvements in the design of communications on the physical space and who asks users about voting systems at close range.

2. FORM A VOTING DESIGN COALITION in your own community. Gather together a group of design professionals that offer your services to your local election commission. If you are willing to volunteer, they will usually take advantage of what you have to offer. These coalitions can get involved in all aspects of voting design from pamphlet design to ballot typography.

3. WORK WITH THE POLITICAL PARTY OF YOUR CHOICE to improve design in the precincts and districts that are targeted for major get-out-the-vote campaigns. Most parties' officials are wary of change, but political parties can and will design educational materials to help or change voter participation. Political parties often hire reformers over ballot layout issues and can use advice from professionals, like you.

4. CALL YOUR CONGRESSPERSON ABOUT HR 3295 the new federal election reform bill passed by Congress. Since its passage will be pressure to the states to improve voting systems and promote reform. Ask your congressperson to donate some of these funds to design related research projects. Follow the money and make sure designers in your state are included in any reform effort.

5. FORM A VOTING DESIGN ADVISORY TEAM within your professional organization. Under HR 3295, a new Election Assistance Commission will be given limited voting reform powers and money. Your professional organization can and should need to have design professionals in Washington to work with this commission and to help guide design guidelines for voting systems. Maybe one of these professionals can be you.

IDEAS AND SOURCES

VOTE PROJECT RESEARCH + DESIGN

DESIGN INSTITUTE KNOWLEDGE MAPS

DESIGN INSTITUTE

UNIVERSITY OF MINNESOTA

모듈 그리드

35 모듈 사이의 유기성을 고려하라

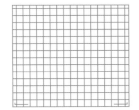

모듈의 격자를 탈출하는 순간, 모듈 그리드의 또 다른 아름다움이 드러난다. 일관된 모듈 그리드에서도 형태나 크기, 패턴을 변형하여 얼마든지 질서정연하면서도 경쾌한 판면을 구성할 수 있다.

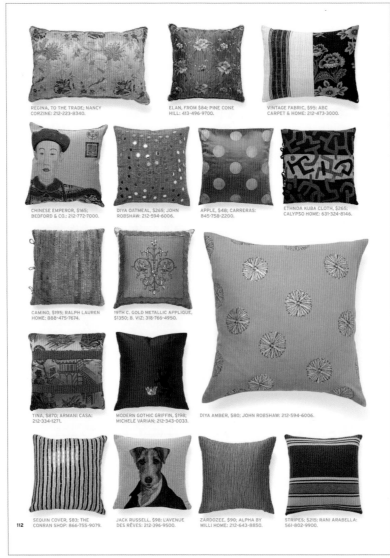

비슷한 색상의 제품들을 모아 팔레트 같은 느낌의 균형 잡힌 판면을 구성했다.

작업명
「House Beautiful」

의뢰인
「House Beautiful」

디자인
Barbara deWilde

명쾌한 디자인 쇄신으로 새로운 활기를 얻은 잡지다.

각 모듈 아래에 일률적으로
구조적인 타이포그래피를
사용했는데, 절제된 대문자
산세리프체 캡션은 그 자체가
질감이 느껴지는 괘선으로
기능한다.

SAN MARGHERITA; $245; RANI
ARABELLA: 561-802-9900.

LATTICE, FROM $95; SEACLOTH:
203-422-6150.

CORAL ON WHITE LINEN, $185;
HOMENATURE: 631-287-6277.

MARYANN CHATTERTON, $498;
D. KRUSE: 949-673-1302.

SEABLOOM, FROM $110; OROMONO: 917-338-7568.

CHRYSANTHEMUM, $55; PINE
CONE HILL: 413-496-9700.

TRANSYLVANIAN TULIP, FROM
$83; AUTO: 212-229-2292.

SUZANI FLORAL, $212; MICHELE
VARIAN: 212-343-0033.

IKAT, $500; D. KRUSE:
949-673-1302.

GREEK REVIVAL EMBROIDERY, $260;
DRANSFIELD & ROSS: 212-741-7278.

PLAID, $135; ALPANA BAWA:
212-254-1249.

WEE LOOPY FELTED, $213; THE
CONRAN SHOP: 866-755-9079.

VESUVIO, $395; DRANSFIELD &
ROSS: 212-741-7278.

NIZAM, $83; JOHN DERIAN DRY
GOODS: 212-677-8408.

CYLINER LINEN, $195; GH
INTERIORS: 888-226-8844.

LINEN, $70; ALPHA BY MILLI
HOME: 212-643-8850.

KAFFE FASSETT HIBISCUS, $68;
PINE CONE HILL: 413-496-9700.

113

36 도표는 하나의 그림이다

작업명
뉴저지 운송회사(New Jersey
Transit) 시간표

의뢰인
New Jersey Transit

디자인
Two Twelve Associates

뉴저지 운송회사의 운행 시간표는 괘선과 박스를 가능한 한 많이 사용하여 모든 정보를 독립적으로 나타내려는 욕심 없이 단순하게 처리했다. 그리고 아이콘, 화살표 같은 장치는 여행자들이 방대한 정보 안에서 각자 자신에게 필요한 정보를 쉽게 찾을 수 있도록 도와준다. 화살표, 아이콘이 상투적일 수도 있지만 때로는 이러한 평범한 장치들이 일반 독자에게 정보를 가장 잘 전달하는 방법이기도 하다.

숫자 정보가 어마어마하게 많은 도표와 그래프, 시간표 같은 디자인은 어려운 작업이라 할 수 있다. 엘런 럽턴(Ellen Lupton)은 『타이포그래피 들여다보기(*Thinking with Type*)』에서 디자이너들에게 선과 박스로 범벅된 정보 지옥을 만드는 것은 타이포그래피로 범죄를 저지르는 것과 마찬가지이므로 그런 짓은 절대로 해서는 안 된다고 충고한다. 럽턴의 충고에 따르면 디자이너는 도표와 그리드, 시간표를 '하나의 그림'으로 생각하고 단이나 열, 영역을 전체 그림에 어떻게 연결시킬 것인지 고민해야 한다.

색상의 음영을 조절하면 보는 이가 빽빽한 정보를 읽어나가면서도 길을 잃지 않게 도와줄 수 있다. 흑백 작업물이든 그 밖에 한두 가지 색이 더해지는 작업물이든 음영은 언제나 효과적이다. 숫자가 가로로 나열되었다면 수평 영역을 음영 처리하여 독자가 자신에게 필요한 정보를 찾아낼 수 있게 한다. 이때 프레임과 괘선은 정보를 조직적으로 나타내는 장치로 사용할 수 있다. 예를 들어, 괘선은 시간표 등에서 목차 부분을 강조하는 특별 영역을 표시한다. 전체 노선의 기차 시간표 같은 보다 복잡한 작업에서는 노선마다 다른 색깔을 지정하여 구분하면 된다.

그리드의 생명은 그 안에 담긴 정보를 제대로 전달하는가에 달렸다. 다단 그리드에서는 명확한 타이포그래피가 생명이다. 공항이나 기차역에서 사용되는 시간표는 타이포그래피에 따라 고객을 편리하게 안내할 수도 있고 정반대의 상황으로 몰아넣을 수도 있다. 정보의 양이 많을지라도 각 줄의 위아래에 적당한 여백을 두어야 한다. 여백은 시간표에 있어서 가장 중요한 가독성을 확보해주기 때문이다.

도표 바탕에 노란색과 흰색을 교차로 넣어 각 역의 정차 시간표를 구분했다. 괘선은 몇 군데에만 명확하게 사용하여 정보의 집합 관계를 나타냈다. 수직 괘선을 넣어 목적지별로 기차역을 나누었고, 수평 괘선을 이용해 지역을 대략적으로 구분했다.

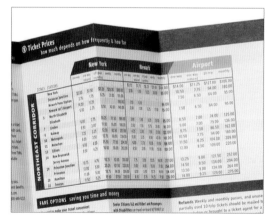

위와 같은 체계의 시간표는 요금표에도 적용할 수 있다. 여기에서도 교차되는 바탕색으로 역을 구분하고, 수평 괘선과 수직 괘선으로 제목부(편도, 비수기 운행 등)를 역별, 요금 등급별로 나누었다.

구매에 필요한 사항을 설명하는 각 영역의
제목부 옆에 그림문자를 넣었다.

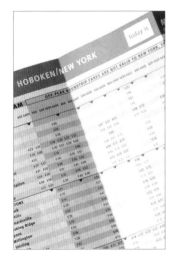

화살표로 급행열차가 정차하는 역을
표시했다.

깔끔하고 감각적인 타이포그래피다. 단과 열 주변에 여백을 넉넉히 주어 빽빽한 정보를 부담 없이 쉽게 읽을 수 있도록 했다.
점 괘선과 물결 괘선은 눈에 잘 띄지는 않지만 효과적으로 기능한다. 흰색 화살표 안에는 열차의 운행 방향 정보를 표시하고, 도표에
음영 변화를 주어 하루의 운행 일정을 명확하게 나타냈다.

37 도표를 강화하라

도표나 그래프는 숫자만 사용해 단순하게 나타낼 수도 있지만, 시각 요소를 이용하여 훨씬 읽기 쉽게 만들 수도 있다. 디자이너와 일러스트레이터는 도표로 통계를 정확히 나타내는 한편, 선과 형태, 색상, 질감, 다양한

아이콘, 정보를 직접적으로 나타내는 재치 있는 그림 등의 시각적 장치를 사용한다. 나타내고자 하는 정보에 따라 다르겠지만 그래픽을 사용하면 도표를 기억하기가 훨씬 쉬워진다.

참조할 페이지
76–77

숫자들의 구성이 훌륭하고, 디자인도 빼어나면서 질서 정연해 보는 사람의 눈을 즐겁게 한다.

작업명
방크 사바델(Banc Sabadell)의
2017년 통계수치와 연차 보고서
(인쇄물)

의뢰인
Banc Sabadell

디자인
Mario Eskenazi Studio

디자이너
Mario Eskenazi,
Gemma Villegas

스페인 은행 방크 사바델의 연차 보고서에 넣으려고 특별히 디자인된 숫자들. 연차 보고서에서 대성공을 거둔 뒤 다양한 홍보자료 (크리스마스, 증정품 등)에 사용하고 있다.

솜씨 좋게 구성된 숫자들이
표지와 목차를 장식하고 섹션
번호로 일관성 있게 반복하여
사용된다.

강조 표시된 통계 수치들이
다채로우면서도 잘 조정된 그리드
안에 들어 있고, 가로와 세로 계층
구조와 명쾌하게 정리된 제목,
부제목을 잘 사용하고 있다.

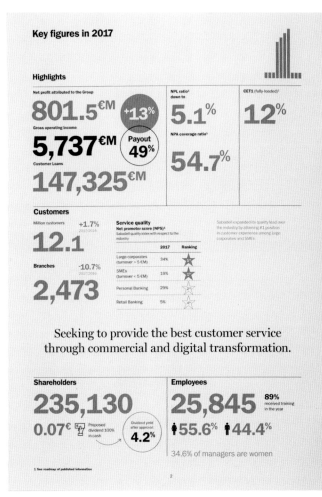

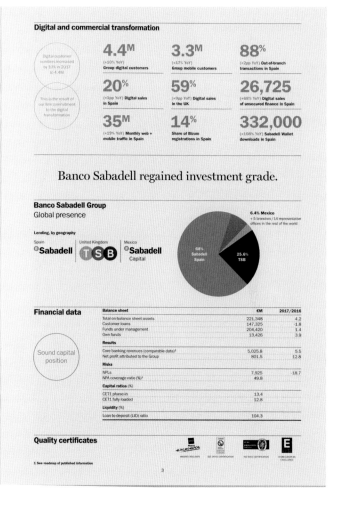

38 성공적인 결과물을 효과적으로 활용하라

연차 보고서용으로 맞춤 제작된 숫자들이 다양한 매체에
걸쳐 일관성을 보이면서 랜딩 페이지에서 사용자를 반갑게
맞이한다. 맞춤 제작된 숫자들과 같은 패턴을 사용하는
지도도 막대그래프, 통계와 잘 어울린다.

참조할 페이지
74–75

작업명
방크 사바델(Banc Sabadell)의
2016년 연차 보고서(데스크톱)

의뢰인
Banc Sabadell

디자인
Mario Eskenazi Studio

디자이너
Mario Eskenazi,
Gemma Villegas

작업명(77쪽)
방크 사바델
2016년 연차 보고서
(모바일 기기)

의뢰인
Banc Sabadell

디자인
Mario Eskenazi Studio

디자이너
Mario Eskenazi,
Gemma Villegas

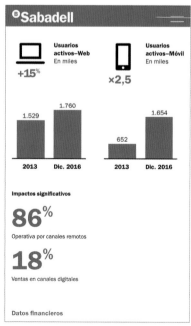

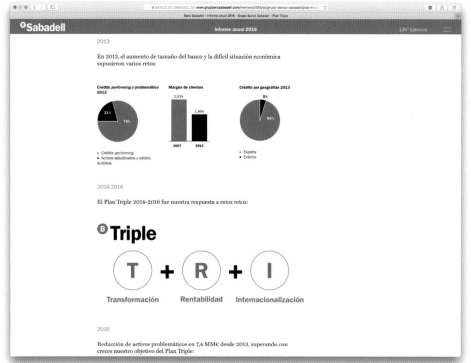

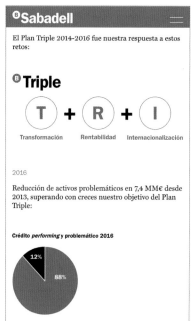

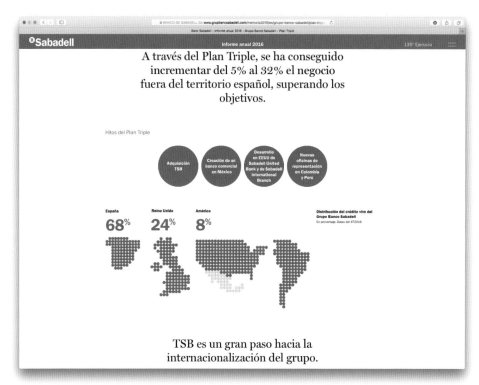

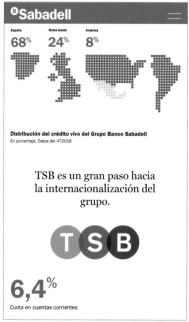

39 테두리를 현명하게 사용하라

표 디자인에서는 구획된 영역이나 박스를 끝도 없이 나열하지 않는 것이 바람직하다. 상황에 따라 다르겠지만, 많은 정보를 주고받기 위해 각 단위를 구획하여 정보를 조직화하는 것이 가장 명확한 디자인 방식이기도 하다. 괘선이나 테두리 또는 경계선을 전혀 사용하지 않은

사용자 작성 용지를 고안해낼 수도 있겠지만, 일반적으로 영역을 구획하고 괘선과 테두리의 두께를 달리함으로써 질서 있는 판면 구성과 신뢰감을 주는 디자인을 완성할 수 있다.

작업명
「暮しの手帖」

의뢰인
「暮しの手帖」

디자이너
Shuzo Hayashi,
Masaaki Kuroyanagi

아름다우면서도 기능적인
독자 엽서다.

郵 便 は が き

料金受取人払郵便

新宿北局承認

4121

差出有効期間
平成21年11月
23日まで
★切手不要★

1 6 9 − 8 7 9 0
133

東京都新宿区北新宿1-35-20

暮しの手帖社

4世紀31号アンケート係 行

ご住所　〒　　　−

電話　　　−　　　　−

お名前

メールアドレス　　　　　@

年齢　[　　　]歳

性別　女　／　男

ご職業 [　　　　　　　　　　　　　]

ご希望のプレゼントに○をつけて下さい。
□「日東紡のふきん」3枚箱入り
□「花森安治の表紙絵ポストカード」5枚セット

いただいた個人情報は、誌面作りや、当選プレゼントの発送、小社グループの商品案内等の送付に利用させていただき、厳重に管理、保管いたします。

＊ご回答は、184ページの記事一覧をご参照の上、番号でご記入下さい。

A．表紙の印象はいかがですか　[　　　]
　　ご意見：

B．面白かった記事を3つ、挙げて下さい　[　　] [　　] [　　]
C．役に立った記事を3つ、挙げて下さい　[　　] [　　] [　　]
D．興味がなかった、あるいは面白くなかった記事を3つ、挙げて下さい
　　　　　　　　　　　　　　　　[　　] [　　] [　　]
E．今号を何でお知りになりましたか　[　　　]
　　その他：
F．小誌と併読している雑誌を教えて下さい
G．小誌を買った書店を教えて下さい　[　　　区市町村　　　]
H．小誌へのご要望、ご意見などございましたらご記入下さい

◎ご協力、ありがとうございました。

괘선의 두께를 섬세하게 조정한 독자 엽서다. 두꺼운 괘선을 사용하여 정보의 성격을 구분하고 중요한 텍스트와 제목부를 강조했다. 또, 서체 두께를 달리하여 균형감을 주고, 강조해야 할 내용과 부차적인 정보를 구분했다.

- ●【定期購読】【商品、雑誌・書籍】のお申込みは、こちらの払込取扱票に必要事項を必ず記入の上、
 最寄りの郵便局に代金を添えてお支払い下さい。
- ● 169項、183頁の注文方法をご覧下さい。
- ● 表示金額はすべて税込価格となっております。
- ● 注文内容を確認させていただく場合がございます。平日の日中に連絡のつく電話番号を、ＦＡＸ番号が
 ございましたら払込取扱票にご記入ください。
- ● プレゼントの場合はご注文いただいたお客様のご住所、お名前でお送りします。

払込取扱票

| 02 | 東京 | | 通常払込料金 加入者負担 |

口座番号 00190-7 45321　金額 6300

加入者名 株式会社　暮しの手帖社

料金　特殊取扱

通信欄

※「暮しの手帖」の定期購読を

20　　　年　　　号より1年間（6冊）申し込みます

※プレゼントされる場合、送付先が異なる場合はご送付先を下欄へ記入下さい。

ご住所 〒□□□-□□□□

ご氏名　tel

払込人住所氏名

（郵便番号　　　）

（電話番号　　-　　-　　）
（FAX　　-　　-　　）

受付局日附印

裏面の注意事項をお読みください。　　（私製承認東第43990号）

これより下部には何も記入しないでください。

各票の※印欄は、払込人において記載してください。

払込金受領証

口座番号 00190-7 45321

通常払込料金加入者負担

加入者名 株式会社　暮しの手帖社

金額 6300

払込人住所氏名

料金　特殊取扱

受付局日附印

記載事項を訂正した場合は、その箇所に訂正印を押してください。

切り取らないで郵便局にお出しください。

払込取扱票

| 02 | 東京 | | 通常払込料金 加入者負担 |

口座番号 00170-1 59128　金額

加入者名 株式会社　グリーンショップ

料金　特殊取扱

通信欄

※プレゼントされる場合、送付先が異なる場合はご送付先を下欄へ記入下さい。

ご住所 〒□□□-□□□□

ご氏名　tel

払込人住所氏名

（郵便番号　　　）

（電話番号　　-　　-　　）
（FAX　　-　　-　　）

受付局日附印

裏面の注意事項をお読みください。　　（私製承認東第44327号）

これより下部には何も記入しないでください。

各票の※印欄は、払込人において記載してください。

払込金受領証

口座番号 00170-1 59128

通常払込料金加入者負担

加入者名 株式会社　グリーンショップ

金額

払込人住所氏名

料金　特殊取扱

受付局日附印

記載事項を訂正した場合は、その箇所に訂正印を押してください。

切り取らないで郵便局にお出しください。

40 틀에서 벗어나 생각하라

디자이너는 틀에 박히지 않은 새로운 형태로 판면의
공간을 섬세하게 구획할 수 있어야 한다. 예를 들어
원 하나를 수평과 수직으로 각각 이등분하여 4분원을
만들거나, 과감하게 파이 그래프 모양으로 만들 수도 있다.

앞면. 한 분원에 이미지를
꽉 채워 사실과 사진 간에 대비
효과를 냈다. 타이포그래피는
단순하다. 반복되는 로고,
그 밑의 볼드체 표제, 같은
서체의 웹사이트 주소가 시선을
끈다. 지하철 차량의 가로
선이 텍스트 영역의 구획으로
연결된다.

작업명
뉴욕 교통 박물관
(New York Transit Museum)
서클북 교육 자료

의뢰인
New York Transit Museum

프로젝트 기획
Lynette Morse and Virgil
Talaid, Education Department

디자인
Carapellucci Design

디자이너
Janice Carapellucci

원판 모양의 이 교육 자료에는
교육, 정보, 활동 등 다양한
내용이 담겨 있다. 게다가
교통이라는 주제처럼 원판이
뱅글뱅글 돈다!

NAME:

NEW YORK TRANSIT MUSEUM

Think About It...

When New York City's first subway opened on October 27, 1904, there were about 9 miles of track. Today the subway system has expanded to 26 times that size. About how many miles of track are there in today's system?

Most stations on the first subway line had tiles with a symbol, such as a ferry, lighthouse, or beaver. These tiles were nice decoration, but they also served an important purpose. Why do you think these symbols were helpful to subway passengers?

When subway service began in 1904, the fare was five cents per adult passenger. How much is the fare today? Over time, subway fare and the cost of a slice of pizza have been about the same. Is this true today?

Today's subway system uses a fleet of 6,200 passenger cars. The average length of each car is 62 feet. If all of those subway cars were put together as one super-long train, about how many miles long would that train be? (Hint: There are 5,280 feet in a mile.)

Redbird subway cars, which were first built for the 1964 World's Fair, were used in New York City until 2003. Then many of them were tipped into the Atlantic Ocean to create artificial reefs. A reef makes a good habitat for ocean life—and it is a good way to recycle old subway cars! Can you think of other ways that mass transit helps the environment?

To check your answers and learn more about New York City's subway system, visit our website: **www.transitmuseumeducation.org**. You'll also find special activities, fun games, and more!

© New York Transit Museum, 2007
The New York Transit Museum's programs are made possible, in part, with public funds from the New York State Council on the Arts, a state agency. All photographs are from the New York Transit Museum Collection.

WORLD'S FAIR
SPECIAL
←LOCAL-EXP→

MTA Metropolitan Transportation Authority

뒷면. 두꺼운 괘선 안에 지시 사항과 빈칸을 넣은 재치 넘치는 디자인이다. 파란색과 빨간색은 실제로 각각 뉴욕 시 지하철의 A, C, E호선과 1, 2, 3호선에 사용된 색깔이다.

41 색으로 주의를 끌어라

출판물에서 그리드가 일정하건 변화무쌍하건 상관없이 강렬한 색을 활용해 섹션이나 이야기를 강조하거나 텍스트를 구획할 수 있다. 바탕이 흰색이거나 비교적 연한 색인 페이지에 바탕색이 진한 페이지를 대비시키면 페이스가 달라지면서 관심과 주의를 끌 수 있다. 사이드바나 보조 텍스트를 다른 색으로 처리하면 괘선이나 테두리가 없어도 다른 정보와 구획이 된다.

여성들이 일하고 소통하는 커뮤니티 공간, 더 윙(The Wing)에서 발행하는 잡지의 창간호와 제2호는 대담한 디자인과 색을 사용해 여성들이 자신의 길을 가고 있음을 알려준다.

작업명
「No Man's Land」

의뢰인
The Wing

디자인
Pentagram

크리에이티브 디렉터
Emily Oberman

파트너
Emily Oberman

수석 디자이너
Christina Hogan

디자이너
Elizabeth Goodspeed,
Joey Petrillo

프로젝트 매니저
Anna Meixler

색깔이 선명한 출판물이 컬러 판면, 배경색, 활자로 인해 내세우는 내용이 더욱 강렬해졌다.

기사 도입부에 사용된 색이 자극을 주고 페이스를 다변화한다.

아래 왼쪽: 배경색이 들어간 스프레드가 가히 혁신적이다.
아래 오른쪽, 상세 내용: 다른 너비의 단에 담긴 색깔 있는 서체의 연대표 텍스트가 길고 빽빽한 텍스트와 확실한 대비를 이룬다.

McGee had seen and done a lot in her post-skate career. She worked on a fishing boat owned a topless bar got divorced raised her kids ran a trading post with her second husband At 72, when life tends to slow down for most people McGee is ready for her next adventure

It was a little too chilly for Patti McGee in the air-conditioned skate shop, so she stood by a glass door, soaking in the California sun, presiding over the conversation like a knowing elder.

She munched on a lettuce-wrapped In-N-Out burger (protein style), her blonde hair catching the light, while the shop's owner, Matt Gaudio, told me the story of how McGee, 72, became the brand ambassador for his local skateboard team. Nearly 50 years after winning the first women's national skateboarding championship title in Santa Monica, McGee's likeness is the calling card of Gaudio's Silly Girls Skateboards, a small Fullerton-area girls' skateboarding team with 13 riders.

Behind McGee, displayed in a tall trophy case, was a Barbie doll styled to look just like her or, rather, who she was in 1965: shoeless, hair in a beehive, and doing a handstand on a skateboard. That was the year she became the first woman to win a national skateboarding competition and became a professional skateboarder. McGee made a career out of the sport before Tony Hawk and Rodney Mullen were

WOMEN SKATING THROUGH HISTORY

1963
Wendy Bearer Bull and her brother Danny become the first professionally endorsed skateboarders to be sponsored by Makaha Skateboard Club.

1965
Patti McGee appears on the cover of LIFE magazine in May 14, 1965. She goes on to become the first Women's National Skateboard champion.

Laurie Turner becomes the 1965 National Girls' Champion.

1975
Peggy Oki, the only woman on the legendary Zephyr skateboard

1997
The first issue of the Villa Villa Cola zine debuts, created by Tiffany and Nicole Morgan, two skateboarding sisters. It uses humor to encourage girls to skateboard and offers advice on how to overcome being intimidated by men in the field. Other zines, Bruisers and 50-50: Skateboarding and Gender, soon follow.

1999
Elissa Steamer is the first woman to appear in Tony Hawk's skateboarding video game series.

2001
Jen O'Brien becomes the first girl to skate at

42 색을 제어하라

색을 많이 쓰면 시선을 끌 수 있지만 너무 많이 사용하면 전체적인 메시지를 압도할 수 있다.

색 사용을 절제해야 주제에 맞춘 초점을 유지할 수 있다. 이 표지는 금색과 검정만 사용하여 다른 표지들과 차별화를 꾀하고 있다. 신중한 사진 크로핑 덕분에 전체 사진을 게재했을 때보다 훨씬 흥미진진해졌으며 안타깝게 일찍 세상을 떠났다는 사실까지 암시할 수 있게 되었다.

작업명
「*King*」
(마틴 루터 킹 주니어 목사 서거 50주년 기념 특별호)

의뢰인
「*The Atlantic*」

크리에이티브 디렉터
Paul Spella

아트 디렉터
David Somerville

디자인 회사
OCD | Original Champions of Design

디자이너
Bobby C. Martin Jr., Jennifer Kinon

강렬한 흑백 판면. 역사를 말해주는 대담한 디스플레이 타이포그래피. 초록색으로 활자를 강조한 것 외에 색 사용을 절제한 것이 기사 전체의 극적인 성격을 고조시킨다.

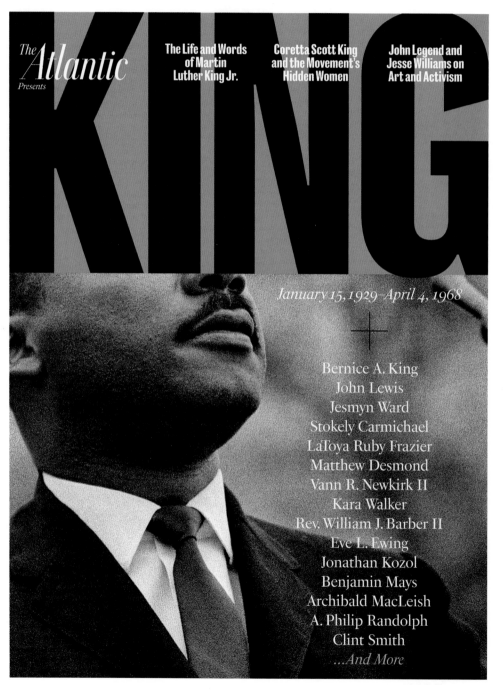

Main article images

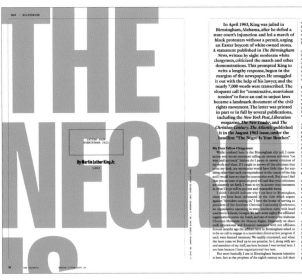

THE NEGRO IS YOUR BROTHER

By Martin Luther King Jr.
1963

LETTER FROM
BIRMINGHAM JAIL

디자이너들이 가끔 '디자인과 영화의
메타포'라는 말을 할 때가 있다.
판면이 포개진 형태의 이들 스프레드는
1963년에 「디 애틀랜틱(The Atlantic)」
잡지가 마틴 루터 킹 주니어 목사의
'버밍햄 교도소에서 보낸 편지
(Letter from Birmingham Jail)'를
게재하면서 제목으로 뽑은 '검둥이는
여러분의 형제(The Negro is Your
Brother)'를 영화 기법처럼 사용한
예다. 여기서 초록색 헤드라인은 시각적
보이스오버에 해당한다.

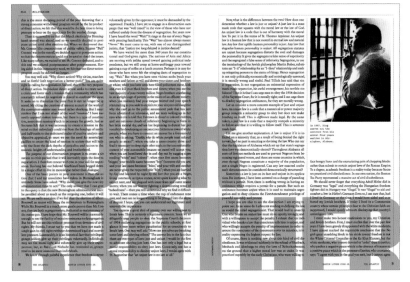

여백과 검은색 활자 그리고 악센트로
사용된 초록색이 기사 전체와 중요한
선언적 문장에 독자의 주의를 끄는 역할을
한다.

이 법칙은 색과 색을 통제하는 것에 관한
내용이지만 이들 스프레드는 그리드
작업의 다른 여러 가지 측면도 생생하게
보여준다. 특히 기사 도입부에서 여백을
어떻게 사용하는지 유심히 살펴볼
필요가 있다. 캡션이 텍스트의 폭을 꽉
채우지 않고 다른 그리드 모듈을 어떻게
사용하는지도 유의해서 살펴보라. 캡션이
마틴 루터 킹 주니어 목사의 사색적인
이미지를 반영하는 것도 여백 덕분에
가능한 일이다.

"Wait"
has almost
always meant
"Never."

The question is
not whether we
will be extremists,
but what kind of
extremists we
will be. Will we
be extremists for hate
or for love?

43 색으로 표현하라

잡지처럼 텍스트가 죽 이어지는 구조에서는 중간에 한 호흡씩 쉬어가는 것도 효과적이다. 이럴 때는 타이포그래피를 단순하게 하고 색 자체를 전면에 내세운다(아름다운 사진이 있다면 더욱 좋다). 책 중반부 지면에 자주 사용하는 방법이다.

총천연색 작업을 하다 보면 색을 쓸 수 있는 만큼 다양하게 쓰고 싶어지는 게 사실이다. 그러나 선명한 이미지를 나타낼 때는 색을 제한적으로 사용함으로써 (예컨대 검은색) 독자들이 이미지에 집중하도록 해야 한다. 화려한 시각 요소가 너무 많으면 오히려 역효과를 불러온다.

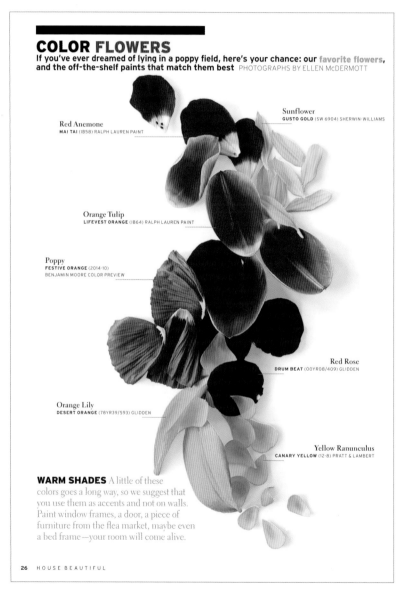

작업명
「*House Beautiful*」

의뢰인
「*House Beautiful*」

디자인
Barbara deWilde

싱싱하고 산뜻하게 연출한 이미지가 지면의 다른 어떤 요소와 비교할 수 없는 독보적인 아름다움을 발산한다.

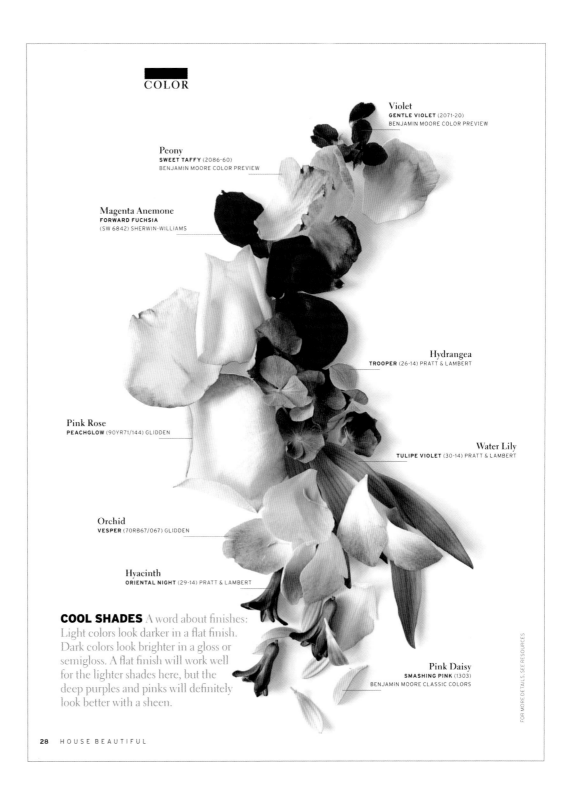

COLOR

Violet
GENTLE VIOLET (2071-20)
BENJAMIN MOORE COLOR PREVIEW

Peony
SWEET TAFFY (2086-60)
BENJAMIN MOORE COLOR PREVIEW

Magenta Anemone
FORWARD FUCHSIA
(SW 6842) SHERWIN-WILLIAMS

Hydrangea
TROOPER (26-14) PRATT & LAMBERT

Pink Rose
PEACHGLOW (90YR71/144) GLIDDEN

Water Lily
TULIPE VIOLET (30-14) PRATT & LAMBERT

Orchid
VESPER (70RB67/067) GLIDDEN

Hyacinth
ORIENTAL NIGHT (29-14) PRATT & LAMBERT

COOL SHADES A word about finishes:
Light colors look darker in a flat finish.
Dark colors look brighter in a gloss or
semigloss. A flat finish will work well
for the lighter shades here, but the
deep purples and pinks will definitely
look better with a sheen.

Pink Daisy
SMASHING PINK (1303)
BENJAMIN MOORE CLASSIC COLORS

FOR MORE DETAILS, SEE RESOURCES

44 타이포그래피와 컬러를 조화시켜라

컬러로 된 설명서라면 되도록 색을 절제하여 설명하고
있는 내용 외의 요소에 독자가 관심을 돌리지 않도록
주의한다. 적절한 색을 선택하고 판면에 적용시켜
타이포그래피에 힘을 실어주어야 한다.

장의 도입부 전면에 색감이 풍부한 사진을 배치했다. 그 풍부한 색상과
볼드체 타이포그래피가 대조를 이룬다.

전면의 사진 페이지 다음으로 서론이 이어진다. 여기에서는 장의
주요 색상을 바탕으로 한 본문의 흰색 세리프체가 장 제목의 두꺼운
산세리프체와 대조를 이룬다.

작업명
『Italic Grill』

의뢰인
HarperCollins

디자인
Memo Productions, NY

아트 디렉터
Lisa Eaton,
Douglas Riccardi

일급 요리사의 요리책으로,
탄탄한 그리드를 선보인다.
밝고 대담한 색상과 무게감이
강한 타이포그래피를 사용했다.
각 장마다 주요 색상에 조금씩
변화를 주어 마지막까지 세련된
분위기를 유지했다.

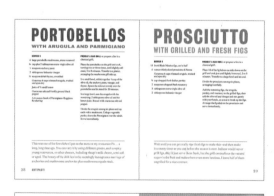

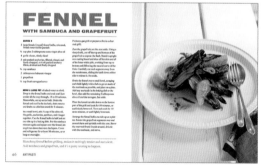

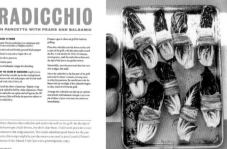

88쪽 아래의 이미지 3개와 89쪽:
각 항목마다 색상을 달리했다.
이때도 색은 컬러 사진을 보완해준다.

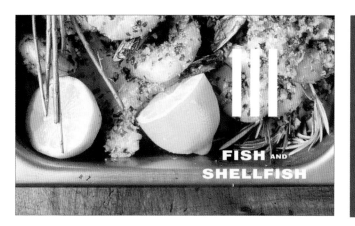

III

FISH AND
SHELLFISH

In Italy, cooking fish is all about freshness and simplicity—as I've said before, the philosophy of Italian fish cookery can be summed up in three words: *Leave it alone.* Complicated sauces and techniques are not part of the repertoire, and, in fact, Italians almost never serve any sauce at all with fish, other than an excellent olive oil. Lemon may sometimes appear, but even that is often considered beside the point. The one exception is *salsa verde,* the fragrant green herb sauce, which may sometimes accompany a fish with character enough to stand up to it, such as a whole grilled branzino (see page 126).

Few Italians would consider cooking anything other than local fish, whether from a mountain stream or the ocean, and I urge you to think in the same way: find a good fish market, and remember that what is freshest is best. If the specific fish called for in your recipe is not available—or doesn't look pristine and glistening—the fishmonger can help you choose another option (I include suggestions for substitutions in many of the recipes). If you are able to get fresh king mackerel for Mackerel "in Scapece" with Amalfi Lemon Salad, you will have the best mackerel dish you've ever tasted; if you can't find it, make the recipe with very fresh bluefish, or move on to another one. Most of the other fish recipes in this chapter, such as Monkfish in Prosciutto with Pesto Fregola and Swordfish Involtini Sicilian-Style, call for widely available varieties. But you'll want to be sure

to get the best tuna available—sushi-quality, that is—for Tuna Like Fiorentina, and you really should use wild salmon for the Salmon in Cartoccio with Asparagus, Citrus, and Mint.

Cooking shellfish on the grill is easy, and the recipes in this chapter use several different techniques for achieving simple perfection. Clams in Cartoccio are wrapped in a foil package and allowed to steam in their fragrant juices. The shrimp in Shrimp-Rosemary Spiedini alla Romagnola are threaded onto rosemary skewers, which impart their herbal fragrance and look sexy besides. I love cooking shellfish (and cephalopods) on a *piastra,* a flat griddle or stone placed on the hot grill (see page 000 for more on the subject), because it gives them a great sear and char, as in Sea Scallops alla Caprese or Marinated Calamari with Chickpeas, Olive Pesto, and Oranges.

Thinking globally while buying locally is especially important when you are buying fish. Some "trendy" fish have been overharvested to the point of extinction, and we now know that there can be problems with farmed fish as well, like salmon. The Monterey Bay Aquarium, at www.montereybayaquarium.com, maintains an up-to-date list of species that are being overfished in the United States and in the rest of the world. It's an invaluable resource, and I urge you to consult it when writing your shopping list, as I do both at home and at the restaurants.

MARINATED CALAMARI

WITH CHICKPEAS, OLIVE PESTO, AND ORANGES

SERVES 6

CALAMARI

3 pounds cleaned calamari (tubes and tentacles)

¼ cup extra-virgin olive oil

Grated zest and juice of 1 lemon

4 garlic cloves, thinly sliced

2 tablespoons chopped fresh mint

2 tablespoons hot red pepper flakes

2 tablespoons freshly ground black pepper

CHICKPEAS

Two 15-ounce cans chickpeas, drained and rinsed, or 3½ cups cooked chickpeas

½ cup extra-virgin olive oil

¼ cup red wine vinegar

4 scallions, thinly sliced

4 garlic cloves, thinly sliced

¼ cup mustard seeds

Kosher salt and freshly ground black pepper

OLIVE PESTO

¼ cup extra-virgin olive oil

Grated zest and juice of 1 orange

½ cup black olive paste

4 jalapeños, finely chopped

12 fresh basil leaves, cut into chiffonade (thin slivers)

3 oranges

2 tablespoons chopped fresh mint

CUT THE CALAMARI BODIES crosswise in half if large. Split the groups of tentacles into 2 pieces each.

Combine the olive oil, lemon zest and juice, garlic, mint, red pepper flakes, and black pepper in a large bowl. Toss in the calamari and stir well to coat. Refrigerate for 30 minutes, or until everything else is ready.

Put the chickpeas in a medium bowl, add the oil, vinegar, scallions, garlic, and mustard seeds, and stir to mix well. Season with salt and pepper and set aside.

93

45 색으로 담고 명확히 하라

아래의 프로그램 달력처럼 그리드 전체에 일정한 크기로 적용되는 모듈 그리드에서는 색 모듈을 촘촘하게 배치하면서도 유연하게 변용함으로써 텍스트와 이미지라는 두 요소를 경쾌하게 디자인할 수 있다. 박스 장치와 색깔은 전체적인 체계와 구조를 결정하는 동시에 정보를 명확하게 나타내는 기능을 한다. 세부적인 항목을 길게 나열할 때는 색 모듈을 조합하여 날짜와 정보를 다른 요소, 즉 웹사이트 주소나 메시지, 배너, 작품의 주 제목 등의 정보와 구분하자.

작업명
프로그램 달력

의뢰인
Smithsonian, Cooper-Hewitt,
National Design Museum

디자인
Tsang Seymour Design, Inc.

디자인 감독
Patrick Seymour

아트 디렉터
Laura Howell

이 계절별 프로그램 안내 달력은 동일한 성격의 정보를 전달한다. 색상과 이미지를 과감하게 응용한 디자인이다.

주요 전시의 개요와 일시가 화면에 넘쳐날 듯 자유로운 이미지를 보충해준다. 프로그램 달력 뒤편에 이처럼 상반된 성격의 이미지를 배치하여 시각적 긴장감과 응집력을 유도했다.

이미지 크기를 다양하게 변형시키고 일부는 윤곽선을 살려 넣음으로써 컬러 모듈 그리드를 (예외적으로 그리드를 침범하기도 하면서) 충실하게 구현했다.

우선 전체 지면의 크기를 파악하고 그것을 동일한 크기의 사각형들로 나눈다. 각 사각형에 바깥 마진을 설정한다. 하나의 사각형을 하나의 박스로 사용하거나 또는 가로나 세로로 2~3개를 연결하거나, 또는 다시 그것들을 합쳐서 사용한다. 담아야 할 내용이 무엇인지 파악한 다음 날짜와 달, 가격, 행사 등등 그에 어울리는 모듈 색을 지정한다. 내용이 딱딱하다면 그에 걸맞은 색깔로 뒷받침한다.

모듈을 사용하여 사진과 일러스트레이션을 훌륭하게 담아낼 수도 있다. 텍스트를 다룰 때와 마찬가지로 모듈 하나에 사진 한 컷을 넣을 수도 있고, 상하 모듈 2개와 좌우 모듈 2개나 혹은 상하좌우 모듈 4개에 사진 하나를 넣을 수도 있다. 이렇게 컬러 박스는 매우 다양하게 조합할 수 있으면서도 질서와 통일성을 유지하는 역할을 한다. 재미를 더하고 싶다면 딱딱한 박스들 사이에 윤곽선을 딴 이미지를 배치해보자. 리듬감과 시각적인 여유로움이 있는 경쾌한 프로그램 일람표를 만들 수 있다.

다채로운 색상이 뒷받침하는 구조에서 정보는 독자적인 공간을 확보할 수 있다. 컬러 모듈을 사용하면 작은 활자의 정보와 큰 활자의 제목부, 두꺼운 글씨의 정보 등 위계가 다른 정보들을 쉽게 읽어낼 수 있다. 다양한 활자 크기와 두께, 대문자와 소문자 등 여러 특징을 이용하여 읽는 이가 날짜, 행사, 시간, 설명 등을 쉽게 훑어볼 수 있게 한다. 또, 여러 모듈을 합친 박스 안에 큰 활자로 표제를 담으면 리듬감과 의외성이 생길 뿐만 아니라 구매 전화, 행사 주체, 광고, 연락처 정보 등 그 밖의 성격이 비슷한 정보들과도 순조롭게 연결된다.

양면이나 펼침면 작업을 할 때는 명확하게 구획된 공간에 따르는 (때로는 그것을 침범하는) 모듈 그리드가 매우 효과적이다.

46 컬러 타이포그래피로 정보를 강조하라

너무 많은 색을 사용하면 번잡하고 혼란스러운 판면이 된다. 하지만 적절한 양의 색을 사용하면 독자에게 어떤 부분의 내용이 중요한지 우선순위를 알려줄 수 있다. 예를 들어, 제목부를 색으로 강조하면 그것이 전체 정보 중에서 가장 중요한 것임을 확실하게 알 수 있다.

작업명
「Croissant」

의뢰인
「Croissant」

디자이너
Seiko Baba

일러스트레이션
Yohimi Obata

색을 정교하게 사용하여 글을 보완하고 잡지 판면에 명확성과 활기를 더했다. 사진의 지면은 「크루아상(Croissant)」의 편집자들이 만든 무크지에 실린 '녹슬지 않는 생활의 지혜'의 일부다.

제목 첫 활자의 크기를 키우고 색을 입혀 시선을 끌었다.

じゃが芋団子

じゃがいもひとつでできる、定番のおやつ。

「おやつによく作ってくれたお団子。じゃがいもをすり下ろして、絞った汁から澱粉を取り出してつなぎにするんです。理科の実験みたいでしょう。ひと手間をかけることで、たった数個のじゃがいもが、もっちりと食べごたえあるお団子になる。「甘いタレで食べるとおいしい。急に友達を連れて帰ったときにも、手早く作ってくれた記憶が」

材料 4人分
じゃがいも（小ぶりのもの）4個 黒蜜り胡麻大さじ6 醤油大さじ1と1/2 煮切りみりん小さじ1 ハチミツ大さじ1 昆布だし大さじ3 白煎り胡麻適量

作り方
1 じゃがいもは皮をむき、おろし金ですり下ろす。
2 1をさらしなどで絞り（写真左）、絞り汁はコップなどに入れて置いておく。汁以外はボウルに入れておく。
3 絞り汁の底に白い澱粉が沈殿してきたら上澄みの汁を捨て、ボウルに入れた2に加えてよく混ぜ、団子状に丸める。
4 3を沸騰した湯の中に入れ、浮かんでくるまで茹でる。
5 絞り胡麻、醤油、みりん、ハチミツ、昆布だしをよく混ぜる。
6 4を湯に取り、水気を切って皿に盛り、5をかけて、白煎り胡麻などをふる。

薩摩芋もち

冷めてもおいしい、さつまいも入りのおもち。

じゃが芋団子と同じくらいの頻度で登場した8。「お餅に芋をつき混ぜて量を増やした。お腹に溜まるおやつでした。さつまいもが入っていると冷めても柔らかく、おいしく食べられる。甘くしたきな粉をまぶしてもいいですが、塩で食べるとさつまいもの自然な甘みが引き立ちます」

材料 4人分
さつまいも1/2本（約150グラム）切り餅3切れ きな粉適量 黒糖またはおろししょうが適量 塩適量

作り方
1 さつまいもは洗って、皮付きのまま蒸気の上がった蒸し器に入れ、柔らかくなるまで20分以上蒸す。
2 1の、途中、残り6分くらいのところで切り餅も入れて蒸す。
3 1のいもの皮をむき、すり鉢などに入れてよく潰し、蒸して柔らかくなっ

た餅とよくつき混ぜる。
4 手に水を付けて3を適当な大きさにちぎり、きな粉、黒砂糖、塩など好みのものをかける。

皮も香ばしく揚げて、トッピングに使う。

茄子の胡麻煮

ごまの香ばしさが引き立つ、なすの煮物。とろりとしたなすの食感を出すのに、皮はどうしても不要になる。「その皮を細く刻んで揚げて、切り昆布のようにトッピングに。相手の胡麻だしで和える人で、皮を揚げるとき真っ黒になるまで揚げるのです。でも苦みが強くなるので、からっとしたら引き上げていくと思います」

材料 4人分
なす4本 だし1カップ 日本酒1/3カップ みりん大さじ3 塩小さじ1 白すり胡麻大さじ3 薄口醤油適量 揚げ油適量

作り方
1 なすは両端を切り落とし、縦に皮をむき茄子の皮を細く刻んで170℃の油でカリッと揚げ、油をよく切る。
2 1の身は深く包丁を入れてから縦に放し、ざるに上げる。皮は細切りにして水にさらし、ざるに上げ（写真）。
2 鍋にだし、酒、みりん、塩を入れてひと煮立ちさせ、水気を切ったなすを入れる。初め中火で、煮立ったら弱火にして柔らかくなるまで煮、すり胡麻

を加えてしばらく煮て、味をみて甘口に仕上げるなら砂糖を少し加える。
3 なすの皮の水気をよく切り、170℃の油でカリッと揚げ、油をよく切る。
2を器に盛り、3を天盛りにする。

だしに使う煮干しも、立派なメインに。

煮干しとごぼうの立田揚げ

「とくに相母が気に入っていた一品。この料理専用のお店が済んであったほどです」。使うのは、ごぼうと煮干し。たったそれだけで、酒と醤油に漬け、片栗粉をまぶしてカリッと揚げるだけで、メインにも酒の肴にもなってしまう、魔法のようなレシピだ。「煮干しは比較的大きめのものを使うと、おいしく仕上がります」

材料 4人分
煮干し24本（1人組6本計算で）ごぼう1/3本 醤油大さじ4 酒大さじ4 おろししょうが大さじ1 片栗粉適量 揚げ油適量

作り方
1 煮干しは頭と内臓を取り、酒の大さじ2、酒大さじ2、しょうが大さじ1/2を合わせた汁に漬けてしばらくおく（写真）。
2 ごぼうはたわしなどでこすって洗い、薄く斜め切りにしてさっと水にさらし、水気を切って1と同量の

漬け汁に漬けておく。
3 1と2の全体に片栗粉をまぶし、水分を軽くはたき落として170℃の油でからりと揚げて油をよく切る。

여기에서 색은 하나의 글을 다른 글과 구분하는 역할을 한다. 이처럼 내용을 명확하게 구별하는 것은 특히 설명서의 경우 유용하고 또 중요하다. 이 요리법 설명서는 부제목과 조리법 순서 번호에 붉은색을 입혀 텍스트와 구별해놓았다.

질문 항목에서 질문(Question)을 뜻하는 문자 Q를 다른 활자들과 다른 두께, 크기, 음영으로 처리하여 질감과 시각적 재미를 부여했다.

お付き合い編　人付き合いを潤滑にする言葉づかい。

Q 近所の主婦の中傷合戦に巻き込まれ、私の名前に。

Q 知人からセールスの勧誘を受けました。うまく断るにはどうすればいいですか？

Q 親しい人との食事、きょうは自分が支払いたい。どう言えばいいですか？

Q 待ち合わせ場所に現れなかった友人に、ひとこと文句を言いたいのですが。

Q お中元やお歳暮をお断りしたいのですが、相手に失礼にならない言い方はありますか？

Q グループのある人に会場の手配を頼みたい。上手にお願いする方法はありますか？

47 색으로 모듈에 생동감을 불어넣어라

색을 사용한 달력은 요일 같은 세부 정보를 알아보기가 쉽다. 색을 입힌 정보는 눈에 잘 띄면서도 지면 전체와 잘 어우러진다. 또한 색은 사진의 색감을 보충하기도 한다. 날짜 정보가 있긴 하지만 튀지 않게 처리해야 한다면, 본 내용을 방해하지 않게끔 부드러운 색이나 음영을 입힌다. 만약 활자를 바탕색 위에 인쇄한다면 바탕색은 옅고 탁한, 회색에 가까운 색상이 가장 효과적이다.

작업명
행사 달력

의뢰인
New York City Center

디자인
Andrew Jerabek

사진과 색채를 모두 고려하여 달력의 음영을 결정했다.

진한 색감의 배경과 화려한 몸동작이 보색을 입힌 달력과 대비를 이룬다.

연하지만 서로 대비가 되는
박스의 색이 아름답게 연출된
사진을 자연스럽게 뒷받침한다.

PENNSYLVANIA BALLET

Nov. 14 – 18
Tickets: $25, $55, $75, $110

Pennsylvania Ballet returns to New York City Center for the first time in more than twenty years with two dynamic programs. The first features a live orchestra in a riveting new *Carmina Burana*, deemed a "triumph" by *The Philadelphia Inquirer* and choreographed by the Company's own Matthew Neenan. The second program features works by Balanchine, Neenan, and Val Caniparoli's vibrant *Lambarena*, a celebration of African and Classical music and dance.

Wed 7:30pm	**Nov 14** **Serenade** Peter Ilyitch Tschaikovsky/George Balanchine **Carmina Burana** Carl Orff/Matthew Neenan
Thu 7:30pm	**Nov 15** **Concerto Barocco** Johann Sebastian Bach/George Balanchine **As It's Going** Dmitri Shostakovich/Matthew Neenan **Lambarena** Johann Sebastian Bach/Val Caniparoli
Fri 8pm	**Nov 16** **Serenade** Peter Ilyitch Tschaikovsky/George Balanchine **Carmina Burana** Carl Orff/Matthew Neenan
Sat 2pm	**Nov 17** **Concerto Barocco** Johann Sebastian Bach/George Balanchine **As It's Going** Dmitri Shostakovich/Matthew Neenan **Lambarena** Johann Sebastian Bach/Val Caniparoli
Sat 8pm	**Nov 17** **Serenade** Peter Ilyitch Tschaikovsky/George Balanchine **Carmina Burana** Carl Orff/Matthew Neenan
Sun 2pm	**Nov 18** **Serenade** Peter Ilyitch Tschaikovsky/George Balanchine **Carmina Burana** Carl Orff/Matthew Neenan

Principal Dancer Amy Aldridge · Photo Gabriel Bienczycki

전체적으로 가을의 계절색을
적용하고 뚜렷한 선황색으로
강세를 주어 역동적인 성격의
사진을 효과적으로 담아냈다.

NY CITY CENTER — MORPHOSES/ THE WHEELDON COMPANY

Oct. 17 – 21
Tickets: $30, $50, $85, $110

Morphoses/The Wheeldon Company makes its New York debut at New York City Center, performing two unique programs featuring seven New York premieres and an American premiere. Founded by internationally acclaimed choreographer Christopher Wheeldon, Morphoses aims to revitalize contemporary classical ballet by marrying dance, music, visual art and design - infusing it with a newfound energy and vision by embracing all art forms in a collaborative environment. The dancers comprise a first-class ensemble of guest artists from leading companies including New York City Ballet, San Francisco Ballet and the Royal Ballet, among others. Celebrated couture designer Narciso Rodriguez will design the costumes for both of Mr. Wheeldon's new works, and will also be working with him on each of the ballets' stage designs.

"...Mr. Wheeldon's mastery is unmistakable..." – Alastair Macaulay, *The New York Times*

Wed 7:30pm	Oct 17, Oct 18*, Oct 19 **There Where She Loved** *New York Premiere* Christopher Wheeldon **Tryst Pas** *New York Premiere* Christopher Wheeldon	**Sat** 2pm	Oct 20, Oct 21 **Mesmerics** Christopher Wheeldon **Slingerland Pas de Deux** *New York Premiere* William Forsythe
Thu 7pm	**Slingerland** *New York Premiere* William Forsythe	**Sat** 8pm	**Propeller** *New York Premiere* Liv Lorent **Satie Stud** *New York Premiere* Michael Clarke
Fri 7:30pm	**Prokofiev Pas De Deux** *New York Premiere* Christopher Wheeldon **New Wheeldon Ballet** *American Premiere* Christopher Wheeldon	**Sun** 3pm	**Vicissitude** *New York Premiere* Edwaard Liang **Morphoses** Christopher Wheeldon

*Special Gala Performance

Join Christopher Wheeldon and Morphoses dancers for a Gala celebration.

For more information please call 212 763 1205.

Generously Supported by

AMERICAN EXPRESS
John Philip Falk
Frederic and Robin Seegal
Anne H. Bass
Douglas S. Cramer
New York City Center Dance Council

Wendy Whelan & Jock Soto · Photo Paul Kolnik

구성 요소로서의 색

48 색으로 정보를 분류하라

색으로 정보를 분류하여 원하는 정보를 손쉽게 찾을
수 있게 하라. 색상 분류를 사용한 판면은 아이콘과
마찬가지로 글 또는 색만 사용했을 때보다 훨씬 많은
정보를 전달해준다.

의뢰인의 요구나 내용의 성격에 따라 색을 밝게 혹은
어둡게 조절한다. 회색기가 없는 밝은 색상은 즉각적으로
보는 이의 시선을 잡아끈다.

연구 센터들과 관련 학위 수여
프로그램을 과목별로 분류한
디자인이다. 과목마다 각각의
색상 체계를 부여했다.

작업명
아이덴티티 프로그램

의뢰인
Earth Institute at
Columbia University

디자인
Mark Inglis

크리에이티브 디렉터
Mark Inglis

컬럼비아 대학 지구연구소
(Earth Institute at Columbia
University)의 연구 과목 6개를
색상으로 분류했다.

색상에 아이콘을 결합시켰다.

아이콘, 컬러 밴드, 활자에 색을 적용했다.

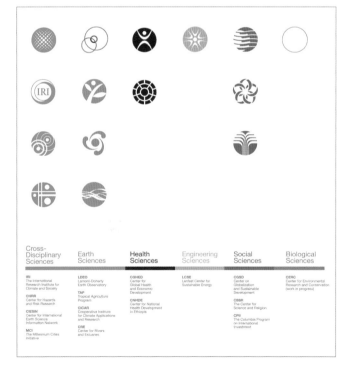

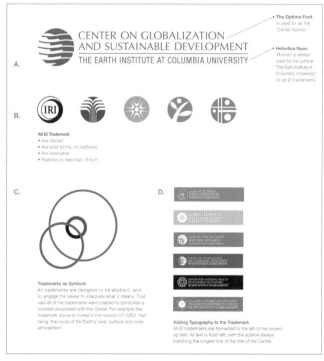

49 색으로 항목을 분리하라

가로, 세로 괘선이 들어간 단을 사용하는 것은 구성 요소를 분리하는 가장 명쾌하고 타당한 방법이지만, 다양한 색의 음영이 화려함과 흥미를 더하면서 다양한 기고자들의 목소리를 차별화할 수 있다. 드롭아웃 활자, 즉 배경색 위로 도드라진 흰색 리버스 활자를 쓰면 효과가 배가된다.

참조할 페이지
100—101

드롭아웃

드롭아웃 활자는 드라마틱하다. 다만 텍스트가 작은 글씨거나 양이 많을 때는 드롭아웃 활자. 그중에서도 특히 세리프체를 쓰면 선명도를 해칠 수 있다. 산세리프체는 그럭저럭 버틸 수 있다. 화면에서는 검은 바탕에 흰색 활자를 쓰면 읽기가 더 어려워서 활자의 크기를 크고 굵게 바꿔야 할 수도 있다.

> *AT SPOTCO, WE BEGIN WORK-ing on a show by understanding its Event. I didn't invent this phrase—it was loaned to me by producer Margo Lion. But what I came to understand it as is quite simply the reason you see a show. Or even more simply, the reason you tell someone else to see a show. It can be straightforward,*

위의 샘플은 실물 크기다.

작업명
『On Broadway: From Rent to Revolution』

의뢰인
Drew Hodges(저자),
Rizzoli(출판사)

크리에이티브 디렉터
Drew Hodges

디자인
Naomi Mizusaki

브로드웨이의 걸출한 뮤지컬 전문 광고 에이전시 스포트코(Spotco)와 함께 일했던 사람들에 관한 추억에 다양한 색의 스포트라이트를 비쳤다.

함께 일한 사람들이 어떤 기여를 했는지 각각의 색이 알려준다. 판면의 끝을 장식한 검은 박스 속 텍스트는 한 사람에 관한 것이 아니라 에이전시의 철학에서 빼놓을 수 없는 '이벤트' 요소에 관한 내용이다

1987

ACT ONE

DREW HODGES
FOUNDER AND CHIEF EXECUTIVE OFFICER

WE OPEN ON A YOUNG design firm called Spot Design. It was named for a dog the landlord said we couldn't have. So I named the office as my pet.

After attending art school at School of Visual Arts in New York City, I had left working for my college mentor Paula Scher and began freelancing solo out of my apartment. I was working in the kitchen of my loft, across from the now-defunct flea markets on 26th Street and Sixth Avenue. This is the same kitchen where producers Barry and Fran Weissler came to see the early designs for *Chicago*—but I get ahead of myself. Ultimately, we were five designers and one part-time bookkeeper doing entertainment and rock 'n' roll work. We were young and laughed a lot. Ten years later, we had been privileged to work with Swatch Watch, MTV, Nickelodeon, the launch of Comedy Central and *The Daily Show*, as well as record work for Sony Music, Atlantic Records, and Geffen/DreamWorks records, where our most notable projects were album packages for downtown diva Lisa Loeb and iron-lunged Aerosmith. We grew adept at strategy, design, and collaboration with many downtown artists, illustrators, and photographers,—all people we would come to take full advantage of as we began our theater work. I went to the theater—it was a New York City joy for me. I had gone since early high school, riding the train to the city. But I never dreamed I would get any nearer than second-acting *Dreamgirls* from the mezzanine.

Two bold incidents happened to change that. First, Tom Viola and Rodger McFarlane were heroes of mine for the work they did through what was to become Broadway Cares/Equity Fights AIDS. A friend and art director from Sony Music named Mark Burdett

was assigned to work with Spot on [an] ad for the Grammy Awards program[.] the prime position of the back cove[r] was Martin Luther King Jr. Day, an[d] clients were all away. So we moaned [about] doing yet another ad filled with albu[m] minis of the labels and latest Streisa[nd] release with hollow congratulations[—] a waste of a great opportunity. We posited that Sony could be the first record company to take a stand aga[inst] AIDS by making a donation and att[ach]ing a red ribbon to the back of each[—] issue of the program. And to pitch [the] idea, we called Rodger and Tom at [their] offices to help us fulfill it. The ribbo[n] was theirs after all. Remarkably, the[y] were working on the holiday and answered the phone. They agreed to [it,] and the rest is history. I believe it w[as] the first awards ceremony to public[ly] script the concern over AIDS, and o[ld] friendships were formed. Later that year, Tom and Rodger called. They [had] an ad due in three days for their ne[w] show, *The Destiny of Me*, Larry Kra[mer's] sequel to *The Normal Heart*. We sen[t] them a design based on a photo of [a] right hand—I guess we felt it seeme[d] personal—and they loved it. This w[as] our first theater poster.

But it would have been a short-li[ved] career without the second event. Tw[o] years later, we had just finished doi[ng] the Aerosmith album for Geffen. R[obin] Sloane, David Geffen's star creative director, called and asked us to mee[t] with the producers of *Rent*—Geffen [records] would be releasing the album. I too[k a] meeting with the ad agency in char[ge] and got the assignment and a ticket [to] the hottest show in town a week aft[er it] had opened Off-Broadway. Within [a] year, we would have designed *Rent* [in] *Chicago*, and Jeffrey Seller sat me [down] in a mall in Miami to ask if we had [ever] thought about starting an ad agenc[y. It] seemed a big risk—but it also seem[ed] like a world where you could actual[ly] meet the people doing the creative [work] you were assigned to promote. And [we] began to try and figure out just how [an] ad agency worked anyway.

8

BRIAN BERK
CO-FOUNDER AND CHIEF OPERATING OFFICER / CHIEF FINANCIAL OFFICER

IN THE SPRING OF 1997, after designing the successful ad campaigns for *Rent* and *Chicago*, we decided to attempt to open a theatrical ad agency. The first question was: What would we need to be able to pull this off? For starters, we would need equipment, office space, a staff, and most importantly, clients.

The equipment was easy. In order to keep upfront costs down, we could lease—a few computers and a fax machine. From there, we could scrape by until we had some clients.

Office space: The design studio was currently housed in Drew's apartment. We knew that for potential clients to consider hiring us, we would need to be in the theater district, and we would need to have a large conference room for the weekly ad meetings. I set out to look at space. One space was located in 1600 Broadway. The building was fairly run-down (and we would later learn it had a mouse problem), but it did have a long and interesting history. It was built in the very early 1900s as a Studebaker factory and showroom. In the 1920s, it was converted to offices and at one point housed the original offices of Columbia Pictures, Universal Pictures, and Max Fleischer Studios, creator of Betty Boop. This seemed a fitting place for a theatrical ad agency. By 1997, the building held a combination of offices and screening rooms. (It has since been torn down.) The space we looked at consisted of two small offices, a big bullpen area for our designers, and one large conference room with the most amazing view of Times Square. We actually found a photograph of a movie executive sitting at his desk in the room that would eventually become our conference room. It has the same wood paneling and window with the view. However, the bearskin rug, which is seen on the floor in the photo, is long gone. The space had character. We had to furnish it on the cheap. We hired a set decorator friend to style the office circa 1940s, so all the used office furniture we purchased would look

like a very conscious design choice. We moved to the space in June 1997.

Staff: We already had a creative director (Drew), four graphic designers, an office manager, and me. I handled finance, administration, and facilities. We needed someone to head account services, an assistant account executive and a graphic production artist to produce all the ads. We'd hire a writer once we had some clients. For the production artist, we knew just who to hire: Mary Littell. She had worked for us before and was great. The person to head account services was harder to find. We needed someone who had worked at an ad agency before and understood media. From what Drew learned, one of the most respected account managers in the industry was Jim Edwards, or as was said by several producers, "He is the least hated." He had worked at two of the existing theatrical ad agencies. But would Jim join a startup? Jim was game and joined our team. Jim walked in the door on July 21, 1997. Mary was at her desk working on dot gain so she would be ready if we were ever hired to place an ad. Now, all we needed were some clients.

JIM EDWARDS
CO-FOUNDER AND FORMER CHIEF OPERATING OFFICER

OF DREW, BRIAN, MARY, BOB Guglielmo, Karen Hermelin, and Jesse Wann, I was the only one who had worked at an ad agency before. Little things like a copy machine that can make more than one copy every thirty seconds was not part of our infrastructure. I started on a Monday, and the pitch for *The Diary of Anne Frank* was that Friday. We didn't have any clients so that entire week was all about the pitch. Thursday night we were there late and inadvertently got locked in the office (how that is even possible still strikes me as odd). We couldn't reach anyone who had a key so we had to call the fire department to let us out. They did—and were adorable too. Once we had a show, we became a legitimate advertising agency, which led to David Mamet's *The Old Neighborhood*, John Leguizamo's *Freak*, and Joanna Murray-Smith's *Honour* within months of being open for business.

Since SpotCo was a brand-new company, we had no credit with any of our vendors. The *New York Times* made us jump through so many hoops about establishing a relationship with them. I think we had to have a letter from the producers of *Anne Frank* saying they were hiring us as their ad agency. When it came time to reserve our first *Times* ad, about a month had passed since all those rules were handed down. Back then, you simply called the *Times* reservation desk and reserved the space. That's what I had been doing for years so I did it again, inadvertently forgetting that the ad needed to be paid for well in advance. I knew everyone there so they accepted my reservation without question. The ad ran. No one said anything. The bill came about a month later, and we paid it. About two months in, the *Times* noticed that we were sliding under their rules but since we were paying our bills and were current, they granted us credit. By that first Christmas, we had established credit everywhere, which was and is a big deal. Not many new companies can make that kind of claim.

In the first eighteen months of SpotCo, I never worked harder in my life. The hours were long (I gained a lot of weight during that time—do not put this in the book), and it wasn't easy, but we also saw direct results from all the hard work. The work was good, and people noticed what we were doing—and we were making money! The Christmas party of 1998 was particularly memorable. That day, we had just released the full-page ad for *The Blue Room*, which was pretty provocative because all we ran was the photo and a quote about how hot the ticket was. It was a big deal for us and kind of heady. The party was at some restaurant, and Brian had secured a private room. There were only three tables of ten, and we shared our Secret Santa gifts. Everyone was really into it and every time someone opened a gift, Amelia Heape would shout, "Feel the *love*, people! Feel the *love*!" Indeed.

TOM GREENWALD
CO-FOUNDER AND CHIEF STRATEGY OFFICER

WHAT AM I, NUTS? IT WAS early 1998. I had a good job, an amazing wife, three adorable kids under five years old, and a modest but nice house in Connecticut. In other words, I was settling in nicely to the 9 to 7, suburban commuting life. But I kept hearing about this guy Drew Hodges. First I heard about him through my friend Jeffrey Seller, who had worked with Drew on the designs for *Rent*. Then I heard about him through my friend David Stone, who was just about to start working with him on *The Diary of Anne Frank*. Then, I realized, they're talking about the tall guy who talked a lot and had barreled his way through meetings at Grey Advertising (where I worked at the time) while designing the artwork for *Chicago*. So when Jim Edwards called me and said, "Hey, I'm joining up with this guy Drew and we're turning his design shop into an ad agency and did you want to meet him." I had to think about it. No way was I going to give up my job security, right? The odds of any theatrical ad agency surviving at all were miniscule, much less one with . . . wait, let me add them up . . . one client. And besides, I'd probably have to take a cut in pay. Only an insane person would consider it. "Sure," I told Jim. "Set it up."

So I went in to talk to Drew, and after about eighteen seconds, I'd made up my mind. When Drew asked if I had any questions, I had only one. "Where do I sign?" I joined SpotCo as the head (only) copywriter, head (only) broadcast director, and head (only) proofreader. On the downside, we were a very lean department. On the upside, I never had any problems with my staff.

Now here we are, almost eighteen years later. My wife is still amazing, my three kids are still adorable (although no longer under five), and my house is still modest but nice (although we redid the TV room). I never did settle in to that 9 to 7 job, though. Instead, I decided to take a chance, a flyer, and a crazy ride—and it's worked out pretty well. So yeah, I guess I was a little nuts. But it turns out craziness has its perks.

THE EVENT

AT SPOTCO, WE BEGIN WORK- ing on a show by understanding its Event. I didn't invent this phrase—it was loaned to me by producer Margo Lion. But what I came to understand it as is quite simply the reason you see a show. Or even more simply, the reason you tell someone else to see a show. It can be straightforward, or subtle. As much as I love advertising, branding and design and what it can do for a show, word of mouth is the number one reason a show becomes a hit. So the most effective branding hopes to invite, encourage, and curate that word of mouth. It has to be true to the experience of that show—otherwise it will fail miserably. If every great musical begins with an "I want" song, then every show's voice begins with "I want you to think of this show this way" tune.

What we as an agency have also learned is you choose your Event or it will be chosen for you, and you (and ticket buyers) may not like the sound of that choice. Lets call that the non-event.

At the beginning of each show presented here, we have listed the non-event first—the thing we feared the Broadway customer would default to when describing a show, knowing little else. This is followed by the Event (capital E!) that we wanted to communicate. Hopefully, this informs our successes and disappointments and, more to the point, why a certain idea was ultimately chosen. —D.H.

50 무게, 크기, 형태를 이용해 색깔을 만들어내라

구성 요소들이 잔뜩 몰려들어 공격을 하는 사태를 줄이기 위해 디자이너들이 흑백 인쇄를 선택하거나 사용하는 색의 수를 최대한 줄이는 경우가 있다. 어떤 때는 예산이 모자라 1도 인쇄밖에 할 수 없는 일도 생긴다. 제한된 수의 색을 사용하건, 단색을 사용하건 상관없이 활자체, 활자 크기, 폰트 그리고 이미지 요소가 판면 그리드에서 차지하는 비율과 같은 수단을 이용해 색과 질감을 창출할 수 있다.

변화무쌍한 그리드는 다양한 너비와 크기를 지원하고 가능한 옵션을 전부 활용해 다양성과 매력을 만들어낸다. 실제로 그래픽 요소에 속하는 여백도 강력한 힘과 대비 효과를 낸다.

색조

사양이나 디자인 환경설정 때문에 단색이나 극소수의 색밖에 사용할 수 없을 때는 엷은 색, 즉 색의 퍼센티지를 활용하는 것도 방법이 될 수 있다. 예를 들어 10% 블리드 블랙 바탕은 100% 컬러로 겹침 인쇄된 텍스트를 얼마든지 지원할 수 있다. 화면이 어두울수록 100% 컬러 활자는 가독성이 떨어진다(활자의 크기나 용지에 따라 다름). 화면이 어두울 때 가능한 선택지는 활자의 밑색을 빼는 것이다. 이 사이드바는 흰 바탕에 70% 검정을 사용했다.

참조할 페이지
98 – 99, 112 – 113

작업명
「King」
(마틴 루터 킹 주니어 목사 서거
50주년 기념 특별호)

의뢰인
「The Atlantic」

크리에이티브 디렉터
Paul Spella

아트 디렉터
David Somerville

디자인 회사
OCD | Original Champions
of Design

디자이너
Bobby C. Martin Jr.,
Jennifer Kinon

서체를 여러 가지 크기로 다양화하고, 그리드의 크기와 여백을 극적으로 사용한 것이 특별호의 서사적 성공을 이끌었다.

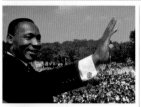

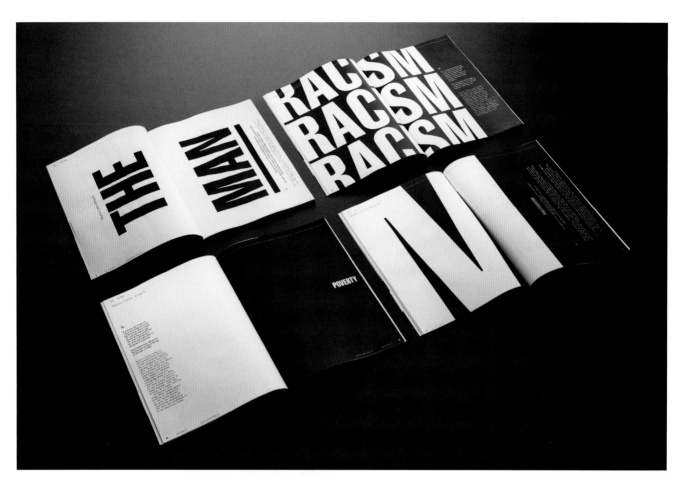

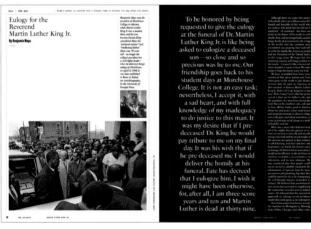

100쪽: 옛날 사진, 인용문, 보도 기사를 훌륭하게 사용한 이 걸작 스프레드는 변화무쌍한 그리드의 여러 측면을 활용해 질감을 구현하고 있다. 서로 다른 세 가지 서체가 1960년대를 떠오르게 하면서 명쾌하게 구획된 섹션에 참신한 느낌을 준다. 섹션의 크기는 각양각색이지만 연대표상의 날짜는 일관되게 유지되고 있다.

위: 네 개의 섹션 도입부는 색이 아니라 크기를 이용해 드라마틱한 페이스를 설정했다. 아래: 마틴 루터 킹 주니어 목사에 대한 찬사가 공손하면서도 역동적이다. 색의 수를 제한하고 검은 배경색에 흰색 리버스 활자를 사용해 문장에 힘을 실었고, 텍스트의 일부를 더 크거나, 더 폭이 넓거나, 더 좁거나, 무게가 다양한 서체로 조판해 강조했으며 그리드를 부분적으로 비움으로써 여백이 기사와 이미지만큼 웅변적으로 바뀌었다.

51 표지판은 영역별로 나눠라

표지판 디자인은 논리, 조직화, 일관성을 요구하는 특별한 디자인 영역이다. 표지 체계 그래픽(특히 4면 설치물 디자인)에 적용할 수 있는 그리드 체계는 다음과 같은 사항을 충족해야 한다.

- '1의 경우, 2의 경우…' 식으로 여러 단계의 정보를 순차적으로 배치한다.
- 외국어 병기와 같은 부가 정보도 중요하다.
- 예컨대 공항의 출입구, 화장실, 식당 위치 등 해당 공간에 대한 필수 정보를 담아야 한다.
- 표지판을 따라 목적지를 찾는 사용자들에게 필요한 복합적인 정보를 담아야 한다. 사용자가 왔던 길로 되돌아가게 하는 일은 없어야 한다.

사용자가 걷거나 운전하는 등 이동 중에도 표지판을 쉽게 발견하고 읽을 수 있도록 반드시 가독성 높은 타이포그래피와 간결한 정보 체계, 주목을 끌면서도 메시지를 방해하지 않는 색을 사용해야 한다.

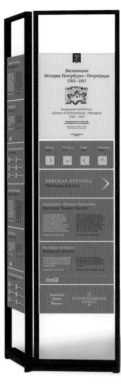
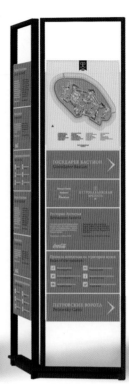

탑형 표지판의 예시. 메인 표지와 그래픽 플레이트로 정보 구역들을 정렬했다.

작업명
아이덴티티와 표지 체계

의뢰인
The Peter and Paul Fortress,
St. Petersburg, Russia

아트 디렉터
Anton Ginzburg

디자인
Studio RADIA

러시아 상트페테르부르크에 있는 페트로 파블로프스크 요새의 아이덴티티 작업이다. 길을 찾아가는 방법이 영어와 러시아어 2개 국어로 쓰여 있다.

그래픽 플레이트의 세부. 디자이너는 여기에 보이는 다양한 종류의 정보를 명확히 드러내야 했다.

탑형 표지판의 텍스트에 깔끔하고 고전적인 타이포그래피를 적용했다. 상트페테르부르크의 유구한 역사가 느껴지는 디자인이다.

파란색 패널은 한시적으로 쓰이는 배너로, 디지털 인쇄 작업을 하여 첨탑에 부착해 그때그때 열리는 행사를 안내한다. 사진 판넬은 이 포스터가 행사용 포맷으로 만들어졌다는 것을 보여준다.

52 밴드를 사용해 체계화하라

정보를 분리하는 명쾌한 방법 중 하나는 가로 계층 구조를 사용하는 것이다. 정보가 가로 밴드 안에 일목요연하게 정리될 수도 있고 내비게이션 시스템의 일부로 존재할 수도 있다. 그런 계층 구조는 모바일 기기와 메인 사이트에 모두 적용된다.

위, 105쪽: 가로 밴드가 뼈대를 제공하고 내비게이션 바는 상단 밴드에 있다. 내비게이션 바에서 선택을 하면 가로 방향으로 정리된 추가 정보가 계단식으로 배열된다.

작업명
유대인 온라인 박물관(Jewish Online Museum) 웹사이트

의뢰인
Jewish Online Museum

브랜딩/프런트 엔드 개발
Threaded

와이어프레이밍
Lushai

웹 개발
Ghost Street Reactive

뉴질랜드는 물론 전 세계를 통틀어 처음 만들어진 유대인 온라인 박물관 웹사이트는 다양한 방문객에게 호감이 가는 교육 자료가 되는 한편, 뭐니 뭐니 해도 뉴질랜드에 거주하는 유대인 공동체에게 기록 저장소의 역할을 하고 쉽게 접근할 수 있는 자료가 되도록 설계되었다.

코더의 중요성

프런트 엔드 디자이너는 대개 백 엔드 코딩을 하지 않는다. 이것이 아주 당연한 일 같지만, 의뢰인은 디자이너가 뭐든지 할 수 있다고 생각하는 경우가 많다. 훌륭한 코더를 찾기란 그리 쉬운 일이 아니다. 유대인 온라인 박물관 사이트의 경우, 디자이너와 와이어프레이밍 회사가 몇 차례 워크숍을 열어 머리를 맞댄 결과 유대인 온라인 박물관 사용자들의 니즈를 충족시킬 수 있는 동적 와이어프레임을 개발했다. 워크숍에서 사용자 인터랙션과 모바일 기기에 대한 반응형 변환도 협의되었다.

회상을 나타내기 위해 밴드를
잘라 다른 모양을 만드는
한이 있어도 모바일 기기는
웹사이트와 일관성을 유지한다.

수평적 계층 그리드

53 여백으로 수평 영역을 정의하라

텍스트 페이지에서 적당한 여백은 판면에 질서와 균형감을 부여한다. 여백을 더 넉넉하게 사용한다면 서론 성격의 제목과 텍스트를 더 설명적인 성격의 캡션이나 단계별 정보와 구분할 수 있다. 여백이 많은 페이지는 판면 전체의 내용이나 성격을 파악하기가 쉽다.

작업명
「暮しの手帖」

의뢰인
「暮しの手帖」

디자이너
Shuzo Hayashi,
Masaaki Kuroyanagi

이미지와 정보를 넉넉하게 배치하는 페이지에서는 수평적 계층 그리드에 따라 제목부의 범위를 정하고 나서 다음 요소들을 배치한다. 그 결과 질서 정연하고 차분한 판면이 독자로 하여금 정보를 쉽게 파악할 수 있게 해준다.

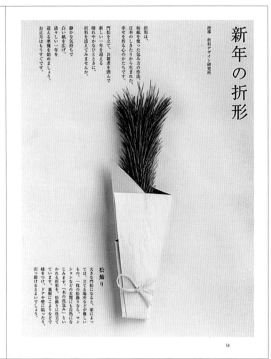

여백은 텍스트와 이미지의 조화를 이끌어내고, 각 구역에 배치된 정보의 성격을 드러낸다.

実際に和紙を折ってみましょう 4種類の作り方です

折形と日本のしきたり

折形は、室町時代に始まった、武家に伝わる礼法と伝えられます。折形をはじめとする日本のしきたりの数々は、本来の意味や由来は忘れられながらも、暮らしの中に生き続けた今に伝わったもの、と折形デザイン研究所の山口信博さんはおっしゃいます。

お正月にお雑煮をいただき、結婚のお祝いには水引をかけたご祝儀袋を贈る。生活の古典、と呼びたいような行事の一つひとつが、民俗学者の折口信夫は、「生活の古典」と呼びました。

「……私どもの生活は、いわばどこからとも思われる様式の、由来不明なる「為来り」によって、純粋にせられることがない。その多くは、家庭生活を優雅にし、しなやかな方を与える、門松を樹てた後の心持ちのやすらいを考えてみればわかる」

（折口信夫「古代生活の研究──祭りの発生」〈古代生活の研究〉──中公クラシックスより）

松飾り

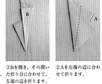

⑤ いったん開いて、同寸の赤い和紙を重ねて折り直します。菊寿を片輪結びにして、半紙を最初から重ねて折ってもいいでしょう。

④ Bを元に戻し、下端を裏側に折り上げます。菊寿を片輪結びにして、半紙を最初から重ねて折ってもいいでしょう。

③ Bを開き、その開いた折り目に合わせて、左端の辺を折ります。

② Aを左端の辺に合わせて折ります。

① 横紙を半紙の大きさに切って、左下の角を対角線で折り上げます。

年玉包み

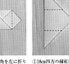

⑤ 出来上がりです。

④ 上の角の2枚の紙の開から三つ折りのお札を入れ、上の角を、下の角の2枚の紙の間に差し込みます。

③ 上の角を上に引き上げて、右辺を中央に合わせて折ります。

② 右端の角を左に折ります。

① 15cm四方の縁紅紙を対角線で折り、左辺を三等分して、上の角、下の角の順に折ります。

お正月は、しきたりが特に身近になる時期。まずは小さな折形から、日本の豊かな心を感じてみてはいかがでしょう。

贈り物を包むことは紙を選ぶときから始まっています。

折形には、和紙で出来た半紙を使います。和文具店などで手に入りますが、手漉きの和紙を使うと、やはり一味違うもの。今回、折形デザイン研究所の美濃和紙、「折形半紙」を使いました。半紙は多少サイズに幅があります。ここでは折形半紙の243×343㎜を目安にしています。今回の折形は、全て折形研究所のオリジナルです。

折形には、真・行・草の格があり、紙と包み方の組み合わせ、贈り物や相手に合わせて格が異なってきます。包み方も同じにしても、格の高い和紙、年玉包みに使用した縁紅紙、彩りに赤い縁が入った正方形の和紙です。松飾りと年玉包みの祝儀袋には、今回は民芸紙を使いました。赤い「におい」は、今回「にじみ」を使っています。

赤い、「におい」、他の赤い和紙でも赤い縁を施したが、片隅に赤い縁が入った折形半紙を使っています。絵の具で端に縁を描いてもいいでしょう。

屠蘇散包み

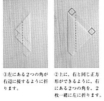

⑤ 赤い紙を、下の三角の上端から少し出る大きさに切って、差し込みます。

④ 上端の4枚の紙を2枚ずつに開いて屠蘇散を入れ、右の角を、下の角に合わせて差し込みます。

③ 下辺を左辺に合わせて折り上げます。

② 右下の角を上辺に合わせて折り返します。

① 横半分に切った半紙を、左辺を右辺に合わせて折り上げます。

箸包み

⑤ いったん開いて、同寸の赤い和紙を重ねて折り直します。赤い紙を最初から重ねて折ってもいいでしょう。

④ 下端を裏側に折り上げます。

③ 左にある2つの角が、右辺に接するように折ります。

② 上に、右と同じ正方形ができるように、右にある2つの角を、2枚一緒に左に折ります。

① 半紙を横半分に切って筒のように置き、左の辺を、右上の辺と平行に折ります。上に正方形ができる位置に折ります。

------ は手前に折る折り目、‥‥‥‥ は裏に折り返す折り目、——— は辺を示します。

62　63

잘 계획된 수평 구조로, 서론에 해당하는 텍스트의 영역을 확보했다.
판면을 가로지르는 이미지와 캡션을 따라 수평적인 흐름이 생기고,
설명부의 이미지와 캡션이 명확하고 읽기 쉽게 배치되었다.

54 연대표에 빛을 더하라

연대표를 단순히 기능적인 정보 요소로만 치부하지 말자.
연대표는 한 인물의 생애나 한 시대를 표현하는 것이다.
그러한 성격을 반영하는 연대표를 디자인하자.

작업명
영향력 지도

의뢰인
Marian Bantjes

디자이너, 일러스트레이터
Marian Bantjes

여기에 소개된 마리안 반티예스
(Marian Bantjes)의 영향력
지도에서 일러스트레이션과 예술
용어 계보는 수공예 솜씨와 세부
묘사가 압권이다. 그녀가
영향을 받은 사조와 흐름,
장식 등이 한자리에 명백하게
표현되었다. 반티예스는
지난 10년 동안 책 디자이너로서
뛰어난 타이포그래피 기술을
보여주고 있다.

이 작품의 서정적인 정서는 일러스트레이션의 곡선뿐만 아니라 괘선의 두께에서도 비롯된다.
자간을 조정한 작은 대문자들은 작품에 질감과 경쾌함을 부여한다. 아름다운 '&' 부호를 눈여겨보라.
이 작품은 섬세하게 정렬된 직선들과 곡선들이 서로 조화를 이루며 매혹적인 움직임을 나타낸다.

MARIAN BANTJES' INFLUENCES & ARTISTIC VOCABULARY AUGUST 2006

55 내비게이션 바를 깃발로 사용하라

항목을 구분하는 가장 강력한 방법 중 하나는 가용 공간을 그냥 나누는 것이다. 깔끔한 수평 바는 주요 정보로 시선을 끌어오는 깃발의 기능을 한다. 이에 더하여 화면 맨 위의

바에 색깔을 입혀 제목부와 나머지 정보를 분리하여 음각 대 양각, 밝은 색 대 어두운 색, 주요소 대 부차 요소와 같은 유쾌한 대립 관계를 만들어낼 수 있다.

작업명
www.mizzonk.com

의뢰인
Mizzonk Workshop

디자인
Punyapol "Noom" Kittayarak

캐나다의 브리티시컬럼비아 주
밴쿠버 지역에 있는 주문가구
제작업체의 웹사이트. 배경에
기울어진 희미한 선들을 넣어
업체의 성격을 표현했다.

수평적 계층 그리드를 사용한 홈페이지. 화면 맨 위에서 아래까지 한눈에 훑어볼 수 있다.

서브 화면에서도 사이트의 내비게이션
바가 견고한 수평 표지판으로 작동한다.

모든 요소의 크기나 배치를 같은 심도로
처리할 필요는 없다. 블록 이미지 아래에
텍스트를 가라앉힌 듯 배치하여 시적인
흐름을 창조했다.

56 명쾌함과 재미, 두 마리 토끼를 잡아라

이 라벨이 뜻하는 바에 관해서는 혼동의 여지가 없다. 모든 것이 두 언어와 두 가지 색으로 명쾌하게 표시되어 있고 알아야 할 모든 통계 수치가(0%까지!) 하나의 시스템으로 일목요연하게 디자인되어 있다. 그리드를 명료하게 사용하면 가벼운 마음으로 즐길 수 있다(그리고 사용자들이 길을 잃는 것을 막을 수 있다).

참조할 페이지
100–101

작업명
프리담(Free Damm) 무알콜
맥주의 아이덴티티와 패키징

의뢰인
Cervezas Damm, Barcelona

디자인
Mario Eskenazi Studio

디자이너
Mario Eskenazi,
Marc Ferrer Vives

공간을 정리해주는 괘선과 대단히
자유로운 사고방식으로 디자인한
기분 좋은 패키지다.

CERVEZA SIN ALCOHOL

FREE DAMM

Proceso de elaboración: Hacemos FREEDAMM con los mismos ingredientes que utilizamos para elaborar una cerveza con alcohol, añadiendo la levadura y dejando que la fermentación produzca alcohol de manera natural. Después, con una avanzada técnica que denominamos destilación al vacío, eliminamos el alcohol hasta llegar a obtener un producto 0,0% alc./vol. KA04412

En la desalcoholización se pierden algunos de los componentes aromáticos que definen el sabor y el aroma de la cerveza. A través de un exclusivo proceso, conseguimos recuperar estos componentes aromáticos e incorporarlos de nuevo, obteniendo como resultado un mejor producto.

0,0 % ALC. VOL

NON-ALCOHOLIC LAGER BEER

LÚPULOS SELECCIONADOS | **MALTA** de variedades puras

DAMM 1876

112쪽: 이 라벨은 병이 아니어도
포스터로 충분히 활용할 수 있다.
프레스 시트(위)는 그 자체로
모듈 그리드가 된다. 라벨에
두 가지 색밖에 사용하지
않았지만, 활자의 크기, 서체,
흰색 드롭아웃 활자 덕분에
강력한 힘과 호소력이 느껴진다.

패키지에서 아이덴티티가
디자인적 요소와 기능적 요소로
모두 효과를 발휘하고 있다.
프리미엄급 브랜딩이다.

57 뒤집어라

타이포그래피는 가로축과 세로축을 따라 동시에 배치할 수도 있다. 세로로 배치한 큰 활자 자체가 작은 정보를 담아내는 틀이 되기도 한다. 각각의 이름은 자간과 활자 크기, 장평, 두께를 섬세히 조절하여 전체 형태에 맞추면 된다.

작업명
「시라노 드 베르주라크(Cyrano de Bergerac)」 공연 광고

의뢰인
Susan Bristow, Lead Producer

디자인
SpotCo

크리에이티브 디렉터
Gail Anderson

디자이너
Frank Gargiulo

일러스트레이터
Edel Rodriguez

이 광고는 공연 제목 중에 가장 중요한 부분인 'CYRANO'라는 이름만 강조하고 비교적 덜 중요한 나머지 부분은 작은 활자로 처리했다.

단순한 구조와 제한된 색만으로도 얼마든지 동적인 화면을 창조할 수 있음을 보여준다. 시선을 사로잡는 볼드체 타이포그래피로 화면 가운데에 텍스트 단을 만들어냈다. 공연 배우들의 이름과 시라노 드 베르주라크의 옆모습을 표현한 일러스트레이션, 그리고 누구도 부정할 수 없을 만큼 아름다운 타이포그래피를 조화롭게 사용했다.

10 WEEKS ONLY

CYRANO
DE BERGERAC

KEVIN KLINE

JENNIFER GARNER

DANIEL SUNJATA

BY EDMOND ROSTAND

Translated and adapted by
ANTHONY BURGESS

Directed by DAVID LEVEAUX

ILLUSTRATION BY GREL RODRIGUEZ

58 완전하게 유지하라

그리드에 사용하려고 그리드 위에 디자인한 서체는 본래
신선하고 완전할 것이다. 그렇지만 글자꼴들의 곡선으로
재미난 시도도 할 수 있고 그 밖에 다른 용도도 많을
것이다.

작업명
세르베사스 빅토리아(Cervezas
Victoria) 타이포그래피

의뢰인
Cervezas Victoria (Damm)

디자인
Mario Eskenazi Studio

디자이너
Mario Eskenazi,
Dani Rubio,
Marc Ferrer Vives

이 알파벳은 2017~2018년에
스페인 말라가의 빅토리아
맥주회사 창립 90주년 기념
전시회를 위해 도자기 타일에
넣을 목적으로 디자인하였으며
그 후 판촉물과 광고 캠페인에도
사용하고 있다.

빅토리아 맥주를 위한 이
알파벳은 창립 90주년을
기념하는 것이자 20년 동안
외지에 나가 있다가 스페인
말라가로 돌아온 맥주회사의
귀향을 축하하는 의미도 있다.
'Malaguena y exquisita'는
'말라가의 맛 좋은 (맥주)'라는
뜻이다.

MALAGUEÑA
Y EXQUISITA

MAL
AGA

59 그리드를 연주하라

재즈의 리듬을 타이포그래피에 적용해보자. 면밀히 계산된 빽빽한 그리드라 해도 얼마든지 타이포그래피로 즉흥 연주를 할 수 있다. 활자의 장평, 두께, 위치 등을 바꿔보는 것이다. 다음 단계에서는 여기서 한 발 더 나아가 타이포그래피의 회전을 시도해보자.

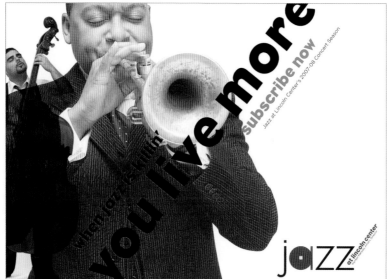

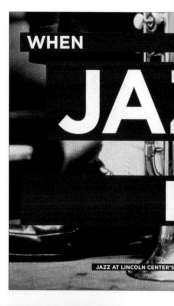

산세리프체의 작은 활자와 큰 활자가 빚어내는 강약 대비가 정보를 더욱 리듬 있게 표현한다. 활자를 기울이고, 2중으로 겹쳐 인쇄한 이미지를 곁들이자 화면에 재즈 리듬이 넘친다.

작업명
광고 및 프로모션

의뢰인
Jazz at Lincoln Center

디자인
JALC Design Department

디자이너
Bobby C. Martin Jr.

링컨 재즈 센터(Jazz at Lincoln Center)는 유래하고 노련하며 에너지가 넘치는 공간이다. 이곳의 디자인은 깔끔하고 정교하면서도 재즈다운 유쾌함이 넘친다.

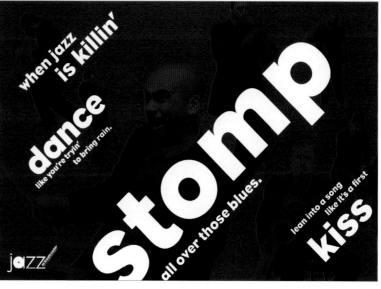

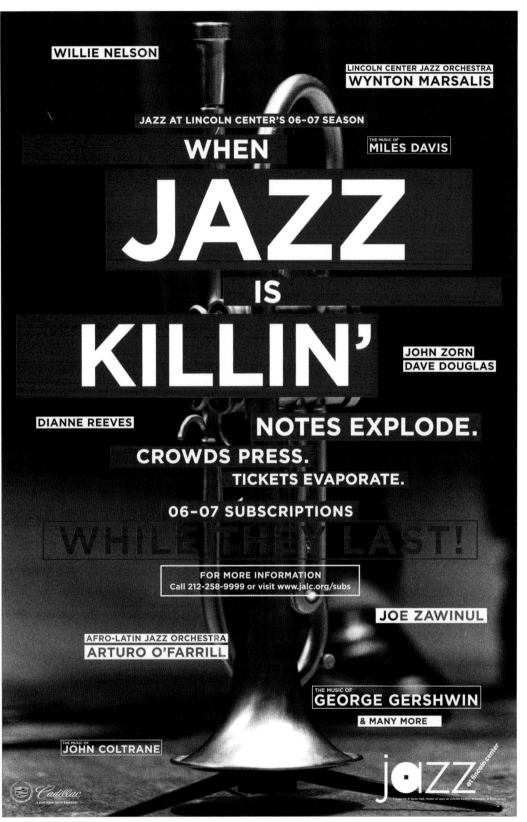

흰색 활자를 담은 다양한 크기와
심도의 박스가 각 화면에
어울리도록 적절히 크로핑한
사진과 함께 날렵하고
리드미컬한 대비 효과를 낸다.

활자와 그리드

60 다른 시각을 가져라

그리드를 포기함으로써 성공하는 그리드가 있다. 활자 크기와 형태, 두께 등을 이용하여 지역 문화 혹은 지구촌 문화를 표현해보자. 독자의 마음을 움직여 지금 당장 행동하게 하는 디자인을 창조하는 것이다.

작업명
기후 보호 동맹(Alliance for Climate Protection)의 광고

의뢰인
WeCanDoSolveIt.org

디자인
The Martin Agency; Collins

디자이너
The Martin Agency: Mike Hughes, Sean Riley, Raymond McKinney, Ty Harper
Collins: Brian Collins, John Moon, Michael Pangilinan

환경 보호를 촉구하는 이 광고는 볼드체 타이포그래피를 활용하여 독특한 디자인을 창출했다.

사용한 문구와 활자 크기는 각 지역에 관한 통계에 근거한 것인 듯하다 (아닐 수도 있다). 큰 활자는 보는 이의 주목을 끌고, 작고 얇은 활자는 큰 활자 사이를 메우는 역할을 한다. 밝은 연두색은 기후 보호를 촉구하는 광고의 의도를 가장 잘 나타내는 완벽한 색이다.

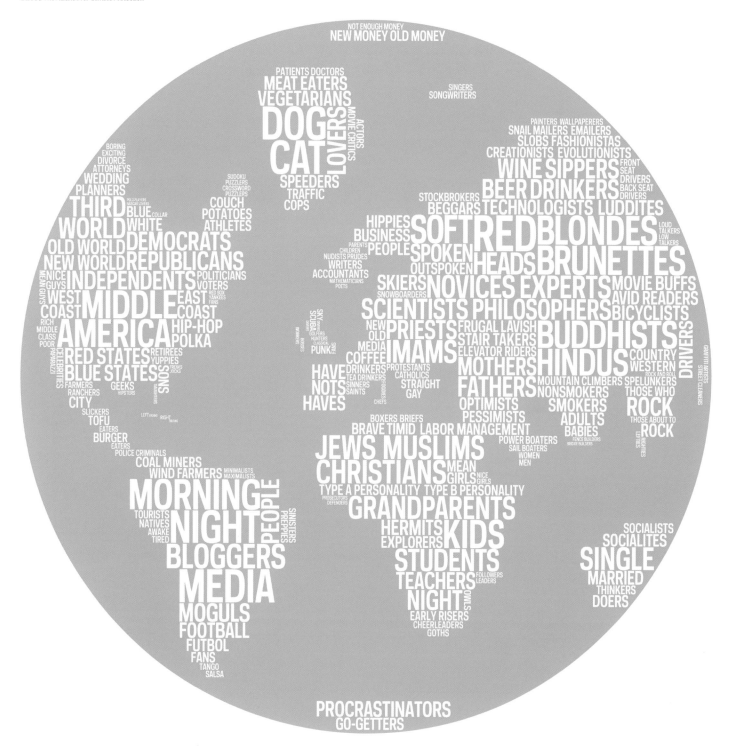

61 좁은 마진을 효과적으로 사용하라

그리드를 면밀히 기획하기만 한다면 마진이 좁아도 문제가 없다. 이미지를 그리드 라인에 정확하게 맞춰 배치하고 여백과 타이포그래피를 섬세하게 조율하면 바깥의 좁은 마진은 그 자체로 견고한 판면을 구성하는 요소가 되는 것이다. 정교하고 질서 있는 판면에서는 좁은 마진이 더욱 돋보이며, 그 결과 매우 절제되어 있으면서도 특색 있는 레이아웃이 탄생한다.

초급자는 마진 설정 단계에서 실수를 저지르기가 쉽다. 그러나 마진은 초보자에게나 노련한 전문가에게나 똑같이 골칫거리다. 그리드를 설정하고 적지 않은 변수를 고려하는 작업에는 균형 감각과 기술이 필요하므로 누구나 시행착오를 겪게 된다. 전통적인 오프셋 인쇄 방식을 사용하는 출판물 작업자들은 좁은 마진을 꺼린다. 바깥 마진이 좁으면 종이가 빠른 속도로 인쇄기를 통과하는 과정에서 발생하는 작은 흔들림에도 영향을 받을 수 있기 때문이다. 그래서 출판물 디자인에서는 바깥 마진을 넉넉히 설정하는 경향이 있다.

모든 요소를 흠 없이 배치한 균형 잡힌 판면으로 그리드의 유연성이 돋보인다. 모든 요소를 정확하게 정렬했으면서도 큰 활자를 사용해 역동적인 느낌을 주었다. 페이지 안쪽의 널찍한 여백과 바깥쪽의 좁은 마진이 대비를 이룬다. 활자의 두께와 크기, 서체, 색상을 다양하게 설정한 타이포그래피가 안정적이고 조화롭디.

작업명
「*étapes*」

의뢰인
Pyramyd/「*étapes*」

디자인
Anna Tunick

프랑스에서 발행되는 디자인 잡지 「에타프(*étapes*)」는 마진이 좁아서 가능한 한 많은 정보를 담을 수 있는 간결한 그리드를 사용한다. 질서 정연함이 돋보이는 그리드다.

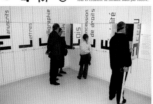

j'ai vu le moment où
l'on allait inaugurer
le bâtiment sans mon
travail. POURQUOI? Parce
que l'on ne parvenait
pas à s'accorder sur sa
dénomination exacte:
"sculpture typogra-
phique" ou "enseigne"?

62 요점을 강조하는 장치를 사용하라

상세 정보가 많고 정보의 성격이 다양하면서 복잡한 경우가 있다. 한정된 공간에 많은 내용을 담아야 한다면, 중요한 내용을 강조하는 장치들을 활용하자. 예를 들면, 제목을 독립된 공간에 담는다거나 컬러 사이드바(색 분류를 적용할 수도 있다), 약물을 붙인 목록, 특정 항목을 강조하는 아이콘을 사용하거나 제목부와 핵심 내용에 색을 설정하는 식이다.

작업명
행사용 자료

의뢰인
Earth Institute at
Columbia University

크리에이티브 디렉터
Mark Inglis

디자이너
Sunghee Kim

이 복잡하고 상세한 교육 자료는 각 부분과 단락이 어떤 내용을 다루고 있는지 알려주기 위해 전체적으로 일정한 아이콘과 색상 체계를 사용했다. 아이콘, 표제, 제목, 텍스트, 이미지, 그래프 등 다양한 시각 장치를 이용하여 다양한 내용을 조화롭게 배치함으로써 보는 이가 정보를 쉽게 파악할 수 있도록 했다. 동시에 여백, 질감, 색상, 구조, 흰 바탕과 짙은 색의 대비, 가독성 높은 타이포그래피 등 디자인 요소들을 최대한 효과적으로 사용했다. 교육적인 정보를 전달하는 데 다양한 장치를 사용하였지만 전체적인 구조가 매우 간결한 까닭에 사용자는 어렵지 않게 정보를 받아들이고 공감하게 된다.

사용한 아이콘의 전체 체계가 각 판면의 맨 위에 나타나 있다. 내용과 관련 있는 아이콘을 흰색으로 밝게 표시하여 강조했고, 각 단락 앞에도 해당 아이콘을 표지판처럼 배치했다.

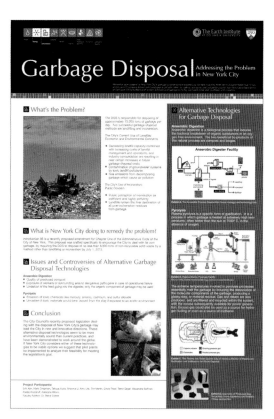

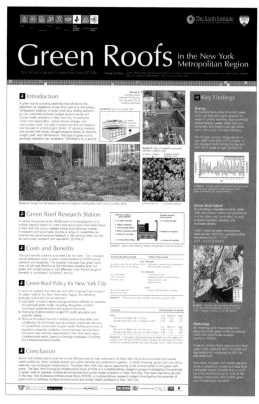

모든 지면에는 검은색 밴드에
제목을 배치한 통합적인 디자인
포맷을 적용하였다. 그 밖에도
검은색 밴드에 아이콘 체계,
컬럼비아 대학의 로고, 대학
산하 지구연구소의 로고, 제목과
부제목을 적절히 배치했다.

검은색 밴드 아래의 각 구역은
아이콘에 이어 지정된 색깔과
서체로 표제, 텍스트를 배치했다.

명확한 타이포그래피다. 약물로
정보를 나눈 부분도 있다. 각
지면은 연구 과목별로 나뉘는데,
특히 매 결론부를 해당 과목의
지정색으로 강조했다.

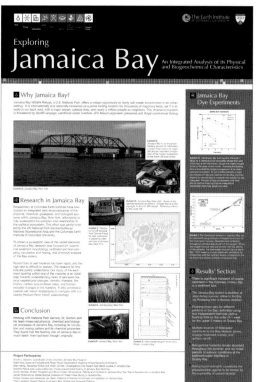

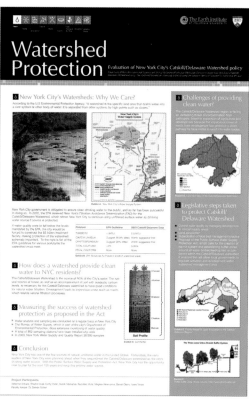

마찬가지로 해당 과목의
지정색으로 처리한 사이드바에는
'실험 및 연구(Experiments and
Research)' 같은 특정 정보를
담았다.

63 숨 쉴 틈을 주어라

어마어마한 양의 기사, 이미지, 도표, 만화, 통계 수치와
온갖 호언장담과 횡설수설을 어떻게 처리해야 할까?
먼저 전체적으로 느슨한 구조 속에 몰아넣은 다음 쪼개라.

127쪽: 신문 창간인과 디자인
담당자에 따르면 도시인들에게
혼잡한 도시 생활을 실감나게
전달하려는 대판(broadsheet)
신문이라 그리드를 사용하지
않는다고 한다. 하지만
디자이너들이 그리드 시스템을
정확히 이해하고 사용하고 있음이
분명하다.

작업명
「Civilization」

의뢰인
Richard Turley

편집자/디자이너/작가
Richard Turley,
Lucas Mascatello,
Mia Kerin,
기타 기고자들

미국 뉴욕 주 뉴욕 시의 일상을
보도하고 해설하는 개인 출판
신문. 대도시의 모습만큼이나
복잡한 단상과 사실과 흥밋거리가
빽빽하게 실려 있다. 2018년에
처음 신문을 발행하기 시작한
창간인은 디지털에 매몰된 세상에
뉴스를 전달하는 수단으로
빅토리아 시대의 기술을
선택했다.

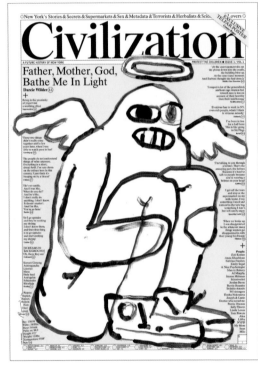

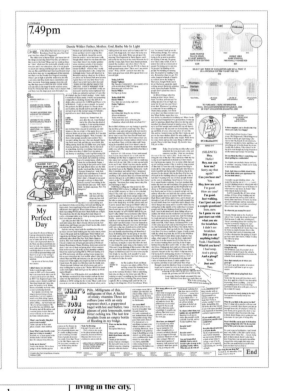

실물 크기로 자세히 보이는
것처럼 스위스 시스템과 시가
만났다.

Darcie Wilder

Cover story: We used to pass this park all the time on the bus, Dead Dog Park. There was a sign and everything. They were trying to up the number of Manhattan parks so they walked looking for squares of grass that could technically be parks. They ran out of names by the time they got to 168th and saw a dead dog and now it's Dead Dog Park, there's a sign and everything.

Father, Mother, God, Bathe Me In Light

○ 2018
HELL'S KITCHEN
1PM
15 NOTIFICATIONS

So I wake up in bed underneath a 25 pound weighted blanket but I just wanted the heaviest thing to put me out and the first thing I touch and look at is this blazing screen, and my eyes are still opening and they're making shapes adjusting to the light, I'm scrolling and looking for my dog and just scrolling and putting on the same podcasts as every morning before and trying to go back to sleep and failing. And then I'm using the new body wash that smells like pears and it's still so cold out, and I just found out my shower curtain was in the wrong place, years of making daily puddles on the floor, except who showers daily, more of a weekly puddle. I just got a new toothbrush that zaps me every thirty seconds, all I do it make it touch my teeth, moving around to a different tooth. My teeth were so soft they were stinging when I brushed, a shooting pain up my gums. I'm trying to figure out what. I'm trying to. Every morning I can't fall back asleep but can't stay awake doing the things I want to do.

It's not that it's especially bad but that it just keeps never getting better, and I wake up around 1pm today so the kids at the high school next door are on their way home. Two recognizable character actors are talking on a bench. I'm throwing a tennis ball with a chihuahua mix and some puppy named Lemon comes up trying to steal it and does for a second. It's the kind of weather that could be fall but is March and taking it's time and even when it finally gets good enough to walk it'll be too hot, too much, too heavy, and I'll be wearing sleeves even when I shouldn't.

App goes off PUSH notification - assault 5 blocks away. Last night, suspicious package. Tonight a car'll jump the curb and a manhole a few miles away will blow off, like I used to imagine happening when I stood on Trump Avenue in the East River, I was a few blocks away. Repeated footage over and over, New York 1 in doctor's office, this is footage of people dying. This is the last moments of five peoples' lives.

Taking her off-leash even though she could die. But everyone, all the time. Aren't we all just trying to keep ourselves alive? It's crazy, they should teach kids about aneurysms earlier. But she's too scared of the curb, too scared of cars, too scared of the brushing whizzing noises to ever go near. Sometimes I worry she'll start chasing a rat, kill a rat with her bare paws and I'll have her, covered in blood, to clean up. My friend's dog killed a rat before they had time to stop her. Rats on 43rd run next to the parking lot

bricks, behind the trees, burrowing deep. I used to sit on the wooden benches with Chiquita till my neighbor Kathy told me. Also the homeless sit there sometimes and you never know about bedbugs. My stomach itches. Peeling, flaking.

Why do croissants always stain the bag? So many greasy patches and they just soak through and I ate a croissant every day, I don't even like them. I guess I crave them when I go without but those bagels from the carts, you know they're either stale or not boiled, they're just straight up bread cut in a circle, they've got to be. Once I saw a delivery guy wipe out, spill all of them on Amsterdam Ave, scattered. Straight up on the pavement. Cart guy picked them up, dusted them maybe a little bit, sold them all day. Like when this girl in high school bought cart coffee, milk and sugar - I only did sugar then, and now I do nothing - and it started splitting out the seams of the cup. In her hand, driblets and then you know it was just all going to pour out. So then the guy's like, doing that hand motion like c'mere, come on, and he takes it from her and says like, they had gotten wet and he let them dry and tried to use them. Soggy cups.

A few weeks ago the G wasn't running and I was stranded at that PS 1 station. I ended up walking over that bridge to Greenpoint thinking I was going to be late because I was the only one that had to deal with it and I walked into the room and no one was there. It was one of those moments where the sun was setting, sky was some color maybe pink or even red, the water was making it colder and I was listening to that Jimmy Eat World song that sounds like a stomach ache when you're on the subway home with too much energy and not enough, and you're just turning everything, everything is about to bloom, it's a fade out that just fades into something else, I was the only one on the bridge taking a video and we were all going against the wind from the exhaust of the cars.

Coco comes when I call and I force the slimy tennis ball out her mouth. She's stripped it bald, tearing out neon green fuzz. I gnawed my teeth down to bits over the years and now they fit like puzzle pieces. This week I couldn't find her peperwork and had one of those spiraling meltdowns, started praying to anyone or no one or something or whatever, and then thought that I had to convince myself I'd never find it because you only get what you want when you don't want it anymore. Found it in a pile of loose papers in the closet.

○ 4PM
TIMES SQUARE

I walk on 42nd by my old office, the corporate office in a huge tower I used to walk there every morning during the Polar Vortex. When I was only wearing skirts and the same torn tights every day, and had to buy new tights

and change before any of the bosses saw me. The wind would whip against my legs and my thighs got this stinging feeling, I wore Doc Marten dress shoes that gave me blisters and read the internet all day. Sometimes I had busy days, making coffee, ordering from Staples, time sheets. I remember phases by the lunches, brief stint doing halal but then the weeks I only craved guacamole, mushrooms, chicken strips, I would order Lenny's egg wraps and dunk them in a tiny tub of Tabasco hot sauce just to feel anything, just so bored and craving anything, and the salt would rush into my, my eyes watered, and my tongue hung out of my mouth I used to drink as much water as I could as fast as possible, Poland Spring after Poland Spring, out of boredom. Then I'd google "water poisoning."

She came from LA, surrendered 10/26/2016, up for adoption for nine months until I found her. The time I spent in LA is a blur, I can't remember if I worked in retail for 3 weeks, 6 weeks, or 3 months. They checked my bag going in and out so I left it in my car and had to pay $20 for a parking spot. Parked next to a matte'd out black sedan and dissociated after work circling the aisles of Target till I drove home.

They tore down the gas station on 44th and now it's a pit. Nearly empty, construction equipment moves around piles of dirt and drills in the middle of the day when I'm checking DMs. It says "Seen." But he hasn't written back and the real read receipts don't have periods but should, to imply that it's the end of the conversation. When did we stop using periods? I don't. The drill goes on and on so I got the blackout curtains and wake up in the single digit afternoon hours, after I wake up around 5 or 6 and look at my phone to avoid evil spirits. A ghost can't get you if you're looking at a screen, so I spent hours and hours staring at my phone in my bedroom, which used to be grandma's bedroom, where I cried and wept next to her bed when they said I should say goodbye to her for the last time. She laid there, and dead bodies look different in every stage, from dying to dead to been dead to on display.

So I light a lot of sage and whisper to myself and say the same non-denominational prayer my uncle told me when I was sleeping on the floor in LA, too scared to sleep in my own room alone, I closed my eyes and a thing, I don't know, something, gripped my throat and cut off my breath and I couldn't speak, couldn't breathe, couldn't, and so now I reflexively repeat "Father Mother God Bathe Me In Light" and ignored the God part for years, and forgot I was saying it for brief stretches of time, the times when I was doing molly on weeknights and coming down when the sun was coming up and sitting in a rocking chair waiting while they met the guy and got more, doing more and

feeling dead or dying and scared of all of it suddenly. I forgot the words but they came back, and now when I close my eyes to say FUCK I accidentally find myself in the single digit afternoon and over like a lotion that absorbed all it can and now it's just swimming on top of pores, it's just too much, like everything I want is always over the surface trying to get in but there's no room, there's no space, we're all just waiting for it to combine, to infuse, to germinate and it never does anything but slick the surface.

○ 2017
9AM
MARCH, APRIL,
MAY, JUNE

It takes me awhile to get out of bed and I finally make coffee, Cafe Bustelo, from the grinds too small, too many of them, and the french press mesh, pushing down the plunger it always flies up, it splashes every day but today burns my fingers, grazes my hand and the counter is filled with puddles of grime and grinds that stay there for weeks, maybe just short of a month, because I feel guilty buying paper towels but it's more that I feel better avoiding tasks, evading errands.

I'm trying to come up with a way where I do what I need. I walk down the West Side Highway, I miss when it was April and May and June, the exhaust would mix with the humidity for something so unpleasant and rank but in that way where you destroy something, you keep on flossing too hard and keep touching a cut, you keep stinging yourself. Walk all the way down listening to headphones so much the soles of your foot hitting the pavement reverb up, bouncing up into your ears against the headphones. Taking selfies on West Street, whatever it's called. Walk until you reach the cobblestones. Up until a certain point and on weekends it's so crowded and I can't leave my house. In high school I rode my bike down Sixth Ave on the fourth of July listening to the cracks of fireworks and avoiding it all, street so clear. Bike rides every month, Critical Mass, used to bike up the highway outnumbering the cars. I gave up when there were too many white bikes, ghost bikes, memorials of hits and dead people. I got hit once or twice.

Remember that guy I got in the cyber fight with? The twitter feud shit thing a few weeks ago? He was biking in Central Park and his handlebars shook, apparently, and he wiped out lost control and his face slid across the pavement.

This was this time right before I kept stealing stuff - but only from Whole Foods and Barnes and Noble - where, for a whole year, I wore these fake glasses. And I never talk about it but a whole year, and no one ever said anything when I stopped wearing them except Carla, but they were $8 glasses from St. Marks.

I like the hot when the diner booths stick to the backs of your thighs and it hurts to move. It stings to stand up. Sometimes they don't even have AC, or maybe they all got AC now. Last time I was at Waverly Diner they guy flashed a blade, maybe just a scissor but still a metal edge, between his cotton glove and the glass window, maybe it's plastic? Flashed a blade while we ate omelets and we told the waitress and she said, "What do you want me to do about it?" He crossed the street, approaching the NYPD van, seemed like he was trying to get arrested. The van revved up, engine on, and pulled out into traffic, ignoring him. And I thought I knew rejection.

We used to come here in the mornings before we both got fired. I asked Dad to tell me about the scar again. Leaving Waverly Diner, where I cried in front of Steve that time in 2010. He tells me about Stuytown again, growing up on 15th and 1st, and climbing the metal fence in the 60s. A group of adults watched him throw himself over and catch his skin on the spike, sliced open, huge scar running down. He tells me about the crying girl in the amputation ward, who just lost her arm. I've never heard this part of the story but each time I find something else new out it's like, yeah.

○ 2014
MALT LIQUOR,
COCAINE,
RED WINE

I started to worry about myself when the grocery store employee, the guy stocking the milk, asked if I was OK. I thought I could just keep circling, no phone service just listening to music, and that no one would bother me but sometimes it's like, the city buffer gives out, it wears down like a rubber sneaker sole, and I end up touching the floor, the cement ground, the bottom, end up having a conversation with someone.

stood in his doorway and maybe, looking back ten years, I should've left? Was that a social cue? It's like, weird with social cues because I have enough of my own brain telling me I'm a piece of shit and that I should just go, that like, I'm fighting that enough that I think normal things are social cues to leave and then I end up missing the real social cues because I'm talking myself down from the imagined stuff, you know?

○ 2014
IPHONE 5
RED WINE,
WHISKEY,
VODKA, WEED

There was that cat, on my way home when I was in Sunset Park, the year before my bag was locked up. When I was on my way home I saw a orange cat, infested and dirty, these huge black splotches of grime, and I kept petting it, talking to it, calling it a rat. My little orange rat. I thought it'd bite me eventually and I didn't want to deal with the paperwork so I kept walking. An hour and a half before on a yellow line train but no one calls them that but that's what they call the orange line. On the way home a guy told me, he was like, 40s maybe? That I should be a teacher. That I'm a "nice girl." It was the same subway station where I called that ambulance the last day of high school. She was nodding out on a bench, poisoned, and the cop asked her why her birth year was scratched out. I ended up going to Methodist and getting an IV and then took a $60 cab ride home. The air is different at the top

⟶ CONT. PAGE 16

○ 2007
ALEX
QUEENS

There was that time ___, ran out of the bookstore because I casually mentioned I made out with Alex - who I think moved to Portland and had a kid? And writes books on anarchist theory? He was living in Queens and no one else was really there, and his Greek landlady would give him liquor and he just

3.2

HERE:
11:19AM, CLOUDY
COULDN'T GET UP
DAY RATE
WELCOME TO ASANA

YOU HAVE 2 TASKS
DUE: 2 INFOGRAPHIC...
AND NEW LAYOUT *: ...
- ____ CREATIVE

YOU HAVE 2 TASKS
DUE: 2 INFOGRAPHICS...
AND NEW LAYOUT *: ...
- ____ CREATIVE

YOU HAVE AN OVERDUE
TASK: 2 INFOGRAPHICS
- NOT YET STARTED -
____ CREATIVE

REMINDER: ____
____ INVITED YOU TO
JOIN ____ CREATIVE

SPECIAL PROJECT: ____

SPECIAL PROJECT:
BRAND CUE]

ASSIGNED TO YOU: DE-
SIGN: ____ [SPE-
CIAL PROJECT: ____]

DESIGN: ____
____ ____ [SPE-
CIAL PROJECT: ____]

ASSIGNED TO YOU: DE-
SIGN: ____ [SPECIAL
PROJECT: ____]

YOU HAVE AN OVERDUE
TASK: DESIGN: ____
- BUFFY CREATIVE

WELCOME TO ASANA

REVIEW DECK AND MAKE
NOTES [# ____ FACE]

ASSIGNED TO YOU:
CHECK OUT THE ____

HOLD: ____ CARD
ON ____ PAPER [. ...
____ CREATIVE

YOU HAVE A TASK DUE
TODAY: CHECK OUT THE
____ CREATIVE

SET LAUNCH DATE
[# ____ ____]

YOU HAVE AN OVERDUE
TASK: CHECK OUT THE
STICKERS? - ____
CREATIVE

YOU HAVE AN OVERDUE
TASK: CHECK OUT THE
STICKERS? - ____
CREATIVE

BRIEF SIDE PROJECT ON
COMMERCIAL SCRIPT
[SPECIAL PROJECT: ...
____ ____]

UNBOXING UPDATE
[. ____ BRAND CUE]

OUTLINE DECK: PRODUCT
FOCUS CONTENT [. ...
BRAND CUE]

YOU HAVE AN OVERDUE
TASK: CHECK OUT THE
STICKERS? - ____
CREATIVE

BRAINSTORM ALTERNA-
TIVES TO THE ____
[SPECIAL PROJECT: ...
____ ____]

YOU HAVE AN OVERDUE
TASK: CHECK OUT THE
STICKERS? - ____
CREATIVE

IDEAS FOR ____
VIDEO? [SPECIAL PROJ-
ECT: ____ ____]

[CONT 16.2]

CLOSE YOUR EYES. THINK ABOUT HOME. DESCRIBE WHAT YOU SEE

"The living room of my mom and step dad's apartment on 91st Street. Oriental rug from my great grandpa, kitschy drippy orange and green glass vases from the 60s, a colossal plant that holds the spirit of my step dad's late mother Evelyn, heavy wrought iron coffee table my parents had made from a bank grate in Philadelphia when they were still in their 20s. Squeaking and squawking cars and sirens from Amsterdam Avenue, coming in from the street."

How many pillows do you sleep on?
Two.

Are you a thief?
Unfortunately I am no longer a thief, at least as far as physical objects are concerned. As a teen I was a consistent, if not terribly ambitious, shoplifter - bent on amassing the sum total of makeup available at a constellation of local CVS's and Duane Reades. I got caught taking a straightening iron (particularly unnecessary, because I have straight hair) one afternoon when I was fourteen.

I remember planning the heist during English class that afternoon. The manager told me she would call my mother, and I looked withering... "my mother is dead!" Then, once they threatened to call my school (something I found humiliating beyond measure),

I recanted and revealed my mother was still alive. Once she arrived to pick me up they told her I'd said she was dead, which she said she thought was pretty ingenious, given the circumstances. I was in huge trouble.

For years later I limited my shoplifting to the costume jewelry at Top Shop - it was kind of my stealing methadone. Eventually I gave that up, too.

To whom are you indebted?
Literally all of my friends (spiritually, not financially).

Changing the names to protect the guilty, what's the worst thing anyone's ever done to you?
Besides a couple gnarly heartbreaks and more-or-less typical divorced-family trauma - the worst things have been creative or collaborative betrayals...like when former collaborators had gone behind my back to talk trash or change an artwork, or bosses made announcements about me to large groups without talking to me first. I'm a Scorpio, obsessed with my work and horrified by loyalty transgressions!

Favorite soup?
Vichyssoise

Favorite scent?
Hinoki; Musty Basements

How do you deal with guilt?
I FaceTime my best friends Alexa and Rachel repeatedly until one of them tells me it's all right, or I write about it, or I psychically bury it!

If you could relive one moment in your life what would it be?
Toss up between a particular lecture and a particular fuck - both experiences of "flow" (blech)

Where do you sit on the many-worlds interpretation of quantum mechanics and the probability of infinite variants of every single moment in time?
Staunchly "pro"

Starsign?
Scorpio, Aries Rising, Leo Moon (<-Profoundly 'unchill' combination)

How long do you sleep for?
Eight hours. Sleep is the greatest determining factor in my sometimes disturbingly volatile mood landscape.

Tell me about the last time someone held your hand?
My long lost friend Elizabeth, dragging me through the streets of Hollywood to pluck an orange off the tree in someone's backyard!

Have you got your dues?
Not even close ○

— EMILY SEGAL IS A STRATEGIST & FOUNDER OF K-HOLE/NEMESIS

CONTAMINANTS DETECTED IN NEW YORK CITY DRINKING WATER

For the latest quarter assessed by the US Environmental Protection Agency (July 2017 - September 2017)

CONTAMINANTS DETECTED ABOVE HEALTH GUIDELINES:

- BROMODICHLOROMETHANE
 Cancer forming
- CHLOROFORM
 Cancer forming
- CHROMIUM (HEXAVALENT)
 Cancer forming
- DICHLOROACETIC ACID
 Cancer forming
- TOTAL TRIHALOMETHANES (TTHMS)
 Cancer forming
- TRICHLOROACETIC ACID
 Cancer forming
- OTHER DETECECTED CONTAMINANTS
 - Chlorate
 - Chromium (total)
 - Haloacetic acids (HAA5)
 - Monochloroacetic acid
 - Nitrate
 - Nitrate and nitrite
 - Strontium

From October 2014 to September 2017 this water utility was in VIOLATION of health-based drinking water standards

Source: ewg.org

SNEAKERS SEEN AT HOME DEPOT IN BED STUY.

NIKE	AIR JORDAN 1	RED/BLACK
ROCHE	RUN	RED
NEW BALANCE		BLACK
NIKE	AIRMAX 180	WHITE
REDBOX	CLASSICS	WHITE
NEW BALANCE	(UNKNOWN)	GREY
ADIDAS	(UNKNOWN)	ORANGE
REEBOK'S	(UNKNOWN)	BLACK
NEW BALANCE	(UNKNOWN)	BLACK
CONVERSE	HI	ORANGE
NIKE	PEGASUS	GREY
SAUCONY	(UNKNOWN)	GREY
NIKE	AIR MAX LOW	BLACK
PUMA HI	(UNKNOWN)	BLUE
NIKE	HUARACHE	ORANGE
CHAMPION	(UNKNOWN)	BLACK

BUSKER
WEST 4TH SUBWAY
SAT, MARCH 17, 2018
11.45PM

I'll tell y'all, first of all, you guys is looking all sad. You guys don't know what sad is. You can't have the half. I'm more than sad, **I'm dismayed**. Have a wonderful night y'all, this song is for us.

[inaudible 00:00:21]

This happened to me the other day too, exactly what happened to me.

[inaudible 00:00:27] do you
[inaudible 00:00:31]

[inaudible 00:00:32] especially with [inaudible 00:00:34]

(singing)

@CivilizationNYC

MOSTLY BELOW 59TH,
USUALLY ABOVE DELANCEY
WEAR US (16)

MY NEW YORK

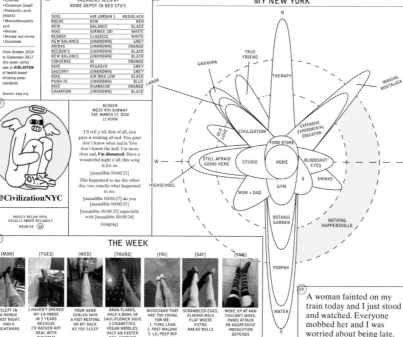

N

TRUE FRIEND

GRANDPA

THERAPY

WANING NOSTALGIA

OLD LOVE

CIVILIZATION

EXPENSIVE EXPERIMENTAL EDUCATION

W

STILL AFRAID GOING HERE

STUDIO

FOOD STORE

HOME

BLOODSHOT EYES

E

HIGHSCHOOL

GYM

$

DRINKS

MOM + DAD

BOTANIC GARDEN

NOTHING HAPPENSVILLE

LABOR

POOPAH

WATER

S

THE WEEK

[MON]	[TUES]	[WED]	[THURS]	[FRI]	[SAT]	[SUN]
SLEPT IN A HOODIE LAST NIGHT. HAD A NIGHTMARE.	I HAVEN'T OPENED MY I-D INBOX IN 3 YEARS BECAUSE I'D RATHER NOT DEAL WITH THE SPAM	YOUR HAND CURLED INTO A FIST RESTING ON MY BACK AS YOU SLEEP	BRAN FLAKES, HALF A BOWL OF CAULIFLOWER SOUP, 2 CIGARETTES, VEGAN NOODLES, HALF AN EASTER EGG, ANOTHER NIGHTMARE	MUSICIANS THAT ARE TOO YOUNG FOR ME: 1. YUNG LEAN 2. POST MALONE 3. LIL PEEP RIP 4. LIL XAN	SCRAMBLED EGGS, ALMOND MILK FLAT WHITE EXTRA BREAD ROLLS	WOKE UP AT 4AM COULDN'T MOVE, PANIC ATTACK OR AGGRESSIVE INDIGESTION DEPENDS WHO U ASK

A woman fainted on my train today and I just stood and watched. Everyone mobbed her and I was worried about being late.

빽빽한 정보

64 최소의 지면에서 최대의 효과를 내라

한정된 범위에서 최대한의 효과를 내야 하는 작업들이 있다. 뉴스레터, 특히 비영리 단체의 소식지는 보통 길이가 정해져 있다. 즉, 사용할 수 있는 페이지 수가 미리 결정되어 있고(보통 4~8쪽) 그 안에 모든 내용을 담아야 하는 것이다. 이럴 때, 공간의 협소함이 오히려 효과적인 구조를 만들어내기도 한다.

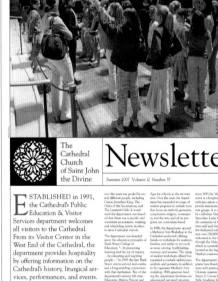

작업명
뉴스레터

의뢰인
Cathedral Church of
St. John the Divine

디자인 감독
Pentagram

디자인
Carapellucci Design

비영리 단체의 이 뉴스레터는
5단 그리드를 자유자재로 활용한
아름다운 작품이다.

위 지면에서 왼쪽 바깥 단은
제작자 이름, 예배 일정, 연락처,
찾아오는 길 등을 열거하는 데
쓰였다. 수직 괘선으로 바깥쪽
단과 나머지 단을 분리하고, 그
네 개의 단에는 에세이 성격의
글을 실었다. 그림 요소와
인용문으로 명상적인 본문을
차분하게 장식했다.

뒤표지(발송자 표시도 겸함)에도
그리드의 구조가 일관되게 나타난다.

그리드를 활용한 행사 달력. 단을 요일별로 세분했는데, 내용에 따라 너비가 다르다. 괘선은 판면을 구획하는 역할을 한다. 두꺼운 괘선에는 활자를 넣었고, 사이드바에는 바탕색을 넣었다. 제목부 활자의 크기를 키워 정보에 변화를 주고 질감을 부여했다.

제목과 해당 기사를 각각 1단, 2단, 3단으로 배치했다. 이미지 크기를 단의 넓이에 딱 맞게 설정하고, 윤곽을 흐리게 한 삽화로 전체적으로 탄탄한 구조에 생동감을 더했다.

65 밀도와 역동성을 결합하라

모든 것을 다 집어넣되 잘 읽히도록 하는 것이 프로젝트의 주된 목표가 되는 경우가 있다. 안내 책자나 용어집, 색인의 경우에 가장 먼저 생각할 것은 모든 것을 어떻게 끼워 넣느냐 하는 것이다.

130쪽: 저항적 성격의 잡지 첫 페이지에 가로로 배치된 명쾌한 간행물 명칭이 상당한 양의 시각적 소란을 꿋꿋이 견뎌내고 있다.

131쪽: 잡지의 단들이 대오를 맞추지 않고 각각 분리된 채 부산스럽게 널려 있는 상자처럼 흩어져 있고 그 안에 질의응답 형식의 기사가 배치되어 있다.

작업명
「*Good Trouble*」

의뢰인
Ron Stanley

디자이너
Richard Turley

'프로 데모꾼'을 자처하는 대판 (브로드시트) 잡지답게 원래 깔끔하게 배치되어 있던 것을 삐딱하게 기울여 그리드 밖으로 벗어나게 했다.

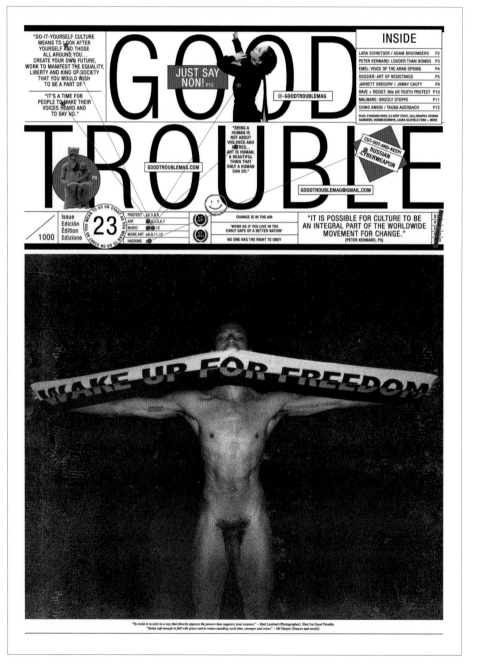

NON WORLDWIDE is a group of African or diaspora musicians and artists. Their tagline is EXORCISE THE LANGUAGE OF DOMINATION. And they're here to shatter every illusion.

JUST SAY NON!

Even by the platform-agnostic standards of today, NON's activities are dizzying. They're a label, releasing stunning, radical music by musicians from Cape Town to Egypt to Virginia to Brixton. They're also magazine publishers who organise talks that run into all-night raves, who have opened a NON-branded range of travel merchandise in a duty-free store in downtown New York. Yet their ambitions go beyond these: NON is a borderless country open to all, a dissident political faction and a tight group of creative idealists…

Though the collective is sprawling and dozens of artists have released through their compilations and EPs, the core group is three DJ-producers-artists – the South African Angel-Ho, the Belgian-Congolese Nkisi, and Nigerian-American CHINO.

AMOBI. After a series of incredible mixes and mixtapes, Amobi has just released his debut album proper – the epic, collisionist double album Paradiso. It's an epic, complex, urgent, thrilling album, themed around an apocalyptic Edgar Allan Poe poem, and a radio station that flickers through moments of hellishness and total beauty. Kind of what life in America feels like right now.

"I like the chaos, throwing different variables in there, letting the chips fall where they may, shattering and breaking the canon in a way," Chino told us over Korean food in Berlin. "The depth and scale of the narrative is wider and deeper than one thinkpiece. The idea of NON is a constant rejection of definition. We're going to tell it ourselves."

THE NATION

You've issued passports to concert attendees in the past. Is NON a nation?
Yes it is. It's a nation, it's a platform, it's an identification. We use the word NON because NON is everything and nothing. It's not limited to one thing. We can do anything. We can work with scientists, non-profit organisations, dancers, mathematicians, publications, designers. We can reflect our interests without things getting watered down. We have citizens all over the world, and ████████████████████ ████████████████████████████ ███ NON in Nigeria, in the US, the NON ████████ represents the universality of the location, where they are and to utilise that ████████ for creative interests in the world.

I love that quote, "Work as if you are living in the early days of a better nation."
I love that too. NON is very nascent. I'm very concerned about giving ourselves space to develop. It's like a garden. Say there's water in the garden. If people hoard the water, the garden suffers. The power of the garden is its diversity. It's important to have that multiplicity of voices. The water is data. And the garden is the systems and infrastructures we work in.

AIRPORTS

You work a lot with air travel – you released an album called Airport Music For Black Folk, and opened a duty free-style shop of NON-branded travel accessories in New York. What's behind this?
I always come back to airports because of what they represent to me. It's a liminal space between cities and countries, and it's a trans space, where we literally are preparing to change our bodies, inside and out, by getting on a plane. It's a very democratic space, but there's so much class things. There's so many codes of society and ideology that's brought to surface this really transparent way. It's almost like a no space. It's like someone took white infinity and made a building out of it. I'm very drawn to that in a very tactile way.

My parents are from Nigeria, and oftentimes Nigeria is on the list of countries for Americans not to visit. So, sometimes I've been questioned and searched heavily, as have other NON artists. I've also had really good experience at airports. I love to people watch. There's multiple things going on: migrants, workers, amazing-looking dogs, the richest people in the country. There's a lot of spontaneity. But spontaneity in this formal way. When statements are isolated in a way, sometimes very mundane actions are way more powerful, because there's so much space around them. Airports are a very "NON" space.

It's between countries, but it's also the only place you can literally point at what a country is. It's a man with a gun saying "You can enter, and you can't." Everything else is scenery. You can really tell a lot from a country by its airport.

RIGHT NOW

Your album is called Paradiso. Are you optimistic?
This time we're in has been growing. Trump is a benchmark, but a certain politicised feeling has been festering for time, with people like Black Lives Matter, the LGBTQ rights community, immigration, terrorism, home-grown terrorism and the way information is disseminated online.; it's all come to a head. it's like a boiling point.

Sometimes I think like the whole thing has to burn down in order for new life to be birthed. I say that optimistically. I'm not talking about masses dying – I don't want that – but destruction causes creation. It's always darkest before the dawn: in my life, the good things have happened directly after the bad.

I feel good about the future, about the youth, the spirituality in youth, the love. I think that the good will triumph. You can strengthen and pressure each other through productive measures. I'm all about shattering illusions, and the more you shatter, the better.

CHRIST

Your album is soaked in Christian allusion. Why is this so important today?
In times of strife which feel very dark, people go to faith to reconcile with what's going on, and [communicate] with something that's larger than themselves. Sometimes Christianity is represented like this fluffy thing, but the bible is super dark. It's gothic as hell. There's a mystery in those words. I'm just more malleable with data than some people are.

I identify as a follower of Christ, but I also identify as a queer body. That's often seen as a contradiction in the world, but the way I think about it, is it's about queering time and space. I really feel like The Bible did that.

Jesus entered time and space in a body that was queer, because only a queer body can transcend time and space, and change it in physical space. I believe that the body of Christ is here with us now and is changing who we are and our hearts. There's a sacred Blood that unites us together in that way, but that bond becomes more than just me, which connects me to other people, which is The Body. I know – it's a lot.

There's a certain magic element of faith that's important. A leap into that magic, I think, can change hearts. I put that into my music, and it's something that brings me closer to NON artists. Two become one. Transindividuation was something I was thinking about heavily on this album.

DIASPORA

For many of the global south, long-distance air journeys are an integral part of life – not a luxury, as in the global north. This may be an obvious point, but it blows my mind.
The diaspora has given people of the global south this fluidity. This, I think, changes how we create. ████████████████████████ ████████████████████████████████ cross cultures, and see how enough hubs intersecting to what's we do. The diaspora and the diaspora ████████████████████████ ████████████ It forces you to think in a way that's multi-levelled, very abstract, and highly conceptual. It's a trans idea.

You've said before that you make music to reject passivity. If you're a migrant, you took the most incredibly active step a person can. Take a lot of guts.
Heavy guts. And urgency. And you can see that urgency, in the work and the conversations. Like, they have so much life. Because you have to have that life – and light, because it can get super dark. And you have to do it together, because your take your family and culture and identity to survive, if you fail a little bit, you have at least that. There's this double consciousness.

MONEY

You're a corporation, rather than non-profit. You had the Duty Free shop, work with Red Bull, and set up Buy-Black Friday. How does money fit in?
I always go back to Robin Hood, man. Steal from the rich to give to the poor. Divide it as equally as we can. We believe in walking in the building and saying "We here. We don't believe in everything you believe, but: We. Are. Here. You need us, we don't need you." We're not playing around, we're smart, you know. Infiltrate and subvert culture in whatever ways we see fit.

It's more honest to operate in these spheres and to politick in them, than go back into the echo chamber and only be around voices that agree with me. Nah. We need a multiplicity of voices, and we deserve to be heard ●
CHARLIE ROBIN JONES
Photography by Johnny Utterback,
Live photography by Brian Whar

"INSTRUCTIONS FOR NON-CITIZENS"

1 — Volunteer at an organization which benefits the quality of life of marginalized people.
2 — Feed your friends. Share your resources with one another.
3 — Spread the message of The Non State.

Q&A. RICHARD CABRAL

Born in the mid-80s into a family of East LA gang members, RICHARD CABRAL did his first time aged 13, going back to jail every year until he was 25. His longest stint, for attempted murder, was his last. On getting out, he left the gang he had grown up in. With the help of Christian organisation Homeboys Industries, he began mentoring those still caught up in gang life and prison, and embarked on a new career as an actor. He secured an Emmy nomination for his portrayal of Hector Tontz, a former gang member struggling to go straight, in the excellent ABC series American Crime, now in its third season.

"People see me how they see me, and that's all they see," Cabral's character says at one point. And Cabral's own story is one of identity and acceptance – of how the marks of a tough, violent past impact the present. But his story is also one of how hard history can be held close, and how loyalty – to himself, as well as his fellow former gang members – can allow radical honesty to help others. "I witnessed guns, and violence, and everything people growing up there witness," he says, as we speak for an hour about prison reform, power and acting. "I finally came home at 25. And then it turned to what it is now."

GOOD TROUBLE: Tell us about life in LA.
Richard Cabral: I'm a second-generation Mexican-American, raised by my mom in East Los Angeles. I grew up in a metropolis of just Mexicans. The inner cities of Los Angeles have been riddled with guns and drugs since the beginning – it was poor, and law enforcement just didn't care. ████████████ ███████████████████████████████ say I was a product of that energy, that time, and that sickness. Gangs, murder, mass incarceration.
LA historian Mike Davies said this explosion of gang violence from the 80s onwards is the result of deindustrialization. You have places where jobs were disappearing, so people were hanging around instead of working. And this coincides with the arrival of crack…
It was like these two forces that coincided at the same time. Boom. In the south side and in East LA, you have these cities which are all industrial. Right along the LA River, it's all factories and warehouses. So, you those kids with the mind to work, but all you have are drugs. The knowledge now is methamphetamine, and has been for the last 15 years. And while it's not as visible as the crack epidemic, it's taken its toll on the communities. The craziness of the stories, mothers killing babies and shit, all that has to do with drugs. The drugs really fucked things up.
One thing I heard about solving gang violence was that only warriors can end the war.
Yeah, that's a good one. For sure, for sure. To talk about the war, you have to know the war. To talk about death, you have to know death. There's a normality to it. It's the philosophy of a warrior, or a man in the army. It's not abnormal to know you might die, because there's a gang of other motherfuckers that might die with you. They all get it: we talk about death, and we talk about jail. The first time I went to jail as a kid, I looked around and thought 'Oh! There's hundreds of others like me.' I remember being young and seeing my uncle go to prison. My uncle has been a gang member since before I was born. You look outside and see gang members. You know the violence and craziness it carries, but you know they're not bad people… They're people.
What was the thing that turned it round?
The truth was I didn't want to spend my life in prison. I spent a year in jail. I had a whole year to think. And through my prayers or whatever, I got five years. But for that whole fucking year, you're thinking you might never come home.
What is the effect of all these years getting handed down by the state on the various communities affected?
You fuck up the community by having kids grow up without their fathers and mothers You destroy the community. My best friend was 15 when he got life. Fifteen! California gives you life.
Why do you not hide from the past you had?
If I don't stand behind it, and say this is what made me, I cannot be inspiration. I cannot go into prisons and talk to people. Embracing it has been the most powerful thing.
Was getting the Emmy nomination for your acting a validation?
Yeah, but a validation I wasn't seeking. I'm happy now. I was in a cell eight years ago. Now I'm out and working and seeing my kids. But it was a surprise, because I just concentrate on the work, and this just meant people recognised the work.
What are your feelings about Trump?
Well, during Obama's reign, he deported more than any other president in history, so we've always been in the shit in a way. But when the threat becomes real evident, it makes people united. If I let someone piss me off, I've given them power. This, Too. Will. Pass. As a prison reformer, we're in a good place. In California, laws are getting passed, and we just need to push on ●
CHARLIE ROBIN JONES
Photography by James Mooney

'VIOLENCE = NO CHANGE'

CALLIGRAPHY

Over the last few months, artist TAUBA AUERBACH has written out the word 'Persevere' thousands and thousands of times.

A series of posters and public installations are now aiming to raise money and awareness for organizations including the Committee to Protect Journalists and GEMS (Girls Education and Mentoring Services).

"My favorite exercise in Daniel T Ames' Compendium of Practical and Ornamental Penmanship shows the word persevere written in lowercase script. Each letter is surrounded by a loop, similar to the a in the @ symbol. The loops are all the same but the letters are different, so the exercise teaches you to maintain a rhythm amidst otherwise varying circumstances."

"Calligraphy has become the activity during which I reflect on what's happening in the world, what's at stake, and what I'm willing to do about it. Maybe I've just needed something to do with my hands while I think. Until now, my politics have manifest mostly in quotidian, domestic choices like being vegan, composting and riding a bike. Feel free to roll your eyes. I support a few organizations. Big deal. I've always spoken my mind, but probably too politely. Besides, all of these choices are luxuries, and none of them registers as a sacrifice because they actually make my life more enjoyable. They are also, clearly, not sufficient."

"While doing calligraphy I've listened to a lot of speeches made by activists and philosophers. I've asked myself frequently if revolutionary change can take place without violence, and I've heard many sound arguments for why it cannot. Nonetheless, I remain certain that violence = no change, and that it is a doomed methodology for achieving it. In my view, violent means not only don't justify but also don't result in peaceful ends because the notion of an "end" is flawed. Now is the end.

Every moment is the end. Civilization will always be in a state of becoming, so how we become what we want to be is what we are."

"Over the last few months, I've probably written the word persevere thousands times and in of hundreds ways. I've needed the time to think about what I can truly offer, about what a real contribution might be. I have some ideas, but I don't yet know if any of them are any good. In the meantime, I'm offering these drawings to support and thank some of the people I've held in my mind as I've written the word."●
TAUBA AUERBACH

Persevere posters are available from diagonalpress.com for $25. 100% of profits benefit the Committee to Protect Journalists, GEMS (Girls Education and Mentoring Services), Chinese American Planning Council, and PLSE (Philadelphia Lawyers for Social Equity)

CLOSING SHOT

SOME PEOPLE ARE SO POOR ALL THEY HAVE IS MONEY

MARTIN SKAUEN

SAVED BY A MASSIVE ██'s history

66 시선을 이끌어라

강렬하게 시선을 사로잡는 작품의 바탕에는 보는 이의 시선을 작품 구석구석으로 이끄는 디자인이 숨어 있다. 괘선, 장식 대문자, 볼드체의 표제 그리고 다양하면서도 절제된 두께와 색상은 읽는 이의 관심이 흩어질 수 있는 길고 빽빽한 글을 흥미롭게 바꿔준다. 그리고 글의 다양한 흥미 포인트와 쉬어가는 포인트를 찾을 수 있게 한다. 이미지를 최적의 위치에 최적의 크기로 배치한다면 읽기의 효과를 더욱 강화할 수 있다.

작업명
「Upfront」

의뢰인
「The New York Times」, Scholastic

디자인 감독
Judith Christ-Lafond

아트 디렉터
Anna Tunick

재치 넘치는 디자인이 이 잡지의 취지를 십분 전달하고 있다. 주 독자층인 청소년들이 지구촌에서 벌어지는 사건들을 접하고 '자신의 일처럼 진지하고 신솔하게' 받아들이도록 한다.

큰 장식 대문자, 볼드체의 부제, 강렬한 독립 인용구가 판면에 색감과 질감, 재미를 부여하는 한편, 사진에 겹쳐 인쇄한 일러스트레이션이 질감과 깊이를 더해준다. 정보로 가득한 판면임에도 공간감이 느껴진다.

괘선과 흰색 활자로 슬로건과 인용구를 강조했다. 그리고 두꺼운 괘선에 캡션을 담아 보는 이의 시선을 자연스럽게 이미지로 유도한다.

EMROZ KHAN IS HAVING A BAD DAY

Which is not unusual, and helps explain why Pakistan's youth are tinder for Islamic extremism.

mroz Khan destroys for a living. He dismantles car engines, slicing them open with a sledgehammer, tearing out pistons, and throwing the metal entrails into a pile that will be sold for scrap. His hands and arms are stained a rich black, like fresh asphalt, and ribboned with scars.

He is 21 and has been doing this sort of work for 10 years, 12 hours a day, 6 days a week, earning $1.25 a day. Emroz rolls up his sleeve and puts my finger along a bulge on his forearm; it feels as hard as iron. It *is* iron, a stretch of pipe

he drove into his body by mistake. He cannot afford to pay a doctor to take it out.

"We work like donkeys," Emroz says, a few paces from the tiny shop where he works in Peshawar, a city in northwest Pakistan. "That's what our life is like. It is the life of animals."

Javaid Khan watches with apprehension. Javaid, who is 17, began chopping up engines four months ago when he left school because he could no longer pay the fees. Javaid wishes he could be one of the clean-cut medical sales reps he sees at the nearby hospital. "I do not have the education," he acknowledges. "It makes me sad to think about it." →

By Peter Maass

AT WORK: Emroz Khan, center, chops engines into scrap for $1.25 a day.

If you want to understand why young Muslim men line up to be suicide bombers, you would do well to stroll down Cinema Road, where Emroz and Javaid work. You would hear the chanting call to prayer, the shouts of peddlers selling bruised bananas, the groan of buses so overloaded that passengers ride on the roofs, and the cries of mutilated beggars pleading for a few cents. And all around, you would notice young men for whom life is abuse. The population of Peshawar (pronounced puh-SHAH-wuhr) reflects the population of Pakistan as a whole—63 percent are under the age of 25.

Most of these young men are not burning effigies of President George W. Bush or fighting Pakistani riot police. Their anger is only loosely expressed, often because they are struggling to survive and cannot afford the luxury of taking an afternoon off to join a demonstration.

They believe, or can be led to believe, that America is to blame for their misery. Many are adrift, cut off from their social foundations. Perhaps they moved to the city from dying villages, or were driven there by war or famine. There is no going back for them, yet in the city there is not much going forward; the movement tends to be downward. As they fall, they grab hold of whatever they can, and sometimes it is the violent ideas of religious extremists.

one he attends is of the extreme variety, as most are these days. I meet him at a protest organized by a pro-Taliban religious party.

"The American leaders are very cruel to Muslims, so that is why I am taking part in the demonstration today," he says politely. What he means is that America supports Israel, which is seen in the Muslim world as oppressing Palestinians, and supports certain Arab regimes, such as the one in Saudi Arabia, which are regarded as corrupt and oppressive.

In the background, a speaker is railing against Pakistan's military government, which supports the U.S. anti-terror campaign. "The generals are stupid," the speaker shouts. Then, like a rock star inviting crowd participation, he calls out, "Generals!" and the crowd roars back, "Stupid!" They are quick learners.

Aziz did not fall into religious extremism by choice; his preferred path, of becoming an engineer, was closed off by poverty. This is common in Pakistan. Poor families do their best to send a son to school, but in the end they cannot manage. The son will get a backbreaking job or maybe keep the donkey's life at bay by enrolling at a madrassa, most of which offer free tuition, room, and board. That's where they learn to think it's honorable to blow yourself up amid a crowd of non-Muslims and that the greatest glory in life is to die in a holy war.

1,000 BRICKS A DAY, SIX DAYS A WEEK

On the outskirts of Peshawar is Dabaray Ghara, an expanse of pits in which several thousand men, mostly Afghan refugees, make bricks. This labor, literally backbreaking, pays next to nothing and takes place outdoors, no matter how hot or cold.

Bakhtiar Khan began working in the pits when he was 10. He is now 25 or 26. He isn't sure, because nobody keeps close track. He works from 5 in the morning until 5 in the afternoon, making 1,000 bricks a day, six days a week, earning a few dollars a week. He is thin, wears no shirt or shoes, and he cannot believe a foreigner is asking about his life.

WORK OR PLAY: Children scoop up ash at a Peshawar brick kiln.

AN ANCIENT CITY PLAGUED BY WAR

Peshawar, once conquered by Alexander the Great and Genghis Khan, is one of the oldest cities in Asia. The city has long been the gateway to Afghanistan—a designation that became a curse 22 years ago when Afghanistan entered an era of warfare that has yet to end. Nearly half of Peshawar's 2 million inhabitants are Afghan refugees, most of them living in squalid camps. The local economy revolves around the smuggling of guns and ammunition, of VCRs and TVs, of heroin and hashish.

Aziz ul Rahman is a product of Peshawar. He is 18 and works in the mornings at a tire shop. In the afternoons, he studies the Koran at a madrassa, or religious school. The

"Life is cruel," Bakhtiar says. "You can see for yourself. You wear nice clothes and are healthy. But look at us. We have no clothes to wear, and we are not healthy. Your question is amazing."

The youths at Dabaray Ghara are illiterate, and the world of politics is beyond their grasp. They can be led to rally behind any person or idea that promises to improve their lot. "I don't know about politics, but for our problems. I blame the world community," Bakhtiar says. "All humans should be equal, but we are not. . . . We arrived from Afghanistan 15 years ago. Since then I blame America.

PETER MAASS is the author of Love Thy Neighbor: A Story of War, his memoir of the conflict in Bosnia. Copyright 2001 Peter Maass.

CHILD LABOR: This 7-year-old works at a brick factory outside Peshawar. About 3.3 million Pakistanis under 14 work full-time.

The youths at Dabaray Ghara are illiterate, and the world of politics is beyond their grasp. They can be led to rally behind any person or idea that promises to improve their lot.

because it used to support us, but now it leaves us in a place like this. So if someone is fighting a jihad against America, I would support them. But if America is willing to help us, we support that, too."

VIDEO GAMES & A FARAWAY FATHER

Ihsan o-Din is enrolled at a civil engineering college in Peshawar. Ihsan, 18, speaks good English, and he has the ultimate luxury in Pakistan—pocket money, which is why I ran into him at a video parlor. Compared with Emroz and the brick makers and most youths here, Ihsan has it good. But there's a catch. Pakistan is one of the poorest countries in the world. Even with a degree, it's very hard to get an

engineering job. You need connections and money. Ihsan's family doesn't have enough of either.

"It is a game of money," he explains. "Even if you are a good engineer, you will not get a positive response when you apply, unless you pay. This has been the truth for 20 years."

The second catch is this: Ihsan's father is staying in the United Arab Emirates, where he works as a taxi driver earning infinitely more than he could in Pakistan. He sends money back to his family so that his children can eat well and go to school, but he doesn't earn enough to buy a plane ticket home.

"I have not seen my father for eight years," Ihsan says. "Is that right? He sends pictures and calls. But we don't want

엄선한 사진과 사진 위에 올린 흰 박스 장치가 이미지의 강력한 구조에 역동성을 더했다.

색상, 장식 문자, 괘선, 박스 등 여러 요소를 사용하여 독자의 시선을 텍스트 맨 앞으로 이끈다. 타이포그래피의 요소들 또한 서로 조화를 이룬 가운데 마음을 울리는 사진으로 시선을 유도한다.

67 이야기를 전달하라

레이아웃은 스토리텔링이다.
이미지를 중심으로 하는
두꺼운 책이라면 더더욱
그렇다. 책이나 잡지의
커버스토리를 디자인할
때는 여러 페이지에
적용될 다양한 레이아웃을
고안해야 한다.

여는 페이지는 여백 없이 전면 인쇄를 했다. 위 판면은 영화 제목이 그 영화의 분위기를 짐작하게 하는
것처럼 뒤이어 전개될 장면들을 극적으로 예고한다.

작업명
『Portrait of an Eden』

의뢰인
Feirabend

디자인
Rebecca Rose

한 지역의 발전사를 상술한
이 책은 다양한 지면 구성으로
독자를 각 시대로 초대한다.

페이지 또는 판면마다 활자 크기, 윤곽, 단, 이미지, 색상 등을 달리하여 내용의 흐름을 조절하고
이야기의 기승전결을 창출했다.

Opposite:
Gertrude leaning against a coconut palm in Lummus Park, 1938. A hedge of Malvaviscus arboreus, a relative of the hibiscus, is in the background. Stretching the length of Ocean Drive from Sixth Street to 14th Place, Lummus Park was donated to the City in 1912 by the Lummus Brothers' Ocean Beach Realty Company.

A Bermuda grass lawn was immediately planted with the hope that its aggressive root system would supply strong underground runners to hold the sandy soil in place. Coconut palms were planted as well, to create inviting shade and a sense of site. Finally, a ten foot-wide sidewalk was installed. From 1912 to 1917, the Lummus Brothers spent $40,000 to create and maintain Lummus Park for the people of Miami Beach.

Left:
Barbara June Oka poses by the Shower of Gold (Cassia fistula), late 1940s. Her right arm mimics the smooth barked limb. Joints of movement and growth, the elbow and node are parallel structures.

Healing Plant
The Shower of Gold tree was central to early peoples dependent on the properties of nature to heal. Cassia fistula was valued by ancient Egyptians for its long cylindrical pods of fruits. Ripening from fresh green in hue to shiny black, these pods grow up to two feet in length. When mature, they contain a sticky brown pulp and several seeds used to cure a multitude of afflictions. Cuttings were carried with the Spanish conquistadors to the New World and firmly planted on the island of Cuba. Angelo returned for Ponce de León, practicing medicinal botany in Jamaica almost three hundred years ago, discussed the calming powers of Cassia and gave a potion for a purgative cure. "The pulp purged twice as much if dissolved." Today the medicinal properties of Cassia fistula are being rediscovered.

Miami Beach of the Orient
Mayor Kenneth Oka fostered Miami Beach's participation in President Eisenhower's People-to-People Program and invited the city affiliation between Miami Beach and Fujisawa, Japan. This bond gained national and international publicity for Miami Beach.

In recognition for his outstanding work in fostering ties with foreign nations, Oka received the annual People-to-People Award in New York City from United Nations Ambassador James Wadsworth. Gertrude took up the brush while spending several months visiting all of her new Japanese friends in the "Miami Beach of the Orient."

Ink drawing by Gertrude Oka, c. 1960.

68 오아시스를 만들어라

비울수록 강해진다.
여백을 활용하여 보는 이의 시선을 잡아끄는 판면을 창조하자.

참조할 페이지
138–139

작업명
콰드로 인테리어(Cuadro
Interiors)기업 비전 설명서

의뢰인
Cuadro Interiors

디자인
Jacqueline Thaw Design

디자이너
Jacqueline Thaw

사진
Elizabeth Felicella,
Andrew Zuckerman

이 인테리어 디자인 회사의 기업
비전 설명서는 모듈 그리드를
바탕으로 압도적인 여백 안에
이 회사가 작업한 주택 및 사무실
공간을 소개했다.

The driving principle of Cuadro Interiors is to ensure the building process works professionally and efficiently. Projects are executed on an individual basis, utilizing a skilled team of long-term employees and tradespeople. Our commitment is to produce the highest quality project in a reasonable and honest manner.

Founded by Raphael Ben-Yehuda and Mark Snyder, Cuadro's approach reflects its partners' backgrounds in fine arts. Their combined forty plus years of building experience includes projects ranging from wood boat building to faux finishing.

Today we are a company with extensive experience in a broad range of project types, from historically accurate prewar homes to modern offices to contemporary residences in a range of materials.

모듈을 모티프로 하여 글의 서두를 열었다.

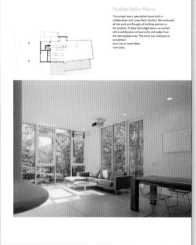

Hudson Valley House

This project was a speculative house built in
collaboration with Leven Betts Studios. We conducted
all site work and brought all building services to
the property. To keep the budget down, we worked
with a combination of local skills and trades from
the metropolitan area. The home was sold prior to
completion.
ARCHITECTS Leven Betts
YEAR 2005

오아시스 같은 흰 여백을
두어서 독자가 이미지와 정보를
하나하나 만끽할 수 있게 한다.

OXO
Industrial design firm
INTERIORS Spokt Haymann
YEAR 2002

69 이미지가 숨 쉴 수 있게 하라

꾸미지 않은 판면은 보는 이의 시선을 곧장 사진이나 일러스트레이션으로 유도한다. 즉, 독자는 아무런 방해 없이 가장 중요한 볼거리에 빠져들게 된다.

여백을 창조하는 법

언제나 디자이너는 작품의 내용에 따라 텍스트와 이미지를 공간에 배정한다. 텍스트가 사진이나 예술 작품, 도표를 언급한다면 그 옆에 해당 이미지를 배치하는 것이 당연하다. 글을 읽다가 그 내용에 맞는 사진을 찾아 페이지를 앞뒤로 넘겨봐야 한다면 읽기 효과가 떨어질 수밖에 없다.

아울러 작품의 비율도 중요하다. 작품의 상세한 부분까지 잘 알아볼 수 있게끔 이미지를 확대하면 화면이 매우 강렬해진다. 독자의 시선을 끌고자 한다면 이미지 주위에 다른 요소들을 배치하기보다는 그 주변을 비워놓는 편이 낫다.

참조할 페이지
136–137

작업명

「*Mazaar Bazaar: Design and Visual Culture in Pakistan*」

의뢰인

Oxford University Press, Karachi, Prince Claus Funds Library, The Hague

디자인

Saima Zaidi

면밀한 그리드와 충분한 여유 공간 안에 파키스탄의 디자인 작품들을 담아 파키스탄의 디자인 역사를 보여준다.

'바위에 새겨진 그림(Storyboards in Stone)'이라는 이 글은 넓은 여백에 연꽃을 든 손 조각 이미지를 배치했다. 캡션과 설명글과 각주는 마주 보는 페이지에 실었다.

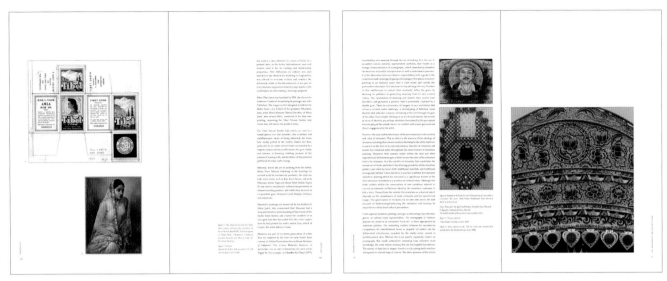

머릿기름 포장지와 초상화 한 점을 여백이 넉넉한 설명글과 함께 배치했다.

원래 트럭 후면을 장식했던 그림과 패턴이다. 다채로운 질감의 레이아웃을 볼 수 있다.

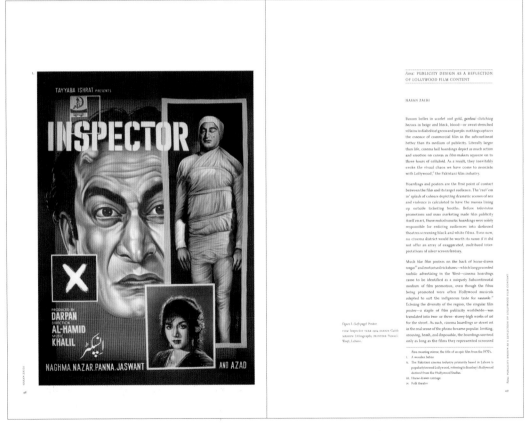

강렬한 이미지로 글의 도입부를 꾸몄다.

70 스케치부터 시작하라

디자이너는 스케치 과정을 통해 아이디어를 구체화하고 출판물 등의 판면 레이아웃을 기획할 수 있다. 초기 스케치는 요소를 하나하나 구별하기 어려운 낙서기는 하지만 전체적인 기획이나 콘셉트를 형상화할 수 있는 중요한 도구다. 이미지가 하나 이상 들어 있는 규모 있는 콘셉트는 우선 기본 골격과 그리드를 구성하고, 여러 요소들이 그 안에서 어떻게 조화를 이루고 메시지를 전달할 수 있을지 설계도를 그려보자.

아이디어와 기본 골격을 바탕으로 설계도를 그리면 작업량을 현저하게 줄일 수 있다. 시행착오 하느라 귀중한 시간을 낭비할 수는 없다. 타이포그래피, 이미지, 손으로 그린 활자나 그림 등 어떤 요소가 어떻게 들어가든 가장 중요한 것은 설계다.

이 스케치는 작품을 고안하고 기획하는 과정, 나아가 한 판면에 다채로운 이미지 요소를 배치하는 방식을 잘 보여준다.

작업명
「*McSweeney's*」 23호

의뢰인
McSweeney's

디자인
Andrea Dezsö

책임 편집
Eli Horowitz

「맥스위니즈(McSweeney's)」 23호 표지 작업. 디자이너 안드레아 데즈쇠는 손으로 그린 데칼코마니 형태의 구조를 반복 사용함으로써 다양한 매체로 작업한 작품들을 한 판면에 담아냈다. 연필 드로잉, 자수, 손으로 만든 입체 인형들을 이용한 그림자놀이 사진, 계란 템페라화 등이 강력한 구조물 안에 자연스럽게 공존한다. 컴퓨터는 이미지를 스캔하거나 합성하는 데에만 사용했다.

위, 아래: 미리 전체 그림을 면밀히 구상하고 계획한 상태에서 각각의 세부 요소를 디자인했다.

패턴과 기획으로 완성한 작품. 다양한 책을 소개하는 책에 어울리는 더없이 화려한 표지다.

프레임 안의 프레임에 책 10권의 표지 일러스트레이션을 실었다. 각 책의 내용은 「맥스위니즈」 23호에 실려 있다. 접혀 있는 표지를 다 펼치면 멋진 포스터가 된다. 손으로 그린 시각적인 틀을 기반으로 개별 작품들을 효과적으로 통합한 이 포스터는 그 자체로 아름다운 작품이다.

71 무질서에 계층 구조로 맞서라

데이터의 양이 너무 많으면 복잡하고 지저분해질 수 있다. 명쾌한 설명과
지시사항이 담긴 간단한 가로 밴드 하나로 도무지 감당하기 어려웠던
것들을 이해의 장으로 끌어올 수 있다.

단순하고 일관적인 밴드 하나로
폐기된 데이터의 재활용 과정을
단계별로 탐색할 수 있게 되었다.

작업명
compost/r

의뢰인
Dopodomani

디자인
Suzanne Dell'Orto

일러스트레이터
Nina Lawson

'콩포스트/알(compost/r)'은
현실 세계에서 음식물 쓰레기가
퇴비화되는 과정을 모방한
앱으로 삭제된 데이터를 바탕화면
이미지, 벨소리, 음악으로
바꿔준다.

Composting!

Composting!

You generated a POEM!

Call Me Later

When I wake up I see a smiley face
it bears resemblance to Beyoncé
from episode 124
of "Call Me Later—Bye"
Season 24: Travel Frog.

Tri-tone! I have a dentist's appointment.
Bing! I have to call my mom
because I'm home at 6,945 steps
near 46th street by the seaside.

24 hours pass, then 42.
Why am I counting?
I could go to 13,240 if I wanted to.
But I don't.
I put that idea in spam.
Goodbye!

5/3/2018

SHARE

72 본능적으로 원칙을 적용하라

작업명
『*Some Fun*』, 『*I'm Special*』,
『*American Nerd*』

의뢰인
Simon & Schuster, Inc.,
Scribner(Simon & Schuster의
임프린트)

『*Some Fun*』
아트 디렉터
John Fulbrook
디자이너
Jason Heuer

『*I'm Special*』
아트 디렉터
Jackie Seow
디자이너
Jason Heuer

『*American Nerd*』
아트 디렉터
John Fulbrook
디자이너
Jason Heuer
사진 일러스트레이션
Shasti O'Leary Soundat

그리드를 엄격하게 적용할 수도
있고 아닐 수도 있다. 세 가지
책표지를 통해 이를 살펴보자.

디자이너들은 그리드를
의도적으로 엄격히
적용하여 디자인할 때뿐만
아니라 본능적으로 적용할
때에도 그리드의 기본
원칙을 적용한다. 그리드에
명쾌하게 배치된 디자인도
있고 시각적 효과에 가까운
디자인도 있다. 심지어
기초공사의 흔적만 있는
디자인도 있다.

『섬 펀(*Some Fun*)』은 그리드를
엄격하게 적용한 다음 마지막으로
책 제목을 넣기 위해 그리드를
파괴한 예다. 이것이 제목처럼
재미 요소로 작용한다.

AMERICAN NERD

Benjamin Nugent

The Story of My People

There are two main categories of nerds: One type, disproportionately male, is intellectual in ways that strike people as machinelike, and socially awkward in ways that strike people as machinelike. These nerds are people who remind others, sometimes pleasantly, of machines. They tend to remind people of machines by (1) being passionate about some technically sophisticated activity that doesn't revolve around emotional confrontation, physical confrontation, sex,

『아메리칸 너드(*American Nerd*)』는 앞뒤가 바뀐 영리한 콘셉트와 사진에서 보듯이 갤러리에서 쓰는 시각적 그리드(수학적 그리드와 반대되는 개념)를 사용하고 있다.

『아이 엠 스페셜(*I'm Special*)』은 그리드를 포기하고 유기적인 느낌을 살린 것이 특색이다. 파란색 줄이 그려진 종이를 살짝 보여주면서 그리드를 쓰지 않은 유기적 디자인임을 강조했다.

수학보다 본능에 의존하는 시각적 그리드

여기 소개된 책표지를 만든 디자이너는 아티스트들이 목적의식을 갖고 그리드와 황금 비율을 적용하기도 하지만 그냥 본능적으로 사용하기도 한다고 생각한다. 제이슨 호이어(Jason Heuer)는 많은 디자이너들처럼 디자인을 할 때는 (수학이 아니라 본능에 의존하는) 시각적 그리드를 사용하고, 마지막에 가서 깔끔하고 질서 정연하게 배열된 디자인 요소에는 수학적 그리드를 적용한다.

73 유려함을 추구하라

구조가 탄탄한 디자인은 비록 구조가 바로 눈에 띄지 않아도
견고한 기반을 가지고 있는 법이다.

작업명
잡지 일러스트레이션

의뢰인
「Print」

디자인
Marian Bantjes

디자인 잡지에 실린 이
일러스트레이션에서는 손 모양의
그림이 달린 곡선이 손글씨
느낌의 정교한 타이포그래피를
가리키고 있다.

미리안 반티예스의 디자인론

"나는 시각적인 질서를 구축하는 사람입니다. 시각적인 질서에 집중해서 작품 안에 어떤 구조를 만들어내는 것이죠. 이미지 요소, 제목부의 굵직한 수직선 등을 이용해 정보를 정렬하고, 그것이 완벽해질 때까지 쉬지 않고 손을 움직입니다. 또 논리적인 구조나 정보의 위계, 일관성에도 매우 집착합니다. 디자인과 타이포그래피는 잘 만든 슈트와 같다고 할 수 있습니다. 보통 사람이라면 손으로 바느질한 단추(장식용 활자)라든가 섬세한 다트 재단 (완벽한 정렬 상태), 고급 원단(완벽한 활자 크기)을 세세히 알아보지는 못합니다. 하지만 그 옷(작품)이 어마어마하게 비싼 것이라는 걸 본능적으로 알아차립니다."

146쪽, 147쪽: 미리안 반티예스는 타이포그래피의 세밀한 부분까지 엄격하게 디자인한다. 예컨대 양끝맞춤 단락에서 활자 간, 단어 간 간격을 일정하게 유지하고, 그녀의 예리한 눈에는 얼마든지 새로워 보이는 지난 특정 시대의 서체를 사용한다. 하지만, 이 디자인의 생명은 뭐니뭐니 해도 그녀의 재치 있는 캘리그래피 아트에 있다.

74 파괴를 기획하라

디자인 과정에서 가장 중요한 것 중 하나가 기획이다. 판형을 결정하는 것도 기획이요, 그리드를 설정하는 것도 기획이다. 그리고 형태의 파괴 또한 면밀하게 기획할 수 있는 디자인의 요소다. 디자이너는 어떤 활자와 기사를 더 크고 두껍게 표현할지, 어느 부분에 색을 입힐지, 장식용 대문자를 사용하는 것이 좋을지 혹은 반드시 사용해야 할지를 결정하고 판단한다. 이것이 바로 타이포그래피로 형태를 파괴하는 디자인이다.

이미지 크기에 변화를 주어 의도적으로 질서를 무너뜨려보자. 작품에 에너지와 활기가 더해질 것이다.

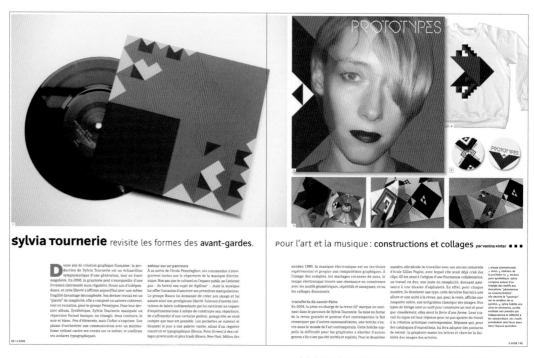

크고 색감이 풍부한 이미지와 단정한 그리드가 대비를 이룬다.

작업명
「*étapes*」

의뢰인
Pyramyd/「*étapes*」

디자인
Anna Tunick

프랑스에서 발행되는 잡지 「에타프(*étapes*)」의 일부다. 크기가 큰 이미지, 실루엣, 넓은 여백 등을 통해 기계적인 형태를 탈피했음을 알 수 있다.

6. pochette du maxi-vinyle "novo screen" pour le groupe bosco, 2007.
7. pochette cd pour panti will, album "h.e.l.l", 2005.
8. pochette de "rattback" maxi-vinyle pour sodex, (pour le label client 20007), utilisation d'une typo originale, la copland.
9. pochette cd pour experience, album "hémisphère gauche", 2004.

ses "gimmicks"

À l'incontournable – et douloureuse – question sur l'auto-définition de son style, Sylvia Tournerie évoque deux éléments signifiants. L'école s'étant équipée d'ordinateurs à la fin de ses études et le recours à la photocopieuse étant également plus facile, cela a entraîné un style repérable, économique, un jeu de découpes. *Mon travail est marqué par des grosses masses noires avec des couleurs primaires.* Difficile de ne pas faire allusion à l'empreinte de Ciesle-wicz. Sylvia Tournerie a étudié à l'ESAG-Penninghen au temps où Roman Cieslewicz y enseignait[1]. Il fut son maître de thèse. De lui, elle se souvient d'un rire qu'il eut, durant un stage, alors qu'il manipulait des formes et concevait un hors-série pour *Le Monde*. Cette excitation, cette légèreté, qui ne s'essouffle pas malgré les années, cette ouverture d'esprit face aux étudiants, n'excluant pas la sévérité, sont les "outils" qu'il lui légua. L'attitude de Cieslewicz, entre détachement et jouissance personnelle d'une affirmation, semble être une aspiration, comme un moteur pour le graphiste. Son style se forgea aussi en raison des contraintes financières qu'elle subit. Les labels n'ayant pas de budgets pour une production photo, jugeant que ses propres photos ne peuvent se suffire à elles-mêmes, elle transforme celles qu'elle reçoit ou qu'elle prend en paysages. Ainsi, ses photos sont-elles plus à l'aise avec l'esprit décalé provoqué par les collages. Dans ces conditions naît la mémorable et si furtive identité de *Point éphémère*, où elle transforme en une toile de Jouy, *les acteurs de la musique*.

émergence

Sylvia Tournerie ne compose que sur ordinateur, et parle de la légèreté de l'outil, puisque, au propre comme au figuré, les données ne pèsent rien. Sur son Mac, un dossier vrac regroupe ses premières sessions de travail peu organisées, *une étape de vidage, suite à ma rencontre avec le commanditaire.* Dans un état presque hypnotique, où *l'important est de se laisser aller*, elle façonne une matière formelle abstraite. Elle la pétrit jusqu'au moment où se manifeste la première émotion, cette émotion, qu'elle peut perdre en cours de route, mais qu'elle *n'a de cesse de faire vivre, de conserver jusqu'au bout du projet.* Tout est dans le doigté et dans ces ressentis impalpables. Sylvia Tournerie parle avec sensibilité, avec intelligence de cette étape de travail, capitale, qui l'interroge douloureusement aussi. Elle évoque son incapacité à décrypter ses convictions. Cette étape est de l'ordre de l'émotion. *J'ai rarement une idée avant de faire les choses.* Ainsi, l'objet graphique émerge-t-il de son façonnage. *Je justifie les formes une fois qu'elles sont là.* Pendant longtemps, il lui fut difficile d'assumer cette prétendue gratuité, aujourd'hui, Sylvia Tournerie se dit plus sereine face à sa façon de composer[2]. Ses formes ne sont pas le fruit du

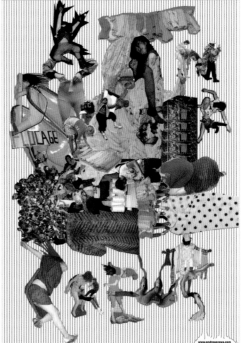

poster pour la styliste andrea crew (avec la participation de leslie david, 2006). Au recto, les mannequins présentaient la collection de la saison et des motifs géométriques auréolaient chaque modèle et accentuaient leurs postures irrévérencieuses. Au verso, le processus de travail d'andrea crows se révèle dans un vaste désordre recollé: la styliste élabore ses pièces uniques à partir d'habits récupérés et recyclés.

www.andreacrews.com

hasard, avec l'expérience, toutes relèvent d'un choix. Sylvia Tournerie agit dans la traduction – le graphisme avec ses composants parle à l'âme directement de la même manière que la musique parle avec ses notes et ses gammes –, elle n'est pas sur le territoire des intentions. Ses identités visuelles ne sont pas des chartes, mais des pulsations, des vibrations, concentrées ou fragmentées.

Peu d'affiches, pas de théâtre, ni d'identité institutionnelle (excepté sa participation avec Gilles Peplin à l'identité du CNAP.é : 126), pas de gros chantiers, ni de régularité (cette situation qu'on retrouve chez d'autres de ses contemporains devrait inciter les commanditaires à défier ces graphistes sur ces terrains balisés). Pourtant, les gammes de Tournerie marquent leur empreinte dans le

윤곽선을 따낸 예술 작품 이미지를 정교하게 조합하여 정돈된 판면에 에너지를 불어넣었다.

75 극적인 효과를 노려라

사진 크로핑이 드라마를 만든다. 촬영된 이미지를 그대로 보여주면 이야기를 들려줄 수 있지만 이미지를 재단하면 특정 논지를 주장하고 관점을 제공하고 공포나 흥분을 유발할 수 있다. 크로핑으로 사진의 특정 부분으로 시선을 돌리거나 불필요한 정보를 제거하여 사진이 전달하고자 하는 메시지를 바꿔놓을 수 있다.

사진 재단 시 제약이 있는지 확인하라

이미지 중에 마음대로 재단할 수 없는 것이 있다는 사실을 알아야 한다. 많은 사진작가, 스톡 사진 회사, 박물관은 예술 사진 복제 재현 방법에 관해 엄격한 규정을 두고 있다. 일부 이미지, 특히 유명 회화 작품이나 조각 사진은 절대로 손댈 수 없다.

151쪽: 이 책표지는 스포트라이트 형식을 취하고 있다. 콜라주 기법이 충격을 약화시킬 수 있었는데 모든 이미지를 크로핑한 것이 신의 한 수가 되었다.

원형 말풍선이 현실을 적나라하게 보여주는 사진들에 변화를 준다.

작업명
『On Broadway: From Rent to Revolution』

의뢰인
Drew Hodges(저자), Rizzoli(출판사)

크리에이티브 디렉터
Drew Hodges

디자인
Naomi Mizusaki

넘치는 활기, 다양한 형태, 사진 크로핑, 멋진 타이포그래피가 명쾌한 그리드로 디자인된 책의 드라마를 고조시킨다.

ON BROADWAY

FROM RENT TO REVOLUTION

DREW HODGES

INTRODUCTION BY
DAVID SEDARIS

FOREWORD BY
CHIP KIDD

RIZZOLI
NEW YORK

76 실루엣으로 생생한 판면을 구성하라

실루엣은 지나치게 조직적이거나 딱딱한 판면을 생기 있는 판면으로 만들어준다.

　디자이너들이 '실로(silo)'라고 줄여서 말하는 실루엣은 배경을 제거하고 실제 형태만 도려낸 이미지를 말한다. 실로는 식물의 잎 같은 유기적인 형태거나 원 같은 정형의 모양일 수도 있다. 실루엣의 형태가 유연할수록 판면에 더욱 강한 리듬감이 생긴다.

작업명
「*Croissant*」

아트 디렉터
Seiko Baba

디자이너
Yuko Takanashi

일본에서 발행되는 요리 잡지 「크루아상」은 실루엣을 사용하여 이야기를 효과적으로 전달하는 질서와 구조를 완벽하게 보여준다. 사진의 지면은 「크루아상」의 편집자들이 만든 무크지의 일부로 제목은 '녹슬지 않는 생활의 지혜'다.

수직, 수평 괘선들로 공간을 깔끔하게 구획하고 그 안에 각각 표제와 도입부 및 정보를 담았다. 설명 정보를 효과적으로 전달하면서 식물의 실루엣 이미지를 사용하여 판면에 생기를 더했다.

おいしいものは、端っこまでおいしい。手を抜かず、手間かけて、余さず食べる知恵と工夫。

たくあんのぜいたく煮

材料（4人分） 古漬け沢庵1本。だし雑魚1つかみ、たかのつめ2、3本。砂糖カップ1/3、みりんカップ1/2、酒カップ1/2
作り方 沢庵は5mmほどの輪切りにし、水につけて塩出しておく。時々、水を替えながら塩出しした沢庵を、ひたひたの水で柔らかくなるくらいまでゆで、だし雑魚、種をとったたかのつめ、醤油、酒を入れる。煮汁が少なくなるようなら、酒を足す。弱火で煮て、沢庵に火を弱めて汁気がなくなるまで煮る。落としぶたを使い、かき混ぜないように。

だし雑魚は頭、わた、骨を抜いて三枚に。この手間でぜいたく煮で、味を決める。

ちりめん山椒

材料（4人分） ちりめん雑魚400g、実山椒カップ1、濃い口醤油150cc、酒250cc、みりん70
作り方 鍋にすべての調味料を入れ、中火で煮立てる。煮立ったら、ちりめん雑魚を加えて火を強め、煮詰めていく。煮詰まると実山椒を加え、弱火で煮て、汁気を止めて水分を飛ばす。「ちりめん山椒は実山椒を入れすぎると香りも味がなくなります。ほんの少し香りを感じる程度に入れて」

首藤さんは多めに炊いて袋に入れて保存している。

かつおと昆布のふりかけ

材料（作りやすい分量） だしをとったあとの昆布、かつお節、砂糖小匙1、醤油小匙1、みりん小匙1、酒小匙1、白ごま小匙1
作り方 昆布は、かつお節と一緒に細く刻み、砂糖、醤油、みりん、酒を加えて混ぜながら弱火で煮る。葉ばしは3組か4組使うと混ぜやすい。汁気がなくなったら白ごまを加えて完成。自己流のふりかけ松の実でも美味しい。冷蔵庫で約2週間ほどは保存できる。「私の場合、ここで使うかつお節は、かんなで削ったものです。ほんと、おいしいんです」

ふきの葉の佃煮

材料（作りやすい分量） ふきの葉3把分、みりん大匙2、酒大匙3、醤油カップ1/2、ちりめん雑魚1つかみ
作り方 ふきの葉は、よく洗っておく。たっぷりの湯で色よくゆで、あまりゆですぎないうちに引きあげたら、20分ほど水にさらし、かたく絞って水をきる。このまま、削りかつおと醤油だけで炒めて味付けをしてもおいしい。佃煮にするときは、調味料をすべて合わせてから中火にかけ、ふきの葉とちりめん雑魚を加える。「葉を3、4組使い、かき混ぜながら、ぱらぱらになるまで炒めてください」

みじみの炊いたん

材料（4人分） しじみ（むき身）400g、酒100cc、みりん20cc、砂糖大匙1、醤油大匙3、水50cc。針生姜
作り方 しじみはざるに入れて何度も振り洗いする。水気を十分に切ったら、鍋にしじみを入れ、調味料と水を加え、針生姜をのせる。落とし蓋をして中火にかける。煮立ってきたらアクを取る。アクを取ったら中火のまま煮汁が少なくなるまで煮る。「琵琶湖の瀬田産の身がぷっくりのしじみで炊くといいんですが、最近は購入物に押されてしまって、なかなか——」

落とし蓋はコーヒーフィルターを、広げると円形になる。

「私の母はつくづくすごい人やったな、と思います。魚を煮たおつゆや、野菜を煮たおつゆをためておいて、合わせておだしをつくって、何種類かの煮汁が混じり合ってつぶり袋った卵の花炊きの味はさや──」

「これが『始末』のお手本です」

複雑さを増したりうまみを引き出したりするための、始末という知恵のこと。だしをとった後の昆布や削り鰹を、細かく刻んだりして作る古漬けやふりかけ、あんのこぼこを使って作る煮物──。その首藤さんにもさまざまな葉伝説がある。捨てるものもとされていたふきの葉を、京都であるとされてからこんなこと言われたんだそうで。「あんたんとこのおかちゃらっとして出ないとか」「余りものを使った料理教室、開いてるんやって」「ちゃんとした料理も教えて。

て言い返したそうだが、ふきの葉のふりかけは、ほろ苦さがうまく残っていて、春の息吹を感じさせるちゃんとした料理です。残りもの料理、おいしく食べるために手間をかける。「京都の女の人は、手間をかけすぎるてきとこの女の料理なんて手間どう調理するか、それぞれの家で頭をつかっていたという。「なんでこういう知恵が、いまの娘さんになくなってしまったんでしょうか。常備菜なんかもそうですね。たくさん炊いたときの保存とか。何かもらったときのお返しにもできるのに。キャセロール着て、ほうやら、なんでしょうか。河原町を歩いていく娘された嫁たちを見ると、そう思ってしまいます」

上・「かつお節はここまで小さくなるまで使います。削るのは今でも私がやっています」中・有次の黒鯛製の鍋、打ち出しが取り切れるほど使い込んであります。すき焼きにも大活躍。下・ごまおろし。「ごまはよく食べますし、炒るにも複合にもコツがあります」

053　クウネル　　　　　暮らしの知恵 052

판면에 괘선을 그어 원래의 그리드 위에 또 하나의 그리드를 추가했다. 요소들이 명확하고 깔끔하게 배치되어 있고, 다양한 형태의 이미지가 조직적이고 질서 있는 판면에 리듬감을 더해준다.

首藤さんは多めに炊いて袋に入れて保存している。

실전 그리드　**153**

유기적인 그리드

77 문화를 받아들여라

강력하고 명쾌한 체계와 숨통 트이는 시각적 산소가
풍부하면 시청자나 독자를 교육하는 것은 물론, 여러
측면에서 프로젝트를 차별화하는 것이 가능하다.
디자이너는 문화적인 스토리나 신화, 상징을 뒤섞어 훨씬

훌륭한 결과물을 만들 수도 있고 세상을 더 작게 축소할
수도 있다. 무엇보다 중요한 것은 다른 문화를 많이 엿보고
이해하면서 세상이 더욱더 풍부해진다는 것이다.

작업명
「*Threaded*」

의뢰인
Threaded Studio(출판사)

디자인
Threaded Studio

디자인팀 디자이너
Kyra Clarke,
Fiona Grieve,
Reghan Anderson,
Phil Kelly,
Desna Whaanga-Schollum,
Karyn Gibbons,
Te Raa Nehua

이미지 크레디트
Threaded Media Limited, 2016/17

뉴질랜드 오클랜드에 본사를 둔
한 디자인 에이전시가 기획·
디자인하고 발행하는 국제적인
잡지의 스무 번째 에디션
「뉴 비기닝(*New Beginnings*)」은
오로지 마오리 예술에 관한
카우파파(kaupapa, 주제)와 이
분야에서 활동하는 디자이너들에
관한 내용으로 채워져 있다.

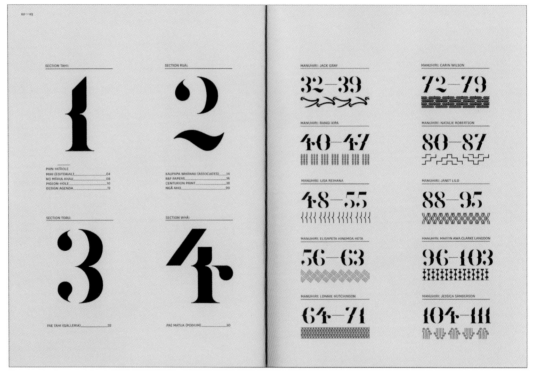

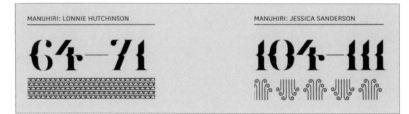

산세리프 타이포그래피와 서정적인 숫자들이 마오리 문화에서 나온 상징들과 멋진 조화를 이룬다.
이 출판물의 편집자들은 기사 속에서 마누히리(manuhiri, 초대손님)가 들려준 코레로(korero, 이야기)에
걸맞은 패턴을 특별 제작했으며 그 도안을 마오리족 디자이너를 가리키는 고유의 문화적 기표로 삼았다.

155쪽: 단순한 그리드와 여유로운
여백이 아름다운 마오리
예술품을 담는 액자의 역할을
한다. 장식품들이 진부함이나
고정관념을 탈피한 채 문화를
영광되게 하고 있다. 장식 없는
산세리프 서체의 부제목과
기본 텍스트가 화려한 이미지와
대비된다.

ON LINE:

I'm acutely aware of how much the power of a line can influence how people read visual material. For me, when i'm working in a sculptural sense i'm analyzing everything by the mana of those lines; if they're transported into low relief or 3D we're talking about edges. Edges are everything. You create a deep or powerful sense of space, direction and form with something that's relatively shallow. The edge of the line enables you to use light to give the impression of depth. i'm aware of it and i just try to exploit it i suppose. There's a beauty in line that's difficult to explain, but i get seduced by the ability to reduce down to linear forms and play with it, there's so much you can do it's really just up to your imagination and over a period of time you get to a point where you can master it and then people, they follow it, they get it. They're not necessarily able to interpret it or explain it but they get it.

The energy contained in the line is no different than the principle of physics. it's the same as how you use your arm to develop a centrifugal force to throw something. The line can do that as well. You can use that energy to influence and to give the impression (of that force) in the same way whether in 2D and 3D.

TOP
—
Wahaika, whalebone

BOTTOM
—
Koiate, whalebone

REGARDING SCALE:

I work in so many different genres and scales. There are fundamental principles to design but there are so many different ways to exploit them, they have weaknesses and strengths. And they can change as soon as you change scale or your relationship - for example physical proximity or moving from 2D to 3D. There are so many ways in which you can change the nature of the game and it forces you to engage differently with those elements or principles. As i get older in my craft and sense of self (if you're fortunate enough to be given the freedom in your practice to pursue your own sense of design truth) you find that as you journey along eventually as you refine based upon your own sensibilities, as you refine your craft you find the sweet spots. You find what works and what doesn't. What works for me in moko, using line at that proximity - you're working within one foot of your hand guiding the gun as its laying ink in the skin - works differently when you're standing away doing a large mural or a 6 metre bronze sculpture. So you can't use and engage the same principles in the same way, you're forced to renegotiate your own axis or your own sense of gravity to your work.

TOP LEFT
—
Heru, whalebone

TOP RIGHT
—
Hei tiki, whalebone

BOTTOM LEFT
—
Koiate, (detail), whalebone

BOTTOM RIGHT
—
Madonna and Child, whaletooth

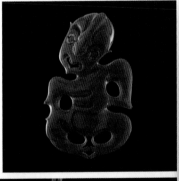

CONNECTIONS AND PATHWAYS:

My artistic practice is strongly influenced by my political belief that we need to be relevant and that we have a role to bridge the past and the future. i'm lucky enough to grow up in my tribal area. i've had strong cultural connections to my community so i have a sense of allegiance to my culture and community that manifests itself in the work. But i can't change the past. i'm trying to visualize a pathway in the future and trying to use my art as a tool to help lay down some of that pathway. i'm trained as a social scientist as well so if you connect that to my cultural background it's part of my imperative to drive my art to always be forward focused. i believe we have a role to visualize the future and make it happen. If you look over my practice over the past 20-30 years, moko was like that, taonga

puoro - Māori musical instruments - was like that, my role in waka in Taranaki was like that. So by kicking those things off and by continuing to push them - the same with taonga whakarakai (adornment arts) - restoring these art forms but restoring them in a way that continues to have relevance not only for now and being present in your work but also into the future. i'm trying to push my work so far ahead that it actually looks futuristic, that people can go 'wow - i really like that'. They can see the footprint of our old world in it but it's also out there tugging on them so the materiality, the aesthetics and the cultural imperative that's subtly locked in there pulls at them.

NEW MATERIALS:

The interesting thing was about seeing how the Māori community would respond to media that wasn't seen as valuable, that didn't have a valuable (cultural) attribution, so creating beautiful stuff out of it, it enables itself to be relevant. The beautiful thing about Corian is you can get a great sense of colour - and if you're really good at finishing the work - it's as seductive as what whale tooth, whale bone or pounamu can be. That was the beauty of that exercise, seeing that material being adopted as a taonga. These approaches to materials are interesting journeys, they're not necessarily answers to questions but they're part of the journey.

> 66 ... you're working within one foot of your hand guiding the gun as its laying ink in the skin... 99

TOP
—
Moko peha

BOTTOM
—
Ponoto, Corian

OPPOSITE PAGE

TOP
—
Hei tiki, Corian

BOTTOM
—
Hourei, whaletooth

78 유연한 시스템을 개발하라

유연한 체계란 다양한 크기, 다양한 형태, 다양한 정보를 다양한 방식으로 배열할 수 있는 체계를 말한다.

스위스의 선구적인 그리드 디자이너들
엘런 럽턴은 스위스의 선구적인 그리드 디자이너 요제프 뮐러 브로크만(Josef Müller−Brockmann)과 카를

게르스트너(Karl Gerstner)가 다양한 시각적 해법을 구축하는 법칙들을 하나의 '디자인 강령'으로 정립했다고 설명한다. 그는 스위스 디자인의 핵심을 이렇게 정리했다. "스위스 디자이너들은 반복적인 구조를 이용하여 그 위에 변화와 의외성을 만들어낸다. 예를 들자면 한 작업물 안에서 조밀한 판면과 여유로운 판면을 혼용하는 것이다."

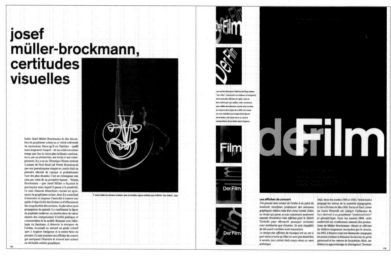

이 구조적인 그리드에서 한 페이지는 1/2, 1/3, 1/4로 분할이 가능하며, 수평으로 세분할 수도 있다.

견고한 그리드에 맞춰 이미지의 크기를 결정했고, 다양한 크기의 이미지를 효과적으로 담아냈다.

작업명
「*étapes*」

의뢰인
Pyramyd/「*étapes*」

디자이너
Anna Tunick

이 잡지 기사는 그리드 디자인의 대가 요제프 뮐러 브로크만의 작업을 보이기 위해 유연한 포맷을 사용하였다.

Überholen…?
Im Zweifel nie!

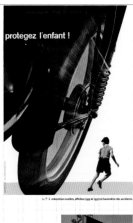

protegez l'enfant !

← ↑ ↓ prévention routière, affiches (1959 et 1953) et baromètre des accidents.

" *En une fraction de seconde, l'affiche doit agir sur la pensée des passants, les contraignant à recevoir le message, à se laisser fasciner avant que la raison n'intervienne et ne réagisse. Somme toute, une agression discrète, mais soigneusement préparée.* **"**

규칙이 엄격한 그리드라고 해서 꼭 재미가 억제되는 것은 아니다. 인상적인 이미지를 역동적으로 배치하여 다채롭고도 놀랄 만한 판면을 구축했다.

이 지면은 그리드 내에 사이드바를 자연스럽게 접목하는 방법과 그리드에서 광대한 여백을 효과적으로 처리하는 방법을 보여준다.

est capable de remises en cause profondes. Malgré le succès de son style illustratif, il sait que les progrès dans cette voie sont déterminés par des talents artistiques dont il se sent dépourvu. Le dessin, le plaisir de conter, le goût de la nouvelle surprise et la joie de la communication spontanée, satisfactions personnelles du graphiste, ne sont pas le langage formel le plus apte à répondre aux aspirations de l'époque, à qui les lois du design et d'un graphisme objectif seraient plus adaptées. La raison essentielle du renoncement à l'illustration réside dans le fait qu'aucune illustration ne résout totalement les problèmes que présente un travail. La conception illustrative à elle seule ne rend pas l'indispensable caractère documentaire de la publicité et confère au dessin une note personnelle qui ne s'harmonise pas avec le style publicitaire moderne. En 1950, la commande de la salle de concerts (Tonhalle-Gesellschaft) de Zurich contribue à ce virage déterminant. Samuel Hirschi, secrétaire du lieu, à programme des compositeurs modernes et cherche à actualiser le lieu. Les deux hommes noueront une amitié solide et durant près de vingt-cinq ans, saison après saison, le graphiste va y expérimenter les possibilités de l'abstraction et de l'art de la construction typographique.

nationalité, objectivité et efficacité

Les progrès sont et resteront déterminés par des créateurs susceptibles de présenter, au travers des tensions latentes, les possibilités nouvelles et de les transformer en certitudes visuelles.

Philosophie de la grille et du design

L'usage de la grille comme système d'organisation est l'expression d'une certaine attitude en ce sens qu'il démontre que le graphiste conçoit son travail dans les termes constructivistes et orientés vers l'avenir.

C'est l'expression d'une éthique professionnelle, le travail du designer doit avoir l'évidente, objective et esthétique qualité du raisonnement mathématique.

Son travail doit être la contribution à la culture générale dont il constitue lui-même une partie.

Le design constructiviste qui est capable d'analyse et de reproduction peut influencer et rehausser le goût d'une société et la façon dont elle conçoit les formes et les couleurs.

Un design qui est objectif, engagé pour le bien-être collectif, bien composé et raffiné constitue la base d'un comportement démocratique. Un design constructif signifie la conversion des lois du design en solutions pratiques. Un travail accompli de façon systématique, en accord avec de stricts principes

formels, permet ces exigences de droiture d'intelligibilité et l'intégration de tous les facteurs aux divers vitaux pour la vie sociopolitique. Travailler avec un système de grille implique la soumission à des lois valides universellement.

L'usage du système de grille implique la volonté de systématiser, de clarifier ; la volonté de pénétrer à l'essentiel, de concentrer ; la volonté de cultiver l'objectivité au lieu de la subjectivité ; la volonté de rationaliser les modes de production créatifs et techniques ; la volonté d'intégrer des éléments de couleur, de forme et de matière ; la volonté d'accomplir la domination de l'architecture sur l'espace et la surface ; la volonté d'adopter une attitude positive et visionnaire ; la reconnaissance de l'importance de l'éducation et les effets du travail conçu dans un esprit constructif et créatif.

Tout travail de création visuelle est une manifestation de la personnalité du designer. Il est marqué de son savoir, de son habileté et de sa mentalité. ~ *Josef Müller-Brockmann*

the architectonic in graphic design
the concert poster series of josef müller-brockmann

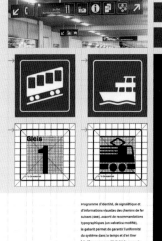

Stellwerk **Bern Wylerfeld**

CFF Cargo

SBB CFF FFS

Gleis **1**

Unis, visite le Mexique et prend des contacts à New York, où il songeait à s'établir, devant la difficulté pour la Suisse à reconnaître et à laisser s'épanouir ses talents, du fait de son esprit de villageois et de paysans. Il retourne finalement à Zurich, où il prend la suite de son professeur à l'école des arts et métiers, Ernst Keller, et met en place la revue qu'il songeait à monter depuis 1955 : *Une publication pour un graphisme rationnel et constructif pour contrer les excès d'une publicité irrationnelle et pseudo-artistique que je voyais autour de moi.* Animée et éditée avec Richard Paul Lohse, Carlo Vivarelli et Hans Neuberg, la revue *Neue Grafik* (*"Graphisme actuel"*), éditée en allemand, anglais et français approximatif, comptera dix-huit numéros publiés jusqu'en 1965. D'abord approchées, des personnalités comme Armin Hoffman ou Emil Ruder sont écartées, leurs productions étant jugées trop diversifiées par le quarteron de puristes. Une idéologie formelle et fonctionnelle se met en place. Les trois mots-clefs en sont rationalité, objectivité et simplicité : *J'en suis venu à apprécier l'Akzidenz Grotesk davantage que ses successeurs Helvetica et Univers. Il est plus expressif et ses*

bases formelles sont plus universelles. La fin du "e", par exemple, est une diagonale qui produit des angles droits. Dans le cas de l'Helvetica et de l'Univers, les terminaisons sont droites, produisant des angles aigus ou obtus, des angles subjectifs. Après la Seconde Guerre mondiale et le désordre nazi, le graphisme espère un retour à l'harmonie et ambitionne un rôle constructeur. La subjectivité du dessin est écartée au profit de l'objectivité de la photo et de la construction. Les règles de la nouvelle typographie constituent avec le fer à gauche une dynamique vers le progrès technique et social : *La symétrie et l'axe central sont ce qui caractérise l'architecture fasciste. Le modernisme et la démocratie rejettent l'axe.* Le savoir-faire du designer se précise et quitte la théorie pour passer à l'épreuve du réel au service des entreprises : *Un design constructif signifie la conversion des lois du design en solutions pratiques.* C'est dans ce sens que s'oriente son premier livre *Problèmes d'un artiste graphique*, dont la publication en 1961 correspond à son départ de l'école des arts et métiers de Zurich, où il n'est pas parvenu à installer son enseignement. Dix ans plus tard, il publie une *Histoire de la communi-*

cation visuelle et (avec sa seconde épouse) une *Histoire de l'affiche*, qu'il organise de nouveau avec l'affiche constructiviste en ligne de mire et l'efficacité en lieu et place de l'expressivité : *En une fraction de seconde, l'affiche doit agir sur la pensée des passants, à se laisser fasciner avant que la raison n'intervienne et ne réagisse. Somme toute, une agression discrète mais soigneusement préparée.* Quatre ans plus tôt, Müller-Brockmann a fondé avec trois associés l'agence Müller-Brockmann & Co, qui intègre la publicité dans son activité régulière, aux côtés de l'identité visuelle, la signalétique et la communication culturelle. Au terme de dix années supplémentaires, en 1981, il publie son ouvrage de référence : *Raster systeme für die*

Programme d'identité, de signalétique et d'informations visuelles des chemins de fer suisses (SBB), assorti de recommandations typographiques (un Helvetica modifié), le gabarit permet de garantir l'uniformité du système dans le temps et d'en tirer bénéfice sur une multiplicité de supports. Projet réalisé par müller-brockmann & co et rester épaulage, primé en 1995 par le swiss design prize.

visuelle Gestaltung. Ses expérimentations dans les affiches du Tonhalle ainsi que son récent travail pour les chemins de fer suisses lui ont permis de forger une théorie mais aussi une éthique de la grille. Derrière son apparence de manuel technique, l'ouvrage est un manifeste. Le livre est introduit par un texte sur la philosophie de la grille et du design (voir encadré) qui conclut par un renvoi à l'individualité du créateur : *Tout travail de création visuelle est une manifestation de la personnalité du designer. Il est marqué de son savoir, de son habileté et de sa mentalité.* Las, les progrès qu'il contient et propose ne seront pas perçus comme des choix déterminés d'un graphiste ou comme des règles parfois compassées proposées à la profession, mais plus souvent

79 타이포그래피로 조절하라

스위스식 그리드는 많은 양의 텍스트도 즐겁게 읽을 수 있는 판면을 만들어낸다. 이 구조는 지면 위에 정보를 화려하고 명료하게 펼쳐놓기 때문이다. 다단 그리드는 본문의 풍부한 내용을 담을 수 있고, 이미지와 색 박스를 사용하여 그 안에 지엽적인 정보를 배치할 수 있다. 스위스식 그리드는 응용력 또한 높다. 여백으로 처리한 공간은 채워진 공간과 대비되어 효과를 높인다.

작업명
구독 안내 브로슈어

의뢰인
Jazz at Lincoln Center

디자이너
Bobby C. Martin Jr.

타이포그래피를 조절하여 다양한 프로그램을 안내하는 정보를 읽기 쉽게 조직화했다.

활자의 두께와 행간, 짧은 문구, 제목, 색상 반전 등을 적절하게 조절한 브로슈어 디자인이다. 정보들을 명확한 위계질서에 따라 깔끔하게 배치하였다. 색 모듈은 7개의 프로그램 시리즈를 구별하여 나타낸다. 각각의 색 모듈 안의 타이포그래피는 크기와 두께로 명확성과 균형감을 부여했고, 덕분에 보는 이는 해당 시리즈의 이름을 한눈에 알아볼 수 있다. 브로슈어 전체 구조에서 가장 효과적으로 쓰인 요소는 색 모듈이다. 우아한 느낌의 서체를 사용해 정밀하게 배치한 모듈은 작은 배너와 같은 역할을 한다.

From Satchmo's first exuberant solo shouts to Coltrane's transcendent ascent, we celebrate the emotional sweep of the music we love by tracing the course of its major innovations. Expression unfolds in a parade of joyous New Orleans syncopators, buoyant big band swingers, seriously fun beboppers, cool cats romantic and lyrical, blues-mongering hard boppers, and free and fusion adventurers. From all the bird flights, milestones, and shapes of jazz that came, year three in the House of Swing is a journey as varied as the human song itself, and the perfect season to find your jazz voice.

7 GREAT SERIES, 7 GREAT EXPERIENCES!

6 SS SERIES

Singin' & Swingin'
The Allen Room
7:30pm & 9:30pm

4 ALJO SERIES

Afro-Latin Jazz Orchestra with Arturo O'Farrill
3 Concerts
Rose Theater, 8pm

COLTRANE/HARTMAN
SEPTEMBER 15 & 16, 2006

PAQUITO D'RIVERA
NOVEMBER 17 & 18, 2006

BEBO VALDES

5 SM SERIES

Singers Over Manhattan
4 Concerts
The Allen Room
7:30pm & 9:30pm

THE BIRTH OF COOL
MARCH 30 & 31, 2007

STEPHANIE JORDAN & THE WESS ANDERSON QUARTET
OCTOBER 20 & 21, 2006

WILLIE NELSON SINGS THE BLUES
JANUARY 12 & 13, 2007

DIANNE REEVES
APRIL 20 & 21, 2007

CUBANA BE CUBANA BOP

DARIN ATWATER GOSPEL
MAY 25 & 26, 2007

7 LAYP SERIES

Jazz for Young People™
3 Concerts
Rose Theater, 12pm & 2pm

TODO TANGO

2 LJ SERIES

Jazz Jam
4 Concerts
Rose Theater, 8pm

3 MM SERIES

Music of the Masters
4 Concerts
Rose Theater, 8pm

WYNTON AND THE NOT FIVES
SEPTEMBER 28, 29 & 30, 2006

FUSION REVOLUTION: JOE ZAWINUL
OCTOBER 27 & 28, 2006

What an amazing show!

RED HOT HOLIDAY STOMP
DECEMBER 14, 15 & 16, 2006

BEBOP LIVES!
JANUARY 26 & 27, 2007

THE LEGENDS OF BLUE NOTE
APRIL 26, 27 & 28, 2007

CECIL TAYLOR & JOHN ZORN
MARCH 9 & 10, 2007

WHAT IS AN ARRANGER?
DECEMBER 2, 2006

IN THIS HOUSE, ON THIS MORNING
MAY 24, 25 & 26, 2007

THE MANY MOODS OF MILES DAVIS
MAY 11 & MAY 12

WHAT IS LATIN JAZZ?
MARCH 3, 2007

1 LCJO SERIES

Lincoln Center Jazz Orchestra with Wynton Marsalis
4 Concerts
Rose Theater, 8pm

HOW DO WE CREATE JAZZ MOODS?
MAY 19, 2007

COLTRANE
SEPTEMBER 14, 15 & 16, 2006

GERSHWIN
NOVEMBER 16, 17 & 18, 2006

JAZZ AND ART
FEBRUARY 22, 23 & 24, 2007

THE SONGS WE LOVE
MARCH 29, 30 & 31, 2007

Jazz at Lincoln Center proudly acknowledges:

Cadillac
Bank of America
BET J JAZZ
Bloomberg
Brooks Brothers
The Coca-Cola Company
TimeWarner

ROSE THEATER

THE ALLEN ROOM

SUBSCRIBE HERE

CONTACT INFORMATION

PAYMENT INFORMATION

80 헬베티카 서체를 사용하라

고전적이고 단정한 스위스산 서체 헬베티카(Helvetica)가 2007년에 탄생 50주년을 맞아 다시 한 번 세간의 주목을 끌었었다. '스위스 그리드' 하면 자연스럽게 헬베티카 서체가 떠오르는 것은 왜일까? 서체의 명칭이 '스위스'를 뜻하는 라틴어 '헬베티아(Helvetia)'에서 비롯되었기 때문만은 아니다. 기능주의적인 헬베티카 서체의 원형인 노이에 하스 그로테스크(Neue Haas Grotesk)체는 형식성이 강한 그리드에 적극적으로 사용되면서 1950년대의 모더니즘을 규정했다.

얇고 우아한 헬베티카 서체를 사용한 차분하면서도 세련된 타이포그래피다.

작업명
헬베티카를 사용한 다양한 작업

의뢰인
• Designcards.nu/
 Veenman Drukkers
• Kunstvlaai/Katja van
 Stiphout

사진
Beth Tondreau

헬베티카는 다양한 두께와 크기로 사용할 수 있는 서체다. 두께가 중간(미디엄)이거나 굵으면(볼드) 대개 일상적인 정보에 진지하게 접근하라는 신호다. 서체의 두께가 가늘어질수록 단순함, 명품의 고급스러움, 명상할 때와 같은 고요한 느낌을 낼 수 있다.

K_nst VI__.|A.P.I.

Art Pie International

Een boek navertellen
op video in precies
één minuut of kom
naar de Kunstvlaai A.P.I.
bij de stand van The One Minutes en
maak hier jouw boek in één minuut.
Van 10–18 mei 2008

Win 1000 euro

Westergasfabriek
Haarlemmerweg 6-8
Amsterdam
www.kunstvlaai.nl

헬베티카는 가독성이 좋은
서체라 타이포그래피의 물과
공기 같은 존재이다.

81 괘선의 두께를 다양화하라

괘선은 쓰임새가 매우 다양하다.

- 내비게이션 장치
- 표제부 장치
- 이미지의 바탕선
- 분리 장치
- 페이지의 상부 구획선

위: 언제나 짜임새를 잃지 않는
비넬리 어소시에이츠의 작업물을
웹상에 구현했다.

아래: 제목부에 프랭클린 고딕
(Franklin Gothic) 볼드체와
그에 대비되는 보도니체, 보도니
이탤릭체를 사용하여 스위스식
그리드에 이탈리아 스타일을
가미했다.

작업명
www.vignelli.com

의뢰인
Vignelli Associates

디자인
Dani Piderman

디자인 감독
Massimo Vignelli

그리드와 괘선의 대가였던
고 마시모 비넬리는 유니그리드
(Unigrid)라는 상표를 그의
웹사이트에 소개했다. 이
스프레드는 비넬리와 동료들에게
경의를 표하는 뜻이다.

다양한 두께의 괘선을 사용하여
분리하고 그 위에 정보를 담았다.

**Acerbis
Serenissimo Table
1985**

This table stresses the contrast between the heaviness of the legs and the thinness of the top. The legs are in steel covered with "Venetian stucco", an interesting revival of a traditional technique. The top, in glass, creates the look of thin and thick not dissimilar from that of a

Bodoni typeface. Another example that "Design is One".

Furniture Design 1 of 2 ▶

**Malma Pasta
Packaging**

Made with the best wheat in the world and processed in their own mills, this is one of the very best quality of pasta, made in Poland with italian equipment.

We designed a new logo and all the packages, which are red for the large market , and clear for the gourmet line, with the identification on a hanging booklet describing the product.

Packaging Design ▶ more

Transportation Graphics

*To design architectural or transportation graphics means mostly to convey the information at the point of decision. Never before, never after.
How the information is conveyed is a matter of interpretation, but even then there are quite precise rules for legibility, distance, and size of type.*

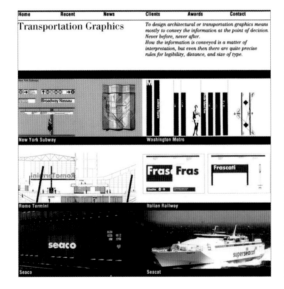

Furniture Design

We design furniture either because we can not find in the market what we need for a specific use, or because we are asked by a furniture manufacturer to design something for them. In the first case, we select the materials; in the second, we articulate the manufacturer's

resources. The manufacturer establishes certain parameters related to his market position and we work within or beyond them, to solve the problem at hand.

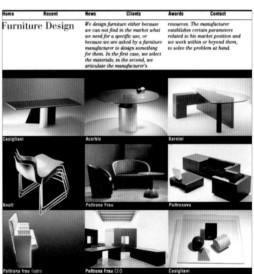

82 수평 그리드와 수직 그리드를 함께 사용하라

한 페이지를 윤곽이 뚜렷한 구역들로 분할해보자. 메모지, 기입 용지, 영수증으로 적합한 동시에 더없이 실용적인 디자인을 만들어낼 수 있다. 수평 그리드와 수직

그리드를 함께 사용하면, 정보 단위들을 하나도 빠뜨리지 않으면서도 예상 밖의 형태로 배열할 수 있다.

작업명
문구용품 영수증

의뢰인
INDUSTRIES Stationery

디자인
Drew Souza

이 영수증 디자인은 전체 지면을 분할 가능한 것으로 사고한 바우하우스 디자이너 헤르베르트 바이어(Herbert Bayer)의 미학을 구현했다.

164쪽, 165쪽: 이 명세서 겸 영수증은 한 판면 안에 수평 그리드와
수직 그리드를 혼용함으로써 여러 정보의 집합을 명확하게 구분하여
배치했다. 정보를 기입하지 않은 상태에서 보면 하나의 추상적인 구성
예술이자 기본 항목들만 배치한 기능적 구조의 영수증이다.

IS

INDUSTRIES stationery

91 Crosby Street
New York, NY 10012
212.334.4447

www.industriesstationery.com

SALES RECEIPT

DATE

REFERENCE NUMBER

SALESPERSON

SOLD TO

SHIP TO

RETURN POLICY
Merchandise may be returned for
exchange or store credit within
14 days of purchase with the store
receipt. Sale merchandise is
non-returnable. All returns must
be in saleable condition.

STORE HOURS
Monday-Saturday 11:00-7:00
Sunday Noon-6:00

ITEM NUMBER

DESCRIPTION

QUANTITY

PRICE

EXTENSION

SALES DRAFT

DATE

REFERENCE NUMBER

SALESPERSON

SOLD TO

DISCOUNT

MERCHANDISE TOTAL

SHIPPING

OTHER CHARGES

TAXABLE SUBTOTAL

SALES TAX

NON TAX SALES

TOTAL

AMOUNT PAID

BALANCE DUE

PAID BY

PAID BY

MERCHANDISE TOTAL

SHIPPING

OTHER CHARGES

DISCOUNT

TAXABLE SUBTOTAL

SALES TAX

NON TAX SALES

TOTAL

AMOUNT PAID

BALANCE DUE

83 일탈을 계획하라

잡지의 그리드 시스템은 기초를 엄격하게 적용하면 전체적인 배치가 완성된다. 그런데 구조가 너무 많으면 세상의 어떤 출판물도 매력을 잃고 지루해질 수 있다. 예상치 않았던 끼워 넣기, 중간에 끊어진 그리드나 공간 사용이 책장을 넘기는 독자들의 손을 재촉하게 한다.

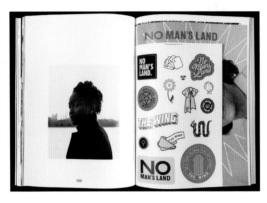

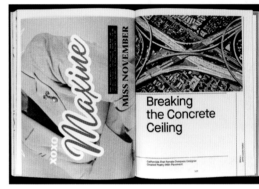

작업명
『*No Man's Land*』

의뢰인
The Wing

디자인
Pentagram

크리에이티브 디렉터
Emily Oberman

파트너
Emily Oberman

수석 디자이너
Christina Hogan

디자이너
Elizabeth Goodspeed,
Joey Petrillo

프로젝트 매니저
Anna Meixler

디자이너들이 강력하게 전체를 지배하는 그리드를 계획했지만, 포스터와 스티커를 삽입하고 타이포그래피를 활용한 시각적 유희를 디자인해 의도적으로 시스템을 방해하고 있다.

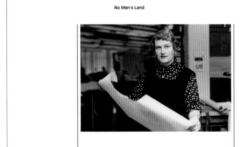

166쪽 위: '캘리포니아에서 여성으로는 처음으로 고가도로를 설계한 디자이너가 아스팔트로 쓴 시(California's First Female Overpass Designer Created Poetry with Pavement)'라는 제목의 특집 기사. 기사 자체가 그리드를 부수고 타이포그래피로 고가도로를 만들면서 콘크리트같이 견고한 작은 시를 짓는다 (탈그리드적 논평: 흥미와 재미를 둘 다 충족하는 기사다).

디지털이 맹위를 떨치는 시장에서 출판물과 독자/사용자/방문자가 친숙하게 만들기 위해 다양한 전술을 구사하는 일이 늘고 있다. 디지털 시대에 인쇄물 잡지를 통해 커뮤니티를 구축한다는 것(이 경우 공통된 철학을 가진 여성들의 커뮤니티 구축)은 위험이 따르는 일이다. 여기서 등장하는 것이 손에 만져지는 특별한 선물이다. 스티커나 비밀스럽게 접어 넣은 페이지 같은 것. 위대한 정치인을 등장시킨 포스터가 화보 모델 대신에 여성 정치인을 이달의 '미스(miss)'로 선정함으로써 잡지의 접어 넣은 페이지에 관한 낡은 고정관념을 뒤엎고 있다.

84 크기를 변화시켜라

전체 그리드가 정해져 있다면 이제 타이포그래피, 비례, 여백, 크기를 어떻게 구사할지 즐겁게 고민해보자. 이미지와 활자의 크기는 텍스트의 내용과 중요도에 따라 정해진다. 여기에 여백의 양을 얼마나 설정하느냐에 따라 역동적인 디자인이 되거나 혹은 지루한 디자인이 될 수도 있다.

책 표지. 더없이 확실한 메시지를 전달하는 이미지를 사용한 덕분에 그 아래의 활자는 최소 크기로 배치할 수 있었다.

작업명
『*What Is Green?*』

의뢰인
Design within Reach

디자인
Design within Reach Design

크리에이티브 디렉터
Jennifer Morla

아트 디렉터
Michael Sainato

디자이너
Jennifer Morla, Tim Yuan

카피라이터
Gwendolyn Horton

세계적으로 '녹색 가치', 그리고 지속 가능성에 대한 관심이 점점 높아지고 있다. 최근 디자인 위드인 리치(Design Within Reach)처럼 많은 기업이 생태에 주목하고 있다. 이 책 13페이지까지는 하나의 이슈, 하나의 이야기를 다양한 레이아웃으로 디자인하여 유려한 흐름을 만들어냈다.

첫 페이지. 그리드의 전 영역을 채운 타이포그래피로 짧지 않은 분량의 선언문을 명확하게 전달한다.

급격한 비례 변화를 구사한 목차 페이지. 수평 구조를 사용하여 편안한 흐름을 만들어냈다. 괘선 같은 장치들이 독자의 시선을 목차에 담긴 정보로 이끈다. 섬네일 이미지가 본문의 내용을 압축적으로 전달한다.

Green is up-cycling cans into a chair that lasts 150 years.

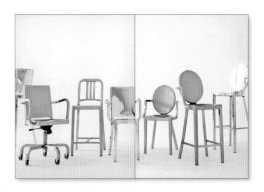

The hand-brushing department at Emeco, U.S.A.
At Emeco, all aluminum waste is recycled, even the aluminum dust that's filtered out of the air.

The upside of up-cycling aluminum: chairs for a lifetime or two.
When Emeco started making its aluminum chairs in 1944, you can be darn sure there wasn't a marketing brief that said, "Make it attractive to the eco-conscious community." Emeco had other things on its mind, namely how to make a chair withstand a torpedo blast. The irony is that Emeco chairs have become an outstanding example of what's commonly referred to as "green." To create the 1006 Navy Chair (1944), Emeco invented a 77-step process to satisfy the military's need for lightweight, corrosion-resistant chairs for destroyers and submarines. In the process, the company invented a method to make aluminum three times stronger than steel, and a chair so durable that it has an estimated lifespan of 150 years. Legend has it that Wilton Dinges, who founded Emeco in 1944, actually tossed a 1006 Navy Chair out the window of a six-story building. The people on the sidewalk below were a bit surprised, but the chair was fine, with the exception of a few scratches. Today, everything Emeco makes is still manufactured by hand using the same 77-step patented process. Emeco chairs and tables all begin with 80% recycled aluminum, which requires only 5% of the energy needed to produce virgin aluminum, and they're all made in Pennsylvania, U.S.A. Emeco's all-aluminum chairs and stools are built to last, and generations from now, when your great-great-grandchildren finally manage to wear out a chair that's tested to withstand 1,700 pounds of weight (big kids), the aluminum can be 100% recycled and made into something else. In recent years, Emeco has partnered with Philippe Starck, Norman Foster and others to create classic designs for a new century, and these collections are made in the same facility, using the same processes and by the same people who make everything else at Emeco. Perhaps Philippe Starck said it best when he explained that "working with Emeco has allowed me to use a recycled material and transform it into something that never needs to be discarded – a timeless and unbreakable chair to enjoy for a lifetime. It is a chair you never own, you just use it for a while until it is the next person's turn." On the next page you'll find Emeco chairs and stools, all of which contribute to LEED™ credit #4.2 Recycled Content (and credit #5.1 if shipped within 500 miles of Hanover, Pennsylvania). For the entire **Emeco Collection**, visit dwr.com.

DESIGN WITHIN REACH: APRIL 2008 | 11

텍스트가 차지하는 넓이가 매우 다양한 레이아웃이다. 어떤 지면에서는 텍스트 블록의 너비가 매우 넓다. 보통은 즐겨 사용하지 않는 디자인이 이 책에서는 일반적인 디자인 법칙을 넘어서서 세련된 스타일로 작용해 강력한 메시지를 전달한다. 재활용 알루미늄 소재 의자에 대해 호기심이 생겼다면 이 텍스트를 읽어보라. 의자에 대한 알찬 설명들이 책의 품격을 극대화시킨다.

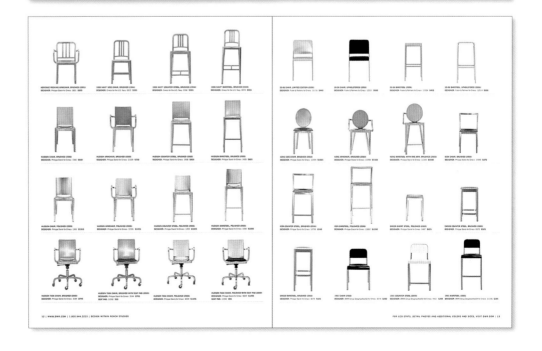

85 무엇을 뺄 수 있을지 고민하라

훌륭한 사진을 가지고 있는데 그것을 사용하지 않을
이유가 있을까? 가능하다면 가위질도 하지 말고 최대한
크게 배치하고 활자나 그래픽 장치를 모두 배제해보자.

다시 말해서, 사진을 그리드에 적용하되 그 밖의 다른
불필요한 요소는 절제하는 것이다.

작업명
잡지

의뢰인
「Bidoun」

크리에이티브 디렉터
Ketuta-Alexi Meskhishvili

디자이너
Cindy Heller

사진
Gilbert Hage (초상화),
Celia Peterson (노동자)

170, 171쪽: 어떤 그래픽 장치 없이 스스로 의미를 발산하는 사진들.
사진 배치만으로도 완벽한 디자인이다.

Cautious Radicals

Art and the
invisible majority

By Antonia Carver

At the 2005 Sharjah Biennial, artist Peter Stoffel attempted to get himself banned. Taking inspiration from the notices placed by employers in local newspapers, featuring the names, nationalities, passport numbers and mug shots of ex-employees, Stoffel requested that the biennial's organizing body fire him and announce his occupational demise in the same way. Other potential employers—presumably those organizing another biennial in the UAE—would be hiring him "at their own risk and responsibility." At the same time, the biennial would write Stoffel a recommendation letter "acknowledging his reliable services as an artist," which would be freely available to visitors to the biennial.

The artist's conceit turned out to be more potent than the proposed work itself. In keeping with the generally taboo nature of discussion surrounding the rights of the Gulf's underclass of foreign maids and laborers, the biennial organizers declined to go along with Stoffel's ruse. During the exhibition, he showed two panels of text—one a narrative explaining his concept and the outcome, the other a page from a local newspaper with advertisements placed by "sponsors" of Sri Lankans and Pakistanis who had "absconded from duty" and were therefore now outside the employer's responsibility.

For Gulf-based biennial visitors, Stoffel's project was audacious in its attempt to query the region's strict racial and financial hierarchy of workers' rights. (Since the biennial, new legislation has begun to address both the rights of the employee in the transferral of sponsorship and the prerogative of sponsors to impose the customary six-month ban—from the country, and or from working for a competitor company—on some employees.)

As he describes it, Stoffel attempted to establish a connection between the smallest minority in the UAE, that of the immigrant artist, and the largest, the immigrant laborer. (About two-thirds of the UAE's work force comes from abroad, and about a quarter of all expats work as unskilled laborers for construction companies.) Stoffel concluded that the "two parallel lines of the biennial artist and the Pakistani worker never cross, and that is the paradox of the biennial: that even as an imaginary point, within an artwork, it's impossible to establish a connection."

Despite being the largest segment within the UAE population, the foreign working class remains by and large a faceless majority, known only to the wealthy minority through increasingly bally local media stories. Every week, the usually self-censoring UAE newspapers detail gory tales of trafficking, suicide, and rape; of false promises made by dubious foreign employment agencies and mounting debts; of dehydration while working in extreme summertime heat and humidity; of industrial accidents and loan sharks; of depressed, desolate labor camps. The Indian Embassy's official list of its functions includes such grisly tasks as "processing applications received for providing free air tickets by Air India/Indian Airlines for transportation of dead bodies of destitute/stranded/absconded Indian nationals."

In many ways, the situation faced by the Gulf's legions of indentured laborers is mirrored worldwide, from Chinese cocklepickers in the UK to Mexican meatpackers in US abattoirs. But the particular state of affairs in Dubai, with its rapid growth and surface profligacy, takes a microscope to what's vaguely termed globalization.

Photos of laborers in Dubai by Celia Peterson, 2005, courtesy of Celia Peterson and ordinaryEye

86 사이드바로 말하라

사이드바란 주요 내용과 관련된 부차적인 정보를 담는 박스 장치다. 본 텍스트와 연관성은 있으나 그것과 분리해야 할 정보를 전달하는 데 매우 유용하다. 그리드 안에 사이드바를 배치하자. 본문을 방해하지 않으면서도 자연스럽게 추가 정보를 전달할 수 있다.

작업명
「*Nikkei Architecture*」

의뢰인
「*Nikkei Architecture*」

디자인
ar

이 건축산업 분야는 박스와 도표 장치로 특수한 성격의 정보를 전달한다.

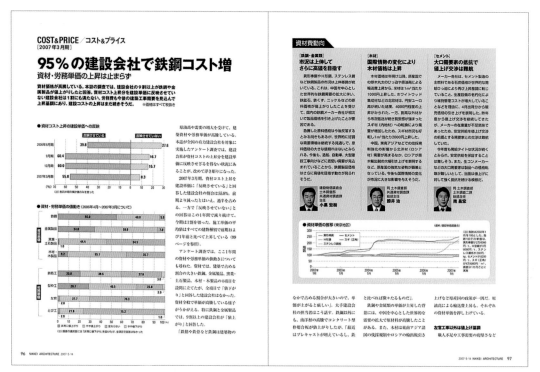

정밀하게 구조화된 그리드에는 1단, 2단, 다단 등으로 너비가 다양한 사이드바나 박스 장치를 자연스럽게 삽입할 수 있다.

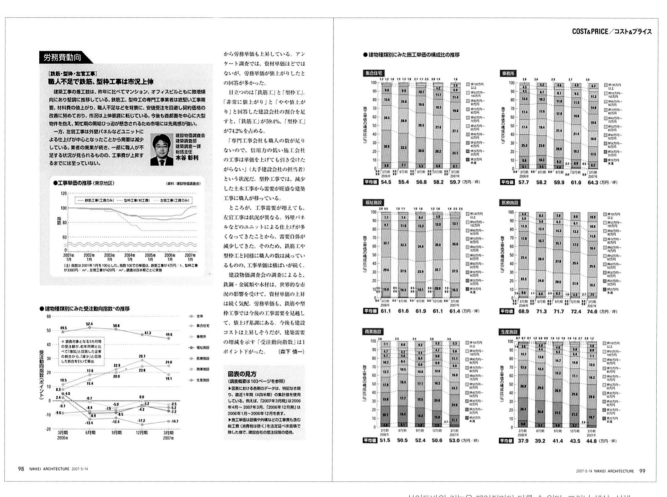

87 거장을 따르라

시각디자인 분야에서 앞서 간 선구자들의 작업을 면밀히 연구해보자. 그리고 그들의 레이아웃을 따라 하는 것을 넘어서 자신만의 독자적인 해석을 가미한 그리드를 구축하자.

저 위대한 스위스 거장들의 업적에 화답하여 오마주로서의 레이아웃을 구성해보자. 이는 그들의 특별한 부분을 그대로 따라 하는 것이 아니다. 그들이 정립한 전반적인 디자인 해법을 완전히 이해하게 되면 얼마든지 새로운 레이아웃을 구축할 수 있다.

작업명
「*étapes*」

의뢰인
Pyramyd/「*étapes*」

디자이너
Anna Tunick

디자인계의 거장 요제프 뮐러 브로크만을 다룬 잡지 기사. 가장 기본적인 그리드에 뮐러 브로크만의 약력, 그가 작업한 책 표지와 작업 과정 등을 담아낸 훌륭한 판면이다.

1914	Naissance de Josef Müller le 9 mai à Rapperswil (Suisse).
1930	Apprentissage à Zurich.
1932 – 1935	Suit les cours de Ernst Keller et Alfred Willimann à l'école des arts et métiers de Zurich.
1934	Débute sa carrière comme illustrateur, scénographe d'exposition et décorateur de théâtre.
1939-1945	Lieutenant dans l'armée suisse.
1943	Épouse Verena Brockmann (violoniste) et adopte le nom de Josef Müller-Brockmann. Courante en suisse, cette pratique le distingue des autres Müller.
1944	Naissance de leur fils Andreas.
1950	Premières commandes du Zürich Tonhalle.
1951	Membre de l'AGI.
1952-1958	Affiches de sécurité pour l'Automobile-Club de Suisse.
1956	Voyages en Amérique : conférences à Aspen et New York, voyage au Mexique avec Armin Hoffman. Songe à s'installer aux États-Unis.
1957	Nommé professeur à l'école des arts et métiers de Zurich.
1958	
1960	Quitte l'école de Zurich. Conférence à Tokyo.
1961	Second voyage au Japon.
1962	Contrats de design et de conseil en RFA. Enseigne à Ulm.
1964	Mort de Verena dans un accident de voiture.
1965	Fonde avec Eugen et Kurt Federer la Galerie 58 (puis Galerie Seestrasse) dans la maison familiale. Le lieu deviendra une référence de l'art concret. Conférences et expositions de Johannes Itten, Max Bill, Karl Gerstner… Fermeture en 1990.
1967	Fondation de Müller-Brockmann & Co avec Max Baltis, Ruedi Rüegg et Peter Andermatt et une quinzaine d'employés.
1971	Mariage avec Shizuko Yoshikawa.
1976	Brouille avec Baltis et Rüegg, qui quittent l'agence. Müller-Brockmann dirige seul l'agence jusqu'à sa fin en 1984.
1975 – 1980	Système de signalétique pour les chemins de fer suisses.
1981	
1989	
1994	
1996	Meurt le 30 août.

82:

Neue Grafik
New Graphic Design
Graphisme actuel
1

Revue *Neue*
(*Graphisme*
avec Carlos
Richard Paul
et Hans Neu

1958

J. Müller-Brockmann
Gestaltungsprobleme des Grafikers
The Graphic Artist and his Design Problems
Les problèmes d'un artiste graphique

Les Problème
artiste graph

1961

Histoire de l
communicat
visuelle.

Histoire de l
cosigné avec
Yoshikawa.

1971

Grid System
Graphic Des

1981

1989 *Fotoplakate – Von den*
Anfängen bis zur Gegenwart.

1994 *Mein Leben : Spielerischer*
Ernst und ernsthaftes Spiel, autobiogra

" *Plus la composition des éléments visuels est stricte et rigoureuse, sur la surface dont on dispose, plus l'idée du thème peut se manifester avec effi- cacité. Plus les éléments visuels sont anonymes et objectifs, mieux ils affirment leur authenticité et ont dès lors pour fonction de servir uniquement la réalisation graphique. Cette tendance est conforme à la méthode géométrique. Texte, photo, désignation des objets, sigles, emblèmes et couleurs en sont les instruments accessoires qui se subordonnent d'eux- mêmes au système des éléments, remplissent, dans la surface, elle-même créa- trice d'espace, d'image et d'efficacité, leur mission informative. On entend souvent dire, mais c'est là une opinion erronée, que cette méthode empêche l'individualité et la perso- nnalité du créateur de s'exprimer. " *

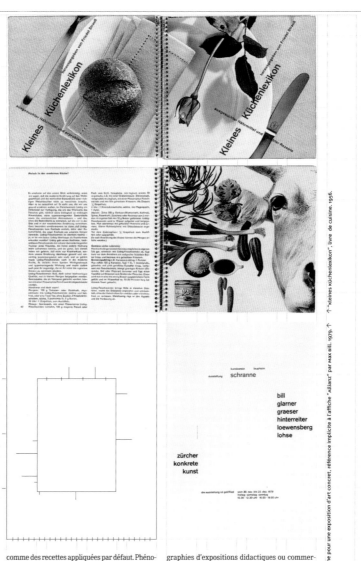

↑ "zürcher konkrete kunst", affiche pour une exposition d'art concret, référence implicite à l'affiche "Allianz" par max bill, 1979. ↑ "kleines küchenlexikon", livre de cuisine, 1956.

comme des recettes appliquées par défaut. Phéno- mène encore appuyé par la structure des logiciels de PAO, qui recourent au gabarit comme point de départ à l'édition de tout document. L'effica- cité radicale de l'abstraction sera quant à elle escamotée au profit d'effets plus spectaculaires et moins préoccupés.

ceci dit, au boulot
Depuis ses débuts de scénographe, Müller- Brockmann a réalisé un grand nombre de travaux, seul ou à la tête de son agence (1965-1984): scéno-

graphies d'expositions didactiques ou commer- ciales, identité, communication et édition (bro- chures, publicités et stands) d'entreprises pour des fabricants de carton (L + C: lithographie et cartonnage, 1954 et 1955), de machines-outils (Elmag, 1954), de machines à écrire (Addo AG, 1960) pour des fournisseurs de savon (CWS, 1958) de produits alimentaires (Nestlé, de 1956 à 1960) ou pour la chaîne de magasins néerlandais Bijenkorf (1960). En 1962, il décroche d'importants contrats auprès d'entreprises allemandes: Max Weishaupt (systèmes de chauffage) et Rosenthal

88 가까이 다가가 재단하라

그리드는 작품 전체를 장악하여 가장 중요한 요소로 부각될
수도 있고, 또는 그와 반대로 보이지 않게 뒷받침하여
어떤 이의 표현대로 '우아하고 논리적이며 다른 요소들을
방해하지 않는 레이아웃'을 구성할 수도 있다.

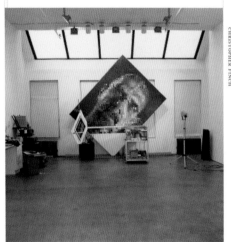

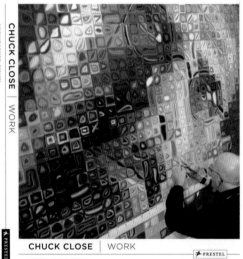

참조할 페이지

18

위: 이 책의 표지가 주는
강렬함은 단순함, 작가와
작품에의 집중력에서 비롯된
것이다. 사진은 책을 제본하기
이전 상태의 펼침면 표지다.

작업명
『*Chuck Close | Work*』

의뢰인
Prestel Publishing

디자인
Mark Melnick

절제되고 우아한 디자인으로
대형 인물화를 선보였다.

오른쪽: 책의 맨 앞과 맨 뒤의
면지에 작업 중인 작가의
옆모습을 담았다.

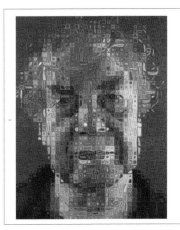

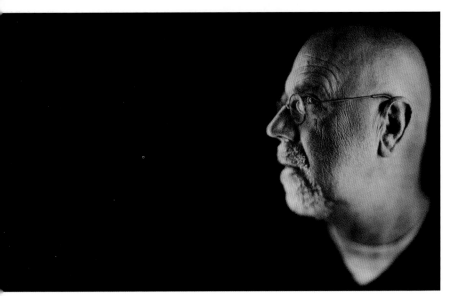

맨 위 왼쪽: 표제지. 작가의 눈을 표현한 대형 이미지다. 여기에서도 책 제목의 타이포그래피를 매우 간결하게 처리했다.

맨 위 오른쪽: 제목과 본문을 명확한 그리드 안에 배치했다.

가운데 두 컷: 이 지면에서도 본문의 그리드가 가장 두드러진다.

89 경계를 허물어라

보조적인 정보도 주 텍스트만큼 아름답게 나타낼 수 있다. 또한 잘 디자인된 부가 정보는 주 정보나 다름없이 주목을 끈다. 부록, 연대표, 각주, 서지 사항, 색인 등 책이나 카탈로그의 맨 뒤에 들어가는 자료들은 성격이

다소 복잡하다. 책의 디자인은 책 전체에 적용해야 하므로, 집중도가 조금 떨어질 수 있는 페이지도 명확하고 세련되게 디자인해야 한다.

작업명
「*Show Me Thai*」
전시회 카탈로그

의뢰인
Office of Contemporary
Art and Culture, Ministry
of Culture, Thailand

디자인
Practical Studio/Thailand

디자인 감독
Santi Lawrachawee

그래픽 디자이너
Ekaluck Peanpanawate,
Montchai Suntives

이 전시회 카탈로그는 활용도
높은 그리드를 이용하여
작업 참가자 명단을 흥미롭게
담아냈다.

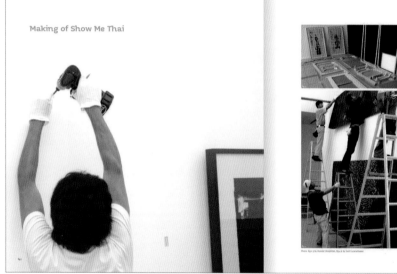

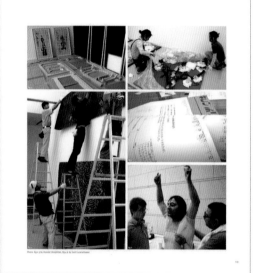

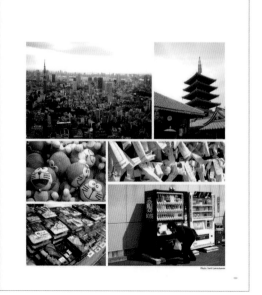

178쪽 위: 판면을 꽉 채운 사진 (왼쪽 페이지)과 그리드 안에 매우 조직적으로 배치한 사진들 (오른쪽 페이지)이 뚜렷한 대조를 이룬다.

178쪽 아래: 왼쪽 페이지에 있는 텍스트 블록의 너비는 이미지 두 개의 너비와 같다. 대개는 텍스트 블록을 이처럼 넓게 설정하지 않지만, 이 지면의 레이아웃은 매우 효과적이다.

3단 그리드와 도표를 사용하여 질서 정연한 판면을 섬세하게 구성했다.

깔끔하고 세련되면서도 흥미로운 도표 형식의 정보다. 장식적인 주요소들이 판면에 질감을 부여한다.

다층 그리드

90 모듈을 만들어라

디자인 단계를 파괴함으로써 상상 밖의 결과물을 얻을 수 있다. 색을 사용하여 형태와 여백을 규정하는 것이다. 옅은 색은 배경색이 되고, 주요한 색이 전면으로 튀어나온다. 여러 가지 색을 겹치는 방법으로 조절하여 작품 전체에 입체감을 줄 수 있다. 다양한 형태와 층을 사용하여 실험을 반복해보자. 정답은 디자이너 본인에게 달려 있다. 그 결과 황금 비율의 완벽한 예를 얻을 수 있을 것이다.

참조할 페이지
29

퍼즐은 궁극의 그리드다. "손에 익은 선들로 성가시지만 흥미를 돋우는 어떤 것을 만들어보는 것을 좋아한다"는 디자이너 마리안 반티예스는 숙련된 솜씨로 입체적인 화면을 만들어냈다.

작업명
「*The Guardian's G2*」
퍼즐 특별호 표지

의뢰인
The Guardian Media Group

디자인
Marian Bantjes

정사각형과 선을 겹쳐 사용한
표지 작업이다.

91 다차원으로 작업하라

그리드가 있는 레이아웃은 대부분 평면 차원에서 구축된다. 하지만 인쇄물, 웹사이트를 막론하고 디자이너는 담아내고자 하는 정보의 입체적 특징을 디자인으로 표현해야 한다. 그런 의미에서 브로슈어는 책이나 팸플릿 같은 평면 인쇄물과 성격이 다르다. 브로슈어는 3차원 작업을 평면으로 디자인한 뒤, 접지할 때 아코디언 접기 (안팎 교대로 접는 방식), 대문 접기(안쪽으로만 접는 방식) 등으로 페이지를 접어 입체적인 작품으로 완성한다.

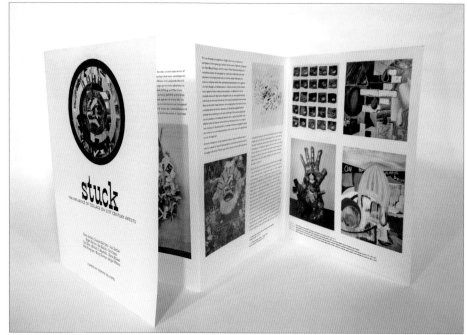

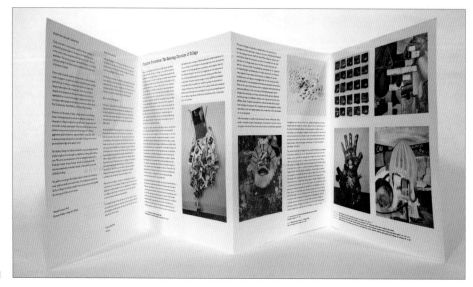

작업명
「*Stuck*」
콜라주 전시 카탈로그

의뢰인
Molloy College

갤러리 감독
Dr. Yolande Trincere

큐레이터
Suzanne Dell'Orto

디자이너
Suzanne Dell'Orto

종이 접는 방식을 정교하게 계획한 이 브로슈어는 갤러리에 선보인 작품들의 유희적 성격을 반영한다.

전통적인 그리드가 기발한 콜라주 전시 작품들을 안정적으로 뒷받침한다. 진지한 분위기의 서체와 균형 잡힌 여백으로 생명력 넘치는 브로슈어를 만들어냈다. 위쪽 사진은 브로슈어의 바깥쪽 지면이고, 아래는 안쪽 지면이다. 종이 양면에 인쇄를 하고 아코디언처럼 접은 입체적인 작업물이다.

182쪽: 브로슈어 안쪽 4페이지 중 한 면. 미술사 서적을 해체한 작품의 사진을 정연하게 배치했다. 콜라주 작품이 여러 요소를 나란히 배열하듯이 제목부에는 익살스러운 P. T. 바넘(P. T. Barnum)체를, 그리고 본문에는 길산스(Gill Sans)체를 섞어서 사용했다.

다층 그리드

92 다층적으로 생각하라

그리드가 있는 판면은 요소를 다층적으로 구성하고 배치할 수 있다. 이때 주의할 점은 다음과 같다.

- 내용의 타이포그래피는 쉽게 읽혀야 한다.
- 여백이 전체적인 구성의 성패를 좌우한다.
- 판면 구석구석을 모두 채울 필요는 없다.

다층 그리드는 기본적으로 보는 이의 관심을 유발하는 효과를 발휘한다. 나아가 다층 그리드의 심층 효과는 여러 요소를 적절히 혼합해내는 데 있다.

작업명
브랜드 포스터

의뢰인
Earth Institute at
Columbia University

크리에이티브 디렉터
Mark Inglis

디자이너
John Stislow

일러스트레이터
Mark Inglis

사진과 선 일러스트레이션, 아이콘을 여러 겹으로 쌓아 판면에 깊이 있는 느낌을 창출했다. 정보의 다층적 의미를 전달하면서도 흥미를 불러일으키는 지면이다.

브로슈어의 표지와 내지. 여러 레이어를 겹친 판면으로 입체적인 느낌을 주면서도 메시지를 분명하게 전달한다.

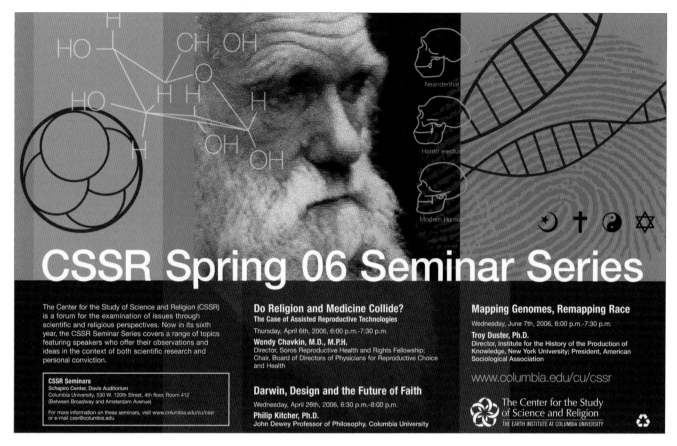

CSSR Spring 06 Seminar Series

The Center for the Study of Science and Religion (CSSR) is a forum for the examination of issues through scientific and religious perspectives. Now in its sixth year, the CSSR Seminar Series covers a range of topics featuring speakers who offer their observations and ideas in the context of both scientific research and personal conviction.

CSSR Seminars
Schapiro Center, Davis Auditorium
Columbia University, 530 W. 120th Street, 4th floor, Room 412
(Between Broadway and Amsterdam Avenue)

For more information on these seminars, visit www.columbia.edu/cu/cssr
or e-mail cssr@columbia.edu

Do Religion and Medicine Collide?
The Case of Assisted Reproductive Technologies
Thursday, April 6th, 2006, 6:00 p.m.-7:30 p.m.
Wendy Chavkin, M.D., M.P.H.
Director, Soros Reproductive Health and Rights Fellowship;
Chair, Board of Directors of Physicians for Reproductive Choice and Health

Darwin, Design and the Future of Faith
Wednesday, April 26th, 2006, 6:30 p.m.-8:00 p.m.
Philip Kitcher, Ph.D.
John Dewey Professor of Philosophy, Columbia University

Mapping Genomes, Remapping Race
Wednesday, June 7th, 2006, 6:00 p.m.-7:30 p.m.
Troy Duster, Ph.D.
Director, Institute for the History of the Production of Knowledge, New York University; President, American Sociological Association

www.columbia.edu/cu/cssr

The Center for the Study of Science and Religion
THE EARTH INSTITUTE AT COLUMBIA UNIVERSITY

사진 위에 여러 요소를 배치하고 색상의 투명도를 조절하여 세 단에
걸쳐진 타이포그래피를 부각시켰다.

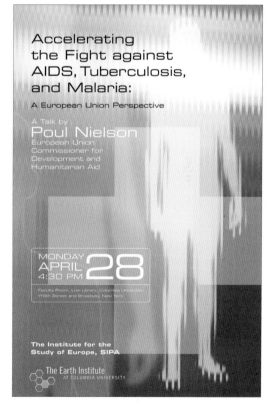

Accelerating
the Fight against
AIDS, Tuberculosis,
and Malaria:
A European Union Perspective

A Talk by
Poul Nielson
European Union
Commissioner for
Development and
Humanitarian Aid

MONDAY
APRIL
4:30 PM
28
Faculty Room, Low Library, Columbia University
116th Street and Broadway, New York

The Institute for the
Study of Europe, SIPA

The Earth Institute
AT COLUMBIA UNIVERSITY

여러 질병에 대해 논하는
강연 홍보 포스터. 당연히
타이포그래피를 제일 위
레이어에 배치했다.

93 모든 플랫폼을 지원하라

웹디자이너도 공간 구획과 색을 통해 정보를 전달한다. 때로는 의뢰인의 이름을 이용한 은유적 표현에 근거하여 색과 움직임을 결정하기도 한다. 내비게이션 장치는 박스에 담거나 구석진 곳에 배치한다. 특히 어느 페이지에서든 정보 범주 목록을 볼 수 있어야 한다. 정보의 밀도가 높은 화면은 마치 대도시의 거리와 같다. 그리드 안이 정보로 꽉 찬 사이트에서는 높은 밀도 자체가 화면의 매력이 될 수 있다.

작업명
웹사이트

의뢰인
Design Taxi

디자인
Design Taxi

디자인 감독
Alex Goh

싱가포르를 기반으로 활동하는 디자인 회사인 '디자인 택시(Design Taxi)'의 웹사이트. 여러 가지 그리드를 활용하여 프레임, 괘선, 박스, 방향 표시, 색상, 음영, 링크, 검색창 등 온갖 다양한 요소로 가득 찬 디지털 대도시로 안내한다. 단, 스타벅스 표지판은 없다.

검은색 제목 띠와 택시를 대표하는 노란색 박스 장치로 디자인 택시 특유의 분위기를 표현했다.

이 사이트는 공간을 프레임으로 구획하고 회색 음영을 활용해 많은 정보를 제공한다. 때때로 흐름이 불규칙할 수도 있다. 제목부를 html로 작성한 솜씨가 엿보인다.

기교보다는 기능을 중심으로 디자인한 타이포그래피. 지속적인 업데이트에 용이하다.

94 기울여라

모듈을 바탕으로 형태를 비스듬히 눕히거나 반복하거나 삭제하면
전체 아이덴티티 시스템의 참신함과 진취성을 유지할 수 있다.

작업명
산타 에울랄리아(Santa Eulalia)
아이덴티티 디자인

의뢰인
Santa Eulalia

디자인
Mario Eskenazi Studio

디자이너
Mario Eskenazi

바르셀로나의 유명 패션 명품
편집샵, 산타 에울랄리아를 위해
디자인 에이전시가 X자처럼
보이는 패턴을 바탕으로
아이덴티티를 디자인했다(여기서
X는 로마인들에 의해 X자 모양의
십자가에 못 박혀 죽은 카탈루냐
지방의 성녀 에울랄리아를
상징함).

2006년에 최초의 아이덴티티가
디자인된 이후 세월이 흐르는
동안 원래의 패턴을 바탕으로 한
다양한 요소(숫자, 그림문자)가
마리오 에스케나지 스튜디오에
의해 추가되었다.

188쪽: 산타 에울랄리아 아이덴티티의 양식화된 X패턴은 단순하고 직설적인 세리프체와 깔끔한 그리드를 사용한 브랜드명과 날짜, 아이덴티티 시스템 표지로 보완되어 있다.

189쪽: 아이덴티티의 기본 패턴이 확장되어 그리드가 훨씬 복잡해졌지만 X자가 포함되어 있는 것은 여전하다.

95 슈퍼 사이즈로 키워라

일상생활의 공간에서 발견할 수 있는 대형 타이포그래피 간판을 슈퍼그래픽(supergraphic)이라고 한다. 슈퍼그래픽의 원칙은 다음과 같다.

• 크기와 두께, 색의 특성을 서로 대비시켜 역동적인 레이아웃을 창조한다.

• 활자의 크기를 충분히 검토한다.
• 작업물 전체의 스케일을 고려한다. 활자가 뚜렷하게 나타나려면 판면 작업을 할 때보다 자간을 넉넉하게 설정해야 한다.

작업명
Bloomberg Dynamic
(디지털 전시)

의뢰인
Bloomberg LLP

디자인
Pentagram, New York

아트 디렉터, 디자이너, 공간 그래픽
Paula Scher

아트 디렉터, 디자이너, 화면 디자인
Lisa Strausfeld

디자이너
Jiae Kim, Andrew Freeman, Rion Byrd

프로젝트 설계
STUDIOS Architecture

프로젝트 사진
Peter Mauss/Esto

강렬한 분위기의 슈퍼그래픽. 전자 디스플레이 장치 위에 움직이는 메시지나 기업의 표지를 곁들인 몇몇 정보를 전달한다.

190쪽과 191쪽: 물질, 통계, 스타일을 혼합한 슈퍼그래픽이다.

가로 방향으로 배치된 네 개의 패널이 보여주는 역동적인 디지털 광고의 색이 수시로 바뀐다. 내용에 따라 활자의 크기와 색이 변하면서 관점과 정보를 생성한다.

96 모듈을 움직여라

지면 디자인도 그렇지만, 웹이나 모듈 그리드에 나타나는
동일한 크기의 모듈은 내용을 매우 유용하게 구획한다.
예를 들어 모듈에 동영상을 담아 웹사이트에 움직임을
가미하는 것이다.

가변성
인터랙티브 디자인에서는 유동적인 그리드와 레이아웃이
매우 중요하게 다루어지고 있다. 이제 종이의 가로세로

길이를 잴 필요가 없는 상황에서 디자이너는 무엇을
알아야 하는가? 종이 위의 세계를 그대로 화면에
재현해야 할까? 아니면 사용자 각자의 화면 크기에
따라 스스로 재구성되는 유동적인 레이아웃을 구축해야
할까? 웹디자이너들은 후자를 선호할 테지만, 유동적인
레이아웃을 구축하는 데는 매우 복잡한 기술적 문제들이
있다는 것을 알아두자.

작업명
웹사이트

의뢰인
Earth Institute at
Columbia University

크리에이티브 디렉터
Mark Inglis

디자인
Sunghee Kim, John Stislow

화면을 모듈로 구획하여 풍부하고
다채로운 정보를 실을 수 있었다.

192쪽과 193쪽 위:
이 홈페이지에서는 주
내비게이션 바 아래 공간을
모듈로 구획했다. 요소들을
다양하게 배치할 수 있는
디자인이다.

- 같은 높이에 있는 모듈들을
 수평으로 연결하여 페이지의
 발행인란(링크 삽입)으로
 사용할 수 있다.
- 모듈 하나에 한 가지 주제를
 담을 수 있다.
- 모듈 두 개를 합쳐 사이드바를
 만들 수 있다.
- 페이지 옆에 모듈들을 수직의
 긴 단으로 만들어 뉴스나
 행사 정보를 담는 게시판으로
 활용할 수 있다.
- 모듈에 영상을 담을 수 있다.

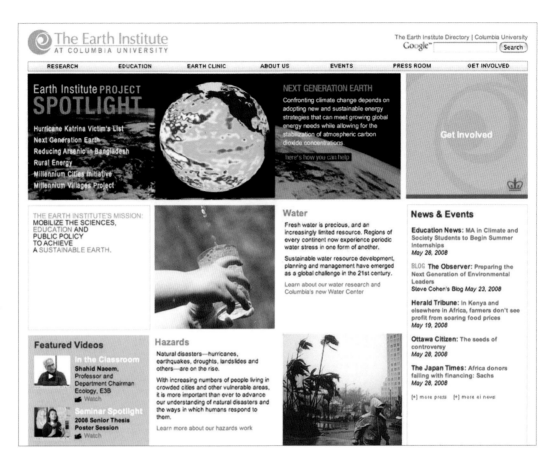

메인 페이지에서 각 정보
화면으로 들어가면 더욱
구체적인 정보를 얻을 수 있다.

모듈을 사용한 서브페이지.
정보의 성격에 따라 수평적인
계층 그리드를 더해 메인
페이지와 구별되는 화면을
만들어냈다.

97 강점에 집중하라

일류 디자이너 중에는 자신의 작업에 그리드를 사용하지 않는다고 말하는 이들도 많다.
그런데도 그들의 디자인은 공간감이 있고, 질감이 풍부하며, 당당한 위용을 자랑한다.
그들은 본능적으로 좋은 디자인을 구성하는 법칙들을 철저하게 따름으로써 정보를
명확하고, 효과적으로 전달하는 것이다.

참조할 페이지
29

다양한 실루엣의 그림 이미지들은 게임 캐릭터들이 어떻게 개발되어
게임 속에 구현되었는지를 보여준다. 수평 괘선 위에 이미지들을
올려놓았고, 아래로 살짝 내려간 괘선은 판면에 리듬감을 주었다.

작업명
『*The Art of Halo*』

의뢰인
Random House

디자인
Liney Li

원래 불사신인 게임 '헤일로
(Halo)' 속 영웅들이 불멸의 예술
작품으로 재탄생했다.

▲ The evolution of Master Chief from wire frame, rendering, and finally clad in his battle armor.

The collaborative process at Bungie wasn't confined to the Halo team. There were several Bungie artists and programmers working on other titles during the various stages of Halo's development. "I didn't do a lot on Halo—I was assigned to a team working on a different project," said character artist Juan Ramirez. "But most of us would weigh in on what we saw. I like monsters and animals and creatures—plus I'm a sculptor, so I did some sculpture designs of the early Elite.

"When I came on, I wasn't really a 'computer guy'—I was more into comics, film, that kind of thing. I try and apply that to my work here—to look at our games as more than just games. Better games equals better entertainment. A lot of that is sold through character design."

▲ One of the public's first looks at Halo came in the November, 1999 issue of Computer Gaming World: the evolution of Master Chief from wire frame, rendering, and finally clad in his battle armor.

THE MASTER CHIEF

Seven feet tall, and clad in fearsome MJOLNIR Mark V battle armor, the warrior known as The Master Chief is a product of the SPARTAN Project. Trained in the art of war since childhood, he may well hold the fate of the human race in his hands.

MARCUS LEHTO, ART DIRECTOR: "At first, Rob [artist Robt. McLees] and I were the only artists working on Halo. After that we hired Sheik [artist ShiKai Wang], who's just great from the conceptual standpoint. I'd do a preliminary version of something, then Sheik would work from that, and really enhance the concept.

"The Master Chief design sketch that really took hold came after heavy collaboration with ShiKai. One of his sketches—this kind of manga-influenced piece, with ammo bandoliers across his chest, and a big bladed weapon on his back—really caught our imagination.

"Unfortunately, when we got that version into model form, he looked a little too slender, almost effeminate. So, I took the design and tried to make it look more like a modern tank. That's how we got to the Master Chief that appears in the game."

4 THE ART OF HALO | CHARACTER DESIGN 5

고전적인 타이포그래피와 전위적
스타일의 타이포그래피를 함께
사용한 책이다. 캡션의 활자는
파란색으로 처리하여 본문과
구별했다. 좌우를 나타내는
화살표와 괘선을 오렌지색으로
강조했다.

The Spartan was huge, easily seven feet tall. Encased in pearlescent green battle armor, the man looked like a figure from mythology—otherworldly and terrifying. Master Chief SPARTAN-117 stepped from the tube and surveyed the cryo bay. The mirrored visor on his helmet made him all the more fearsome: a faceless, impassive soldier built for destruction and death.

The technician felt a pang of fear—and sorrow for the Covenant troops that would have to face this Spartan in combat.

—Excerpt from Halo: The Flood, by William C. Dietz, the novelization of the game.

An integral part of creating a good story is the creation of believable and interesting characters. Bungie's 3-D modelers craft designs of the various characters that appear in-game, which must then be "textured"—telling the game engine how light and shadow react with the model. From there, the models must be rigged so they can be animated. "Overlap is vital, particularly among modelers and animators," says animator William O'Brien. "We depend on each other for the final product to work—and none of us can settle. We always have to up it a notch."

"Our job is to bring the characters to life in the game," said Nathan Walpole, animation lead for Halo 2. "It's what we're best at. We don't use motion capture—most of us are traditional 2-D animators, so we prefer to hand-key animation. Motion capture just looks so bad when it's done poorly. We have more control over hand-keyed animation, and can produce results faster than by editing mocap."

Crafting the animations that bring life to the game characters is a painstaking process. "Usually, we start with a thumbnail sketch to build a look or feel," explained Walpole. "Then, you apply it to the 3-D model and work out the timing."

"Sometimes the timing's a bit off. It's hilarious," adds animator Mike Budd. "Everyone comes over and has a good laugh. Working together like we do keeps us fresh. There's such a variety of characters—human and alien. And you work on them in a matter of weeks. You're always working on something new and interesting."

▲ A pair of Grunts prepare to engage the enemy. Screen capture from Halo.

To design the characters' motions, the animators study virtually any source of movement for inspiration—though this can create some challenges for animator William O'Brien. "Just being surrounded by people with good senses of humor makes it easier to do your job. The drawback is, I've always had my own office. To animate a character, I often act out motions and movements; this gives you a sense of what muscle and bone actually do. But now, I have an audience. 'Hey, look at the crazy stuff Bill's doing now!' So now, I tend to do that kind of work on video, in private."

◄ Opposite page: Captions needed for illustrations 1, 2, 3, and 4.

2 | CHARACTER DESIGN 3

판면 왼쪽의 바탕에 이미지를
넣은 공간은 사이드바로
기능하는 동시에 본문에서 어떤
캐릭터를 다루는지 알려준다.

실전 그리드 **195**

98 유연하라

마진은 넉넉하게, 활자는 쉽게 읽히도록, 작품이나 책 제목은 이탤릭으로…. 하지만 때로는 이런 정해진 디자인 규칙을 잊어버리는 것이 좋다. 맥락만 확실하다면 '반칙적인' 디자인도 얼마든지 통용될 수 있다. 보는 이의 이성이나 상상력을 자극하고자 하는 커뮤니케이션에서는 때때로 규칙을 넘어선 디자인이 정답일 수도 있다.

오른쪽: 유연하다. 입체적이다. 유혹적이다.

작업명
Design and the Elastic Mind

의뢰인
Museum of Modern Art

디자인
Irma Boom, the Netherlands

표지 타이포그래피
Daniël Maarleveld

'디자인과 유연한 생각(Design and the Elastic Mind)' 전 카탈로그를 작업한 디자이너는 전통적인 디자인 방식을 버렸다. 그 결과 전시 자체에서 느껴지는 도발적이고 때로는 보는 이의 신경을 자극하는 면모가 카탈로그에 그대로 구현되었다.

Foreword

With <u>Design and the Elastic Mind</u>, The Museum of Modern Art once again ventures into the field of experimental design, where innovation, functionality, aesthetics, and a deep knowledge of the human condition combine to create outstanding artifacts. MoMA has always been an advocate of design as the foremost example of modern art's ability to permeate everyday life, and several exhibitions in the history of the Museum have attempted to define major shifts in culture and behavior as represented by the objects that facilitate and signify them. Shows like <u>Italy: The New Domestic Landscape</u> (1972), <u>Designs for Independent Living</u> (1988), <u>Mutant Materials in Contemporary Design</u> (1995), and <u>Workspheres</u> (2001), to name just a few, highlighted one of design's most fundamental roles: the translation of scientific and technological revolutions into approachable objects that change people's lives and, as a consequence, the world. Design is a bridge between the abstraction of research and the tangible requirements of real life.

The state of design is strong. In this era of fast-paced innovation, designers are becoming more and more integral to the evolution of society, and design has become a paragon for a constructive and effective synthesis of thought and action. Indeed, in the past few decades, people have coped with dramatic changes in several long-standing relationships—for instance, with time, space, information, and individuality. We must contend with abrupt changes in scale, distance, and pace, and our minds and bodies need to adapt to acquire the elasticity necessary to synthesize such abundance. Designers have contributed thoughtful concepts that can provide guidance and ease as science and technology proceed in their evolution. Design not only greatly benefits business, by adding value to its products, but it also influences policy and research without ever reneging its poietic, nonideological nature—and without renouncing beauty, efficiency, vision, and sensibility, the traits that MoMA curators have privileged in selecting examples for exhibition and for the Museum's collection.

<u>Design and the Elastic Mind</u> celebrates creators from all over the globe—their visions, dreams, and admonitions. It comprises more than two hundred design objects and concepts that marry the most advanced scientific research with the most attentive consideration of human limitations, habits, and aspirations. The objects range from

좁은 마진, 괴상한 서체, 좀처럼 눈에 띄지 않는 페이지 번호와 바닥글은 정보를 보는 이의 호기심을 유발하고 주재료의 성격을 반영하기 위해 의도적으로 계획된 것이다.

sometimes for hours, other times for minutes, using means of communication ranging from the most encrypted and syncopated to the most discursive and old-fashioned, such as talking face-to-face—or better, since even this could happen virtually, let's say nose-to-nose, at least until smells are translated into digital code and transferred to remote stations. We isolate ourselves in the middle of crowds within individual bubbles of technology, or sit alone at our computers to tune into communities of like-minded souls or to access information about esoteric topics.

Over the past twenty-five years, under the influence of such milestones as the introduction of the personal computer, the Internet, and wireless technology, we have experienced dramatic changes in several mainstays of our existence, especially our rapport with time, space, the physical nature of objects, and our own essence as individuals. In order to embrace these new degrees of freedom, whole categories of products and services have been born, from the first clocks with mechanical time-zone crowns to the most recent devices that use the Global Positioning System (GPS) to automatically update the time the moment you enter a new zone. Our options when it comes to the purchase of such products and services have multiplied, often with an emphasis on speed and automation (so much so that good old-fashioned cash and personalized transactions—the option of talking to a real person—now carry the cachet of luxury). Our mobility has increased along with our ability to communicate, and so has our capacity to influence the market with direct feedback, making us all into arbiters and opinion makers. Our idea of privacy and private property has evolved in unexpected ways, opening the door

16 top: James Powderly, Evan Roth,
Theo Watson, and HELL.
Graffiti Research Lab. L.A.S.E.R.
Tag. Prototype. 2007. 60 mW green
laser, digital projector, camera,
and custom GNU software (L.A.S.E.R.
Tag V1.0, using OpenFrameworks)

New forms of communication
transcend scale and express a
yearning to share opinions and
information. This project simulates
writing on a building. A camera
tracks the beam painter of a laser
pointer and software transmits
the action to a very powerful
projector.

17 bottom: James Powderly, Evan
Roth, Theo Watson, DASK, FOXY
LADY, and BENNETT4SENATE.
Graffiti Research Lab. L.A.S.E.R.
Tag graffiti projection system.
Prototype. 2007. 60 mW green
laser, digital projector, camera,
custom GNU software (OpenFrameworks),
and mobile broadcast unit

for debates ranging from the value of copyright to the fear of ubiquitous surveillance.[2] Software glitches aside, we are free to journey through virtual-world platforms on the Internet. In fact, for the youngest users there is almost no difference between the world contained in the computer screen and real life, to the point that some digital metaphors, like video games, can travel backward into the physical world: At least one company, called area/code, stages "video" games on a large scale, in which real people in the roles of, say, Pac Man play out the games on city streets using mobile phones and other devices.

Design and the Elastic Mind considers these changes in behavior and need. It highlights current examples of successful design translations of disruptive scientific and technological innovations, and reflects on how the figure of the designer is changing from form giver to fundamental interpreter of an extraordinarily dynamic reality. Leading up to this volume and exhibition, in the fall of 2006 The Museum of Modern Art and the science publication Seed launched a monthly salon to bring together scientists, designers, and architects to present their work and ideas to each other. Among them were Benjamin Aranda and Chris Lasch, whose presentation immediately following such a giant of the history of science as Benoit Mandelbrot was nothing short of heroic, science photographer Felice Frankel, physicist Keith Schwab, and computational design innovator Ben Fry, to name just a few.[3] Indeed, many of the designers featured in this book are engaged in exchanges with scientists, including Michael Burton and Christopher Woebken, whose work is influenced by nanophysicist Richard A. L. Jones; Elio Caccavale, whose interlocutor is Armand Marie Leroi, a biologist from the Imperial

이미지가 책의 제본 과정에서 유실될 수 있으므로 일반적인 작업에서는 금하는 디자인이다.

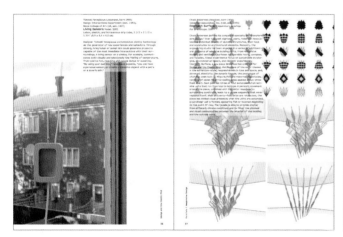

의도적으로 작품 사진 위에 활자를 겹쳐 배치했다.

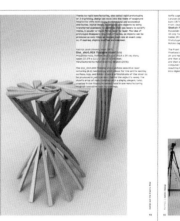

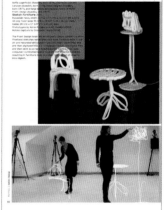

이미지 위에 반투명한 텍스트 박스를 올려놓았다.

99 마음으로 디자인하라

프로젝트에 맞는 그리드를 결정하는 일은 퍼즐을 맞추는 것과 비슷하다. 때로는 콘셉트 자체가 퍼즐이다. 내용 면에서도 그렇고 중요한 신념을 전달해야 한다는 책임 면에서도 그렇다. 그렇게 의미 있는 명분이 있으면

거기에서 받은 영감으로 귀중한 메시지를 전달하고 몸과 마음을 풍요롭게 하는 강력한 결과물을 낼 수 있다. 목표 대상을 사로잡을 커뮤니케이션에 대한 애정과 이해가 반영된 작업을 기획하는 데 중요한 요소로 작용한다.

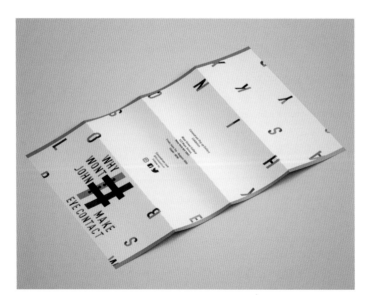

작업명
Conundrum

디자이너
Dayna Iphill,
New York City College
of Technology, 2018

교수
Douglas Davis

코넌드럼(Conundrum)은 자폐증에 대한 인식을 높이는 사업을 하는 단체다. 자폐증이 뭔지 모르는 사람들에게는 발달 장애가 불편한 문제일 수 있으므로 타이포그래피 퍼즐의 형태로 개념을 소개해놓았다. 코넌드럼의 아이덴티티 시스템으로는 로고, 포스터, 소책자, 웹사이트, 소셜 미디어 플랫폼이 있다.

198쪽: 코넌드럼의 로고/로크업은 퍼즐 모양이지만 팜플렛은 읽기 쉽도록 명료한 2단 그리드를 사용했다. 디자인 구성 요소 전체에 파란 세로 괘선이 반복적으로 등장한다.

199쪽: 팜플렛에서 본 파란 괘선이 웹사이트의 맨 위에 들어가 있다. 소셜 미디어의 화면 디자인은 단순해졌고 지하철과 버스 정류장 포스터는 퍼즐 모양의 로고에 텍스트를 통합시켜 사용하고 있다.

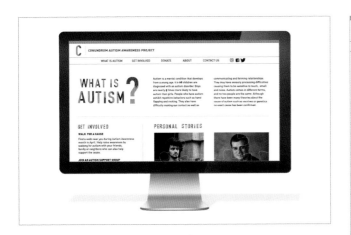

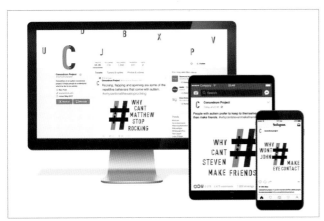

100 규칙을 무시하라

이 책은 타이포그래피, 공간, 색 등 레이아웃의 필수 요소에 관해 다루면서 그리드 시스템을 이용한 커뮤니케이션을 광범위하게 보여준다. 앞에서 언급한 것처럼 가장 중요한 규칙은 그리드 시스템으로 디자인과 내용을 연결하는 것이다. 타이포그래피에 유의하면서 정보의 계층 구조를 명쾌하게 설정해야 한다. 그것이 고전적이고 알기 쉬운 것이든, 다양한 서체와 무게가 경쾌하게 혼합된 것이든 마찬가지다. 레이아웃에서는 공들여 만드는 기교가 중요하다. 균형을 잡고 일관성 있게 작업하자.

이 책의 핵심 내용을 배우고 익혔으면 스스로 생각할 줄 알아야 한다. 정해진 법칙을 숙지하는 것도 중요하지만 가끔은 규칙을 깨는 것도 필요하다. 모든 것을 시시콜콜 가르쳐주는 책이나 사이트는 세상에 없다. 관찰하고 질문하고 함께 작업하면서 남들로부터 배워야 한다. 필요하면 도움을 요청하라. 유머 감각을 잃지 마라. 언제나 유연하고 집요한 자세로 임하라. 연습하고 또 연습하라. 디자인의 성공 비결은 과정을 즐기면서 같은 일을 끊임없이 반복하는 것이다. 내게도 기탄없이 질문해주기 바란다.

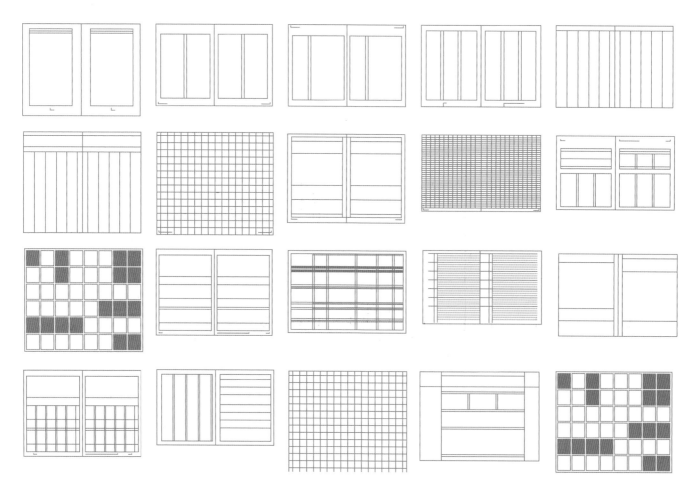

"그리드에 지배당하지 말고 그리드를 지배하라.
그리드는 사자 굴과 같다. 조련사가 안에 너무 오래 머물면 결국
잡아먹히고 만다. 언제 사자 굴 밖으로 나와야 하는지 알아야
한다. 여러분도 그리드에서 벗어나야 할 때를 알아야 한다."
–마시모 비넬리

"그리드 시스템은 보조 장치가 아니라
품질보증서다. 사용 방법이 무수히 많아서
디자이너가 자기 스타일에 맞는 해법을
모색할 수 있다. 다만, 그리드 사용법은
배워야 한다. 그것은 기술이고 기술을
구사하려면 연습이 필요하다."
–요제프 뮐러 브로크만

"그리드는 속옷과 같다. 자신을 위해 입는 것이지 남에게
보여주기 위한 것이 아니다." **–마시모 비넬리**

용어 정리

그리드 디자인 규칙을 설명하는 데 쓰이는 주요 용어들

겹치기 인쇄(Surprint): 한 번 인쇄한 뒤에 겹쳐 찍는 인쇄 방식.

고아(Orphan): 한 단락의 첫 줄이나 마지막 줄이 본문과 떨어져 다른 단(페이지)에 배치된 것을 말한다.

고채도 색(Saturated): 회색기가 거의 없는 강렬한 색이다. 채도가 높아질수록 회색의 양이 줄어든다.

네거티브 스페이스(Negative Space): 형태와 형태, 물체와 물체 사이의 공간. 주로 회화, 조각, 음악 등을 설명하는 데 쓰인다.

단(Column): 활자나 이미지를 담는 수직 방향의 면. 텍스트 자체는 수평으로 배치한다.

레이아웃(Layout): 활자, 이미지를 판면(화면)에 배치하는 것.

머리글(Running Head): 페이지 맨 위에 있는 제목부. 내용의 해당 장과 순서를 나타낸다. 머리글에 페이지 번호를 배치할 수도 있다. 같은 역할을 하는 페이지 하단의 요소는 바닥글(Running Foot)이라고 한다.

무선철 제본(Perfect Binding): 접착제를 사용하는 제본 기술. 인쇄가 된 전지를 접은 뒤 책등에 풀을 붙이고 표지를 싼 다음 책등 외의 나머지 3면을 재단한다.

미망인(Widow): 다른 단(페이지)으로 떨어져 배치된 단락 맨 끝부분의 짧은 행이나 단어 혹은 단어의 일부를 말한다. '고아'와 혼용되기도 한다. 이 책에서는 『시카고 스타일 매뉴얼(The Chicago Manual of Style)』의 설명을 따랐다.

발행인란(Masthead): 출판물에 참여한 사람들의 이름과 직함 목록. 해당 출판물의 정보를 함께 수록하기도 한다.

본문(Running Text): 내용이 빽빽한 텍스트. 제목이나 도표, 일러스트레이션 같은 요소를 함께 배치하지 않는 것이 보통이다.

부제(Deck): 태그라인과 같은 말.

부차 정보(Back Matter): 부록, 주석, 서지 사항, 용어 사전, 색인 등 본 텍스트에 속하지 않는 부수적인 정보를 말한다.

서체(Typeface): 특정한 특질이 있는 활자 디자인. 한 가지 서체의 각 활자에는 공통되는 특징이 있으며, 이탤릭체, 볼드체, 소형 대문자, 두께 설정 등을 포함한다. 서체는 디자인의 핵심이다.

스펙(Spec): 설계 명세서(specification)의 준말. 서체 사용 설명서. 요즘에는 페이지 레이아웃 프로그램의 서식 시트 기능을 사용한다.

실루엣(Silhouette): 배경을 제거하고 형상이나 물체만 남긴 이미지.

싱크(Sink): 판면에서 가장 중요한 요소 아래의 공간.

양끝 맞춤(Justify): 텍스트의 양끝을 단의 마진에 붙이는 것.

여백(White Space): 텍스트나 일러스트레이션이 없는 판면의 빈 공간.

오른쪽 끝 맞춤(Flush Right): 텍스트를 오른쪽 마진에 정렬하고 왼쪽 끝은 자유롭게 흘리는 정렬 방식.

웹 오프셋(Web Offset): 낱장이 아니라 두루마리(롤) 용지를 쓰게 되어 있는 인쇄 기계를 이용한 오프셋 인쇄(여기서 '웹'은 두루마리 또는 롤 모양의 종이를 가리킴). 이미지가 인쇄판에서 직접 종이에 인쇄되는 것이 아니라 블랭킷이라는 고무 롤러에 전사된 다음 용지에 인쇄된다.

왼쪽 끝 맞춤(Flush Left): 텍스트를 왼쪽 마진에 정렬하고 오른쪽 끝은 자유롭게 흘리는 정렬 방식.

전문(Front Matter): 책에서 본문이 시작하기 전까지의 페이지를 말한다. 표제지, 간기면, 목차 등이 여기에 속한다.

중철(Saddle Stitched): 철사나 스테이플을 사용한 제본.

타이포그래피(Typography): 활자부의 스타일, 배치, 모양을 총칭한다. 서체를 선택하고 그 서체를 이용하여 디자인하는 기술이다.

태그라인(Tagline): 본문을 압축적으로 나타내는 어구나 본문에서 추출한 짧은 인용구.

파이카(Pica): 활자 크기를 재는 단위. 1파이카는 12포인트다. 포스트스크립트식 프린터에서 1파이카는 1/6인치다.

포인트(Point): 타이포그래피의 단위. 1파이카는 12포인트고, 1인치는 대략 72포인트다.

폰트(Font, 글꼴): 디지털상에서 폰트는 단일한 스타일, 단일한 활자 체계를 말한다. 폰트를 이용하여 조판한다. 폰트는 서체와 같은 말로 쓰이기도 하지만, 엄밀히 말하자면 이 둘은 같지 않다. 폰트는 활자 설계를 뜻하고, 서체는 활자의 디자인적 속성을 말한다. 즉, 서체는 동일한 형태와 크기의 활자 한 벌을 말한다.

화소(Pixel): 컴퓨터 화면상에 나타나는 최소 단위인 4각형 점. 픽셀은 picture elements의 준말이다.

CMYK: 사이언(C), 마젠타(M), 옐로(Y), 블랙(K)으로 이루어진 색 체계. 컬러 인쇄에 사용된다.

JPEG: 'Joint Photographic Experts Group'의 두문자어. 전통적인 인쇄 제작이 아니라 인터넷에서만 사용 가능한 압축 방식이다.

RGB: 빨간색, 녹색, 파랑색. 컴퓨터 화면상의 색 체계다. 포토샵에서 스캔 이미지는 RGB로 구성된다. 오프셋 인쇄에서는 이미지를 CMYK tiff 포맷으로 처리해야 한다.

TIFF: 'Tagged Image File Format'의 두문자어. 전기적으로 저장, 전송하는 비트맵, 그레이스케일, 컬러 이미지의 파일 형식. 전통적인 인쇄 방식에 적합하다.

추천 도서와 오디오 자료

도서

스티븐 헬러(Steven Heller)의 150권이 넘는 (지금도 계속 늘어나고 있는) 그의 저서 중 아무거나

『*Anatomy of a Typeface*』, Alexander Lawson, David R. Godine Publisher, Inc., 1990.

『*Bookmaking: Editing, Design, Production*』 Third Edition, Marshall Lee, W. W. Norton & Co., 2004.

『*Chip Kidd: Book One: Work: 1986–2006*』, Chip Kidd, Rizzoli International Publications, Inc., 2005.

『*Chip Kidd: Book Two: Work: 2007–2017*』, Chip Kidd, Rizzoli International Publications, Inc., 2017.

『*Design and the Elastic Mind*』, Paola Antonelli, Museum of Modern Art, 2008.

『*Design Form and Chaos*』, Paul Rand, Yale University Press, 1993.

『*Graphic Arts Encyclopedia*』, George A. Stevenson, Revised by William A. Pakan, Design Press, 1992.

『*Grid Systems in Graphic Design*』, Müller–Brockmann, Niggli, Bilingual Edition, 1996(『디자이너를 위한 그리드 시스템』 요제프 뮐러 브로크만, 비즈앤비즈, 2017).

『*How to use graphic design to sell things, explain things, make things look better, make people laugh, make people cry, and (every once in a while) change the world*』, Michael Bierut, Harper Design, 2015.

『*Making and Breaking the Grid*』 Second Edition, Timothy Samara, Rockport Publishers, 2017.

『*Notes on Book Design*』, Derek Birdsall, Yale University Press, 2004.

『*Printing Types; Their History Forms, and Use*』 Volumes I and II, Daniel Berkeley Updike, Harvard University Press, 1966.

『*Stop Stealing Sheep & Find Out How Type Works*』, Erik Spiekermann and E. M. Ginger, Peachpit Press, 2003.

『*Stylepedia: A Guide to Graphic Design Mannerisms, Quirks, and Conceits*』, Steven Heller and Louise Fili, Chronicle Books, 2007.

『*The Elements of Typographic Style*』, Robert Bringhurst, Hartley & Marks Publishers, 1992, 1996, 2002 (『타이포그래피의 원리』, 로버트 브링허스트, 미진사, 2016).

『*Thinking with Type*』 Second, Revised and Expanded Edition, Ellen Lupton, Princeton Architectural Press, 2010 (『타이포그래피 들여다보기』, 엘런 럽튼, 비즈앤비즈, 2013).

『*Universal Principles of Design*』 William Lidwell, Kritina Holden, Jill Butler, Rockport Publishers, 2003 (『디자인 불변의 법칙 100가지』, 윌리엄 리드웰, 크리티나 홀덴, 질 버틀러, 고려문화사, 2006).

『*Visual Grammar*』, Christian Leborg, Princeton Architectural Press, 2004(『비주얼 그래머』, 크리스티안 르보, 비즈앤비즈, 2015).

웹사이트 및 기사

http://www.aiga.org/content.cfm/theyre–not–fonts
『They're not fonts!』, Allan Haley.
subtraction.com
『Grids are Good (Right)?』, Khoi Vinh.

팟캐스트

The Observatory, Design Observer
Design Matters with Debbie Millman

도움을 주신 분들과 단체

법칙 **8**, 17쪽
Sean Adams, Burning Settlers
Cabin

법칙 **7**, 16쪽;
법칙 **20**, 40-41쪽
AdamsMorioka, Inc.
Sean Adams, Chris Taillon,
Noreen Morioka, Monica
Shlaug

법칙 **32**, 64-65쪽;
법칙 **54**, 108-109쪽;
법칙 **73**, 146-147쪽;
법칙 **90**, 180-181쪽
Marian Bantjes
Marian Bantjes, Ross Mills,
Richard Turley

법칙 **4**, 13쪽;
법칙 **5**, 14쪽;
법칙 **11**, 22-23쪽;
법칙 **12**, 24쪽;
법칙 **16**, 32-33쪽;
법칙 **94**, 188-189쪽
BTD NYC

법칙 **28**, 56-57쪽;
법칙 **40**, 80-81쪽;
법칙 **64**, 128-129쪽
Carapellucci Design

법칙 **17**, 34-35쪽;
법칙 **65**, 130-131쪽
The Cathedral Church of Saint
John the Divine

법칙 **60**, 120-121쪽
Collins
Brian Collins, John Moon,
Michael Pangilnan

법칙 **18**, 36-37쪽;
법칙 **46**, 92-93쪽;
법칙 **76**, 152-153쪽
Croissant
Seiko Baba

법칙 **34**, 68-69쪽
Design Institute,
University of Minnesota
Janet Abrams, Sylvia Harris

법칙 **84**, 168-169쪽
Design within Reach/
Morla Design, Inc.
Jennifer Morla, Michael
Sainato, Tina Yuan, Gwendolyn
Horton

법칙 **93**, 186-187쪽
Design Taxi

법칙 **28**, 5-57쪽;
법칙 **71**, 142-143쪽;
법칙 **91**, 182-183쪽
Suzanne Dell'Orto

법칙 **70**, 140-141쪽
Andrea Dezsö

법칙 **22**, 44-45쪽;
법칙 **25**, 50-51쪽;
법칙 **35**, 70-71쪽;
법칙 **43**, 86-87쪽
Barbara deWilde

법칙 **72**, 144-145쪽
Simon & Schuster, Inc.
Jason Heuer

법칙 **37**, 74-75쪽;
법칙 **38**, 76-77쪽;
법칙 **56**, 112-113쪽;
법칙 **58**, 116-117쪽;
법칙 **94**, 188-189쪽
Mario Eskenazi Studio
Mario Eskenazi, Gemma
Villegas, Marc Ferrer Vives,
Dani Rubio

법칙 **42**, 84-85쪽;
법칙 **48**, 96-97쪽;
법칙 **62**, 124-125쪽;
법칙 **92**, 184-185쪽;
법칙 **96**, 192-193쪽
The Earth Institute of Columbia
University
Mark Inglis, Sunghee Kim

법칙 **19**, 38-39쪽
Heavy Meta
Barbara Glauber, Hilary
Greenbaum

법칙 **85**, 170-171쪽
Cindy Heller

법칙 **49**, 98-99쪽,
법칙 **75**, 150-151쪽,
Drew Hodges
Naomi Mizusaki

법칙 **21**, 42-43쪽
Katie Homans

법칙 **98**, 198-199쪽
Dayna Iphill

법칙 **82**, 164-165쪽
INDUSTRIES stationery
Drew Souza

법칙 **29**, 58-59쪽;
법칙 **31**, 62-63쪽;
법칙 **39**, 78-79쪽;
법칙 **53**, 106-107쪽
「暮しの手帖」
Shuzo Hayashi, Masaaki
Kuroyanagi

법칙 **97**, 194-195쪽
Liney Li

법칙 **26**, 52-53쪽;
법칙 **59**, 118-119쪽;
법칙 **79**, 158-159쪽
Bobby C. Martin Jr.

법칙 **9**, 18쪽;
법칙 **71**, 142-143쪽;
법칙 **88**, 176-177쪽
Mark Melnick Graphic Design

법칙 **5**, 14쪽;
법칙 **25**, 50-51쪽
Martha Stewart Omnimedia

법칙 **60**, 120-121쪽
The Martin Agency
Mike Hughes, Sean Riley,
Raymond McKinney,
Ty Harper

법칙 **44**, 88-89쪽;
법칙 **58**, 116-117쪽
Memo Productions
Douglas Riccardi

법칙 **27**, 54-55쪽
Metroplis magazine
Criswell Lappin

법칙 **13**, 26-27쪽
Fritz Metsch Design

법칙 **98**, 196-197쪽
The Museum of Modern Art
Irma Boom

법칙 **47**, 94-95쪽
New York City Center
Andrew Jerabek, David Saks

법칙 **30**, 60-61쪽
The New York Times
Design Director: Tk

법칙 **28**, 56-57쪽
New York University School of
Medicine

법칙 **86**, 172-173쪽
Nikkei Business Publications, Inc.

법칙 **28**, 56-57쪽
New York University School of
Medicine

법칙 **55**, 110-111쪽
Noom Studio
Punyapol "Noom" Kittayarak

법칙 **10**, 19쪽;
법칙 **12**, 25쪽;
법칙 **42**, 84-85쪽,
법칙 **50**, 84-85쪽
OCD, Original Champions of
Design
Bobby C. Martin Jr. and
Jennifer Kinon

법칙 **41**, 82-83쪽;
법칙 **83**, 166-167쪽
Pentagram, Emily Oberman,
Partner
Creative Direction, Emily
Oberman
Christina Hogan, Elizabeth
Goodspeed, Joey Petrillo, Anna
Meixler

법칙 **3**, 12쪽;
법칙 **23**, 46-47쪽;
법칙 **37**, 74-75쪽;
법칙 **38**, 76-77쪽
Open, Scott Stowell

법칙 **65**, 130-131쪽;
법칙 **95**, 190-191쪽
Pentagram Design
Paula Scher, Lisa Strausferd,
Jiae Kim, Andrew Freeman,
Rion Byrd, Peter Mauss/Esto

법칙 **24**, 48-49쪽
The Pew Charitable Trusts
IridiumGroup

법칙 **72**, 144-145쪽
Picador
Henry Sene Yee, Adam
Auerbach, Julyanne Young

법칙 **89**, 178-179쪽
Practical Studio/Thailand
Santi Lawrachawee, Ekaluck
Peanpanawate, Montchai
Suntives

법칙 **67**, 134-135쪽
Rebecca Rose

법칙 **57**, 114-115쪽
SpotCo
Gail Anderson, Frank Gargialo,
Edel Rodriguez

법칙 **14**, 28-29쪽;
법칙 **51**, 102-103쪽
Studio RADIA

법칙 **68**, 136-137쪽
Jacqueline Thaw Design
Jacqueline Thaw

법칙 **50**, 101쪽
ThinkFilm

법칙 **52**, 104-105쪽,
법칙 **77**, 154-155쪽,
Threaded
Kyra Clarke, Fiona Grieve,
Reghan Anderson
Phil Kelly, Desna Whaanga-
Schollum, Karyn Gibbons, Te
Raa Nehua

법칙 **15**, 30-31쪽;
법칙 **17**, 34-35쪽;
법칙 **45**, 90-91쪽
Tsang Seymour Design
Patrick Seymour, Laura Howell,
Susan Brzozowski

법칙 **66**, 132-133쪽
Anna Tunick
The New York Times and
Scholastic
Creative Direction: Judith
Christ-Lafund
Photo Illustration: Leslie
Jean-Bart

법칙 **6**, 15쪽;
법칙 **61**, 122-123쪽;
법칙 **74**, 148-149쪽;
법칙 **78**, 156-157쪽;
법칙 **87**, 174-175쪽
Anna Tunick
Pyramyd/*étapes* magazine

법칙 **63**, 126-127쪽,
법칙 **65**, 130-131쪽
Richard Turley

법칙 **36**, 72-73쪽
Two Twelve Associates
New Jersey Transit Timetables.
Principals: David Gibson, Ann
Harakawa; Project Manager:
Brian Sisco; Designers: Laura
Varacchi, Julie Park; Illustrator:
Chris Griggs; Copywriter: Lyle
Rexer

법칙 **33**, 66-67쪽
The Valentine Group
Robert Valentine

법칙 **80**, 160-161쪽
Veenman Drukkers,
Kuntsvlaai/ Katya van Stipout,
Photo Beth Tondreau

법칙 **81**, 162-163쪽
Vignelli Associates
Massimo Vignelli, Dani
Piderman

법칙 **69**, 138-139쪽
Saima Zaidi

한눈에 보는 그리드 디자인

1
재료 파악 단계

❏ 주제가 무엇인가?
❏ 길게 이어지는 본문 텍스트가 있는가?
❏ 본문 외에 요소들이 많은가? 섹션마다 제목이 있는가?
　부제가 있는가? 제목이 많은가? 그래프, 도표, 이미지가 있는가?
❏ 편집자가 정보 간의 위계를 설정했는가?
　아니면 디자이너가 직접 정보를 분류해야 하는가?
❏ 그림을 만들거나 사진을 찍어 넣어야 하는가?
❏ 전통적인 인쇄 방식으로 제작하는가?
　아니면 온라인에서 쓰일 것인가?

2
판면 기획 및
제작 사양 확인

❏ 어떻게 인쇄할 것인가?
❏ 1도 인쇄, 2도 인쇄, 4도 인쇄 여부
●●● 전통적인 방식으로 인쇄하려면 이미지를 해상도 300dpi의 tiff
　포맷으로 맞추어야 한다.
●●● 72dpi의 jpeg 포맷 파일은 인쇄에는 쓸 수 없고 온라인에만
　사용 가능하다.
❏ 본문 외에 요소들이 많은가? 섹션마다 제목이 있는가?
　부제가 있는가? 제목이 많은가? 그래프, 도표, 이미지가 있는가?
❏ 전통적인 인쇄 방식으로 제작하는가?
　아니면 온라인에서 쓰일 것인가?
❏ 판면의 재단 크기는 얼마인가?
❏ 페이지 수가 정해져 있는가? 아니면 디자이너에게 재량이 있는가?
❏ 의뢰인이나 제작자가 마진의 최소 한계치를 설정하고 있는가?

3
포맷, 마진,
서체 결정하기

❏ 여러 판면(화면)에 적용할 수 있는 가장 효과적인 포맷을 선택하라.
●●● 전문적인 내용을 다루거나 판면의 크기가 클 때는 2단 이상의
　다단 그리드를 사용하는 편이 좋다.
❏ 마진의 양을 정하라. 초보 디자이너에게 가장 까다로운 작업이라고
　할 수 있다. 시간을 두고 실험을 반복하여 최적의 마진 양을
　산출하라. 한 페이지에 많은 내용을 담아야 할지라도 여백은 언제나
　넉넉하게 두는 것이 좋다.
❏ 1단계에서 파악한 재료의 성격을 바탕으로 서체를 결정한다.
　하나의 서체를 사용하며 두께를 달리하는 것이 좋을지, 여러 서체를
　사용하는 것이 좋을지 판단한다.
●●● 대부분 컴퓨터에는 다양한 서체가 내장되어 있다. 하지만
　디자이너라면 여러 서체군을 속속들이 알고 있어야 한다.
　가끔은 대담한 서체를 사용해보자. 언제나 안전한 서체만
　사용할 수는 없다.
❏ 활자 크기와 행간을 계산하라. 실제로 초안을 짜보고, 거기에
　텍스트를 앉혀 판면이 어떻게 구성될지 가늠하라.

4
타이포그래피 구축 단계

❑ 마침표 다음에는 스페이스를 한 칸만 띄운다.

●●● 디자인 프로그램은 워드 프로세싱 프로그램과 다르다. 디자인 프로그램에서는 활자들을 다시 한 번 제대로 배열해야 한다. 한때는 구식 타이프라이터 흉내를 내느라 마침표 다음에 스페이스를 두 칸씩 준 적도 있었지만, 그렇게 하는 것은 말 그대로 구식이다.

❑ 한 단락 안에서 하이픈이 과도하게 사용되거나 텍스트가 부자연스럽게 끊기는 것을 방지하려면 소프트 리턴(자동 줄 바꿈)만 사용하라. 엔터를 사용하여 단락을 두 개로 나눠서는 안 된다.

❑ 인용구를 표시할 때는 해치마크(인치(inch), 피트(pit)를 나타내는 특수 문자)가 아니라 따옴표를 사용해야 한다.

❑ 맞춤법 검사기를 사용하라.

❑ 사용한 이탤릭체, 볼드체가 해당 서체의 것인지 확인하라. 디자인 프로그램 자체에 이탤릭체, 볼드체 설정 기능이 있더라도 그것을 사용해서는 안 된다.

❑ 행갈이가 적절한지 확인하라. 이름이 행으로 나뉜다거나 한 줄에 하이픈이 2개 이상 있거나 또는 1개라 해도 행 끝에 줄표가 붙는 것을 피하라.

❑ 종류별 이음표 사용법

줄표(—, 엠 대쉬(Em Dash)): 문법적이거나 내용적인 필요에 따라 문장을 끊어야 할 때 사용한다. 줄표의 길이는 사용 서체의 'm'의 장평과 같다.

반줄표(–, 엔 대쉬(En Dash)): 시간 표시, 숫자 연결에 쓰인다. 반줄표의 길이는 줄표의 반, 즉 사용 서체의 'n'의 장평과 같다.

하이픈(-, Hyphen): 단어나 구를 연결하는 데 쓰인다. 행의 맨 끝 활자를 쪼개는 데도 쓰인다.

꼭 체크해야 할 것
"이상한 따옴표"

"이게 아니라"
"이것입니다"

"이게 아니라"
"이것입니다"

5
효과적인 판면 구축

판면 구축

❑ 판면을 짤 때는 '미망인'과 '고아'를 피하라.(202쪽 용어 정리 참고)

❑ 이 책을 들춰 보라. 하지만 그대로 따라 하는 일은 없길 바란다.

❑ 작업물을 제작소에 넘길 때 작업에 사용한 서체와 이미지를 함께 보내야 하는데, 쿽(QuarkXpress)의 경우엔 '출력용 파일 모으기'를 해서 보내고 인디자인(InDesign)은 '패키지'로 만들어 보내야 한다.

저자 소개

베스 톤드로(Beth Tondreau)는 출판용 서적과 책 표지 디자인, 중소기업을 위한 로고, 아이덴티티 디자인, 웹사이트 개발을 전문으로 하는 디자인 회사 BTD의 설립자 겸 대표다. 현재 뉴욕시티텍대학교에서 디자인 강의를 맡고 있으며 AIGA/NY 멘토링 프로그램의 멘토, AIGA/NYC 이사회 이사로 활동하기도 했다

감사의 말

이런 책을 만들어낸다는 것은 모험이자 의미 있는 경험입니다. 나에게 이런 기회를 준 스티븐 헬러에게 감사드립니다. 또한, 인내심을 갖고 기다려준 주디스 크레시와 외교적 수완을 발휘해 준 데이비드 마티넬에게도 감사의 말을 전합니다. 이 책에 언급한 전문 디자이너들은 직접 자료를 찾아주고, 나의 의문을 해결해주었으며, 무엇보다 그들의 작품을 사용하도록 흔쾌히 허락해주었습니다. 그들 모두에게 감사와 존경의 말을 전합니다. 그들의 빛나는 재능과 아름다운 작품에서 정말 많은 것을 배웠습니다.

　나에게 교육자가 될 기회를 준 도나 데이비드는 이 책의 용어 정리에 많은 도움을 주었습니다. 감사합니다. 이 책에서 나는 '그래픽 디자인이란 협업'이라는 말을 자주 했습니다. 재니스 카라펠루치가 그 산증인입니다. 조지 가라스테기 주니어가 초판을 다시 읽고 통찰 가득한 논평과 제안을 해주었으며 덕분에 학생들과 현장에서 뛰는 디자이너들 모두에게 더 유용한 개정판을 만들 수 있었습니다. 푸냐폴 "눔" 키타야라크, 수잔 델로르토, 케이 얀 왓, 도모 다나카, 요나 하야카와, 주디스 마이클, 애나 튜닉 그리고 미셸 톤드로. 나와 시간을 함께하며 대화를 나누었던 고마운 분들입니다. 특히 예리한 관찰력과 재능의 소유자이며 믿음직하고 책임감 강하고 타의 모범이 되는 동료 패트리시아 창에게 깊은 감사를 전합니다.

　내가 가장 좋아하는 작업자 팻 오닐은 특유의 친절하고 유쾌한 성격으로 내가 이 책을 쓰는 동안 결정적으로 중요한 역할을 했습니다.

옮긴이 소개

오윤성

서울대학교 인문대학 미학과를 졸업하였다. 역사, 에세이, 처세술, 교양, 아동서 등 다양한 분야에서 활발한 번역 활동을 하고 있으며, 현재 번역에이전시 엔터스코리아에서 전문 번역가로 활동하고 있다. 옮긴 책으로는 『월터 포스터 하우 투 드로잉』, 『크리에이티브 드로잉』, 『루브르: 루브르 회화의 모든 것』 등이 있다.

이희수

서울대학교에서 언어학을 전공하고 프랑스 파리 제7대학에서 언어학과 석사 과정을 마쳤다. 현재는 영어, 프랑스어 전문 번역가로 활동하고 있으며, 옮긴 책으로는 『로고 디자인의 비밀』, 『디자이너, 디자인을 말하다』, 『그래픽 디자인을 바꾼 아이디어 100』, 『디자인 불변의 법칙 125가지』(공역), 『타이포그래피 불변의 법칙 100가지』, 『책 읽는 뇌』 등이 있다.